Arte Italiana 1960-1982

Arte Italiana 1960–1982

Arts Council
OF GREAT BRITAIN

Electa International

Electa Editrice

Editorial Director
Carlo Pirovano
Managing Editor
Stefano Magistretti
Art Director
Pierluigi Cerri
Technical Director
Gianni Gardel
Editorial
Gabriella Borsano
Gail Swerling
Layout
F.G. Confalonieri
Eliana Gelati

Introductory essays
translated by John Mitchell
Other translations by
Howard Rodger MacLean

ISBN 0 7287 0328 9

Printed in Italy

Arte Italiana 1960-1982

Hayward Gallery, London
20 October 1982 to 9 January 1983

Institute of Contemporary Arts, London
12 to 24 October 1982

Exhibition and events organised
by the Comune di Milano

Arts Council of Great Britain

The exhibition being presented at the Hayward Gallery is without doubt one of the most important exhibitions of modern Italian art to be put on abroad.

That is cause for profound satisfaction to the City of Milan, which has sponsored the venture in accordance with a policy of fostering cultural exchanges between European countries.

The exhibition is particularly complex in its planning and lay-out since it is intended to illustrate clearly and comprehensively the development of Italian art from 1960 to the present day, tracing the main lines of progress and emphasizing the most significant phases in a national and international context.

In 1976 the Palazzo Reale in Milan housed a remarkable exhibition devoted to contemporary British art, carefully planned and executed in accordance with certain historical and scientific criteria and put on under the auspices of the British Council and the Comune di Milano. The present show, organised by the City of Milan and the Arts Council of Great Britain, has availed itself of critical contributions from Guido Ballo, Renato Barilli, Flavio Caroli, Vittorio Fagone, Mercedes Garberi and Roberto Sanesi. Both exhibitions owe a debt of gratitude to Elio Santarella for all his enthusiasm and hard work and to the Arts Council and the British Council for their own invaluable help.

The current exhibition comprises work by visual artists as well as other sections devoted to performances, nuova spettacolarità and to immagine sonora. Some artists will be showing films and videocassettes. The whole adds up to a representative sample of Italian artistic endeavour over the past two decades.

Carlo Tognoli
Sindaco del Comune di Milano

This exhibition has been designed to give the public in England a critical view of Italian art as it has developed over the past twenty-two years. These have been crucial years, one of their points of departure being Lucio Fontana, who in his way of breaking with the past and confronting the future exercised a substantial influence not only in Italy but internationally as well.

Within the period concerned, the exhibition sets out to show in ten sections — with certain inevitable lacunae — the salient movements which have taken place, and attention has been given to ensure as far as possible the inclusion of all significant lines and trends. This will be of special relevance to those of the public who may be acquainted with only a few, and perhaps unrelated, aspects of Italian art. And, of course, an event such as this one — organized by a public body — should always provide a clear and in-depth coverage of its subject matter if it is to be of cultural and educational value.

In addition to the established visual arts, a place has been found in the exhibition for artists' films, videotapes and performances.

The artists represented come from all parts of Italy. This is of particular importance since Italy — unlike most other nations — has numerous and independent centres of culture with often tenuous links between them.

I believe that this exhibition will have succeeded in its aim if it opens up a wide field for dialogue and discussion.

Guido Aghina
*Assessore alla Cultura e Spettacolo
del Comune di Milano*

Contents

13 From the spirit of inquiry to the pleasure principle
Caroline Tisdall

15 The artistic climate of the Sixties
Guido Ballo

20 Towards and beyond the new abstraction
Vittorio Fagone

23 The object, the story
Roberto Sanesi

27 Arte povera, conceptual art, multimedia
Renato Barilli

30 Latest developments
Flavio Caroli

Catalogue

33 Spazialismo

37 From Azzeramento to Modulazione oggettuale

49 Arte cinetica and Arte programmata

61 Visual poetry, new writing
Roberto Sanesi

62 Poesia visiva and Nuova scrittura

71 Oggetto popolare, Immagine

110 Astrazione lirica and Nuova astrazione

149 Arte povera, Arte concettuale, Multimedia

191 Scultura

212 Nuove tendenze

237 From "naked" to "clothed" performance
Renato Barilli

238 Through the media towards a new totality in art
Vittorio Fagone

239 Performance, Nuova spettacolarità, Immagine sonora

248 Film and Video

256 Television as memory
Luciano Giaccari

259 Chronology 1960-1982
Loredana Parmesani

269 Biographies

285 Lenders and photographic credits

From the spirit of inquiry to the pleasure principle

Caroline Tisdall

In art as in life Italy, of all European countries, is still the most extreme, the most divided, and for that reason probably the most alive. The extremes may be hard to locate in this exhibition, partly through the moderation with which it has been selected, and partly because of the extraordinarily oblique and often esoteric way in which so many Italian artists reflect contemporary reality. Since this is the first full-scale exhibition of recent Italian art to be seen in this country, it might be worth considering a few of the basic characteristics which make it all so rich and tasty, so complex and sometimes so frustrating!

First of all Italy is a country with its feet in the Mediterranean, its head in the industrial north, and its heart somewhere in between. The Italian artist works with many traditions and several identities in cities which are encrusted with antiquity, crammed full of the paintings, monuments and architecture of the renaissance, mannerism and the baroque. Yet at the same time these cities are resolutely modern, blighted with speculative sprawl as more people drift from the land, glistening with the sophistication of Italian Modern Design, the cacophony of 3000 private radio stations, more TV stations and pirate videos than anywhere bar the United States.

Between north and south there is a real divide, economic and cultural as well as geographic. It has probably affected artists more than writers and film makers. Indeed it is only among the new young generation of painters that you find artists born south of Rome (Francesco Clemente, Mimmo Paladino, Nicola de Maria, all of whom now live in the various art cities of the north). Balancing this is something quite unknown in Britain: the presence in provincial places of galleries and collectors of international standing. In Bari, Naples or Pescara you can find outposts of the avant-garde which leave us standing. It's hard to imagine a dentist in Scunthorpe surrounding himself in Modern Design *and* the very latest fashion in art, but that is a reality in Italy.

It is the reality of the art market, and with it the apparatus of galleries and critics, which most dominates and conditions the Italian artist. This is more so than in other countries because in Italy there is really no other possibility. There is no cushioning of Arts Council awards or bursaries, and a far less extensive network of art schools employing teachers who can move in and out of academic work. In fact it is very rarely that college or academy are even mentioned as part of the artist's experience: the avant-garde in Italy is its own school. Community art hardly exists, and it's hard to imagine it finding much interest, let alone public funding. Even the presence of the largest Communist Party in Europe has not really changed the mould. In the past it certainly supported a figurative painter like Renato Guttuso (now familiar to London audiences through the Marlborough Gallery!). More recently with the Partito Comunista Italiano controlling many of the large cities and even with art critic G.C. Argan in office as communist mayor of Rome, the strategy has been to open up the discussion of art with generously sponsored events which retain their avant-garde nature, to bring more people in as public rather than seeking to change the practice.

Discussions about the democratisation of art in general and the Venice Biennale in particular have gone on since 1968 and have become almost another stylistic feature of Italian art, but without ever really challenging the esoteric nature and dominance of fashion and trends. Exceptions are to be found among feminist groups and video workshops, all self-funded, and indeed groups, sometimes formed in self-defence against cut-throat bohemianism, have come and gone as part of the scene since Azimuth, Gruppo T and Gruppo N with which this exhibition opens. But these groups too essentially were about autonomy and the freedom to question art within art's terms. The strategies of art in Italy have become their own brand of "politics", an absorbing and sometimes Machiavellian game which leaves little space for the "other realities" of Italian life: perpetual governmental crisis, scandals, bombs and kidnappings by Red Brigades and neo-fascists, floods and earthquakes, even the football fever which brought the World Cup home to Italy, of all these things you will find no echo. Instead you will find a search for language, a lyricism of line and a poetic handling of material often tinged with theatricality and the melancholy of several tragic and premature deaths, among them Manzoni, Lo Savio, Tancredi and — last year — Vincenzo Agnetti.

By 1960 when this exhibition begins, the cinema was already well established as the most spectacularly inventive of art forms in post-war Italy. Any view of Italy was conditioned that year by a bumper crop of films: Fellini's "La Dolce Vita", Antonioni's "L'Avventura" and Visconti's "Rocco and his Three Brothers": three different ways of exploring the extravagance, angst or social trauma of contemporary Italian life fifteen years after Fascism. In art there had been a slower recovery from the isolation of those years when Italy was cut off from the rest of Europe and particularly her natural intellectual rival, France. State manipulation of culture under Mussolini created a wariness of anything that could be used so directly, except for painters of the left like Renato Guttuso and Emilio Vedova. Guttuso's popularity was perhaps predictable, while Vedova's vitality in applying the streaming energy of gestural painting to the theatre of modern life was, for me at least, exemplary and inspiring, and no doubt difficult to follow. For most artists there was a real difficulty: the immediate past was dirty, from the realism of the early Forties and the Thirties, right back to the historical tradition of Futurism.

All the more understandable that the first generation we see in this exhibition, represented by Lucio Fontana, should have sought so deep and so long for a language of art on a higher plane, above manipulation and able to express the "modernity" of the new age. Fontana and Alberto Burri have always seemed like complementary figures to me, both seminal for a generation of younger artists. Fontana analysed the implications of our new knowledge of space and time, ranging wide to programmatic writings and manifestos on the meanings of television and so on, and then brought it all back to the picture surface, slashed or perforated, made environmental as proof of a fresh analysis of what the work of art could be. Burri probed the philosophy of materials, those great scumbled surfaces where material is material, and process is process. Between them they established a grand legacy for the next generation, particularly the arte povera strategists who were able to fuse philosophy and material, and the new generation of "lyrical abstractionist" painters who brought together analysis, colour, and minimal means.

Alongside Fontana's monochrome surfaces, his whites, yellows and blues, came Piero Manzoni's *Achromes*: manifesto pieces of philosophy, poetically demonstrating that the picture surface need not belong to traditional pigment, but to any material. Cotton wool balls, egg shells, stitched material, each had its own kind of beauty. In Manzoni, surely the most lovable of artists, the game of strategy became overt, but distinguished with a style, wit and creative invention which really did turn everything he touched to art-gold. The most famous example will be remembered by anyone who saw the long overdue retrospective organised by Germano Celant at the Tate Gallery in 1974: tins of preserved "artist's shit" to be sold for their weight in gold, and still increasing in value!

Here it is worth remembering that it was not until the mid 70s, over a decade after Manzoni's death, that his contribution was generally recognised by an international art public. Acknowledgement of Lo Savio as an independent precursor of minimalism with an extra dose of European philosophy took even longer, and it was with amazement that the subtlety of his filter drawings and simple sculptural forms came home to a public too accustomed to overlook anything that was not American innovation. This emargination is fairly common and applies equally to Italian authors, many of whom would cer-

13

tainly be better known and widely translated if they were anglophone, French or German. It is a sign of increased Italian confidence that "cultural export" has become much more strident and determined over the past five years. The days of deference are gone and Italian artists are at last receiving major exposure abroad: the "return matches" for endless hospitality offered to American and other European artists by Italian critics and collectors.

Some tendencies within Italian art, being internationalist in character, have always received attention abroad. Groups like Azimuth, Gruppo T and Gruppo N particularly, were able to link up with other artists in France, Germany and Poland and to create their own circuit of interest. In the early stages of this exhibition the legacy of Fontana can clearly be felt in the search for new visual languages through optical and kinetic art. Gruppo T which was based in Milan, and Gruppo N in Padua, combined physical works designed to challenge the perception of the visitor with elaborate "strategies" exposing the structure of the world of art and its established values or pomposities. A classic example in December 1960 was Gruppo N's "closed exhibition", a room containing nothing, though the keen critic of the newspaper *Il Resto del Carlino* wrote enthusiastically of the "excellently executed paintings" he had spied through the keyhole!

The extent to which this earlier generation had probed the workings of the art world may explain why artists who became prominent or controversial in the years after 1968 felt justified in probing esoteric regions while the post-68 debate about the democratisation of the arts continued. By the early Seventies when arte povera and performance art had all but squeezed painting out of the picture in terms of media clamour, the list of subjects you might encounter in an afternoon of Italian art had become extraordinary. Androgyny, alchemy, incest, alienation, introspection, withdrawal, voyeurism, nostalgia, enigma, archeology, mythology and the longing for immortality, all had become part of the new theatre of the arcane. In character it was predominantly Roman, reaching extremes in the immortality charades of Gino de Dominicis whose presentation of a mongol boy as part of his living tableau for Venice Biennale visitors caused a major row about the (im)morality of art. Vettor Pisani's use of living figures, usually naked, female and beautiful seemed aimed at the same enraged response, compounded with games and titles drawn from the history of the avant-garde (from the silence of Duchamp to the noise of Beuys) which were custom built for a critic like Achille Bonito Oliva who energetically promoted the return of mannerism, cynicism, and the "ideology of the traitor".

Even at its most extreme and ephemeral, Italian performance demonstrated a disconcerting consistency with what had gone before. Arte povera, poor in means, but rich in material meaning, had set the tone for a generation. Artists like Jannis Kounellis, Mario Merz, Alighiero Boetti, Michelangelo Pistoletto, Pier Paolo Calzolari and Gilberto Zorio established a poetry of materials organised with style and elegance in space and resonant with meaning which was quite without parallel in the art of the late Sixties and early Seventies, and which continues to evolve today. Like the Milanese poet Vincenzo Agnetti (d. 1982) whose work ranged from the printed polemic of *For a Political Hamlet* to recent paintings of the *Four Seasons*, they share a terrific versatility. Many of them started as painters, like Merz or Kounellis. Seen with hindsight, now that many of them are painting again, it should have been foolish ever to have thought that their inclusion of sculptural environment, photographic material and performance meant a break with painting. If they share a common characteristic it is that they all have an uncanny ability to extend the painter's eye into life and material. They explode the myth about the separation of one medium from another in art, the rivalry of this over that, and put the emphasis back on meaning, whatever the medium. In this they exemplify the point about the fusion of two lines in Italian art: the concept of Fontana and the material of Burri. It has become fashionable in certain art circles in Italy to express a jaded sense of ennui when such aspirations are mentioned. The French school of *nouvelle philosophie* has its adherents in Italy too! Translated into art terms it means: there is no such thing as progress, change / progress is an illusion, to strive to change anything through art is therefore pointless, utopian, uncool, passé. The generation who tried to, however obliquely, is now referred to as "the generation of doubt". Achille Bonito Oliva goes so far as to write of repression and masochism in their work, of depersonalisation, asceticism and "moral character". A new tune has been called, and galleries and collectors are dancing to it in delight. Now we have the rude boys, the painters of big loud canvases full of farts and references to Italian art from Masaccio to De Chirico. The spirit of "inquiry" of the old avant-garde makes way for the pleasure principle, the personal occupies the entire field of the canvas, anything goes: lechery, ambiguity, permissive messiness are such *fun* this year.

The Italian critics who selected this show have maintained their pragmatism throughout, and are therefore able to include the new rude crude painting as just one of the "new tendencies" alongside less clamorous work. They have been restrained about the "Italian-ness" of the art of this period, perhaps through wariness of anything that smacks of nationalism, perhaps through a desire to redress the balance towards something less theatrical, and perhaps too because in times of uncertainty and turmoil, options are left open. As all those nouveaux philosophes keep telling us: "Zarathustra wishes to *lose* nothing of the human race's past: he wishes to throw it all into the crucible".

The artistic climate of the Sixties

Guido Ballo

Many artists after the Second World War turned with fresh attention to Futurism, the Italian avant-garde movement which in the early years of this century had enjoyed such an influence both in Europe and America. They did this not so much for Futurism's myth of the machine or for its glorification of mechanical speed as for its new techniques in scene-setting, for its vitalism and for the freedom it preached in utilizing a wide range of materials. These artists rediscovered Umberto Boccioni and re-evaluated Giacomo Balla for their sense of the "continuous", which lent a provisional quality to every margin, and for their ideas on a more "programmed" experimentation. With his manifesto on sculpture in 1912 Boccioni was already opening the way to the multi-material development; while Futurism's concept of conveying a scene with force-lines of simultaneous universal dynamism would eventually lead to the artistic phenomenon of the "environment". As for vitalism seen as a primary expressive drive, this was to point to the poetic of the gestural sign. Balla, more methodical in his experimental analyses, was regarded in a new light for the colour and modulated rhythms with which he initiated the concept of "continuity", to be developed later by a group of artists in and around the Sixties. His "plastic complexes", objects in movement constructed in 1915, the year of his manifesto on the "Futurist Reconstruction of the Universe", also signed by Fortunato Depero, aroused curiosity among the kineticists as well as supporters of programmed art. Classifying by centres of artistic activity, one could say that Boccioni was taken up after the Second World War in Milan, by Lucio Fontana and his circle, while Balla was adopted by those who worked in Rome, by the "Form 1" group and above all by Piero Dorazio.

Certain trends in the Sixties were also affected by Metaphysical painting (another Italian vanguard of international standing) and especially by De Chirico, not by reason of his dummies or masks or his oneiric *"aggregates"* but for his sense of the ironic, for his implied sense of theatre — which was to inspire another kind of stagecraft — and also for a heightened sense of colour harmony and spatiality suspended outside time.

As a special tribute to the artist, we are opening this exhibition with one of Lucio Fontana's "spatial environments". It was on his return from Argentina to Milan in 1947 that Fontana set about establishing what was to become a mediation between the Futurist movement of the early twentieth century and the explorations carried out later by artists in the Fifties and Sixties (which were also of course subject to various international influences both from Europe and America). In creating his "spatial environments" he was motivated by a desire to overcome the pictorial two dimensions and by the impact of surroundings on behaviour. A feeling for depth also inspired his "spatial concepts" in which he punctured and cut the picture surface with his vitalistic "gestural sign". Many of these were in monochrome and he tended to the greatest simplicity of materials and means. In this respect he seemed, as it were, to be starting from scratch, going back to the beginning, showing the way to a new line in research which was to lead to arte povera and conceptual art. So it was no accident that he called these works "spatial concepts".

Fontana's first "spatial environment" was shown at the Galleria del Naviglio in 1949. To the first Futurists it owed only an urge to surpass the two dimensions, but the effect was novel and striking, with forms suspended in a dim light which seemed to enfold the visitor in a stupefying, dream-like, liquescent atmosphere. Another of Fontana's spatial environments, the *Arabesco fluorescente* at the Milan Triennale in 1951, was a linear design in neon evoking, as the artist himself said, "the trail of a torch brandished in the air". So this too was a kind of gestural sign, materialized through a constructed model in the guise of a luminous labyrinth. The spatial environment *Fonti d'energia*, which he did for the Turin exhibition "Italia 61", was more structural with taught lines of light on various planes, but its geometry and structure did not cancel out the emotive colour which provided an indefinite element and thus a different kind of maze. The spatial environment reconstructed for the present exhibition goes back to the show at Foligno in 1967 but gives an idea of the 1949 work. It transports us straight back to a universe of irrational, magical values, to a universe of the negative, of emptiness, blackness, through indeterminate spaces, with signs of lights in allusive flight. It is the concrete staging of his various "concepts". In this environment too Fontana concerned himself with the question of behaviour: the visitor at the end is forced to exit by another kind of spatial flight.

Fontana's environments are perhaps the works most obviously associated with the technical manifesto which he wrote on the occasion of the "Primo Congresso Internazionale delle Proporzionali" at the Milan Triennale in 1951. But other works of his prove themselves to be more various and complex expressions of his language, even if the result is still an elementary synthesis. His gestural sign, which consists of perforating and cutting surfaces, is charged with vitality and stems from his long experience as a sculptor: yet his "spatial concepts", while they break the surface, end by exalting it and exalting its pauses

15

and its silence. He applies sequins and fragments of vitreous stones to his surfaces, with new use of material in counterpoint to his perforations; he uses colour-free canvases to make the gestural sign more elemental and absolute; he perforates with gestural force his *Nature*, spheroidal masses of grès, concepts of another kind redolent of primordial matter from unknown planets: but his conceptual eloquence rests always on his impressive ability, on the almost musical relationships he achieves between sign and space, on his mastery of expressive means. The perfection of Lucio Fontana's workmanship was integral to each of his "spatial concepts", even though he felt the need — and was among the first in Italy and on the international art scene — to choose the path of starting again from scratch.

Piero Manzoni developed Fontana's initiative and carried the conceptual beyond the phase of perfect workmanship: in this he was influenced by other international artists such as Yves Klein, whose friend he was. But his use of materials which once would never have been employed for a picture, such as expanded polystyrene, kaolin or phosphorescent paint, fibreglass, wads of cotton-wool, cotton-wool steeped in various substances, or the division of the canvas into barely perceptible chalk-drawn squares or the crimping of the canvas itself into varied horizontal folds, all originates from the climate created by Fontana, which seemed to be reproposing Boccioni's manifesto on sculpture advocating the use of whatever material was needed to match up with new forms of expression. At the same time new international contacts were leading to the rediscovery of Schwitters, Picabia, Duchamp and other artists, near and far, who had already gone beyond the conventional limits of painting. Following this path, Manzoni arrived at lines twenty or more metres long, which could not be seen because painted on rolls of paper and shut up in a box — pure "concept". He also developed gestural ideas such as "imprints" or so-called "body-art". In this way he went beyond space as defined by vision through a new link with certain Dadaist ideas then being revived both in Europe and America. That was Piero Manzoni's contribution to going back to zero. He called into question the perfect execution of the work: he demonstrated that the work could be invisible or — even if intended to be seen — could be created of unusual *poor* or *simple* materials, in elementary and basic language.

It was in fact this feel for the elementary, rather than an absolute return to zero, which developed in the wake of Fontana. It had always existed as a trend right from the first European avant-garde movements, but it now set the new Italian artists off in other directions: some went decisively beyond the surface towards the "object picture";

others chose the minimalist road; others developed the gestural sign, or the pure sign; others created environments in motion or in some form so as to involve and provoke the behavioural participation of the visitor; while others inclined to programmed methods for new results in association with technology; and yet others, setting out to explore the purely pictorial possibilities of relations between space, colour and light, brought painting back to a new basic. In 1959, in Milan, Enrico Castellani and Piero Manzoni brought out the first number of *Azimuth*. Published in a climate of opinion dominated by the "spatial" thinking of Fontana, to whom it paid open tribute, its contents dealt with the problems of communication and consumption in modern art, the question of automatism and the notion of going "beyond the picture". It also contained reproductions, among others, of works by Fontana, Rauschenberg, Yves Klein, Schwitters, Castellani, Rotella, Arnaldo and Giò Pomodoro, Bonalumi, Mack, Tinguely, Dorazio, Manzoni, the Zero Group and Picabia. The general impression it gave was of a cultural atmosphere with no limits. Between 1955 and 1959 there was also published in Milan *Il Gesto*, founded by Baj, Sergio Dangelo and Jaguer, and calling itself the "international review of free forms". It was run by the "Movimento Arte Nucleare" who were in many respects close to the spatialists but of a more ironical primitivism owing to the presence of Baj, who used one of his "ultracorpi" in a picture composed in 1958 together with Piero Manzoni called *Achrome-Ultracorpi*. Dangelo, on the other hand, influenced by Mark Tobey's pictorial sign language and later by that of Gorky, was evolving a subtle, intimist kind of calligraphic painting. In this group the vitalistic gesture translated into spatial mazes, similar to those of Fontana, was being promoted also by Roberto Crippa. Later, in 1961-62, the exhibition "Continuità", put on in Rome and Milan before going on tour abroad, assembled the work of non-figurative artists of differing persuasions but who all felt in common the need to go "beyond the margins": an idea proposed by Balla starting with his series of *Compenetrazioni* dated 1912 and now finding fresh develpments through relationships between sign, colour and spaces, the composition no longer having a centre but becoming "a slice of the infinite".

Around 1960, in Rome, Francesco Lo Savio, a few years before his sudden death, withdrew into a search for the minimal, modulating his surfaces in space with an always mat-black metal, uniform in its purity. The result was a surface which absorbs and just shifts the light, giving off the sort of contained primal energy which Malevich had already sought in his suprematist works. In Lo

Savio, rigour verging on chaste simplicity does not exclude — rather it accentuates — imaginative inventiveness, even while reducing it to unqualified essentials.

By the end of the Fifties the pictorial sign had been developed in many ways. There had been Tobey and the so-called Pacific school, and surrealist automatism, and works inspired by Japanese writing, and all the variations of the gestural sign to be found in American action painting; there had been Gorky's particular kind of sign, which did not annul an inventive image, and the sign of Capogrossi — for instance — in Rome, which owed something to prehistoric rock painting. However, in addition to these, there emerged another kind of sign which gave a quite contrasting impression. Some years prior to 1960, Umberto Milani was showing surfaces with harsh, bald signs whose simplicity acquired a value from the rhythms between signs and spaces: later Milani abandoned this simplicity of the sign for effects of expressive corrosion, but he was among the first to launch the development of the sign in sculpture.

It can be said with certainty that Pietro Consagra is the sculptor to have developed (more than all others in Italy) the sign with original coherence into new two-dimensional plastic forms: after his period of structural sculptures, built up of linear elements (*Omaggio a Boccioni* is a clear example), Consagra began evolving his series of *Colloqui*, increasingly flattening the sculptured form into a surface where organic woods are given semantic meaning with branding marks or additions of iron or steel; then he flattened the surface further into ever thinner sheets of metal where the signs exist in a pattern of spaces which glory in their rich monochrome tones. This tenacious research, eliminating the third dimension — to remove from sculpture its totemic or at any rate statuary power — is charged with expressive abstract fervour, plastic in its always rigorously controlled definition: the simplicity of his sharp language, with its rare tendernesses, connects him with his lost roots (even though living in Rome, Consagra is of Sicilian origin, a sort of ancient Phoenician Sicilian, projected into the future), with a primal consciousness which tends to renew itself in the futuristic construction of a "città frontale", an architectural and plastic invention of semantic inspiration. In this way, Consagra always arrives at a clarity of sharp abstract rhythms, expressed with moral strenght reinforced by a trait of intransigence and a secret ancestral obsession.

The sign of the Genoese Emilio Scanavino, from 1957 and throughout the Sixties, shows the influence of surrealist automatism and abstract expressionism. It is a cursive sign which in its frenzy recalls internal confusions and which avoids

any suggestion of colour in its greys, blacks and dazzling whites. Tancredi, on the other hand, having frequented Peggy Guggenheim's circle in Venice where he was able to see the works and meet the artists of various European and American movements where the sign has often been given a quality of existential freedom or the character of a violent wrench, rendered the sign chromatically active, joyfully (and in this he was close to Fontana, even though his general lineage was more from Klee and Tobey and also Max Ernst) in spaces where the counterpoint creates movements which go beyond the margins, modulating themselves abundantly in the patterns of the signs arranged in groups, so as to provide images which can be viewed in their entirety with a serene detachment. Few artists have had such faith in life or have glorified it with such innocent and joyous wonderment as Tancredi: for this reason, when he ran into real obstacles — the difficulties and bitternesses of life which might have induced him to bend in compromise — he chose instead to break. His colour sign as it appears in his series of paintings *Venezia*, which are being shown here, loses the limitations of the stroke and turns also into line or network; it transposes into abstract spatiality imaginary voyages or the life and emotions of the lagoon: there is in his language the assimilation of an old-fashioned international culture conveyed in a singularly poetic tone of voice which parallels the Romanesque mosaics of St Mark's in its synthesis of experiences superseded by time. In the Sixties, when he moved to Milan, he turned the sign, with prophetic insight, to indicate falls in space (with terrifying little figures) as though he had a presentiment of his own end, but he also composed vast collages where the colour acquired an exciting sharpness and refinement.

Arnaldo Pomodoro has felt from the first the value of the sign in sculpture, for which he went back to pictorial and graphic examples of Klee, Wols and Gorky: but in the evolution of his plastic language the sign had not always been the determining element, chiefly due to the solidity of this materials — embossed and moulded cast lead, negative castings of the same substance, cement often left unadorned or mixed with graphite or with iron oxide or lime: and so we come to his *Muro* (1957) where his sign breaks up lines — sort of vaguely defined bars — on various planes, but in a "continuum" beyond the margins, then in volumes — cubes, spheres, columns with gashes of signs which do not obliterate the feeling of depth but charge it with an existential tension — especially as these sharp signs follow each other in rapid succession, rather in the manner of electronic music, creating a mesmeric, obsessive effect. Then at a certain moment Arnaldo Pomodoro's geometric structures

became barer, losing any sense of breaking up in ferment, resuming a more architectural aspect, where the sign itself, when it is there, is clearer and appears to have a constructional use. His *Colonna*, too, in order to convey the restlessness of instability and the provisional, does not rely on the sign in its corrosive form but on diagonal cuts which give an effect of side-slip. Arnaldo Pomodoro did not confine himself to this line of research, however, responding instead to new needs for clarity in his relationship with architecture: his *Colonna a grandi fogli*, his *Sfere*, or his *Rotanti* in the squares of different cities, his fantastic *Progetto per il Cimitero* at Urbino are telling examples of the pure sign being transposed into animated structural forms, constituting a new kind of link (not objective) with Boccioni and other avantgarde movements of the past.

Giò Pomodoro, too, in his first phase, developed the sign in sculpture, but with a more evident plastic full-bodiedness; having gone through a period of gestural vitalism, he had passed on from the sign to the idea of sculpture as a "continuous presence" (of which an example was reproduced in the first number of *Azimuth*). Before being cast in bronze or other moulding materials, this type of sculpture was fashioned with a surface — of rubber, latex, polyester, cloth — a surface deformed with studs and stitching and above all by means of the brace; a surface made to move by the artist in a chosen dimension, in a continuous dialogue with the material and its expressive possibilities. While the tension recalls the gestural act, the sign is submerged in the shifting of the planes: but the sign exists, infrequently, becoming a protuberance from the inside, as a counterpoint to the turning of the planes themselves which evoke the sense of continuity. The effect is of a sculpture (because everything is resolved in the casting) which bears the likeness of an ambiguous, sensual, surrealist substance that is poised for flight. This may be seen in the works *Fluidità contrapposta*, *Coesistenza* and *Dilatazione di presenza*, which all give an idea of surfaces that move in enigmatic and unending shifts of light and shade. With these works Giò Pomodoro in fact contributed to the development of the "object picture" and the tensions of its modulated surfaces, even though he has persistently remained a sculptor. Indeed, during the Sixties, he became attracted to carving from stone, carrying out his *Presenze continue* in black Belgian marble. From then on he abandoned the sign and concentrated on the sculptural representation of show elements, returning to the source of materials and working directly at marble quarries. Later, in the course of the Sixties, partly for a closer involvement in social life, he developed settings in which sculpture was intimately connected with

the idea of architectural structure but in the service of the community: the sketches of works already carried out — for the *Piano d'uso collettivo: a Gramsci, Ales 1977*, and *Luogo di misure* in Trani stone (1977/78) reveal a new sculptor who, while integrating architecture and sculpture, is developing abstract forms adapted to social man.

From the spatial climate engendered by Fontana there emerged on the other hand the monochrome *Superfici* of Enrico Castellani, which also contain an element of the sign: but here the sign comes from the three-dimensional elaboration of the canvas with nails behind the canvas frame which imprint the surface with embossments and introflexions: these embossments, varied with positive areas of light and negative zones of shade in their spatial modulations, create new rhythmic signs with such a rigour of perspective and compositional alignment as to make this kind of "object picture" seem like a technological prototype: but the imprecision due to the artist's manual intervention gives a breath of idiosyncratic life to the deliberate structural coldness.

The evolution of Agostino Bonalumi's "object picture" has been different. It quickly outgrew the sign and with the years matured in various ways exploring the relationships of the surfaces, which curve dynamically modulating themselves in spatial rhythms against the setting: another consequence of early Futurist premises and, more recently, of Fontana's influence. Even if the individual works are in shades — albeit sharply heightened — of the same colour, Bonalumi's object picture does not seek isolation but implicitly appeals to others of different colouring and looks for an active spatiality outside its limits: this artist has in fact created real environments and more recently has broken up his modulations with grafts from other surfaces and other potential spaces, thereby integrating painting, sculpture and architecture.

In the Sixties, Giuseppe Capogrossi continued to compose his *Superfici*, featuring a detached sign in the guise of a strictly imaginative ideogram with rhythmic assonances of modulated colour in counterpoint with a sense of continuity beyond the margins; while Alberto Burri was still putting materials to expressive use with hessian, unexpected spots of red paint and tar, scorch marks, tears and other signs arranged in secret rhythms which do not exclude effects of tonal origin, even if everything is resolved on the surface. At the same time, in Rome, Piero Dorazio, Achille Perilli, Antonio Sanfilippo and Carla Accardi, all coming from the "Forma 1" group, were developing in their different ways a kind of semantic painting. Perilli started off with a sign on white backgrounds which is still interpreted

as a journey to the unconscious with roots in Surrealist automatism. Then, after a period in which expanses of clear colour alternated with others containing allusive signs, he arrived at a subtly timbre-modulated tonal painting overturning structural surfaces; a painting in which clarity of imaginative invention is consistently backed by a non-objective rigour.

Piero Dorazio has also gone beyond the sign: he does use it in touches of colour, but since about 1960 his painting has tended towards the *Superfici*, in which the inspiration of Balla's *Compenetrazioni iridescenti* finds fresh interpretations, partly thanks to this painter's international contacts. In the "Continuità" exhibitions these *Superfici* were already proving to be among the most singular contemporary compositions: the continuous becomes a tension of subtle interweavings in which the colour, while resonant, goes beyond the simple optical vibration previously pursued by the Neo-Impressionists. The surface — although showing coloured threads which almost perceptibly wind over and under each other giving a first impression of being concerned primarily with the pictorial sign — nonetheless becomes a true "presence" where life seems to be cocooned in a many-hued euphoria, bringing us into association not with objects but with the infinite. Dorazio at a certain point opened out these interweavings: the threads turned into broad bands of colour, crossing diagonally and melding at the meeting spots to striking pictorial effect. Then, later, he broke up this pattern of interweaving and recomposed his canvas into larger elements, which were no longer geometric but existential in their matching and clashing colours. Then, after other rhythmic variations, Dorazio in these last years has invented further fantastic weaves. These consist of interrupted paint lines whose individual strokes alternate with each other in sequence, in a new relationship between space, surface and linear colour sign: the whole effect adds up to a limpid, coherent painting of great poetic value.

In the Sixties, in Milan, Mario Nigro had already developed the pictorial sign to accentuate its dynamic quality with streaks in the manner of Boccioni's lines of force: an original concept which in the following years was amplified through research into absolute elementary, with linear signs in oblique but secretly proportional relationships: the surface — or rather the wall, because Nigro also uses this with coherence — expands into another slice of the infinite, which conceals the "golden number", the mystery of cosmic measurements.

In his first phase in Rome, where he established himself in 1955, Gastone Novelli favoured the gestural sign with material effects: but after a few years he outgrew this gestural period and the real theme of his non-figurative images became the irrationality of life's continuous changes. In this journey to the unconscious, influenced by Surrealist automatism, he sought to convey the absurdity of chance collisions and encounters with sudden spell-like interjections of written phrases, giving new effects of visual poetry, where sign and word, colour, material and verbal resonance intermingle in active cohabitation. So Novelli found himself in fabulous labyrinths recalling coloured meanders which could continue forever: in fact he too took part in the exhibition "Continuità". In the clarity of colour and sign, the internal/external ambiguity of his journeying to the unconscious and escape towards the light is charged with psychic tensions and becomes a motif of disquieting but limpid fantasy, rendered in a lucidly whimsical style not unconnected with his Middle European background (Novelli was born in Vienna in 1925). His works of 1968, prepared for showing at the Venice Biennale — but no one saw them then, a few months before his death, because the climate of political protest led to his closing the room in which they were housed — were his last poetic cry: a protest against unjust war incarnated in rousing pictorial signs (although predominantly in grey with notes of red and little other colour), with writing on the surface of the paintings, which once again become total "presences" where fundamentality, or the absolute, assumes a musical clarity of tone. He was a painter-poet who, with the passing of the years, seems increasingly relevant.

But around 1960 there emerged in Italy another line of research opposed to any lyrical surrender: the trend towards programmed art, which can also be kinetic or group art. The first origins of this trend go back to Futurist and Constructivist premises, and certain Dadaist developments, to the *Compenetrazioni iridescenti* and the *Plastico mobile* of Balla, to Tatlin, Rodchenko, El Lissitsky, Gabo, to Duchamp and his *Rotary glass plaques*, to Johansen, Albers, Erlich, Moholy-Nagy and Calder. With his *Macchina inutile No. 2* Munari had already in 1933/34 revived the question of the kinetic in visual works: but the kinetic is only one aspect, and not the principal one, of programmed art, which is based primarily on the science fiction idea of working by laboratory experiments and thereby eliminating uncertainties of mood. The term "programmed art" started in Italy with a phrase used by Umberto Eco in the catalogue of an exhibition in Milan in May 1962 showing the works of Munari, Mari, Gruppo T, also called "Miriorama", and Gruppo N of Padua: it conjured up the concept of continuous experimentation with practical outlets not only in craftsmanship but in industrial production: whence arises the prospect of conveyor-belt works in which it is no longer the individual expressive element that counts but the *Gestalt*, the new form of continuous production, of becoming. Imaginative invention is not to be obliterated but controlled by cool intellect and guided towards the production of objects — not pictures or sculptures — with new industrial materials, leading to "open works" which do not seek to obtain a definitive result but are to be developed by the spectator who integrates them through his participation. They may therefore incorporate certain kinetic elements, put in motion by atmospheric, electrical or mechanical means, and their envisaged method of production tends to presuppose the myth of the no longer individualistic group: a myth because our civilization *is* individualistic, and all the groups — T, N and 1 — after a few years broke up.

The researches of Enzo Mari developed in a programmed way but with results which in the end seemed — in their connection of colour with volume in three-dimensional spaces, with surprising rhythmic variations — to evoke the coldness of distant planets: in his first phase he used cubes, all — starting with his works of 1956/57 — in varying shades between black and white: then he reinforced the spatial structure; to the horizontal-vertical he added a new element, the circle; and to shades ranging only from black to grey to white he added blue and red. Thus he arrived at his *Prog. 1059A* of 1964 in natural and black anodized aluminium and *Prog. 857* of 1952/67 and *Prog. 912* of 1968, which all reveal a lucid fantasy where everything seems mechanically "logical": a fantasy of cold Plutonic humours. Among the kineticists, "Miriorama", or Gruppo T, was formed in Milan in October 1959 by Giovanni Anceschi, Davide Boriani, Gianni Colombo and Gabriele De Vecchi, joined in 1960 by Grazia Varisco. Although in their works of those years, all of them sought a relationship with technology in their way of using programmed methods, they ended up with ironical or at any rate irrational results: Colombo's *Strutturazione pulsante* of 1959 in wood and expanded polystyrene surprises the spectator with the imperceptible electromechanical movement of the elements of its "wall", not without irony; Boriani's *Superfici magnetiche 59/62*, with its sudden and unpredictable movements of agglomerations of iron filings, is inclined to astound with another kind of irony; Anceschi's *Percorsi fluidi orizzontali* of 1962 creates ever-changing "images" with coloured liquids and bubbles of air; while De Vecchi's *Superficie in vibrazione* of 1961 assumes a sense of rhythm which, beyond his intentions, reveals moods of subtle sensibility; Grazia Varisco, finally, with *Schema luminoso variabile* of 1962/63 achieves kinetic effects

which at first sight appear fantastic even though obtained with the electro-magnetic method. But this group, like the Paduan Gruppo N (founded by Alberto Biasi, Toni Costa and Manfredo Missironi of Padua, Ennio Chiggio of Naples and Edoardo Landi of Modena) or the Roman Gruppo I (including Gastone Biggi, Nicola Carrino, Nato Frasca, Achille Pace, Pasquale Santoro and Giuseppe Uncini) soon disbanded and all the members went their own way. From Gruppo N — the most rigorous in maintaining anonymity — Toni Costa's *Visione dinamica* is among the works in which changeability of form is most clearly and tangibly expressed; Alberto Biasi, in his triptych *Ergo sum*, verges on a visual dynamic which from the rigour of its programmed technical premises arrives at effects which evoke the abstraction of dawning truth. Getulio Alviani of Udine has adopted a different, somewhat isolated stance: his recesses in steel also reveal a programmed method but have no kinetic quality: his strict rhythm, as well as his extreme technical bravura, gives tension to his surfaces with their ingenious variations which bring to mind analogies with electronic music. Lastly, there is Dadamaino who in her use of monochrome has been close to Piero Manzoni and Enrico Castellani and the climate of Azimuth; from *Volumi a moduli sfasati* of 1959/60 to *Rilievi modulari* to the more recent *Costellazioni* she achieved a new dynamic with luminous vibrations repeated on surfaces of metal or paper: these vibrations constitute signs — and in fact the *Costellazioni* are done with pen on canvas — whose dense rhythm gives a fantastic sense of endless continuity and of the elementary, which quite surpasses the artist's technological premises.

But in these last years there has been a fresh interest in the trend which impinges on behaviour: *Entrexit*, the environment of Gianni Colombo, who for some time has been pursuing his own researches in isolation, poses — as did Fontana's environments in another way from 1949 to 1967 — the question of provoking reactions, and not just on the optical-perceptive level. His *Afterstructures* for the "Trigon 67" at Graz was an early example of an environment where certain aspects of optical perception acted aggressively: in a dark cubic room, projections of light along parallel lines, in very brief flashes, set up in the retina persisting but fading impressions which were constantly being superimposed with others, for as long as the spectator could endure the experience. His environment at the Venice Biennale of 1968, *Spazio elastico*, which had been planned some years before, was made up of elastic threads in fluorescent colours, ultra-violet light and electric motors: the visitor was involved in surroundings which seemed to expand and contract so that the kinetic became an expression of relativity, of the mobility of structure, of the lack in today's man, in his behaviour, of any fixed point, despite his undisputed technological progress: all in all, in its effects, a work of high fantasy. After his "*bari-estesie*", realized at Kassel — environments in the form of tunnels where the floor and all the walls were sloped in a gradual succession of degrees so as to sensitize the visitor to varying states of psycho-physical equilibrium — Gianni Colombo in the following years built other environments from *Zoom Squares* to the *Campo praticable* and several others until this recent *Entrexit*, where in various ways the visitor is provoked and shaken out of his usual behaviour, involved ever more deeply in the ambiguity of a reality that has no fixed laws: a mode of aesthetic communication, slyly ironic, where a lucid mental dream is translated into freakish results, but with the disciplines of the new "open system" which supersede any preordained programming.

Towards and beyond
the new abstraction
Vittorio Fagone

1. The generation of artists working in Italy from the beginning of the Sixties had been the first to escape the cultural conditioning of the Fascist era.

In the Thirties and early Forties Italian art operated in a strange environment. Pressed to participate in the formation of a grand consensus by a totalitarian regime which liked to define itself as "national" and "proletarian", artists either refused and shut themselves up in silent isolation (Giorgio Morandi) or conformed and helped create the heroic figures of a new mythology (Arturo Martini and Mario Sironi). In the immediate post-war period the widespread adherence of Italian artists to the post-cubism of Picasso was governed by a sense of political commitment as much as formal concerns. The realism of artists such as Renato Guttuso constituted an original reply to the magniloquent rhetoric of the Fascist years, seeking as it did to blend artistic images with social reality in a single vision.

The Fifties saw the radicalisation of the dialectical divide between those who, following the experience of European art informel, sought a new and free lyrical dimension within an abstract framework, and figurative artists who were set on giving order, dimension and perspective to their own view of reality. This argument, among the bitterest to take place in Italian art circles this century, is understandable only if one looks at the isolation endured by Italian art during the Thirties and the early Forties: isolation from the live circuit of international art, separation from a direct contact with the drives and dreams of everyday life. The great polemic of the Fifties between supporters of the abstract and the figurative was an extreme projection of the ambiguous condition which for some twenty years had afflicted Italian art, on the one hand exalted as being of indispensable importance to a new civilization while in fact being confined to a detached role. The argument was eventually resolved from within by a new generation of figurative and abstract artists who, free from old resentments, were highly critical of the populism of the political image and favoured a swifter, if fragmented contact with everyday life and who, in the case of the abstractionists, uncovered the possibilities of a new lyricism outside any formalistic bounds. It was above all the generation of the Sixties, as represented by Piero Manzoni, who showed how old-hat and irrelevant the great Fifties squabble had become. It counted more to measure up to new ideas on the international scene; it counted more to establish the physionomy and horizons of the artist in a new set of circumstances, to find out about new processes and how to take part in them.

2. On 4th January 1960, in the Azimuth Gallery which was housed in the basement of a furniture shop at 12 Via Clerici, Milan, an exhibition entitled "La nuova concezione artistica" opened, in which the works of Manzoni and Castellani were shown with those of Breier, Holweck, Klein, Mack and Mavigner. They were all works which sought to extend the bounds of visual experimentation by exploring its objective optical dimensions. Manzoni showed two *Achromes* of 1957 and 1959, two white backgrounds covered in kaolin, and also his *Linea di m 20.01* (a long line of some twenty metres traced on a roll of paper) together with a *corpo d'aria* (body of air) of 70 centimetres. While Castellani was experimenting in concrete physical space to heighten the capacities of visual perception, Manzoni was starting his explorations on the more mental plane where all artistic processes are first conceived. During this exhibition there appeared the second and last number of the review *Azimuth*, living testimony to the radical change that had overtaken the practice of art. In it, Manzoni wrote: "The verification of new conditions and the proposing of new problems in order to find new solutions requires new yardsticks and new methods: we won't achieve take-off by running and jumping; we need wings; modifications aren't enough: the transformation must be integral. For this reason I am unable to understand painters who, while saying they are interested in modern problems, still continue to confront a picture as if it were a surface to be filled with colours and forms, conforming to taste that can be more or less appreciated, and more or less picked up. They draw a line, they take a few steps back, they look at what they've done, cocking their heads and half closing an eye, then they bound forward again, adding another line, another colour from the palette, and they continue this gymnastic feat until they've filled the picture, covered the canvas: the painting is finished: a surface of limitless possibilities is now reduced to a kind of receptacle into which have been forced and compressed unnatural colours and artificial meanings. Why not instead empty this receptacle? Why not liberate this surface? Why not try and discover the limitless significance of a total space, of pure and absolute light?" For Piero Manzoni the *integral transformation* could only take place in one direction: *there is nothing to say, you must just be, you must just live*. Lines drawn on rolls of paper, the artist's breath, bodies of air, people signed as works of art, pedestals for works of living art, were expressions of a new mode of measuring the artist's field of existence and revelation.

Azimuth was born as a review in 1959. Beside the contributions of Castellani and Manzoni it gathered the ideas of Agnetti (constant if not always explicit), contributions from the new

generation of artists who were emerging in Europe and the work of the "novissimi" poets Porta and Balestrini who would later come together in the literary Gruppo '63. The gallery too began operating in 1959 and closed in the summer of 1960. But in this short period it managed to bring together and present some important new realities in Italian and international art: the young artists who would go on to make up the Milanese Gruppo T, the Paduan members of the Gruppo N, Dadamaino, Mari and many European artists whom Manzoni had met at various international exhibitions where he had participated with Castellani and Bonalumi, including the Dutch followers of the Zero Group. Azimuth marked a turning point for the Gruppo Nucleare founded by Fontana, Baj and Dangelo. At the end of the Fifties Azimuth was advocating a sort of pre-eminence of the picture, the removal of all redundant material and colour, the recovery of an elemental space as a field for minimal, but effective and meaningful, interventions.

3. On 15th January 1960 at the Pater Gallery, 10 Via Borgonuovo, Milan, the exhibition "Miriorama 1" opened. Giovanni Anceschi, Davide Boriani, Gianni Colombo, Gabriele De Vecchi, presenting themselves as Gruppo T, all declared: "Every aspect of reality, colour, form, light, geometrical spaces and astronomical time is a different aspect of space-time: or better, a different manner of perceiving the relationship between *space* and *time*. We therefore consider reality as a continuous evolving of *phenomena* which we perceive in their *variation*. Since a reality understood in these terms has displaced in man's consciousness (or only in his intuition) a reality that is fixed and immutable, we see in the arts a tendency to express reality in terms of becoming. Therefore, considering a *work of art* as a *reality* made up of the same elements as those which comprise the reality surrounding us, it is necessary that the work itself should be in continuous variation. With this we do not refute the validity of such means as colour, form, light etc. but we redimension them admitting them into the work in the situation in which they are to be found in reality, that is to say in continuous variation which is the effect of their reciprocal relationship". It is known that at the sixth "Miriorama" exhibition Grazia Varisco was added to the other artists mentioned above. But the shows followed each other in rapid succession and enabled all exhibitors to make clear their motives and strategies for conveying a varied and changing image, for revealing the dimension of time as an active element in the perceptive process.

The contribution of Gruppo T to kinetic art as it developed in Europe and Latin America is today unanimously recognized. The utopia of programmed art reminds us of the importance, certainly not yet fully realized, of the encounter in this century between art and science. In any event, the movement always had a strongly international dimension and, in seeking to stimulate the perception of the spectator, led to a new model of what constitutes a work of art. While the other members of Gruppo T were trying out modes of visual communication which radically opposed the exclusively aesthetic use of perceptual data, Gianni Colombo was probing the terms of reference which were clearly formulated in "Miriorama 4" (February 1960) as follows: "Out of mental laziness, the only thing that many require of the artist is to fabricate solid objects; thus for years our surroundings have been filled with panels and dummies whose opaqueness and inertia prevent us from appreciating the factor of change which, in them, is solidified into the form of symbols". Colombo was convinced that "only in variation can an object show its true aspect and display its true character by emerging from the uniformity of its circumambient space. In fact, only through including the temporal component can we experience reality; the same elusiveness that characterizes the succeeding phases of a phenomenon is an essential constituent of reality, which cannot be fully expressed by means of static symbols". Hence the necessity of creating pictures, and so environments, where "an authentic element of change is incorporated which may communicate itself to the eye (and the mood) of the observer". The possibility of the picture can be realized "only in the speed of an unforeseeable order of succession" which unexpectedly disturbs habits of perception thereby becoming action and establishing a creative and original reflex.

4. In May 1965, in the studio of Lucio Fontana at 23 Corso Monforte, Milan, the works of some thirty artists were assembled and presented under the title "Zero Avant-garde". Here contributions from Italian artists such as Fontana himself, Bonalumi, Castellani, Manzoni (who had died in 1963), Simeti and Vigo offered themselves for comparison — or rather were placed side by side — with works of other artists operating on the lively international scene, i.e. Paul Bury, Hans Haacke, Heinz Mack, Otto Piene, Jesùs Soto, Gunther Uecker and several more including the Belgian and Dutch artists Leblanc, Verheyen, De Vries and Peeters. The show later travelled to two or three other cities and has an impact which we can well imagine today. Gillo Dorfles, presenting it at the Cavallino in Venice, classified the artists as "perceptivists": "perceptivists rather than op artists since, while every visual artist has to concern himself with the optical factor, these researchers are appealing first and foremost to the perceptive element as a determining substratum of every creative inspiration and every plastic or chromatic fruition. And I've used the word perceptive (and not sensory or intuitive or emotive) advisedly to underline the fact these artists are actuated by the results — known, unknown, fully demonstrated by psychologists or still sub-judice though they be — which derive from a penetrating enquiry into the perception of visual events, or rather into that type of perception which seemingly lends itself to the ambiguous, the illusory and the paradoxical". The focal point of the exhibition, typical of the wide horizons of research in the mid Sixties, consisted of new spatial structures, created both by Italian and foreign artists, which, because of their physical characteristics, were by self definition *object-pictures*. They were orientated towards a critical relationship with their environment which exposed certain spatial constants (surface, relief, depth, contour) while submitting to a fresh analysis the space-light relationship beneath the neutral appearance of the surface: the structure of the luminous picture.

The "Zero Avant-garde" exhibition not only demonstrated Fontana's readiness to help younger artists in Italy but showed how some of them (who were joined by Scheggi in other exhibitions) had taken Fontana's work (one might say teaching) as a definite point of reference and, with a diversity of strategies and results, had applied themselves to exploring the possibilities of development which the paradigm of the "spatial concept" proposed by him.

5. In the second half of the Sixties, the objectivity of the picture began to be questioned. The *idea of art*, the non-physical measure of its relationships, the possibility of providing images which had a value not beholden to their material, all became fields for fertile experiments. These were the years of vital expansion in arte povera, an art which invades nature, the environment, which breaks conventional disciplines and at the same time establishes a subtler mental rule of identification. If an object is materialized, its materiality is illusory, it is not the material of art. Particularly effective examples of this new trend may be found in the work of Fabro, Anselmo, Penone, Paolini, Mario and Marisa Merz. Also interesting in this period was the use that painters made of other media. Photography became a medium for expressing ideas and projects in meaningful sequences, as in the work of Tagliaferro, Patella and Zaza. Bruno di Bello, too, used photography as a valid means for investigating articulation of light; while Cioni Carpi, La Pietra, Berardinone and Paradiso were using film to realize the potentialities of the dynamic image. Film has in fact given rise to a new linguistic exploration, avoiding market conditioning and getting away from the fetishization

of the object. If in 1968 film was seen as an instrument for active involvement in social change and the uprisings in the big cities, in the Seventies it became a field for investigating visual phenomena, visual ideas, the formative mechanisms of the image.

In this period we should also consider the two seemingly, but only seemingly, different approaches then being used: *conceptual reflection*, the analysis of the art world together with its essential postulates, and *behaviour art* to effect the transition of art from the aesthetic to a new modality where the artist herself/himself becomes the subject as the person who experiments and provokes new ways of behaving. These two paths of enquiry met in the work of Agnetti, through his experience of Azimuth and his companionship with Manzoni and through his own activity as an acute practitioner of experimental writing. In these years he was able to formulate and apply various texts in which he theorized on the role and message of the artist and examined possible routes for revisiting the past to dramatize consciousness of the image outside any illusionistic duplication.

6. On 20th June 1970, at Mantua in the Casa del Mantegna, the show "Pittura 70" invited reflection on the practicability of painting, which at that time had been declared out of line with avantgarde research. Presenting a small line-up of painters, among whom Olivieri and Vago may be seen here in London, I wrote: "Painting remains the least dialectical yet the riskiest area to explore by those who feel that the language of signs of painting (as opposed to the depiction or representation of objects) is still vital as a characteristic instrument of human expression, who feel that painting is like writing in all its inexorable duration and density".

In the summer of 1973, at the Palazzo Sturm at Bassano, for the exhibition "Fare Pittura" (Make Paintings) — which beside Olivieri and Vago gathered together the work of Battaglia, Griffa, Guarneri, Matino and Verna — I expanded on the theme. "Raising once more the fundamental problems of painting as painting forces the artist to identify the essentials of plastic reality, to make an analysis of the pictorial process which cannot be separated from the *act of painting*, which must dispense with all equivocation of detachment or distance. The dimension of colour is the first to be debated and verified. Colour is not symbol, it does not constitute an element of representation. It is a physical field which can be manipulated in two principal ways: for continuity and the emanation of light. Line is no long writing or contour but scansion; often it is only implied by the juxtaposition of two bands of different colour or of the same colour in two different saturations. The space and the area of the canvas are not the same thing; an important aspect of space is expressed in the physicality of the support: and this is a key-point in the relationship between the surface and the support. The painting no longer has to be isolated on a flat surface nor to be enclosed within defined bounds: a painting can continue and multiply with others, it can combine according to variable modules: it can be a non-painting, existing in detachment from a rigid support".

To flesh out these ideas, I went on to explain how in the *new painting* the *process of painting* was, generally speaking, "always committed to a continuity in time and not an external one: it is a painting of becoming, of happening; by denying the three-dimensional and even the two-dimensional features of illusionism, it does not propose closed images but the possibility of a new imaginary process. Meanwhile Italian art as presented here shows certain agreements and disagreements which amount to a lively, dialectical relationship, and a healthy autonomy. Only consider when these researches first began and the depth and consistency with which they have since been carried out. There is a particular subtle and indirect play of influences: Licini's and Fontana's effects of space — abstract and diffused on the one hand, baroque and violent on the other — which one glimpses in the work of Olivieri and Vago; Dorazio and Calderara, one generation on, are seen to have heralded the work of Verna and Battaglia and of Matino".

The Italian character of this phase in painting is evident in its results. Over the years there was an unstoppable lyrical progression, but always without sentimentalism; painting drew up its composite standards of judgment; a strong individualism was shown in every chosen line of action. Without the earlier explorations which I have tried to describe, a consciuos reconquest of the painting process, the regained awareness of the new abstraction, probably could not have taken place. The boundary between conceptual formulations and experiences governed primarily by pictorial materiality is not hard to cross. Each can recharge the other in a sort of oblique dialogue. *Object pictures*, Fontana's conception of space, Manzoni's *Achromes*, Colombo's games with perception all had an undoubted influence on the new "field" of the canvas.

But more subterranean and restless is the inheritance from painters like Tancredi and Novelli, who exalt the pictorial sign with its impassioned dispersion over vibrant surfaces in a game of colour-dynamics (Tancredi) or in search of dazzling and fragmented apparitions (Novelli). Carried along by these two problematic positions — the striving for a lyrical quality of pictorial materialisation and the search for a rational, distilled scansion in the formative process — the new painting has confirmed itself as an original matrix for research in the Seventies. It is not surprising that with the coming of the Eighties the return to loud and violent images should "use" the analyses, scansions, modules and caesuras which the new painting explored first. The thread of continuity is recognizable, even if denied and contested.

What we have said about artists of the Sixties being the first generation not to be influenced somehow by the Italian national situation applies in a particular way to sculpture. The international prestige gained by Arturo Martini, Marino Marini and Giacomo Manzù did not condition the new sculptors of the Sixties. Or if it did condition them, it was only to free them from any illusionistic references. The sculpture of the Sixties (Uncini and Carrino, Spagnulo and Pardi, Staccioli and Coletta) lives in an intense rapport with its materials; it has invented calibrated geometrical shapes as signs; it has discovered a new plastic control of appearance, of the image, and of the obligation to proclaim consistency and structure. It is of singular validity as an expression of Italian artistic experience today. The least sensational perhaps, but the strongest.

The object, the story
Roberto Sanesi

As the Fifties gave way to the Sixties, with *art informel* still at its zenith (despite fissiparous tendencies within the movement and worries over its increasing imprecision of expression), one began to see in some artists of the younger generation an attempt to organize, if not theoretically justify, that chromatic, scriptory and gestural freedom which had been won in face of the excessive rigour and mimesis of the past. The art scene at that moment was dominated by an implicitly neo-romantic individualism, by a sort of striving for the unfinished, showing in some of the most significant examples a *besoin de fatalité* in the act of painting (as if reflecting a process of psychical drowning: and it was aptly that we spoke of "existential realism" resisting any pull towards naturalism). Of course, the general position was — as ever — far from simple and conflicting stimuli from various sources also introduced a note of self-contradiction.

The logic of incompleteness, of the fragment lyricized through private self-analysis or of the fragment which simply as a part of some larger whole carried in itself an obscure symbolism, had become the logic of the infinite. But the quest for a pantheistic totality was vain because the fragment was the only experience real to the painter's self and the painting, so that the presumed unity to be attained and put on show became purely hypothetical. The risk was an idealistic one, while the motivations of the younger artists was quite often in the opposite direction. For them it was not enough to affirm that the duty of *art informel*, even more than with other genres, was to seek awareness through concentrating on a detail to reach the universal (a suspect term) in order to draw from the disjointed struggle of their own existence those images laden with meaning which otherwise remain hidden by existence. Nor could they console themselves by saying that as an "apparition", as a manifestation of creative activity, any work connected with the visual arts is an image. And yet, up until then, what could later be defined as a sort of nostalgia for the image or, more precisely, for the object, only continued to be a nostalgia for the object/painting.

Meanwhile it would be unfair to forget that the use to which the *informel* was put in Italy was particular and unorthodox when compared with its origins, producing much original and talented work by painters of different generations. One only has to think, for example, of the strongly expressionistic gesturalism of Emilio Vedova, which does not conceal an architectonic memory and a desire for structuring; or the nervous organic "writing" which constitutes such an integral part of the pictures of Emilio Scanavino, who during the Sixties through an ever more insistent linguistic articulation interpreted every-day objects to the point of re-discovering an accord between form (including geometric form) and that "obscure flood of matter and sign" which is one of the characteristics of *art informel*. One must not overlook either the contacts and cross-fertilizations, mainly in the Lombard sphere of influence, between the *informel* movement and surviving traditions of impressionism and "Divisionismo", which were to lead, without any apparent break, to the development of neo-figuration.

In understanding at least some of the reasons for the last twenty years' revival of concern with the object in italian art, a revival generally untouched by a temptation to find naturalistic solutions and which probably goes back to more remote experiences (to models provided by certain previous avant-garde movements in Italian art, in particular the so-called "Metafisica", and sometimes with explicitly literary connections), one valid point of reference is the exhibition which took place at the Attico gallery in Rome during May 1960. Organized by Enrico Crispolti, Roberto Sanesi and Emilio Tadini (then known as a novelist and critic) under the title of "Possibilità di relazione", the exhibition put forward a series of hypotheses all directed towards a solution of a dialectical and "narrative" kind. Directly or indirectly, according to the sensitivity and experience of the critics and artists who provided the catalogue with theoretical texts or declarations of personal poetic intent, what one began to catch sight of in the suggestion provided by the new phenomenological perspectives which were being debated in those years, above all due to the contribution of the Italian philosopher Enzo Paci, was the need of a "project" for art and the consequent dilemma between objectivity and individualism. A dilemma accentuated by the ideological, moral and social standpoints of most of the artists and critics who, while they could not give up complete freedom of expression, did not underestimate the dangers of an excessive self-preoccupation, of a solipsism difficult to sustain and thus leading sooner or later to a stylistic conformity contrary to that very freedom of expression which they were defending against, for example, the solutions of "socialist realism". Nor did they want to risk a return to naturalistic values or at any rate to those based on a concept of mimesis.

Perhaps it was because of this predicament that some of the artists afterwards took off on a complete pillage of the object-as-the-image, with purist or neo-constructivists solutions, and others towards a sort of spectral figure painting, while yet others entrenched themselves in the *informel* or neo-surrealist positions which had already become their personal trademarks. However that may be, several of the artists

whom we still recognize as protagonists of the new objectuality (a term we must accept as meaningful for want of anything more exact) had lined up with decisive statements all marshalled round a brief quotation from Enzo Paci: "The universe is not static immobility but transcendence of *finite forms* which emerge from the infinite past to realize possible forms for the future." The declaration suggested a dynamism in "finite forms" (a metamorphosis continually in progress but not denying the object) which could be found neither in the generic psychologism of *art informel* nor in the descriptivity of traditional realism, nor in the conceptual (ideal) rigour of abstraction. It was a dynamism that suggested, together with the object, the "story". Giuseppe Romagnoni wrote: "one ought somehow establish an organism... a series of connections whose results may be continuously specified and displaced at the same moment... This organism is not the sum of various elements but the resultant of occurrences: it is something that is impelled to occur. Things in a picture must therefore be moved by narration." Valerio Adami, who had already started adopting the photograms of the "cartoon" and humanizing his own expressive modules, summed it all up by declaring that "to paint today is to enact a story". Very critical of the *informel* school ("The dynamics of reality are cast down and contorted by a banal analogy with the eddying of lifeless matter"), Emilio Tadini foresaw an "integral realism" to "overcome any superficial alternative of realism and spiritualism". In declarations like these, which imply also a possible coming together (in the "story": and one must not forget the influence at that moment of the *nouveau roman*) of pictorial representation and verbal description, one sees the reaching out for a new semantic intensity, the feeling towards a complex "figure" in which thought applied to the method of composition is incorporated and accorded its full causal value (the dialectic of subject/object reappears). The illusionistic and analogical process is questioned but the aim of objective portrayal is equally firmly retained. Among the somewhat mixed group comprised in "Possibilità di relazione", it was Giuseppe Romagnoni who in his passage from a "rhetorical" phase to a phantasmic and, finally, to a globalizing phase, reached a sound, comprehensive conclusion. Indeed, in his shrewd and very inventive enquiry into the structures of representation he seems to be abolishing conventions of language (against which appropriately enough Crispolti had directed his text) and to be seeking a verbal equivalent to his visual techniques (the tearing up and reassembling which one sees, for instance, in his use of photographic fragments). But "Possibilità di relazione" was only one indication of the crisis taking place among the

younger generation in *art informel*, since the paths which led to a neo-figuration incorporating object and "story" were many and varied, originating as they did from a range of previous experiences and running in parallel with each other, or else were specified after that episode. So as not to be confused by terms, we should emphasize here that the analogy between pictorial representation and verbal description has nothing to do with "literary painting" and only a minimal connection with "visual poetry". What it refers to is structure and, although an object seems to be a necessary ingredient, it does not have to be immediately recognizable or true to life. And even where it *is* true to life it functions, like a figure of speech, as a metaphor: a metaphor which can be enlightening even while forgoing a descriptive depiction of real life, a metaphor which can probe into reality using reality only as a tool. As happens somehow or other in poetry–where the image is obviously inseparable from its vehicle (the word, which is the substance of poetry) — so in neo-figuration does the means of portrayal enter into and take part in the object/subject of the picture. In this context, it is not by chance that the images used are often gathered from the museum, that they often include the written word and that they tend to act ideologically (in the political sense) giving a collective impression that is at one and the same time ambiguous, provocative and conceptually cold. In certain cases, where there is a stressing of intellectual detachment quite contrary to the individual psychologism previously in vogue, this becomes translated into an analytical disintegration which, like a puzzle, may carry within in the possibility of an ordered recomposition but which nonetheless can be a vision which is both ironic and grotesque.

This happens, for example, in the painting of Enrico Baj, who affronts traditional iconography (that of verism or realism where the content is most of the message) by utilizing collections of the most banal objects, including various myths and modern status symbols, which — assembled in a sort of disjointed manner owing something to Jarry and his "pataphysics" — end by calling attention to their own being ridiculous. This critical process in Baj started with the experiments of the "Movimento Nucleare" (promoted by him in 1951) and the foundation (with Asger Jorn) of the "Mouvement International pour une Bauhaus Imaginiste", subsequently enriched by the revival of dadaism, by contacts with surrealism and with pre-Pop connotations. It must be said of Baj that right from the Fifties he gave notable attention to the values of composition, material and colour, so different from Pop art, which characteristically favoured the "document" and not always with any irreverent intent. As far as

Baj's "furniture pieces" are concerned, although from the outset the aim of the artist has been to show that things are always something else, that despite their existence as objects things feed on their own meanings, one sees that the opposite is equally true. For the simple reason that these chests of drawers, cupboards and tables do not aspire to be other than themselves (not metaphors, not symbols, not even ideas), the identity of these objects with their own nature produces an astonishingly alienating effect.

The "document", where it exists in the works of Baj and others like him, appears in a tangential, allusive manner and is nevertheless in its turn an object to be submitted to a process of obfuscation and signifying distortion. In Pop art, by contrast, one could say that its use is frequently inappropriate, or designed to demonstrate its inappropriateness. To illustrate this point, one only has to consider the *décollages* of Mimmo Rotella, who in his attempt at direct appropriation from real life works in depth, by subtraction, by decodification — with his "representationalism" passing from dadaism to *nouveau réalisme*, leaving traces, not proposing new fetishes. Actually, in the process of laceration, the object (and its myth, like every myth) once more appears for what it is. The images doubly torn from the advertisers' walls and billboards, "elevated" to the level of art work, are freed from their mystifying context. Subjected to critical treatment, the figure acquires a new and often more human objectivity.

Among the artists approaching and/or crossing Pop art in their new mastery of the real, one could include Pino Pascali. However, his recourse to "things themselves" is different, even in its aims, from the ambiguous fragmentation of the French *nouveau* réalisme (a bit aesthetic in spite of everything) as it is from the American epic of the everyday object. What Pascali was doing with his obviously direct and literal descriptions of things in an indistinct area between the pictorial and plastic solution, was "exploiting the gulf", as Barilli wrote, "between the abstraction of naming and the concreteness of the thing", reintroducing semantic correlations and inviting a metaphorical interpretation.

By means of this game in the hazy area between true and false, Pascali's works can crystallize even the most atrocious drama, frozen in space as an emblem and a warning. And here we should plumb the significance assumed by the fetish, the "thing itself", emerging in such diverse yet assimilable forms. Because if in reproposing the object, the figure (I am deliberately avoiding the term "image") the method used seems contrived, governed by nostalgia and suspicion, desire and wariness, revealing the inner conviction that a return is not really possible, then — whatever the

position assumed by the artist — one will always note the dialectical function entrusted to the act of execution. There follows a completely intellectual detachment from the subject, an aversion towards any declared emotion, and salvation has to be sought in the "ludus", in artifice which does not shrink from exposing the artificiality of art itself and stands out not just as an instrument but as an inevitable component. The method by which the work is made becomes the subject/object of the work, and this may be seen not least where the narrative drive (dynamic, metamorphic) is most explicit, i.e. where the real and/or metaphorical object is proposed as the protagonist, placed on stage to the point of theatricality. This happens, even though in opposite ways, in the sculpture of Alik Cavaliere and Mario Ceroli. Cavaliere does it by crowding and the delirious suggestion of organic element presented like discoveries. These are meticulous replicas and, with their fragmentation and allusions which are sometimes funereal and sometimes ironic, create an effect that is palpably fictitious and bewildering: a kind of highly mobile theatre in which the characters and the stage props all act on the same level in the same drama. In *I processi* the Shakespearian references are only a pretext for the use of music and words, of direct and indirect quotation (the tape made by Canino and Sanesi forms part of the work), so as to relate the polyvalent meaning of the whole event to a precise historical place. Ceroli gains his effect with a composure which introduces into his carved and very solid shapes a "metaphysical" quality, accentuated by his very disciplined game with the thicknesses, by a rhythmically balanced arrangement of the figures and perspectives, by the spaces between one figure and the next, which being in many cases the "negative" of the carving, or a hint of its duplication, are charged with an emblematic strength. There is also a feeling of revisitation and simultaneous questioning of the numerous quotations — from the visual arts, from literature and from the theatre — in order to produce a new kind of legibility, by a new critical use.
One can say the same, at least in part, about Mario Schifano, who uses in his work a repertoire of references to banal everyday articles of the consumer society with typical Pop art effects but also often reducing images relating to the history of art, such as a well-known photograph of a group of Futurists to the status of consumer articles. This creates an effect of "freeze" and estrangement which almost contradicts those remains of pictorial gesturalism (the roughness of the brushwork, the trickles of enamel, the colour which tends to drown the image etc.) which also belong to the conventions of Pop art. In abstracting the object from its most obvious context (and

the painter knows perfectly well that an object placed in parentheses is not in the process robbed of its phenomenological position), Schifano acts by continual lexical recoveries. Hence the frequent naming of the article depicted, quotations included: a kind of absolutization achieved through fission and duplication, creating an unstable relationship between the thing and the name of the thing, with finely precarious results. The critic Maurizio Calvesi put it well when he spoke of "a destructive velocity", of "a gesture which begins elegantly and ends by burning itself out".
Plastic theatricality, ludus as a method and an end with ideological and political intentions, irony and the grotesque used as critical indices, quotation as a mark of continuity within non-continuity... These are elements which, employed in varying proportions and arrangements arising from different motivations and points of departure, add up to distinct and recognizable personalities as they converge in the paintings of Concetto Pozzati, Lucio Del Pezzo, Ugo Nespolo and the young Aldo Spoldi. The youthful work of Spoldi has a particularly narrative character, to which use of the comic strip is fundamental. He has been equally influenced, one assumes, by the painting of Adami and Tadini in the clear separation of his figures from the surrounding space, the tendency to flatten perspective and in the fragmentation of compositive elements for the purpose of a hypothetical and arbitrary reconstruction, valid according to the associations of an internal and secret logic, but unexpected at an immediate level. The whole is disposed with strong rhythmic scansions and plunged into a stylistic atmosphere which conjures up indifferently, but with irony, a late Victorian illustration or some charming *carnet des modes* of the Twenties as seen through the eyes of Utamaro.
Marcello Jori, on the other hand, after pushing the comic strip towards the playful and the absurd, has moved increasingly in a scriptory direction, a style in which suggestions of writing are gathered together in a richly textured and nervous painting. His work has flashes of colour probably owing something to Futurism (visible in his technique of collaged layers and cut-out shapes) but also with intense lyrical reverberations, achieving an imagery which combines the impatience of a sort of restrained action painting with a tenderness achieved through an unusually magical and fairy-tale quality, above all in his recent emotive geometry.
We find ourselves confronted by three competing interpretations of language, all leaning in a figural direction: one which uses pictorial language in a fairly traditional way; one which promotes the intellectual (reasoned) recuperation

of the creative act and of its meaning and lastly a style which reveals itself as a deliberate plundering of stylistic modules to be freshly codified in a new context. As for Pozzati, although this does not apply only to him, G.C. Argan noted that the dialogue takes place "completely inside the painting but also in its history". And after demonstrating the high value of craftsmanship and the function of irony as the antidote to anxiety and its forerunner too, Argan went on to state that Pozzati's painting was "enumerative like a dictionary or one of those syllabaries in which next to the letter you find a figure". This is an associative mechanism whose consequence had already been perceived by Guido Ballo when he spoke clearly of "pictorial writing". But one should not forget, as regards Pozzati, works which function on an ethical and political level, such as his *Suicidio di Grosz*.
The répêchage used by Del Pezzo is in a certain sense more circumscribed. In place of mockery, one sees first a taste somewhere between the decadent and the funereal. With a metaphor one could say that if Pozzati trains his sights on the supermarket, Del Pezzo moves through his forays in Neapolitan junkshops or the sacresties of baroque churches to a strict museum of the metaphysical. There one finds a popularity *ante litteram* crossed with references to a visceral surreality, crowded, gaudy — a sort of magical alchemistic mannerism of the religious object. Within this revisitation of the museum, we are provided with a lucid and ordered exposition, but with memories of *melancholia* which justify an explicit reference to Dürer. It is a metaphysical puzzle. What distinguished the metaphysical from the surreal is the silence and the solitude which comes from it. The surreal involves the subject, it springs from the depths of the subject, it connects with the subject and squeezes images out of it; while the metaphysical separates subject and object, and the object becomes estranged, shifted into another context and presented as emblematic, as a *thing*, and so it is in fact and never more than when it inclines to abstraction. Hence the rather hallucinated pleasure to be derived from the combination of geometric and refined figure, honed works resolved in plastic form.
The quest (desired yet denied) for a legitimization of the *objet d'art* by turning it into a museum piece creates the effect of a play within a play in Nespolo's work, exploiting the ludus and deliberately appealing to childlike wonder, to the point at which the art work is constructed purely and simply as a toy. Here Nespolo's very clever craftsmanship obviously plays an essential role. In his explicit puzzle in which all objects are transformed with a single object but with each part separate from the other, Nespolo ironically

disturbs the presumed feeling of unity to the point of cancelling it or showing it up as specious. Thus he not only confronts technological products in order to reduce them to a common level (one of his constant operations seems in fact to be that of levelling, eliminating any "symbolic" difference between a computer and a building worker's paper hat or between the engine of a racing car and an *art déco* lampshade etc.), but also to deflect their functions not so much towards the useless as towards a use that is completely imaginative. His method is based on a witty mechanism which seeks to recuperate the act of spontaneous and original creativity, and in doing so encounters and translates a concept: that of the *making*, and of the artifice.

Giosetta Fioroni too started off with a mixture of *art informel* and sign-making, the tendency to translate the subtlest emotive stimuli into graphic marks bordering on handwriting, and then turned suddenly towards objectivity. At first her images seem to be governed by a stylistic memory oscillating between Futurism and Pop art with sometimes explicit references — in particular to Jim Dine — for the ecstatic subtlety of his drawing, which reveals in the deliberate suggestion of expressive surrender an analytical intention left cleverly in suspense. But the truest and most recognisable characteristic of Giosetta Fioroni emerges at the moment when the figure, which was initially only a shadow of a memory, takes shape, evoking a display of malaise and morbidity, of fairy-tale reveries and of personal dramas, which frequent use of photographic documents at times renders all the more sinister and stunning. Despite her gentle touch, Giosetta Fioroni's "subjects", whether they be apparitions of sylvan spirits or taken from some pathetic family album or from a blood-chilling manual of forensic medicine, often seem to be observed with the uninnocent eye of the voyeur.

Consistent with the thinking of the exhibition "Possibilità di relazione" — which was to find a way out of the formal and psychological tangle of *art informel* and to strive for expressive clarity by rehabilitating the object without denying the persistence of an ambiguity (not only visual) in the object itself — Valerio Adami and Emilio Tadini adhere to the stylistic modules of Pop art but in a typically European way. In Adami's painting, one notices that the process taking place is all-embracing, that it aims at the restitution of a complete and articulate syntax in its images by a method of association. One of his early models was Matisse, with the difference that the sharpness of Matisse's line is resolved into a spatial scansion which, in separating object from object, creates a series of correlations through which one detail seems to expand, by reflection, into the

next. And yet any sign of metamorphosis is only apparent: the effect is sometimes that of a suspended metaphysical strength. So much so that in the space — coaxed out with random signs, words, objects — it is often the minutia of detail which suggests the discourse, the "plot" of a story; while it is the voids, the distances, the absences which bind together each element and render it objective. Although the arrangement of elements involved is more cumulative than linear, so it is the fragmentary *mise en image* of the even more subtle and secret allusions and of some decidedly learned projections (which recently include clearly mythical references) which reinforces the syntactical global unity.

This process of recognition, particularly evident in Adami's "portraits" where meaning seems to accumulate in inverse ratio to the economy of the image, becomes in Emilio Tadini somewhat more ironic and complex. The usually white space of some of his works in which certain of his figures appear to float without direction like epiphanies, is assimilable to an analytical conception of "Pop" painting but perhaps also has connections with the blank page of Mallarmé's *Un coup de dés*. In Adami, space expands the objects, submerges and binds them; in Tadini, it entices from within — through an ever more frenetic atomization of the objects — the emergence of the story. It is not a void, it is not a space to be crammed full of objects, words, quotations and sounds; rather is it an indeterminate whole from which may flower a series of meaningful finds freely offered up for scrutiny, for deciphering, in the full awareness of their relative interchangeability. In this space in which moves — as on a cinema screen — a heterogeneous stream of ready-made and dejà vu articles (stereotypes taken from the history of art, from the supermarket, from literature, from advertising etc., shaken up and forced out of context as if in search of a new cohesion), there is realized the hypothesis of "global realism" which Tadini had postulated in his criticism printed in the "Possibilità di relazione" catalogue.

In general, the various artistic solutions mentioned here seem more interested in posing questions than in giving answers. One notices in almost all the questions (which show a remarkable flair for "suspense") the problem of the presence or the absence of the narrator (the artist). As I have already had occasion to write elsewhere, one asks oneself if the narrator is to be found outside (as agent) or inside the story (as happens in a painting that is openly *informel*) and, in the event of his being inside the story, whether he is — precisely as agent — the sole element (i.e. object) to be *acted upon*; just as one asks oneself, and tries to show, what relationship is to be established between the narrator and the narrated and

how the narrator might be replaced by the observer, or by a mirror. However that may be, each work of the kind we have been discussing refuses to give us back reality in illusionistic terms (it rather tries to relate two illusions) and presents itself as a site for experimenting on objects, or as a place for events, a point of conflict, a point of exchange between objects and notions where one not only comes to expand the concept of reality, of objectuality, but also and above all where the creative act and the critic act could coincide.

Arte povera, conceptual art, multimedia
Renato Barilli

In Italy, as in every other country of advanced culture, there was a remarkable change around 1967 in the climate of artistic research. The wave of the first half of the decade, which had found its chief point of reference in stereotyped figures from advertising and the mass media, was by now exhausted. There was a resurgent feeling for the informel, emphasizing the processes, attitudes and behaviour rather than objects or finished products. But it was an art informel very different from the one that had dominated the Fifties, because then artists kept themselves within the accepted limits of the canvas and employed the traditional means of painting, (using, however, the spatula or other brut tools), in an atmosphere of exaggerated individualism of existential or positively romantic inspiration. It had been a "warm" line of research in psychological terms, or "hot" in the technical sense made famous by McLuhan, in that it had favoured visual aspects without conceding much to other senses (touch, space, movement, sound). The new informel which was to dominate the late Sixties and early Seventies was by contrast "cool", that is to say much less romantic from a psychological point of view, and much less visual, readier to invade the environment and appeal to every organ of the senses, using for the purpose cool electronic technology (from neon lighting to video and soundrecording). However, one must not overlook that in Italy there were several intermediate stages between the "warm" historical informel of the Fifties and the "cool" informel which concerns us here. For example, a typically romantic-expressionist — or warm — artist such as Emilio Vedova had given us his famous "multiples" (plurimi), breaking up his canvases and developing them into spatial and stage compositions to great effect; the Torinese Pinot Gallizio, with his "Laboratorio sperimentale di Alba", had tried to reconcile the relentless individualism of gestural and material painting with assemble-line production methods capable of coming up with the "big number". Another sensitive and intelligent informel artist, Vasco Bendini, had felt the need to coagulate his colour into "concrete" works which provided a third dimension. In a quite different sense, and already in a rigorously cool climate, Piero Manzoni had foreshadowed every possible operation of a corporeal and conceptual character, forcibly introducing Italian culture to the provocations of Dadaism, and giving them a "normalised" extension.

The first chance to perceive the new climate of research in Italy was probably the exhibition "Lo spazio dell'immagine" which was held at Foligno in the spring of 1967. Various leading exponents of Pop art, such as Ceroli and Pascali, took part, which insisted in propounding closed and well-defined images, but along with them there were others who were attempting to submit their forms to a process of opening-up. A case in point was Pistoletto, then known as a typical Pop artist. Everyone was familiar with his glassy surfaces which could either accommodate fleeting images or capture photographic items as rigid and static as corpses. But at Foligno Pistoletto did something else. He no longer showed a flat surface but a well-head with a mirror at the bottom instead of water. In such a way the object ventured into space and required a more committed participation on the part of the spectator, pushing him into the role of actor. Another example, perhaps even more resounding and explicit, was that of the young Eliseo Mattiacci, who created a freely three-dimensional structure of a giant pipe wound all round itself, going into knots and tracing soft sinuous bends, as if suggesting a sequence of waves, and so indicating the end of the machine age and the advent of the age of electronics, the transition from hardware to software.

In the succeeding months the most alive centre of art in Italy was undoubtedly Turin, where there was emerging what Germano Celant later defined as arte povera. Among its exponents was the same Pistoletto, who after his well-head at Foligno was breaking out in ludic exercises and ephemeral objects (the famous paper ball or the "Venus of rags"), producing them as free events in galleries and in the streets. At the other pole in Turin there was Mario Merz, who earlier in the Sixties has passed through the first "warm" informel phase; from 1966 he had been proposing "ready-made" objects, which could have been mistaken for Pop works except that they were traversed by a neon tube resembling a flash of lightning or a violent electric shock, so that the inertia of the material was dissolved and transformed into energy. In this manner Merz was tuning his research into a wavelength analogous to that of Beuys in Germany and Nauman in the USA. Some months later Merz discovered the fascination of the Fibonacci series, a numerical progression which is reputed to govern many natural phenomena (the forking of branches on a tree, the rings on snail shells, the scales on a crocodile skin) or architectural principles (the curvature of an igloo) or social behaviour (the rhythm with which people sit down at tables in a restaurant). For many years thereafter, Merz will devote himself to discover in almost all aspects and circumstances of the universe the occult presence of the Fibonacci series, drawing attention to it with neon lighting and by other ingenious means, all the while alternating between conceptual phases on the one hand and objectual and pictorial means on the other.

27

Strictly close to Merz in spirit has been Gilberto Zorio, but in place of neon he has preferred to use the incandescence of electrical resistance or the laser beam, applying them to organic materials such as enormous cow hides or distilling them in their pure state as emanations from sharp, angular figures representing, say, the five-pointed star or the javelin. Zorio exemplifies in the best way McLuhan's assertion that there is a kind of short circuit between typical nomadic cultures of hunters and fishermen and any other populations who live by gathering food, and our own post-modern present day in which we have all become gatherers of electronic information. Zorio in fact passes with ease from archaic forms which look like traps or weapons of defence or tools of primeval labour to sophisticated conceptual instruments, in which an impalpable mental energy is condensed.

No survey of Torinese arte povera would be complete without mentioning other personalities of high standing such as Emilio Prini, Giovanni Anselmo and Giuseppe Penone, who have not however been selected for inclusion in the exhibition owing to exigencies of space which has obliged us to sacrifice complete representation for significant examples. One should also remember Luciano Fabro, ever various and unpredictable, capable of swinging from the most intense conceptuality to inventions of an almost baroque flavour, with a happy feel for noble, traditional materials such as marble and Murano glass. More in the informel mood is the Bolognese Pier Paolo Calzolari, very close to Merz in his use of "cool" means like neon, with which he knows how to obtain the most beautiful lyrical effects brilliantly blended with the visual impact of certain natural materials such as leaves or wax. His work too confirms the sympathy which exists between organic elements of the earth or of vegetable life and "soft" electronic technology.

To complete the Torinese panorama it remains for us to speak of two very important artists who introduce a somewhat different theme. One of these is Giulio Paolini, who presses cool, conceptual means into alliance not so much with nature as with history; a veritable U-turn in research, which instead of exploding towards space and enlarging the environment, implodes towards its own origins. Paolini started by turning his attention to the work itself and its components, analysing the canvas and the stretcher, or investigating the graphic elements of the squares on a piece of drawing-paper. But thereafter he passed on to a wider analysis where the single work was replaced by a complete system of all the works realized in the history of art, that is to say the museum. So we then had a series of brilliant references to Lotto, Raphael, Poussin, De Chirico and so on. It is worth remembering that at the start of the Seventies there was a large exhibition of De Chirico in Milan which allowed to re-interpret the old painter in this manner, as someone who had undertaken a methodical revisiting of the past, ending up with tributes to his own earlier works. In the same way, Paolini quickly passed on to quoting himself, systematically taking his previous works and putting them in perspective (metaphorically and literally). There was a difference between them, however. De Chirico "quoted" resorting to the traditional medium of painting and so nurturing the suspicion that his was a process of simple involution, while Paolini insisted on the use of conceptual and "poveri" media such as photography, collage and writing, so confirming his general character of coldness which however in the course of the Seventies came to seem insufficient. It was in fact another Torinese, Salvo, who a little later, starting from the same conceptual premises, felt the need to return to manual painting and in short to take up De Chirico in a much more direct way, while distancing himself with criticism and irony from the images quoted. A case similar to Paolini is that of Alighiero Boetti, who has always worked serially but with the difference from Merz that his series have never been taken from nature but from artificial cultural phenomena and interpersonal communications. Thus his works appear like enormous collections of objets trouvés, or rather of manufactured articles turned out with the help of an array of anonymous collaborators. Each one of these objects, however, contains a rich vein of fantasy making it picturesque and enjoyable. In recent years Boetti, in tune with the general return to values of colour and craftsmanship, has been concerned to carry out his ambitious "programmes" all by himself, leaving nothing to chance or the collaboration of outsiders.

After Turin, the other Italian centre of arte povera was Rome, where the dominating personality was Jannis Kounellis, of Greek origin but resident in Italy since the early Sixties, when he gave us gigantic canvases scattered with signs and letters of the alphabet in typical Pop idiom, except that his predilection for black and white was already clear. In 1967 Kounellis, in certain provocative works, began exalting the primal value of earth, coal or wool, or the presence of animals: a live parrot placed next to a metal panel, horses assembled in a basement which then formed the premises of the Attico gallery. This gallery, under the direction of Fabio Sargentini, was the focal point of all the best in Rome's experimental art, as Gian Enzo Sperone's gallery was in Turin. Both these gallery owners were very alive to the international scene and contributed significantly to launching Italian artists abroad. In fact, our exponents of arte povera have probably enjoyed more réclame abroad than any Italian avant-garde movement since the times of Futurism.

Kounellis, like Merz, can be ranked with the world's most noted practioners of anti-form, the art of earth and process (Beuys, Bob Morris, Nauman, Sonnier and so on). But in him, beside the explosive and cosmic aspect, which carries him along and engulfs him in great waves of natural energy, there is also the opposite: the implosive trend, the attraction of origins, the desire to recover an archaic, ritualistic and mythological Mediterranean culture. Hence the masks of Greek tragedy or fragments of statues partake of the work along with the allusions to natural events like fire and smoke. The most tangible present and the most remote past converge in one space, which moreover always has a theatrical dimension. But while the theatre of Kounellis is made up of primordial elements, suspended between nature and anthropological rituality, that of Vettor Pisani appears rather more subtle: almost a chamber theatre or a philosophical theatre which, in the manner of Paolini, stages elements of culture and artifice rather than those of a "povera" and primordial nature. The works of Vettor Pisani in fact are interwoven with quotations and abstruse references to alchemy and other esoteric traditions; the flat surface or three dimensions are used with no apparent preference.

With artists living in Rome, too, we have had to restrict our choice to certain key examples. Among important contributions which are not included is the work of Dominicis, perhaps our "hardest" conceptual artist, capable of fostering absurd, paradoxical thoughts, to which he gives a coherent and exasperated materialization: the laws of physics defied by a mind that won't give up and dares the undarable. Another absentee of importance is Luca Patella who by contrast represents the soft character of our electronic age, acting like an enormous data bank in which is stored all kinds of information: visuo-graphical, sonic, literary, sociological. On the other hand, an isolated figure here accorded due prominence is Maurizio Mochetti, whose lineage may be identified as that of a strict constructivism without any concession to the informel. But certainly he too has applied elements of his rigorous visual grammar to the invasion of space and time, giving us luminous moving lines, ricocheting sounds, invisible trajectories described in the air.

In general the artists mentioned up to now have acquired a well deserved international fame and undoubtedly will be already widely known to the British public. This is partly due to the intelligent and wide-ranging activities of the two gallery owners referred to above, Sperone and Sargentini (the latter becoming "creative" to the extent

of closing his gallery and of creating directly theatrical pieces). To these must be added the assiduous and coherent critical efforts of Germano Celant. As I have just observed, not for decades had a group of Italian artists achieved such acclaim outside our country. After such a due acknowledgement however, we must now turn to other artists represented here who are equally important, even though less established on the international scene, perhaps because of not having been in the right group at the right time. Among these the first name to come to mind is that of Vincenzo Agnetti, who sadly died a year ago. Perhaps Agnetti was Milan's most lively and original contributor to artistic experimental research in the Sixties and Seventies, together with Manzoni to whom he was both friend and authoritative critical interpreter. Agnetti was able successfully to combine a scientific vocation for numbers and diagrams, the sort of intellectual tensions which are at the roots of natural and social phenomena, with a capacity for expressing them in lyrical forms. There was in him the rigour of a Kosuth or a Venet but it was always enriched by a flicker of poetry, of fantastic invention. He is the best proof that there need be no divorce between the "two cultures", between art and science: the first can live happily amid the disincarnate, mental formulae of the second, which in turn can accommodate aesthetic beauty without necessarily betraying its mental and impalpable nature.

Another important presence at the exhibition is that of Franco Vaccari, who like Douglas Huebler knows how to use photographs and writing to confer form on great social phenomena, and — to use his own words — how to bring to awareness the "technological unconscious", that stratum of creativity in each of us which can be mined with the aid of numerous devices such as the polaroid camera or sound and video recorders. Still talked about is his work at the Venice Biennale in 1972 when he made a photomatic booth available to members of the public inviting them to participate in a process of mass artistic creativity, a vast enterprise which Vaccari himself managed to coordinate, reconciling chance and spontaneity with programmed control. Emilio Isgrò, like Paolini and Vettor Pisani, withdraws into the world of culture, on which he operates analytically and with subtle irony, imparting an "estranged" quality to aspects that would otherwise be too familiar and trite. Among his most noted operations is the systematic crossing out of all the words in a volume of the Encyclopedia Treccani: an oppressive bulk of knowledge is thereby returned to a state of fanciful and creative lightness, thanks to an act of negation which in fact kindles fresh energy and makes us see things with a renewed sensibility: just as Christo knows how to renew at a macroscopic level the customary appearance of certain buildings by "packaging" them. Of the same genre are the photographic "blow ups" which Isgrò uses in other instances still with the intention of "estranging" forms and objects which are too well-known. Another outsider to be considered is Michele Zaza, perhaps our best adherent, together with Vaccari, of "narrative art", who resorts to series of photographs in order to pursue and define the forms of extremely complex and "open" social phenomena. Lastly, there is Beppe Devalle, who subjects Pop art images, obtained from fashion and news photographs, to conceptual treatment. He follows a double road, sometimes dissolving the concreteness of these images into an abstraction which almost causes them to disappear into the void, or else, quite oppositely, starting with a blank space and conjuring from it as though by magic the delineation of a face owing something in its build-up to the process of the identikit.

These are the main achievements in Italy, during the late Sixties and early Seventies, pursued by artists who were exploring the poetics of concept and behaviour, and so reached a correlation between archaic means and those of a most sophisticated and advanced technology character. One should add the names of another wave of artists younger by some ten years who also began their working with photographic or other extra-artistic media: for example — in addition to the already mentioned Salvo — Luigi Ontani, Francesco Clemente, Mimmo Paladino, Luciano Bartolini, Antonio Faggiano, Luigi Mainolfi and Aldo Spoldi. But most of them are duly represented in the next section of the exhibition, reserved to the last trends. Indeed, in the early Seventies we had the birth of that movement already referred to: the transition from explosion to implosion: from an almost Futurist impulse of conquering the entire universe, back to the search for origins. The cult of De Chirico was renewed and re-examined in a conceptual light with particular reference to his late works, which had once been considered as signs of decadence and regression, but which were now seen as a lucid retrieval of stereotyped forms from the history of art, or as a systematic revisiting of the museum, surveyed methodically room by room. In 1974, in sympathy with this new climate an exhibition in Milan coined the slogan "Ripetizione differente", offering to the artists the possibility of seeking the new through the old, of quoting the masters of the past. A possibility which is available only if the quotation is accompanied by suitably critical and ironic distance and, in short, conveys an awareness of having finally reached the end of everything, a post-historical and post-avant-garde age.

Latest developments
Flavio Caroli

In recent years, young Italian art has achieved international acclaim both for its quality and originality. This remarkable burst of fame has occurred in two successive waves, and any reasoned account of the latest tendencies must start from a chronological survey of this phenomenon. The first group to distinguish itself internationally — composed of Paladino, Chia, De Maria, Cucchi and Clemente — came to prominence in 1977-78; and works by Francesco Clemente and Mimmo Paladino have been selected for inclusion in "Arte Italiana 1960-1982" as being representative of this circle, according to the criteria adopted throughout the exhibition.

In the second phase, sub-groups of some diversity, but also largely convergent, classified by critics under the heading "Magico Primario" and by Renato Barilli under the title of "Nuovi Nuovi", have had a well documented success; and here the works of Aldo Spoldi, Gianfranco Notargiacomo, Luciano Bartolini, Marcello Jori, Omar Galliani and Luigi Mainolfi are particularly significant.

The organizers of this exhibition, however, have not wanted to leave out other artists who for many reasons have remained outside the logic of the "groups", pursuing their own personal and coherent lines of research. Of these, Piero Manai and Giuseppe Maraniello exemplify two diverse aspects of a development which cannot be enclosed, even geographically, within the bounds of a definable trend.

In the realm of generalities, we are all agreed that art in the Eighties is devoted to a sort of "horizontalization" of cultural experiences which avoids favouring some artistic antecedents at the expense of others and which reserves to itself the right to paint and sculpt with the maximum creative freedom and enjoyment, an outlook for which strong precedents were set in the Seventies in the work of two artists who introduce this section of the exhibition: Salvo and Ontani.

In these two artists, a broad conceptual approach always goes hand in hand with a quest for seductive images which has been culled from the history of art: history used as a storehouse of images, as a source of Beauty and Perenniality, as a depository of past values which, by returning to the present, render it magical, sparkling and — in a word — timeless. For this come Salvo's "quotations" from ancient art (but quotation is a thread running through the whole of art history: only think of the relationship between Velazquez and Titian, Picasso and Courbet or Velazquez himself, between Vedova and Tintoretto and so on ad infinitum). Painting with all its mysterious alchemy returns to the "classical" dimension with that touch of naiveté which belongs to the spirit of the times. From this too comes the everlasting youthfulness, the agonizing infan-

tilism of Luigi Ontani who loses himself among pastel tints, among angelic diabolic fairy-tale memories in a dream extended from his *tableaux vivants* of the Seventies.

These foretastes of an art that was original in conception while loaded with disorientating ideology of the past were followed towards the end of the last decade by *arte del saccheggio*, or "loot art", a style defiantly Mediterranean in its loud, gaudy palette — and indeed its practitioners all came from the centre and south of Italy. For their quotational spoils the looters turned to Italian painting of the earlier twentieth century (Rosai, Carrà etc.) to the secessionists and expressionists. Out of this experience sprang the sexual and faecal obsessions of Francesco Clemente, who follows a tortuous and tormented path in his own search for identity. Almost the opposite was born of this too — the fiery, violent palette of Mimmo Paladino. Onto his clear tonewashed foundations are grafted suggestions of Nordic expressionism, metaphors of death, skeletal ghosts, drawn with massive strokes resembling the technique of the wood-cut.

The "second wave", which came into favour at the beginning of the Eighties, has a more thought-out nature and is inclined to psychoanalytical themes, looking back through the history of art for the origins of the myths of the subconscious. It relates to the experience of "art as the history of art" and indirectly to the researches in this direction of artists like Vettor Pisani. Perhaps in this case it would be more correct to speak of "inspiration" from the past since with these artists "quotation" has a profoundly different meaning from the one it bore towards the end of the Seventies: there is no longer any question of an open and infantile plundering and assemblage being carried out on the art of the present century, but rather a regression to the forms of the past in order to uncover the intriguing origins of the present.

This can be seen in the work of Luciano Bartolini who seeks out the archaic origins of decorative motifs which he then transfers to a present informed by Klimt's "rhythm", Burri's absoluteness and Matisse's "joy of painting", charging it all with the esoteric symbolism of an agonizing personal mythology. It is to be found too in the work of Omar Galliani which combines an extraordinary taste for craftsmanship with renaissance "styles" to achieve solemn and caustic images which owe something to the contemporary cinema. Again it can be seen in the alluring and very colourful work of Marcello Jori who goes back to primitive caverns for caskets of dazzling riches, who swings between the poles of form and formlessness cutting in the material perfect diamond outlines which, multiplied in space, turn into clear, impossible architecture.

Very complex and very considered is the design of Aldo Spoldi's image, a metaphysical drama which occupies the work like a dressed-up, tragic ghost, a two-dimensional ghost because it is forbidden the renaissance rules of perspective. The work is broken up not for the sake of destroying a balance, but in order to recompose a new art which follows an absurd compositional rationale and, because of that, is provocative.

Gianfranco Notargiacomo is the "romantic" of the present scene. It would be inexact, however, to see him as being tied too closely to German followers of the neo-informel, even though one must recognize his past work as having been some two or three years in advance of the new international action painting. Behind his stormy skies, behind his free-for-all battles (almost all his pictures have the title *Tempesta e assalto* which recalls "Sturm und Drang") there is that profoundly Italian tradition of painting which flows through Vedova and, specifically, Schifano, one of the protagonists of the "Roman school" of which Notargiacomo is the latest exponent.

Luigi Mainolfi, on the other hand, belongs to the lineage of arte povera. For him, too, art sinks into the viscidity of magic and the archaic, in this case evoking myths and legends of the Vesuvius district where he has his roots. The homeric, grotesque characters in his learned-popular epic are tinged with the red of molten lava, a colour which also covers nature making it scorched and burnt, in a sort of suspended eternity; a colour that also enshrouds the "great bell", which is perhaps the most emblematic work of all Mainolfi's output: a Trajan column of memories from the deep, the concentrated sum of a poetic idea and an extraordinary executionary skill.

Then there are the artists who cannot be pigeonholed into a group: Piero Manai with his harsh and sometimes cruel inspiration, tenacious champion of the sign and its symbolic potentialities, or Giuseppe Maraniello, clever scene-painter of great monochrome backgrounds aligned with a colouristic sumptuousness which is at the same time tonal and "meridional".

Roughly speaking, one might say that the strongest personalities to emerge on the Italian art scene in recent years are these, and most have already been "officially" recognized as such. Of the artists chosen for the exhibition at the Hayward Gallery, a great proportion are veterans of the Biennale in Venice and of Kassel's Documenta, exhibitions which, with all their contradictions, are still the most accurate barometers in international art.

Catalogue

Lucio Fontana

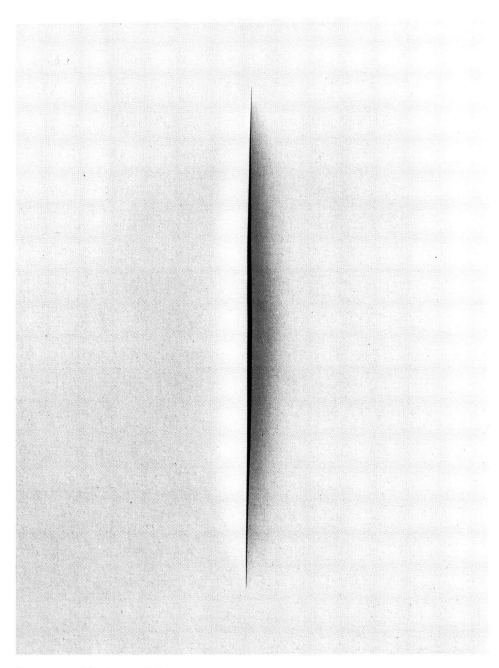

Concetto spaziale: Attesa, 1960
(Spatial Concept: Expectation)
116×89 cm

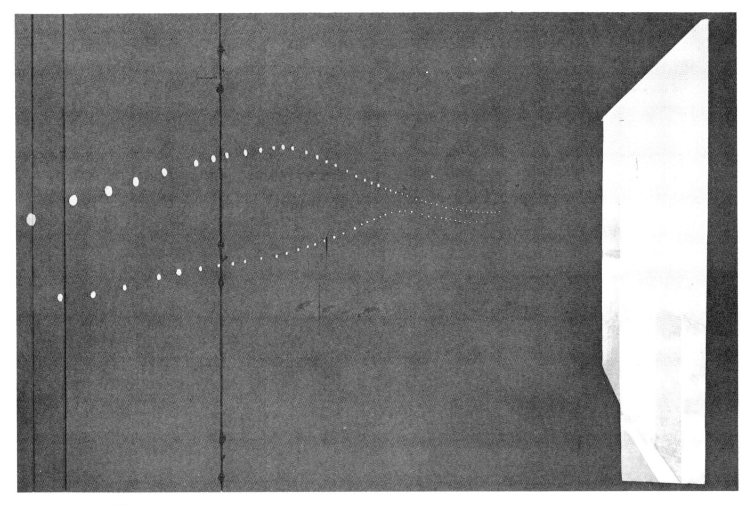

Ambiente spaziale, 1967
(Spatial Environment)
300×500×300 cm

Concetto spaziale, 1957
(Spatial Concept)
81×71 cm

Concetto spaziale: La fine di Dio, 1968
(Spatial Concept: The End of God)
178×123 cm

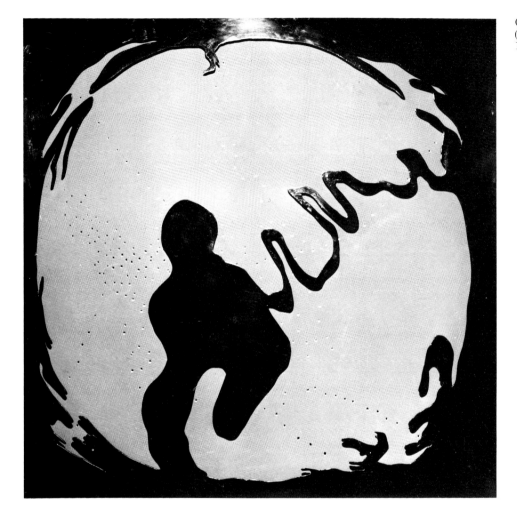

Concetto spaziale: Teatrino, 1965
(Spatial Concept: Little Theatre)
175×175 cm

Blu, 1965
(Blue)
145×185 cm

Rosso, 1959
(Red)
60×90 cm

Rosso, 1982
(Red)
200×300 cm

Divertimento, 1978
(Amusement)
71 × 70 cm

Dadamaino

Volume a moduli sfasati, 1960
(Volume of Out of Phase Modules)
120×120 cm

Ritmo — Rodhoid bianco, 1961
(Rhythm — White Rodhoid)
100×120 cm

Costellazioni, 1982
(Constellations)
200×200 cm

Un foglio dei fatti della vita, 1980
(A Sheet of the Facts of Life)
200×90 cm

Francesco Lo Savio

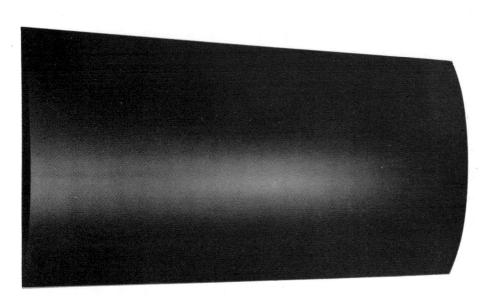

Metallo nero opaco uniforme — articolazione
di superficie parasferica estroversa, 1961
(Uniform Opaque Black Metal — Articulation
of Extroverse Paraspherical Surface)
92×200×12.5 cm

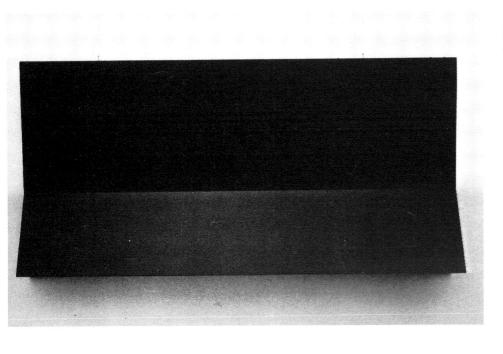

Metallo nero opaco uniforme — articolazione
di superficie orizzontale, 1961
(Uniform Opaque Black Metal — Articulation
of Horizontal Surface)
95×200×20 cm

Articolazione totale, 1962
(Total Articulation)
$100 \times 100 \times 100$ cm

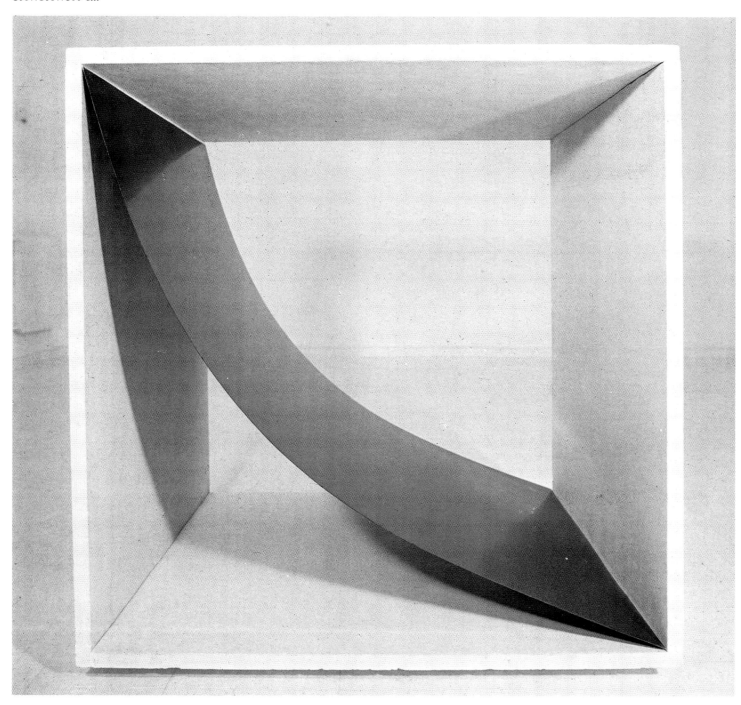

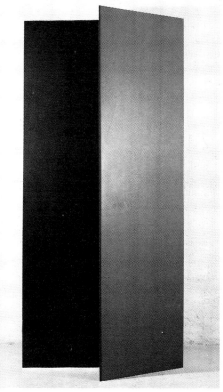

Progetto per metallo parasferico —
articolazione di superficie parasferica
estroversa, 1962
(Project for Paraspherical Metal — Articulation
of Extroverse Paraspherical Surface)
80×200 cm

Metallo nero opaco uniforme con articolazioni,
1963
(Uniform Opaque Black Metal with
Articulations)
200×95×29 cm

Piero Manzoni

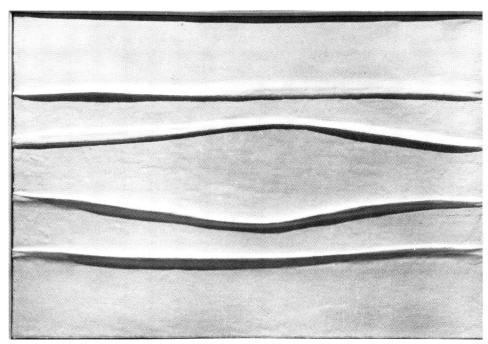

Achrome, 1958-1959
40 × 60 cm

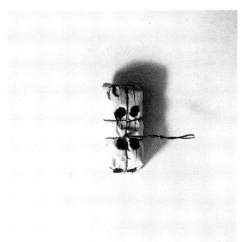

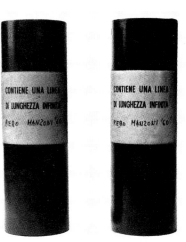

Pacco, 1961
(Package)
60 × 60 cm

Due linee infinite, 1960
(Two Infinite Lines)

Base magica, 1961
(Magical Base)
80 × 80 × 80 cm

Lana di vetro, 1961
(Glass Wool)
30×23 cm

Achrome, 1962-1963
30×30 cm

Percorsi fluidi, 1962
(Fluid Routes)
42×42 cm

Gruppo T (Davide Boriani)

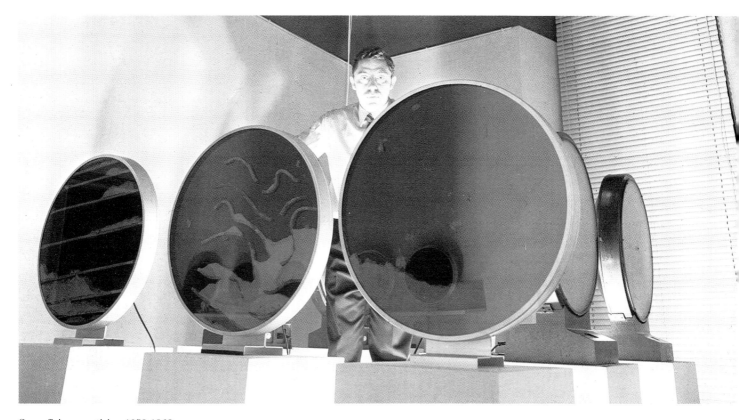

Superfici magnetiche, 1959-1962
(Magnetic Surfaces)
64×60×15 cm

Gruppo T (Gianni Colombo)

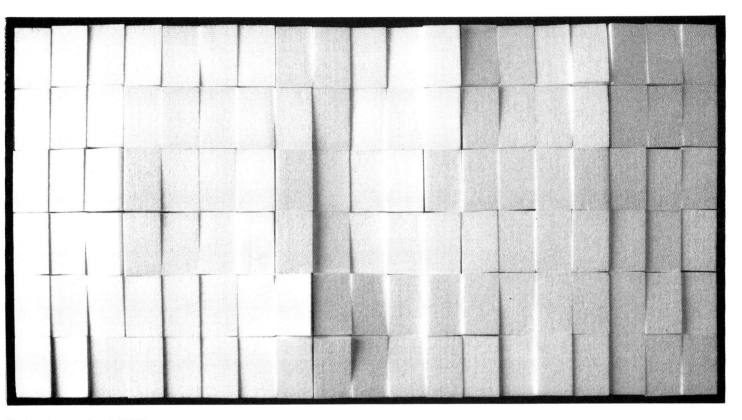

Strutturazione pulsante, 1959
(Pulsating Structuration)
$100 \times 200 \times 15$ cm

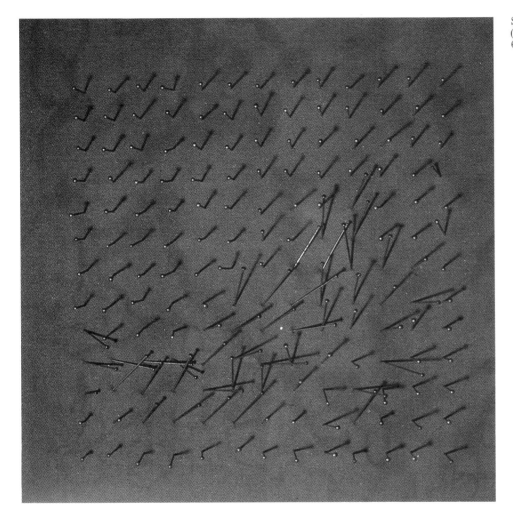

Superficie in vibrazione, 1959
(Surface in Vibration)
60 × 60 cm

Reticolo frangibile, 1965-1971
(Breakable Reticulated Structure)
35×105 cm

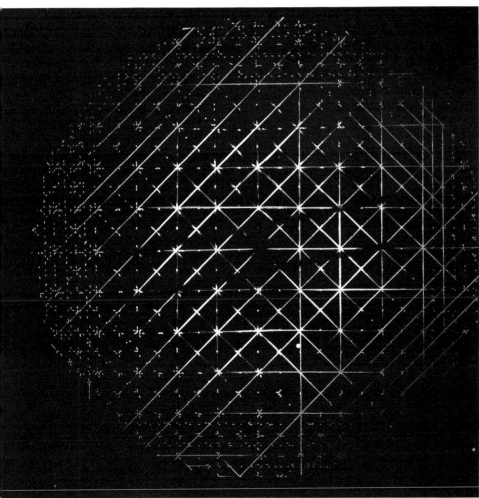

Schema luminoso variabile, 1962-1963
(Variable Luminous Scheme)
90×90×14 cm

Alberto Biasi

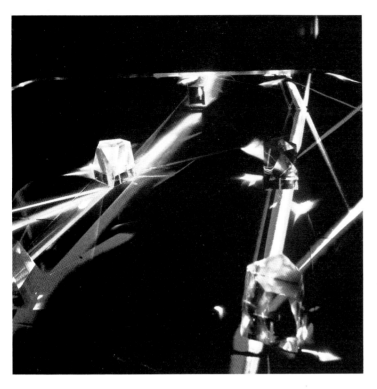

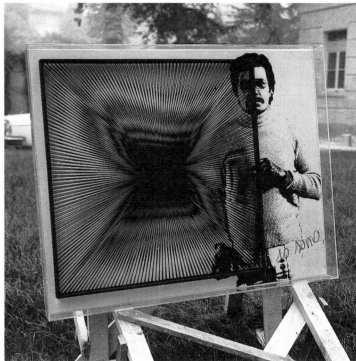

Cinereticolo spettrale, 1963
(Spectral Cinereticulated Structure)
120 × 100 cm

... Ergo sum, 1962

Gianni Colombo

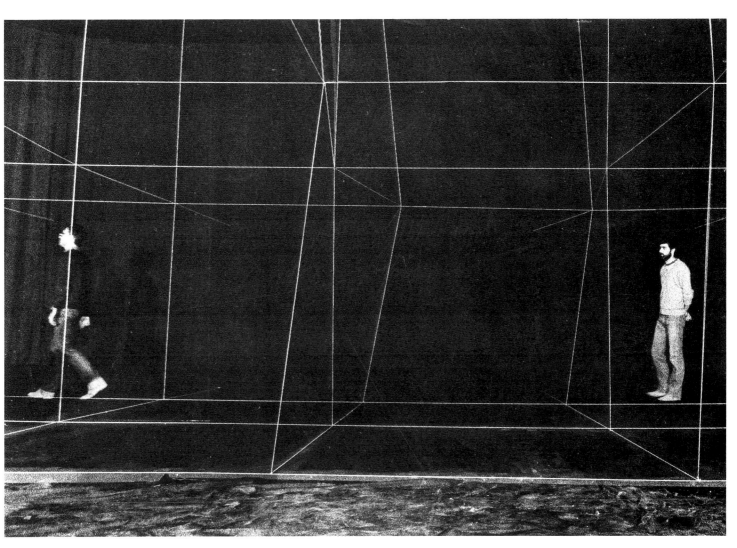

Spazio elastico, 1967
(Elastic Space)

Four entrexit situations from
Henry Van de Velde, 1980

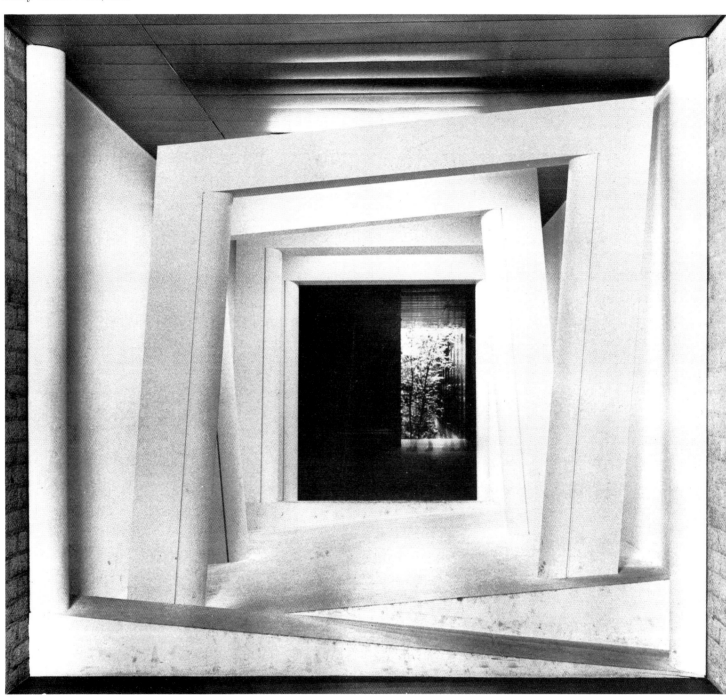

Entrexit, 1980-1982

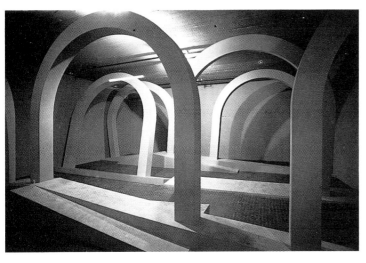

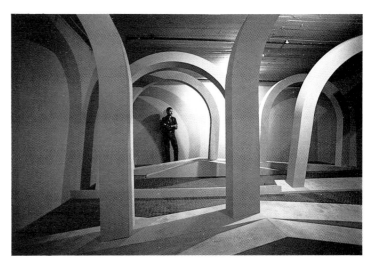

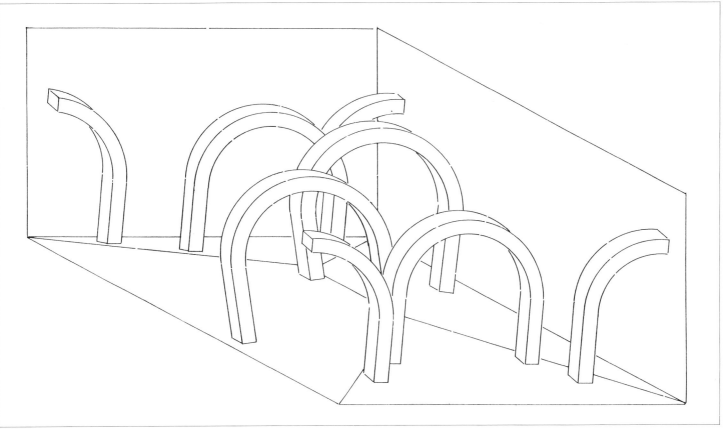

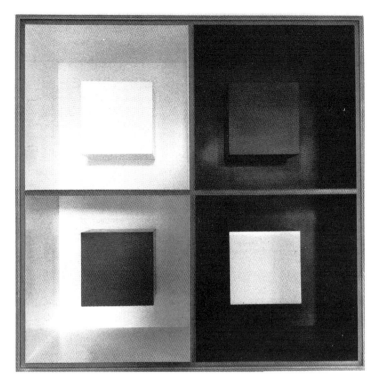

Prog. 857, 1952-1967
78×78×37 cm

Prog. 1059 A, 1964
141×141×10 cm

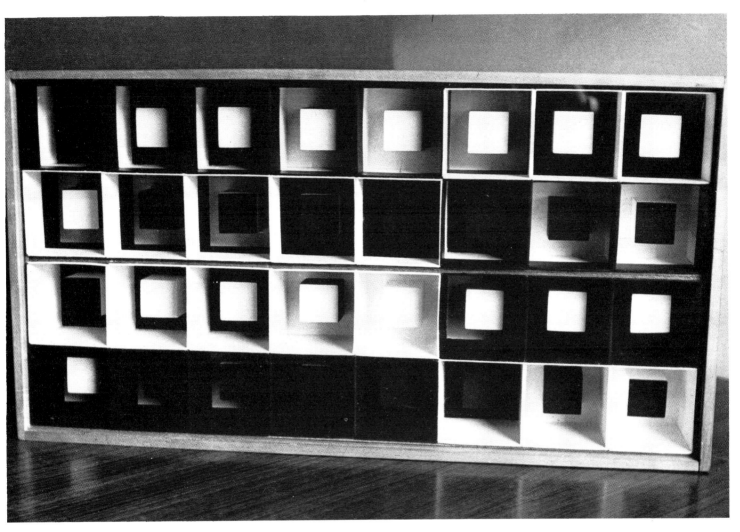

Prog. 305, 1956
30×59×9 cm

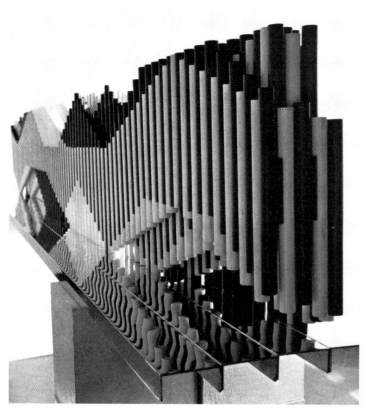

Prog. 795, 1965
30×241×34 cm

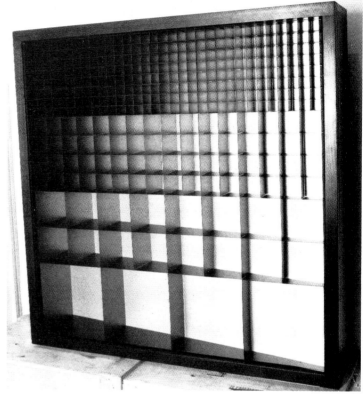

Prog. 912, 1968
104×104×22 cm

Visual poetry, new writing

Roberto Sanesi

"With the term visual writing we mean to refer to the creative experiences which place themselves — with relationships which are from time to time different and in the perfectioning of different operative strategies with regard to 'normal' poetry — between the pole of the word and that of the image, between the temporal consecutiveness of the written-read sign and the simultaneism of the visual message."
(Encyclopedia Feltrinelli-Fischer)

In a general way, to the research of real or presumed precedents, to refer more or less correctly in consequential relation to the actual practice of Italian visual poetry and to the particular variants of the so-called "new writing", one could affirm that some coincidence between a concept of "visuality" and a concept of "signness" has also been manifested in the past and with characteristics which were aware of a non-secret desire for simultaneous communication if not of coincidence with painting. With respect to the most recent tendencies they are examples which are not totally convincing and, however, it is not possible to forget Greek figurative poetry, the "peacock tail" poems of the Alexandrines, the scriptural figuration of certain research works carried out among the mystical and the alchemical in Renaissance and Baroque zones, the attempts of a "metaphysical" like George Herbert, the mentions of emotional signness of Sterne and the pictoric-poetic interdependence of Blake. As poetry is, *par excellence*, the specific place of ambiguity (and not only for reasons of verbal image, metaphor etc.) it is completely natural that the word should sometimes be forced to evidence polysemical characteristics to the maximum, to the point of rendering a possible stratification of the implicit meanings visible and moving attention, to an increasingly greater extent, onto the signifiers. Although it is by starting out from a text (and not by chance within the symbolist ambit) like *Un coup de dés* by Mallarmé, with the corollary of some eccentric examples of graphical transposition of the word on the part of some isolated authors (one thinks of Christian Morgenstern) and then with the "parole in libertà" of the Futurists and the *Calligrammes* by Apollinaire, that the still stricly linguistic area in which the experiments were confined opens itself to an autonomous practice within which — and indifferently — poets and painters converge. And in fact the contribution of pictoric experiences and their interdisciplinary impetus cannot be undervalued, above all with the alternating of the so-called "historic" avant-gardes: being able to cite, though with caution, some Cubist or Russian Cubist-Futurist solutions, and certainly more appropriately the *i-Gedicht* of Schwitters and the Dadaist "poémes object". Later, upon divergent positions, we have the Brazilian experiences by Noigandres (towards concrete poetry) and those of "Lettrisme" by Isidore Isou where the conviction that at the basis of every poetic process there exists an inseparable graphic-phonetic unity, a sort of "objectuality" of the linguistic sign, which is strengthened in an explicit way. The situation — within and without the official areas (and acknowledged) of the avant-gardes — is however complex: fecund remains the debate on the individuation of the precedents, on the acceptance or not of the fact that this is a new and advanced version of the concept of *ut pictura poesis*, on the level of correlation with the practice of painting, upon the same definitions of "visual poetry", "new writing", "active writing" etc. This is a discussion, which, here, I feel is opportune to postpone to the various theoretical interventions to be seen on the part of Lamberto Pignotti as well as to detailed studies such as: *Verso la poesia totale* (Towards total poetry), 1969, by Adriano Spatola; *Il segno poetico* (The poetic sign), 1977; second illustrated edition 1981, by Vincenzo Accame; and *Scrittura attiva* (Active writing), 1980, by Ugo Carrega — all of which are fundamental. As regards the sense of the typically Italian line and notwithstanding the considerable differences which are perceptible between their authors, these research operations — which often oscillate between a possible outlet into conceptual art and a textual recovery at the limit of poetry *tout court*, even if with an accentuated ideographical relief — are characterized by a profound meditation of the most advanced studies of semiotics (starting from the concept of "sign" in De Saussure and Morris, for example) and for an extremely articulated use of the most varied extra-linguistic relations: to the point of consenting to "a new 'metric' capable of superimposing itself upon the traditional one, forged on verbality", supplying a formal specific with increasingly more autonomous ability of adhering to intentions of mobile globalness. An instrument which in forcing the signified and the signifier to find themselves "in a dialectic relationship void of subterfuge, face to face", is capable of provoking — with effects which are eminently visual although not for this reason extraneous to verbal tradition — not only a series of theoretical reconsiderations concerning the interdisciplinary nature of the sign as linguistic element confined within a "genre" but above all — according to Vincenzo Accame — capable of taking "the word beyond the limits of a lingual practice, exploiting all of its properties inherent in the language in relation to the signified... and entrusted to a potential formality which is practically limitless". Thus, the working of the visual poetry as the dialectical element between the two poles of the written (prefigured) image and of the figured image, *outside of metaphor*.

Continuare, 1981
(To Continue)
50×35 cm

Linea gialla, 1981
(Yellow Line)
50×35 cm

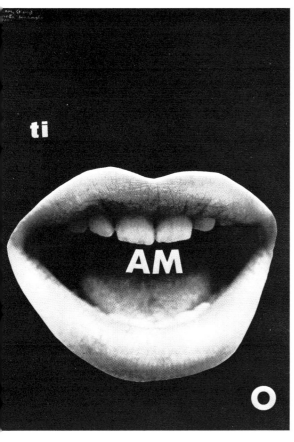

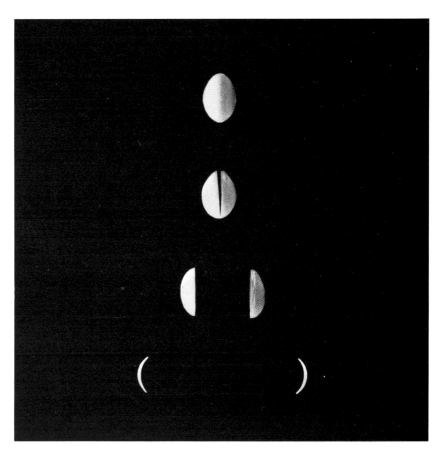

Am (Ti amo), 1970
[Am [I love you])
70 × 50 cm

Eclipse, 1976
50 × 50 cm

Sospensione verbo visuale, 1966
(Visual Word Suspension)
30×30 cm

Manità, 1965
30×30 cm

Vincenzo Ferrari

Dalla scrittura dell'immagine all'immagine
della scrittura, 1982
(From the Writing of the Image to the Image
of the Writing)
60×40 cm

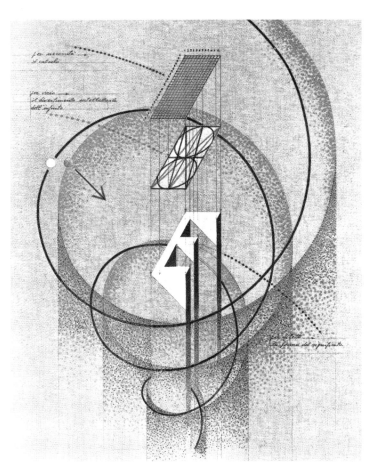

Dalla scrittura dell'immagine all'immagine
della scrittura, 1982
(From the Writing of the Image to the Image
of the Writing)
60×40 cm

Eugenio Miccini

... quella che vi abbiamo raccontato è una storia d'amore

... Una storia d'amore, 1982
(... A Love Story)
70×100 cm

ἤλιος γὰρ οὐχ ὑπερβήσεται μέτρα...

Il sole non oltrepassa mai la sua misura..., 1982
(The Sun Never Exceeds its Own Measure...)
70×100 cm

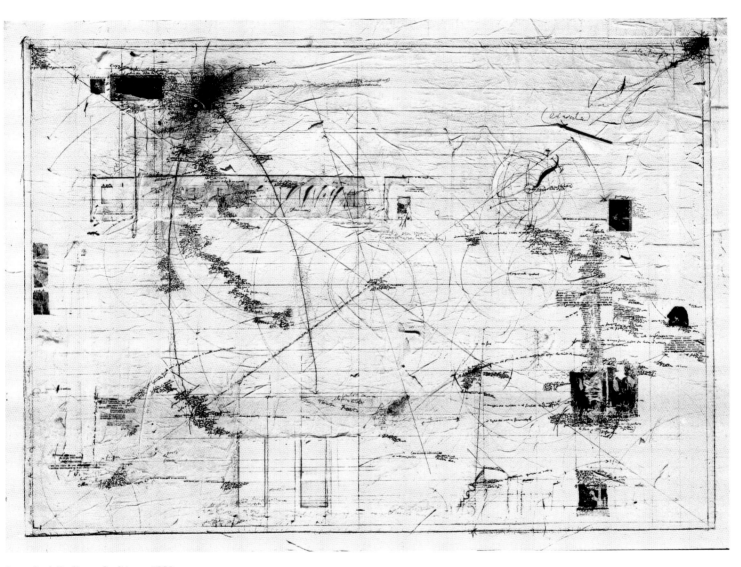

Ismaele delle Sacre Scritture, 1980
(Ishmael of the Sacred Scriptures)
89×122 cm

Anna Oberto

L'utopico. Eanan e la scoperta del linguaggio, 1974
(Utopian. Eanan and the Discovery of Language)
115×85 cm

Martino Oberto (OM)

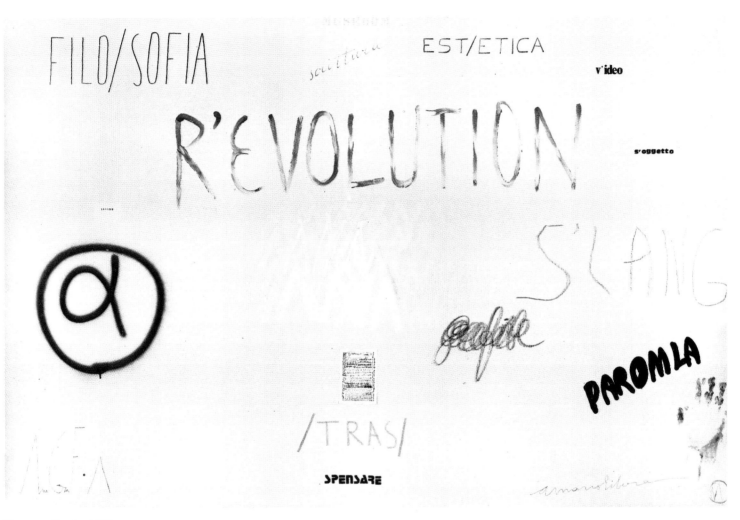

Museoom-Parole, 1975
(Museoom-Words)
162×240 cm

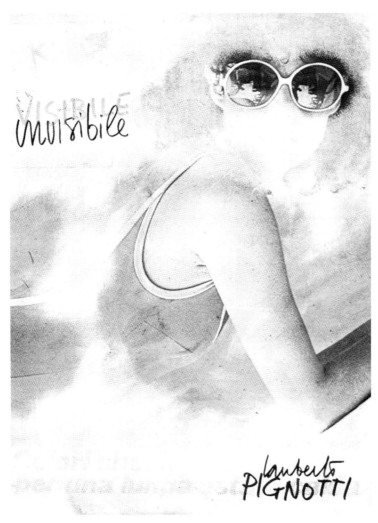

Visibile invisibile, 1980
(Visible Invisible)
31×23 cm

Visibile invisibile, 1980
(Visible Invisible)
31×23 cm

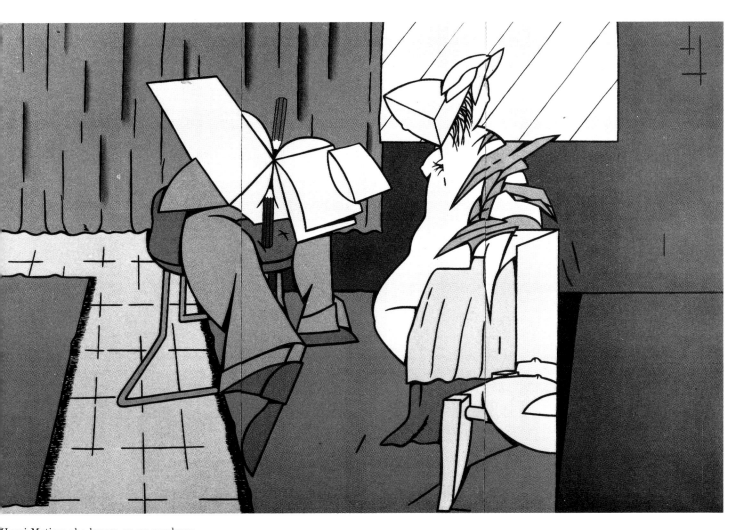

Henri Matisse che lavora su un quaderno
di disegni, 1966
(Henri Matisse Working on a Drawing Pad)
200×300 cm

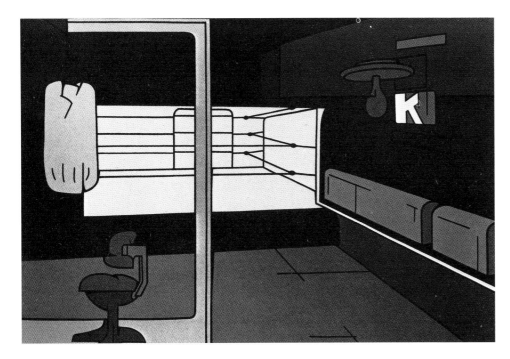

Il Ring, 1969
(The Ring)
243×365 cm

Vetrina, 1969
(Shopwindow)
243x365 cm

Metamorfosi, 1982
(Metamorphosis)
194×260 cm

Teseo, 1982
(Theseus)
194×260 cm

Enrico Baj

Personaggio in montagna, 1960
(Personage in the Mountains)
114 × 146 cm

Tavola intarsiata, 1961
(Inlaid Table)
77 × 100 cm

Personaggio, 1961
(Personage)
146 × 114 cm

Modello D A — H E 803, 1965
(Model D A — H E 803)
154 × 89.5 × 50 cm

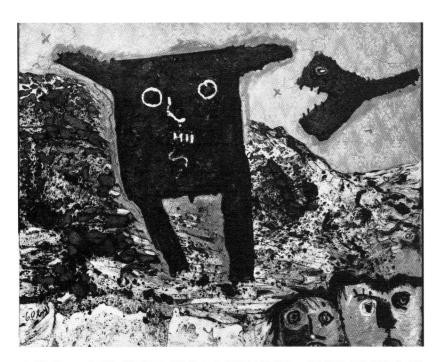

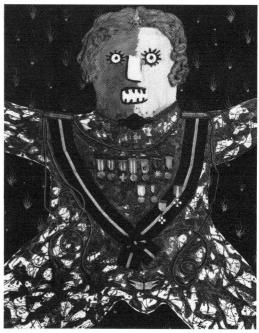

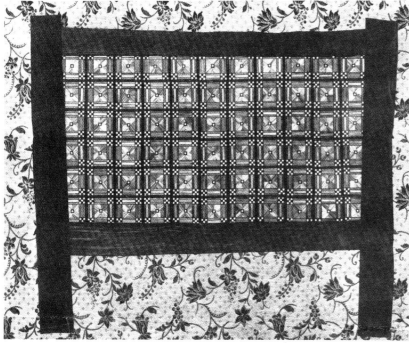

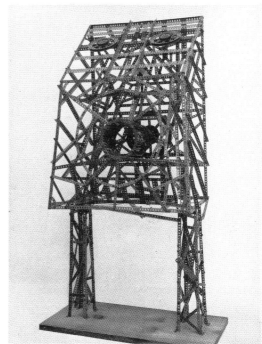

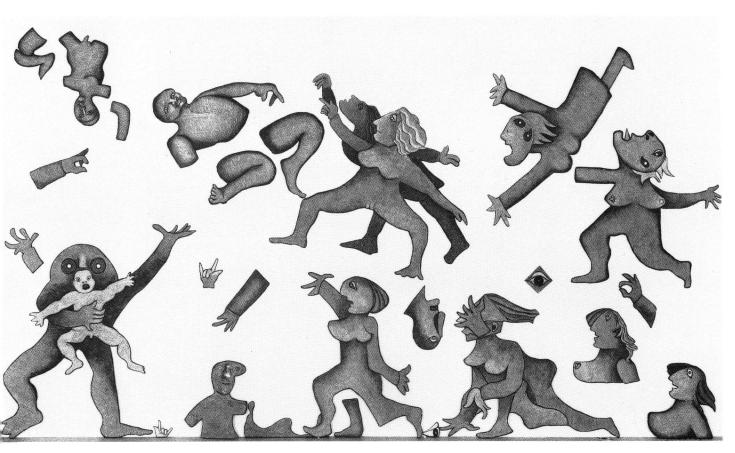

Apocalisse, 1979-1980
(Apocalypse)

Commode de style, 1961
96×130 cm

Mobile, 1961
(Furniture)
73×116 cm

Alik Cavaliere

Processi dalle storie inglesi di Shakespeare,
1971
(Trials from the English Stories
by Shakespeare)
500 × 1000 × 1000 cm

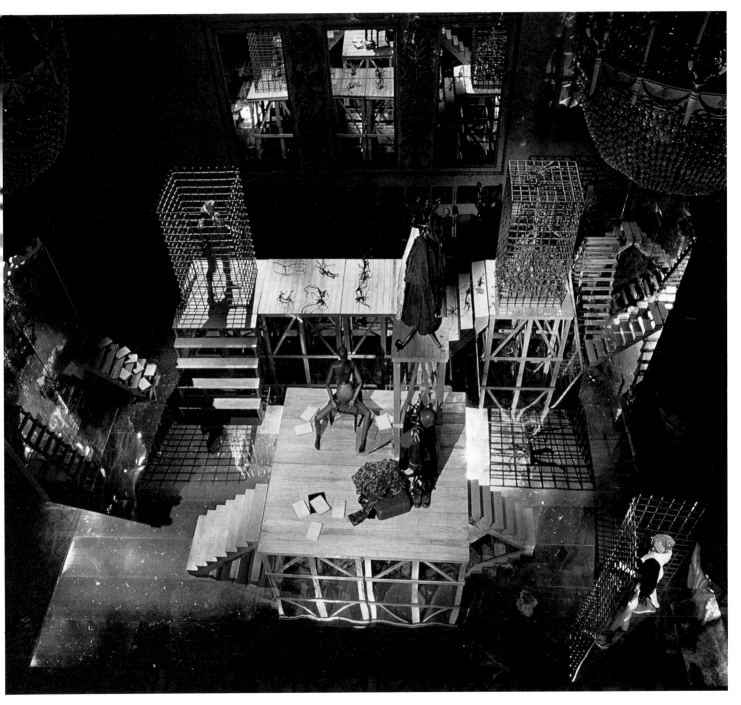

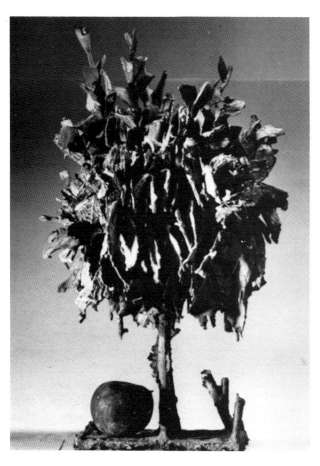

Terras frugiferentis Concele bros, 1963
h. 58 cm

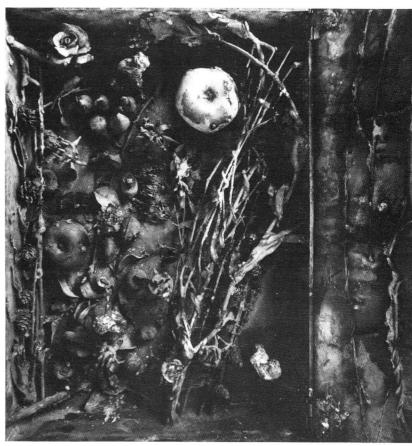

Scatola di Pandora, 1964
(Pandora's Box)
15×52.5×38 cm

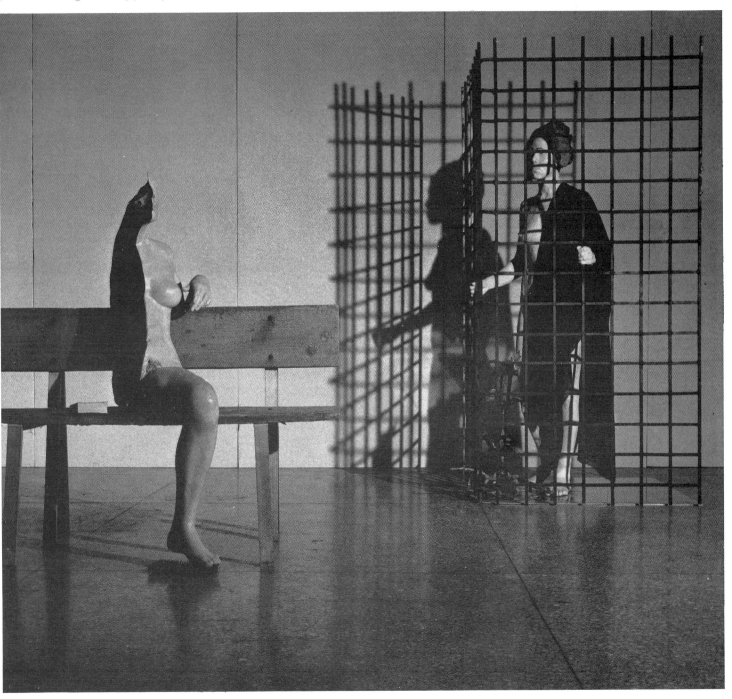

Mario Ceroli

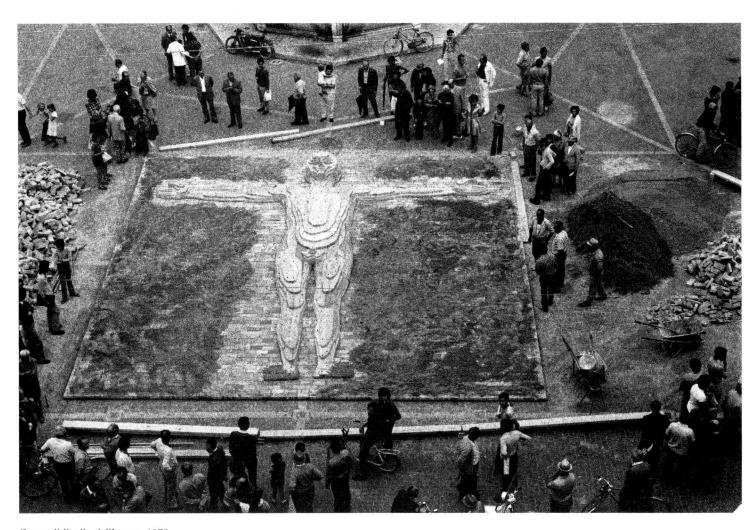

Curve di livello dell'uomo, 1972
(Curves of the Level of Man)
500×500 cm

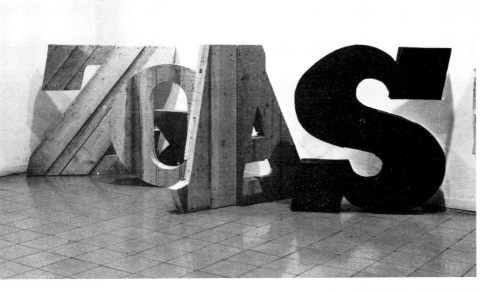

Lettere, 1961
(Letters)
120 × 100 × 20 cm

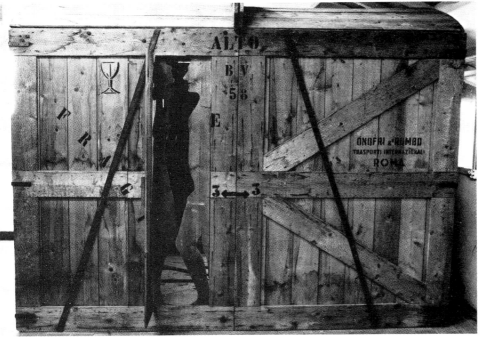

Cassa Sistina, 1965-1966
(Sistine Box)
207 × 245 × 300 cm

Casa di Dante, 1965
(Dante's House)
260×320×30 cm

La Cina, 1966
(China)
700×700 cm

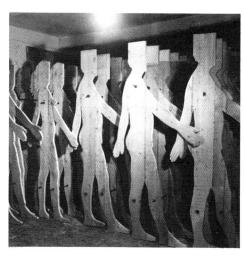

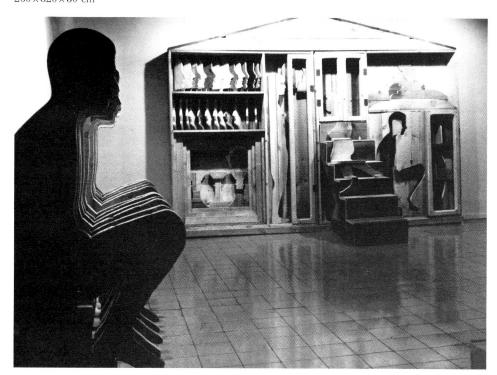

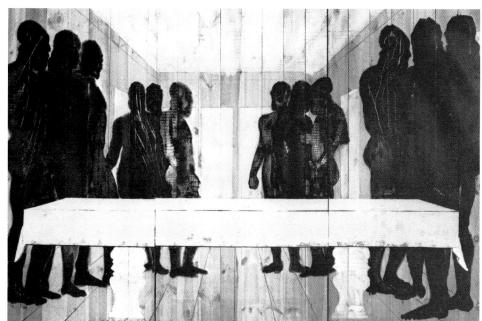

L'Ultima Cena, 1981
(The Last Supper)
220×320 cm

Nello stile italiano, 1964
(In the Italian Style)
200×162 cm

Pittura con rotoli, 1962
(Painting with Rolls)
146×114 cm

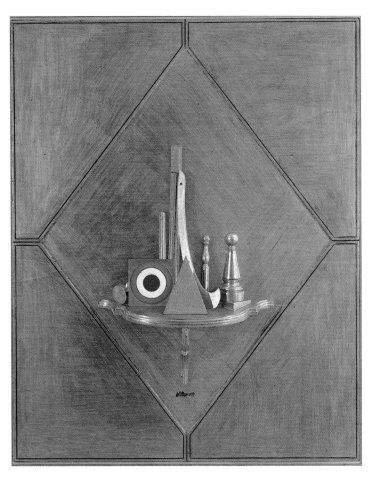

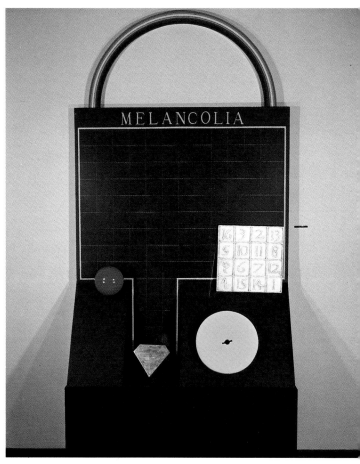

Grande quadro d'oro, 1964
(Large Gold Painting)
162×130 cm

Melancolia, 1970
(Melancholy)
220×130×68 cm

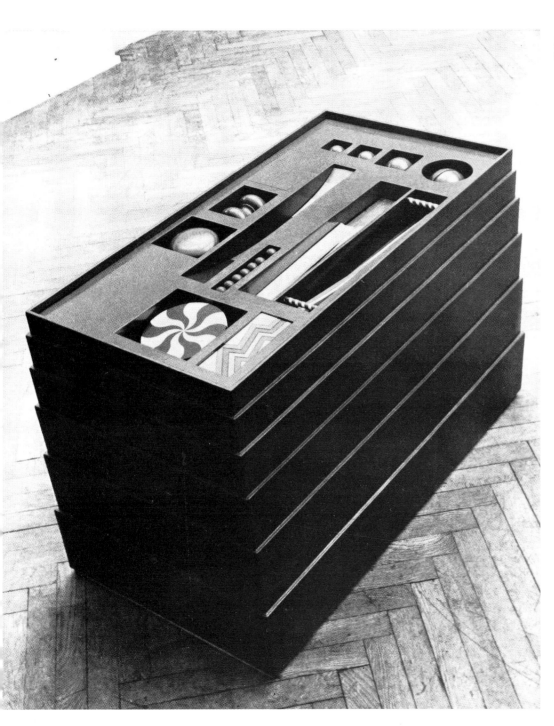

Flipper, 1966
(Pin-ball Table)
93×152×80 cm

Giosetta Fioroni

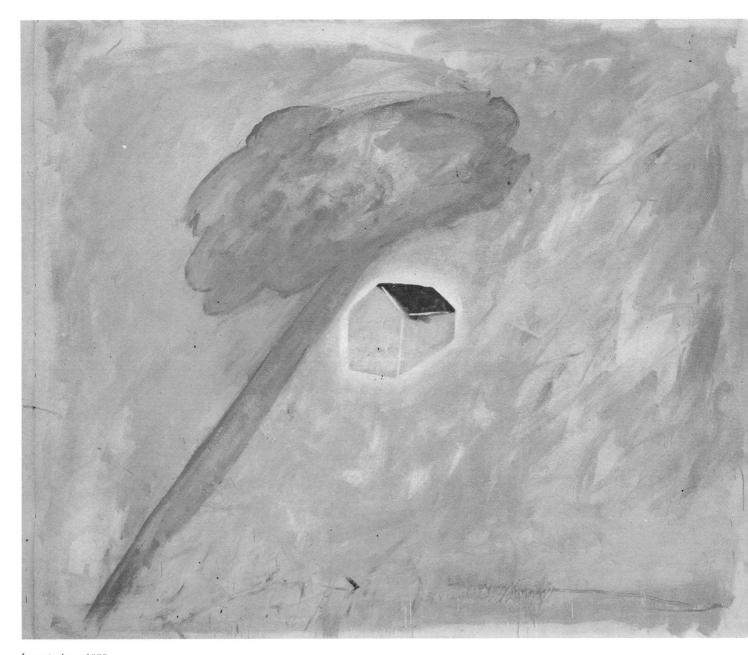

Incantesimo, 1980
(Spell)
200×230 cm

Summertime, 1980
200×230 cm

Oltre le terre lontane, 1980
(Beyond Far Away Lands)
200×212 cm

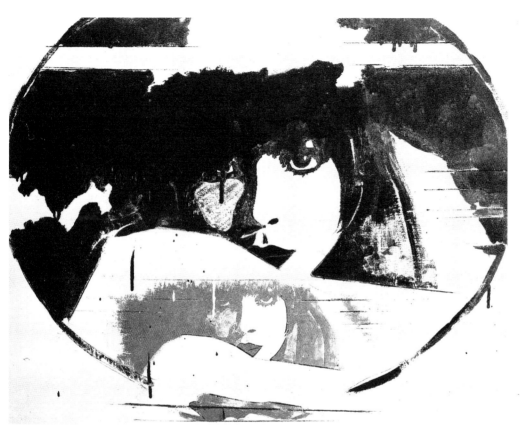

Doppio, 1964
(Double)
80×100 cm

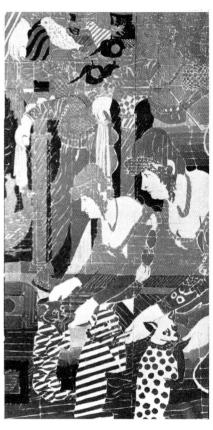

Da Carpaccio, 1967
(From Carpaccio)
200×100 cm

Ugo Nespolo

Al Museo, 1981
(At the Museum)
158×119 cm

Tra metafisica e non, 1981
(Between Metaphysics and Not)
100×70 cm

Alteration & Tailoring, 1982
180×120 cm

Il grande studio rosso, 1981
(The Big Red Study)
170×250 cm

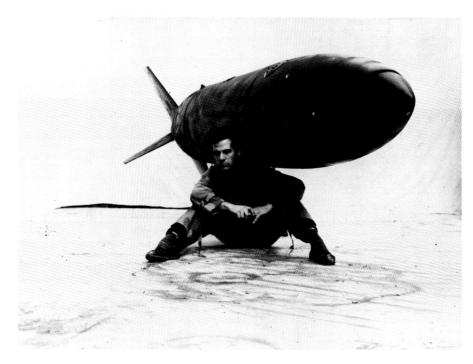

Il missile, 1965
(The Missile)
⌀ 100×500 cm

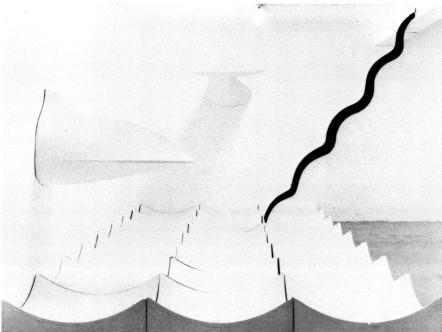

Mare, 1966
(Sea)

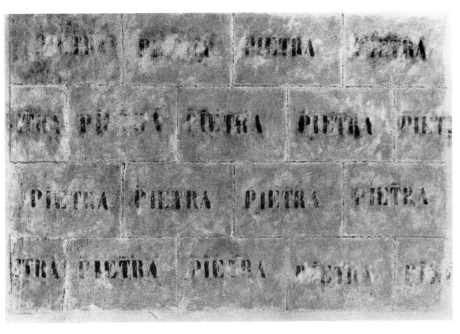

Muro di pietra, 1964
(Stone Wall)

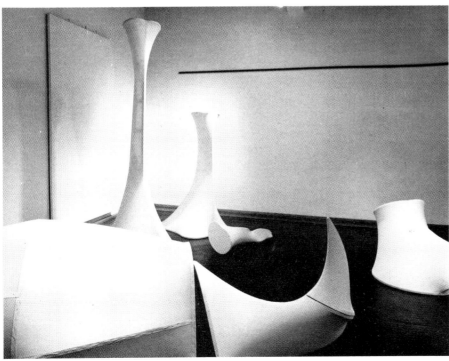

Rinoceronte e giraffe, 1966
(Rhinoceros and Giraffes)

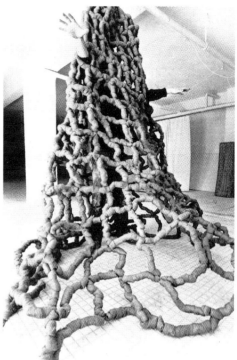

La Trappola, 1968
(The Trap)

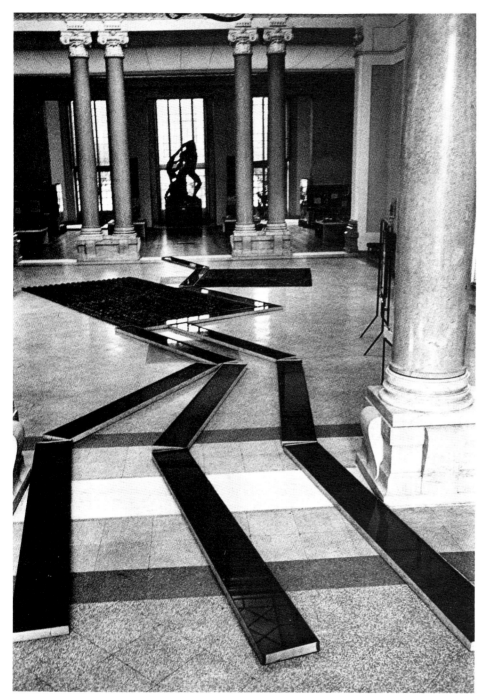

Fiume a foce tripla con campi arati, 1968
(River with Three Outlets with Ploughed
Fields)

Dal Suicidio di Grosz (particolare), 1969
(From the Suicide by Grosz) (detail)

Dal Suicidio di Grosz, 1969
(From the Suicide by Grosz)
260×750 cm

Natura morta, 1967
(Still Life)
175×200 cm

Canterano profumato, 1971
(Perfumed Chest of Drawers)
175×200 cm

Racconto, 1963
(Tale)
100 × 80 cm cm

Racconto, 1962
(Tale)
100×120 cm

Strano amore, 1964
(Strange Love)
100×100 cm

Al centro, 1964
(At the Centre)
100×100 cm

100

Carabiniere, 1962
100×73 cm

Scotch Brand, 1960
146×114 cm

Prendi il piatto, 1961
(Take the Plate)
35×35 cm

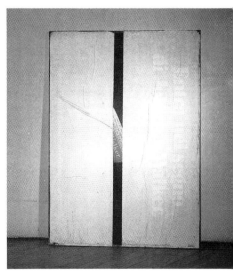

Blank Fissuré Walker, 1980
100×140 cm

Coperture, 1980
(Coverings)
150×300 cm

Io non amo la natura, 1964
(I Don't Love Nature)
200×300 cm

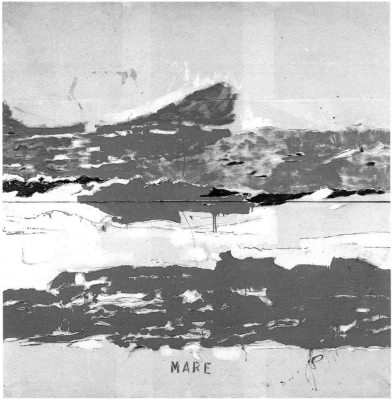

Mare, 1963
(Sea)
200×200 cm

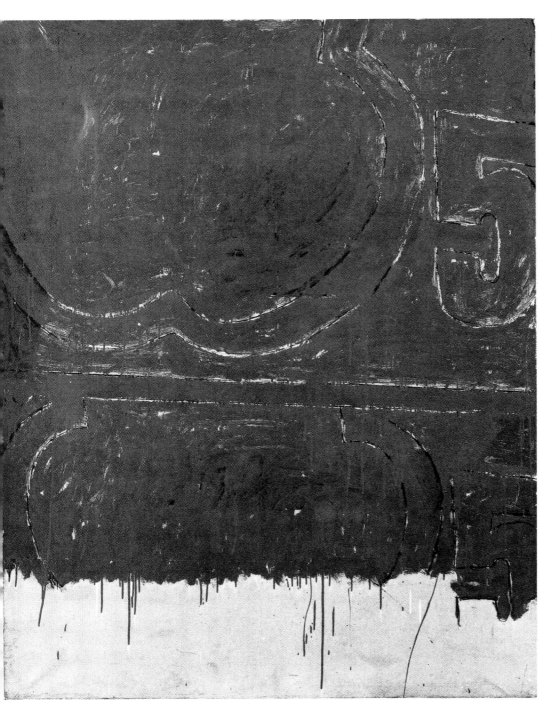

Particolare di esterno, 1962
(Detail of an Exterior)
180×140 cm

Camminare, 1965
(To Walk)
200×300 cm

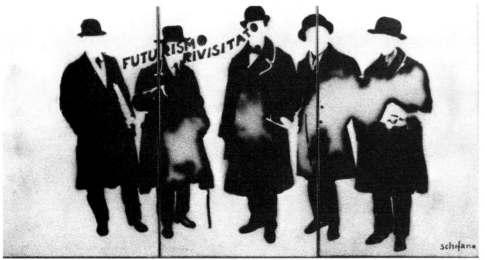

Futurismo rivisitato, 1966
(Futurism Revisited)
170×345 cm

Emilio Tadini

Color & Co., 1969
162×130 cm

Museo dell'uomo, 1974
(Museum of Man)
162×130 cm

L'occhio della pittura, 1978
(Painting's Eye)
260×800 cm

Il desiderio del pittore, 1976
(The Painter's Wish)
160×200 cm

Le mani di Renoir, 1979
(Renoir's Hands)
146×114 cm

L'occhio della pittura (particolare), 1978
(Painting's Eye) (detail)
260×800 cm

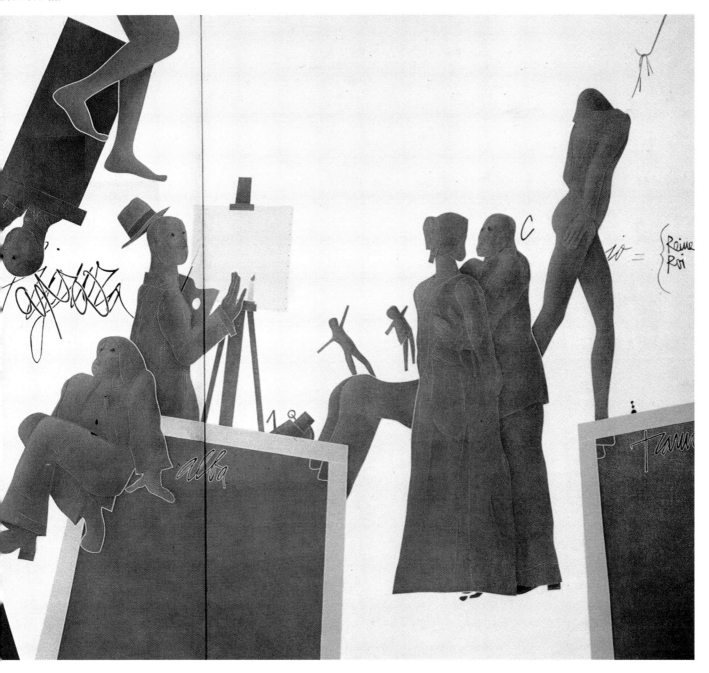

Omaggio a Che, 1967
(Homage to Che)
200 × 124 cm

Dialettica, 1968
(Dialectics)
205×30 cm

Un obelisco per la memoria, 1968
(An Obelisk for the Memory)
204×30 cm

Linea, 1968
(Line)
205×30 cm

Tonnerre Printanier, 1968
205×30 cm

L'oriente risplende di rosso, 1968
(The East Shines with Red)
201 × 123.5 cm

L'esercizio della libertà, 1968
(The Exercise of Freedom)
205 × 100 cm

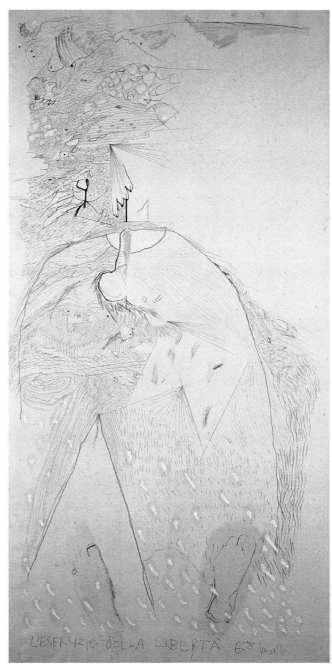

Tancredi

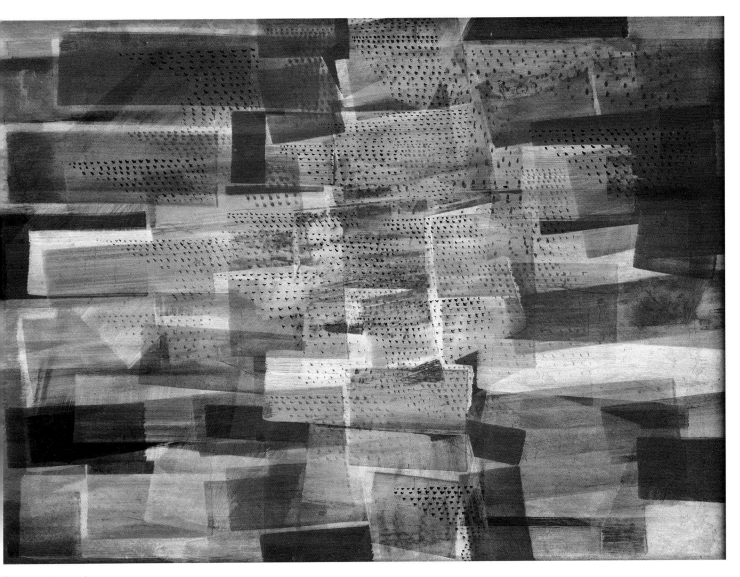

Composizione, s.d.
(Composition, n.d.)
90×124 cm

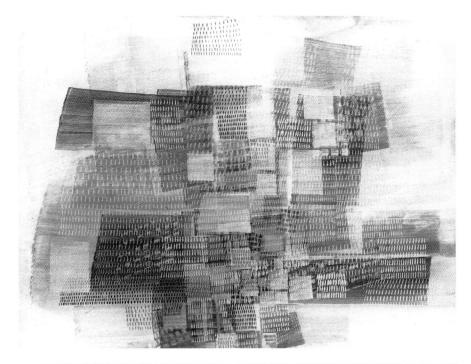

Composizione, 1953
(Composition)
125×170 cm

Untitled, 1954
94×127 cm

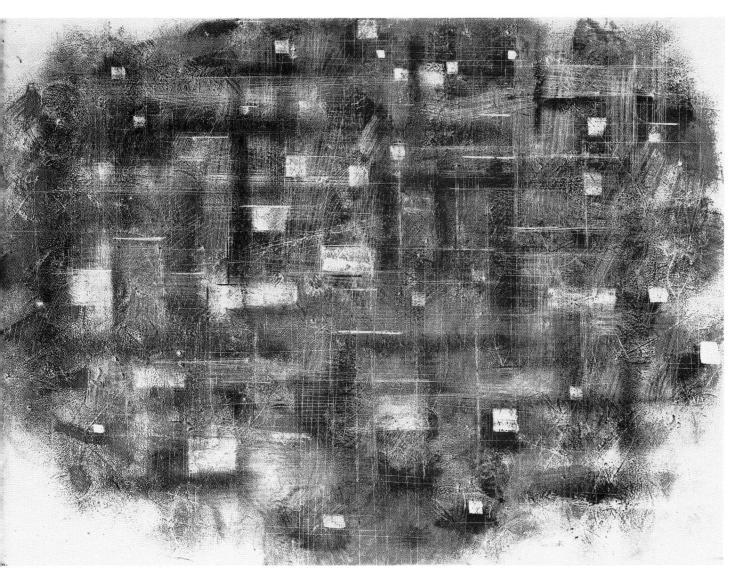

Untitled, 1954
94×125 cm

Piero Dorazio

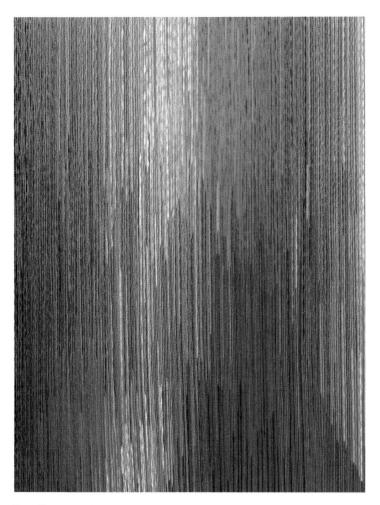

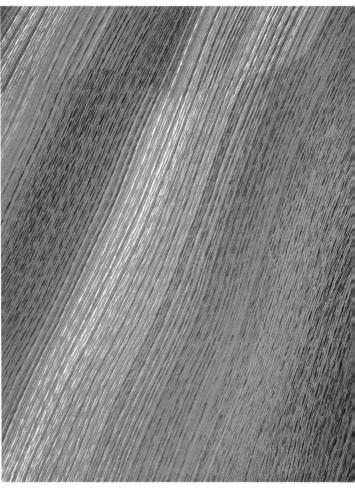

Smagliante, 1982
(Radiant)
200 × 150 cm

Rara, 1982
(Rare)
200 × 150 cm

"Mytification", 1962
130 × 160 cm

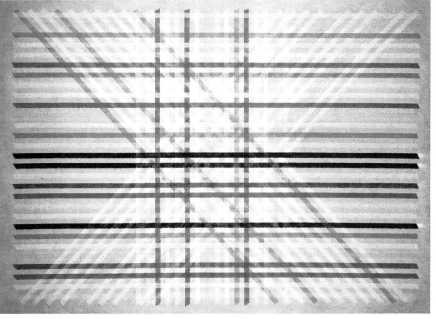

Cercando la Magliana, 1964
(Looking for the Magliana)
197 × 230 cm

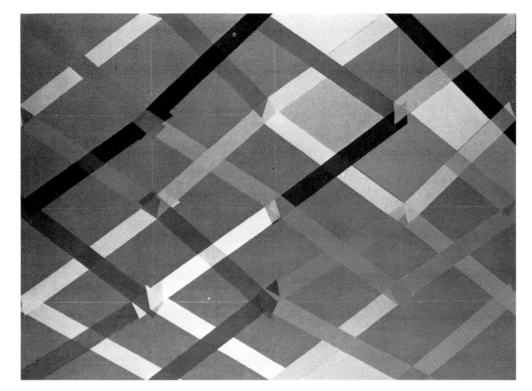

Scavezzacollo, 1968
(Reckless)
180 × 250 cm

Elites, 1980
70 × 120 cm

Quattrocento, 1970
140 × 400 × 10 cm

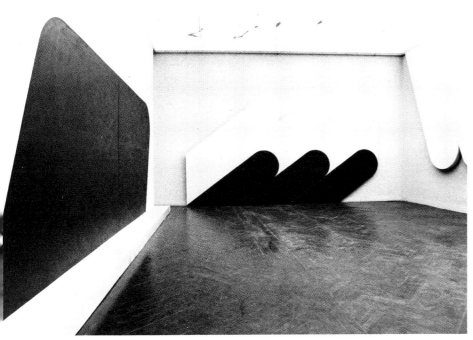

Sala Biennale, 1968
(Biennale Room)

Contaminante 53/A, 1974
(Contaminating 53/A)
230×600×6 cm

Clinamen, 1982
242×600 cm

Prospettiva per Paolo Uccello, 1970
(Perspective for Paolo Uccello)
400 × 160 cm

Carlo Battaglia

Pelio, 1972-1973
(Pelium)
140×280 cm

Anacreonte, 1973-1974
(Anacreon)
100×260 cm

122

Riflessione (particolare), 1977
(Reflection) (detail)
210 × 100 cm

Oltremarina uno, 1981
(Ultramarine One)
200 × 190 cm

Calypso, 1970
160×300 cm

Nicola Carrino

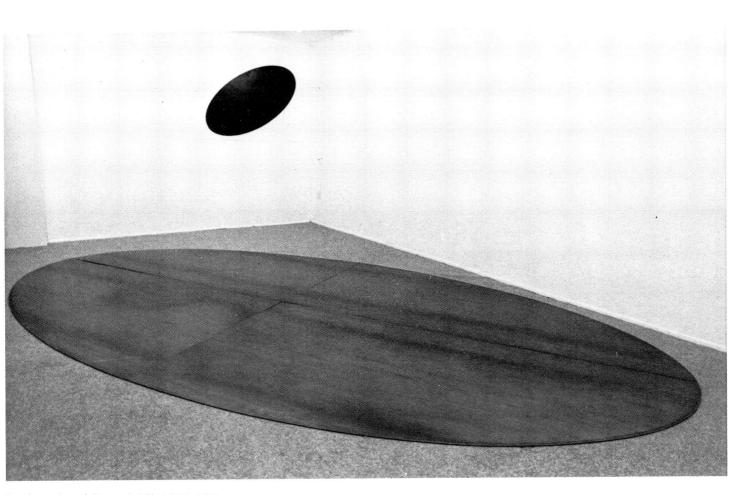

Trasformazione dello spazio/ellissi 2/81, 1981
(Transformation of the Space/Ellipsis 2/81)
600×300×0.6 cm

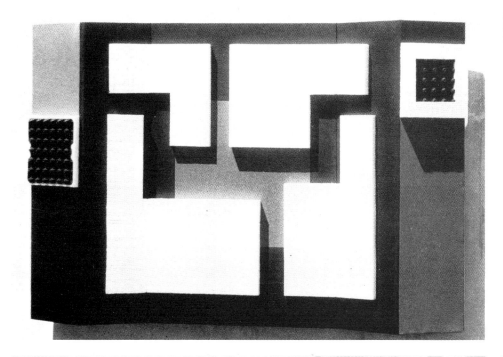

Costruttivo Alfa, 1963
(Constructive Alpha)
106 × 136 × 35 cm

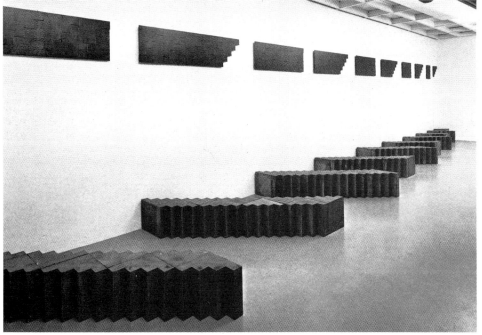

Processo 1.10 orizzontale/diagonale, 1976
(Process 1.10 Horizontal/Diagonal)

onstruction/Destruction, 1970

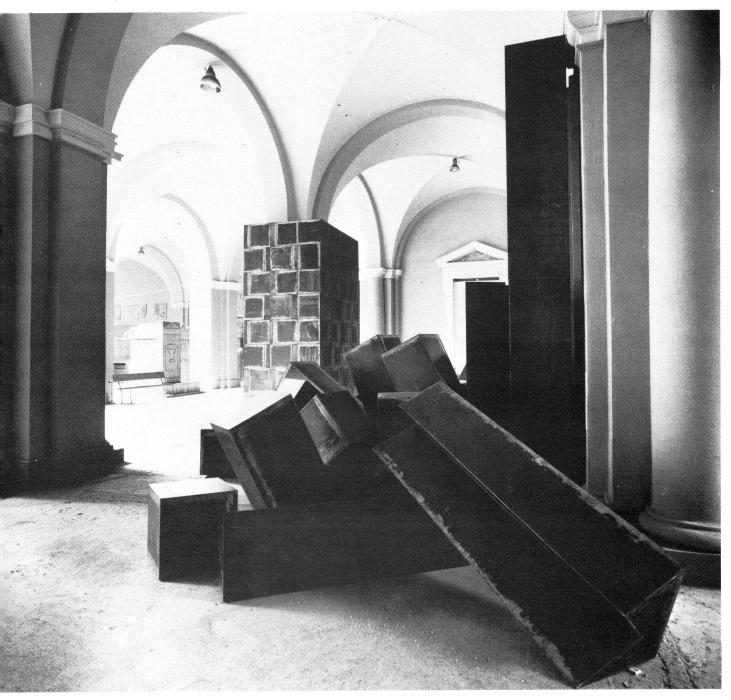

Marco Gastini

Acrilico M1, 1974
(Acrylic M1)
200×280 cm

Acrilico M2, 1974
(Acrylic M2)
200×280 cm

Acrilico M3, 1974
(Acrylic M3)
200×280 cm

Untitled, 1969
300×300 cm

Paesaggio I, 1977
(Landscape I)
260×260 cm

Dipinto I, 1979
(Painting I)
200×225×30 cm

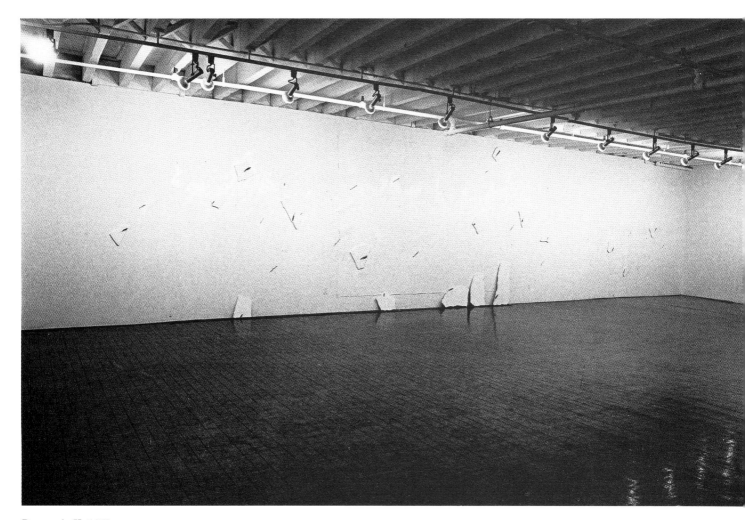

Paesaggio II, 1979
(Landscape II)
295×1344 cm

Orizzontale, 1971
(Horizontal)
70×100 cm

Linee verticali, 1974
(Vertical Lines)
120×120 cm

Frammenti (particolare), 1979
(Fragments) (detail)
120×100 cm

Orizzontale policromo, 1973
(Polychrome Horizontal)
150×150 cm

Untitled, 1982
300×110 cm

Vittorio Matino

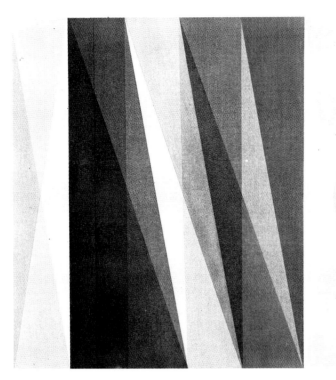

Untitled, 1972
140×140 cm

Untitled, 1976
170×170 cm

134

Untitled, 1975
170×170 cm

Untitled, 1981
24×91.5 cm

Untitled, 1982
244×91.5 cm

Claudio Olivieri

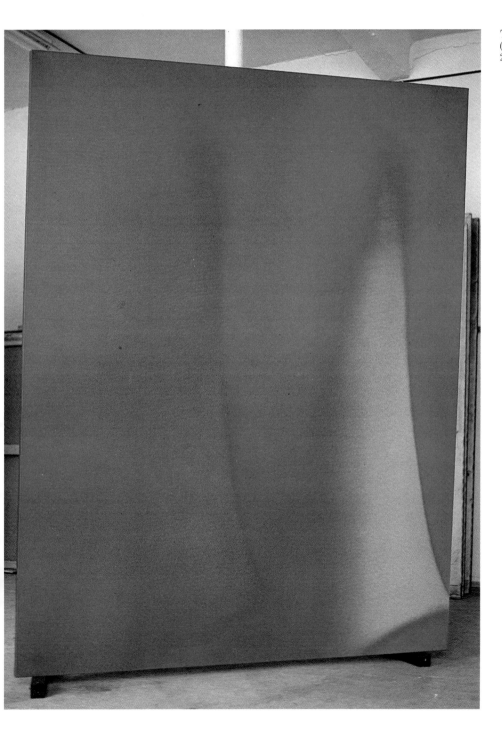

Tantalo, 1982
(Tantalus)
260×200 cm

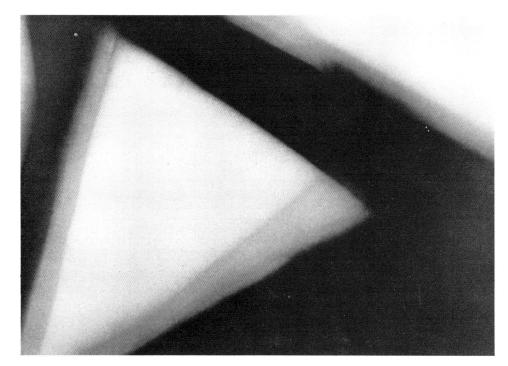

Tensionale, 1971
(Tensional)
200×300 cm

Ephemera, 1972
200×150 cm

Greyout, 1978
200×160 cm

Erratico grigio, 1979
(Grey Erratic)
220×200 cm

Gianfranco Pardi

Diagonale, 1982
(Diagonal)
233×360×360 cm

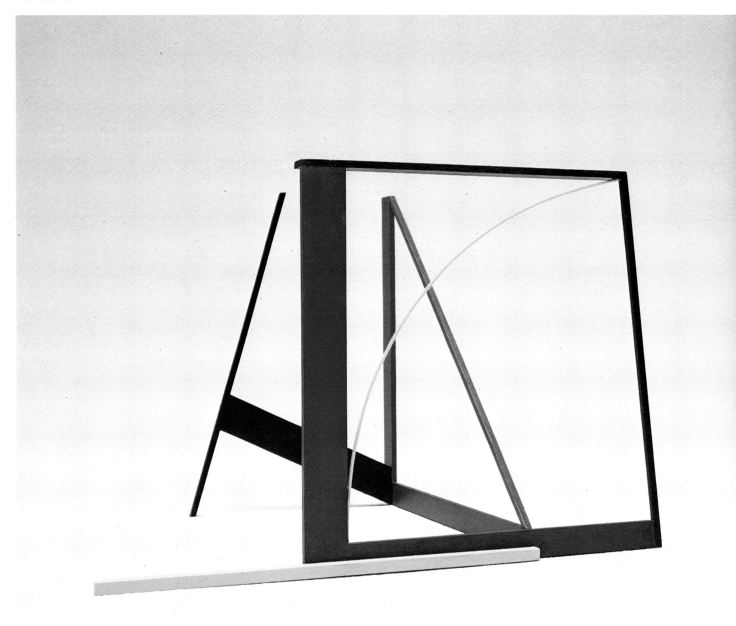

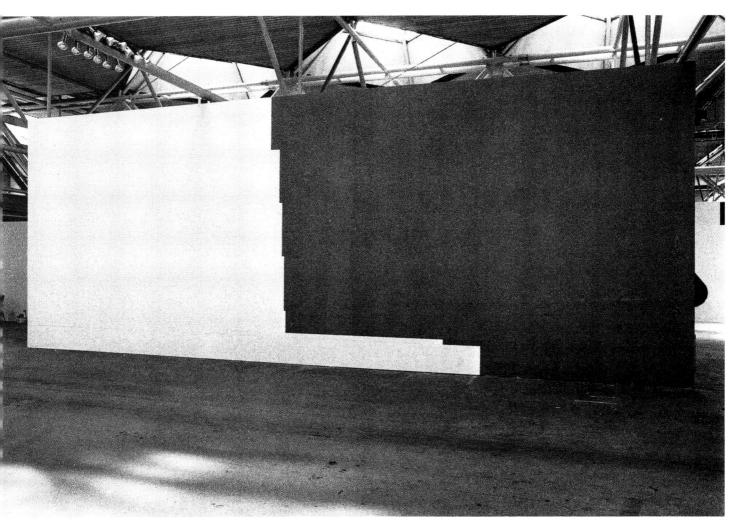

Diagonale, 1979
(Diagonal)
1200×450 cm

Abside, 1981
(Apse)
80 × 100 cm

Diagonale, 1982
(Diagonal)
200 × 300 cm

Casa, 1980
(House)
50 × 15 cm

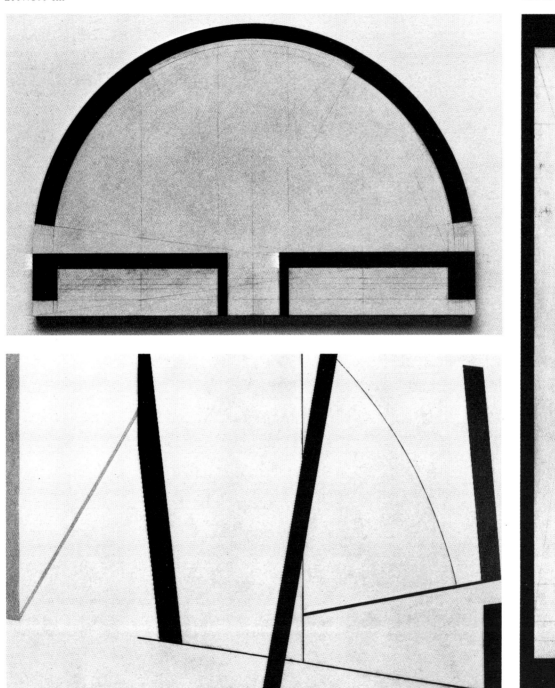

142

Apparizione, 1960
(Apparition)
75×135 cm

P.E. 96, 1972
240×180 cm

M.C. 85, 1981
200 × 150 cm

I.R. 89, 1974
180×240 cm

M.C. 52, 1981
200×150 cm

Giuseppe Uncini

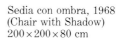

Sedia con ombra, 1968
(Chair with Shadow)
200 × 200 × 80 cm

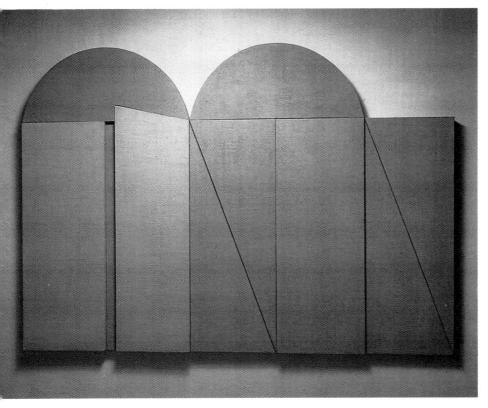

Dimore n. 12, 1982
(Abodes No. 12)
151×214×8 cm

Cementarmato, 1960
(Reinforced-concrete)
200×100 cm

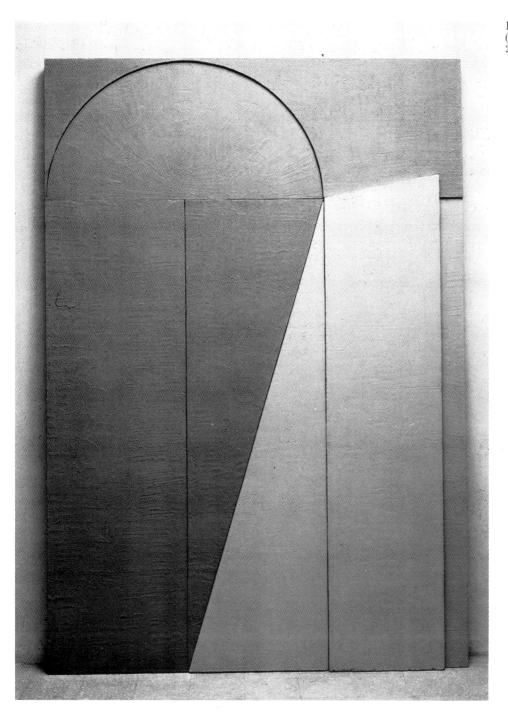

Dimore n. 13, 1982
(Abodes No. 13)
231×161×8 cm

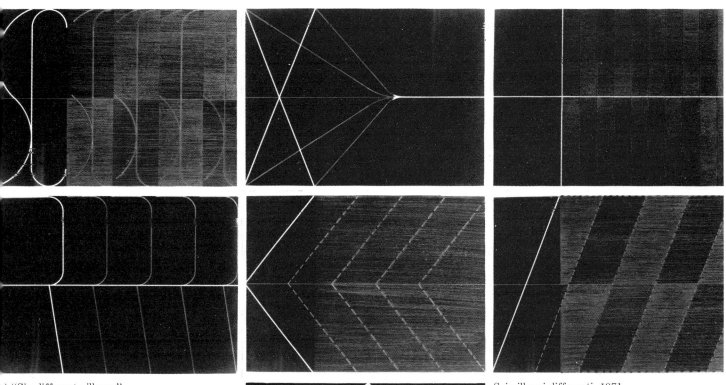

a) "Six different villages".

b) Six consonants like six words; like words
enclosing the last trace of many talks, useful
and otherwise. Like six talks of six different
villages. Forgotten perhaps, perhaps lost. Six
sounds like six signals, like signs; like
everything and nothing in background
language.

b1) SC,X,H,R,K,Z: the six consonants engraved
on the surfaces of the pictures graphically
represent their own phonemes.

b2) The cottage in the seventh picture
represents our world, today's village.

c) While the six consonants refer to sounds
which are the common denominator of each
relative village, the cottage is reinforced by
a tape which reproduces the live sounds of the
city of today.

Therefore, against a tangible fullness of
communications is counterpoised the emptiness
of the six villages. Two opposites which equal
each other to the extent in which both the
emptiness and the fullness have nothing more
to add to themselves.

Agnetti, 1974

Sei villaggi differenti, 1971
(Six Different Villages)

Le stagioni si ripetono, 1976
(The Seasons Repeat Themselves)

Semiosi, 1969
(Semiosis)
47 × 40 cm

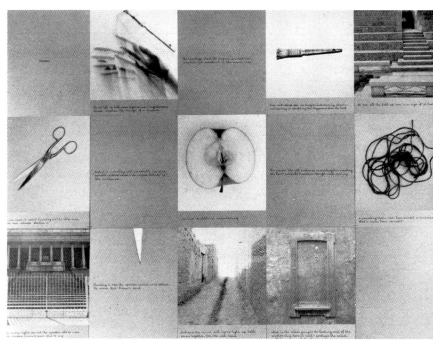

Il delitto, 1977
(The Crime)

Della provvisorietà, 1978
(On Temporariness)

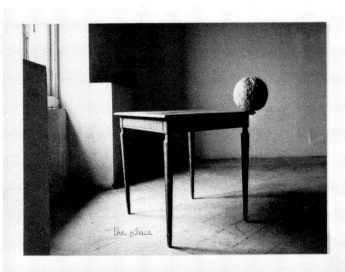

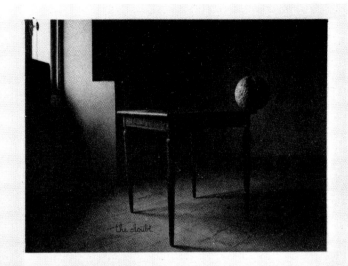

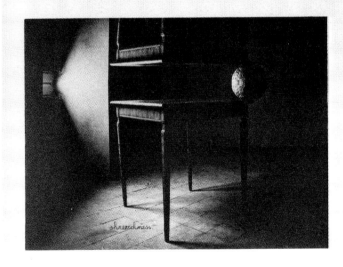

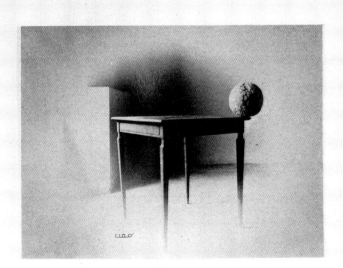

Alighiero Boetti

Colonna, 1968
(Column)

Faccine, 1977
(Little Faces)

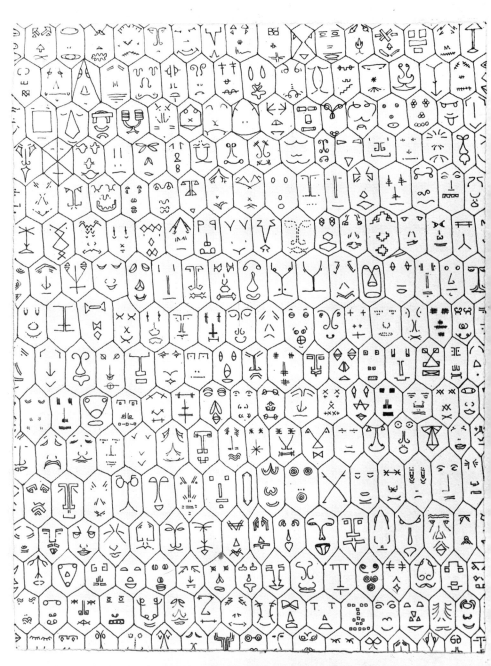

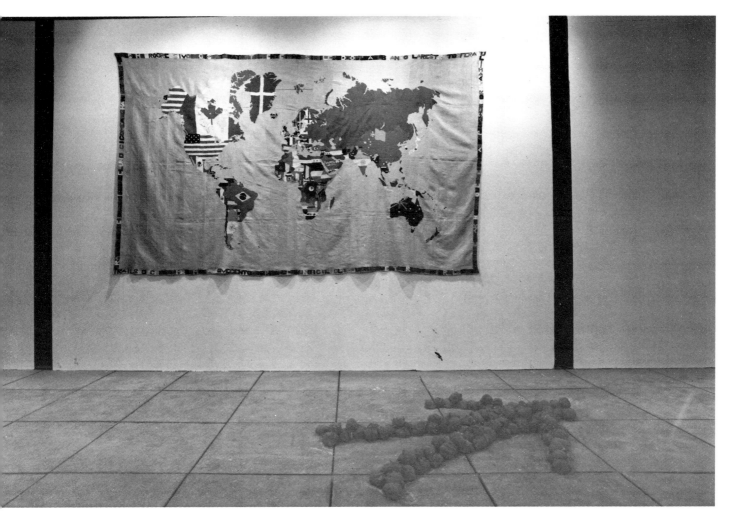

che prendo il sole a Torino il 29 gennaio
)69, Mappa, 1969
Sunbathe at Turin on the 29th of January,
)69, Map)

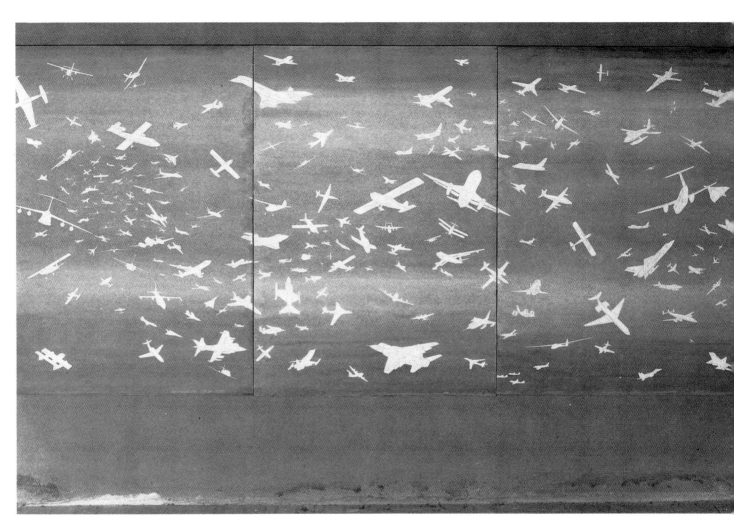

Aerei, 1971
(Airplanes)
210×100 cm

Beppe Devalle

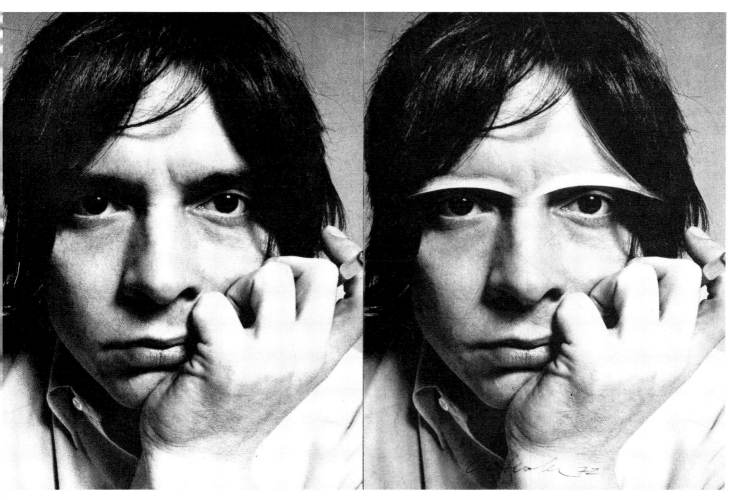

Mr. Bailey and Dr. Jekyll, 1973
23.3×31.3 cm

Karl Lagerfeld, 1974
73×102 cm

Aetatis meae XXXVI, 1976
102×73 cm

Rocce nere, 1975
(Black Rocks)
73×102 cm

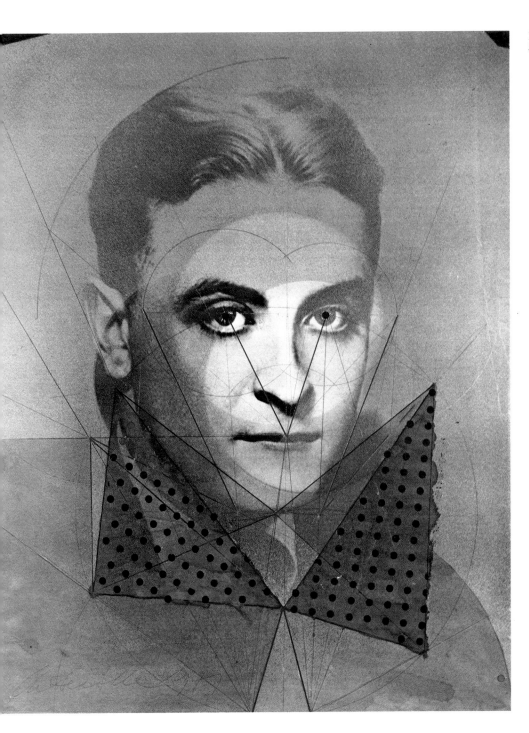

F.S. Fitzgerald, 1972
35×25 cm

157

Emilio Isgrò

Libro cancellato, 1964
(Cancelled Book)
40×60 cm

Enciclopedia Italiana fondata da Giovanni
Treccani, Volume XXXII, 1970
(Enciclopedia Italiana founded by Giovanni
Treccani, Volume XXXII)
94×50 cm

MAO TSE-TUNG
DETAIL ENLARGED 915 TIMES
DETAIL AGRANDI 915 FOIS
PARTICOLARE INGRANDITO 915 VOLTE

Fryderyk Chopin ipotecò queste note (e non altre) in una osteria nei pressi di Linz dove era sceso a orinare durante un viaggio in carrozza. Credeva che fossero elefanti. *Luglio 1831.*

Particolare da Mao, 1970
(Detail from Mao)
116×89 cm

Chopin (particolare), 1979
Chopin (detail)

Chopin, partitura per 15 pianoforti, 1979
(Chopin, Score for 15 pianos)

Jannis Kounellis

Untitled, 1960
220×330 cm

Rosa, 1967
(Rose)
200×130 cm

Z. 44, 1959-1962

Cavalli, 1969-1976
(Horses)

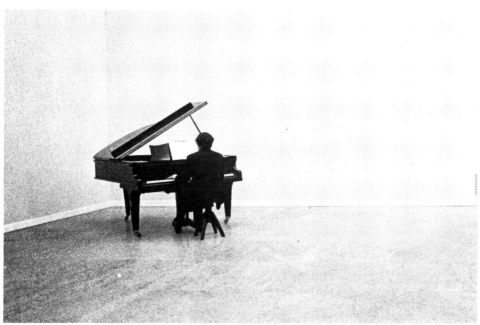

Nabucco, 1970

162

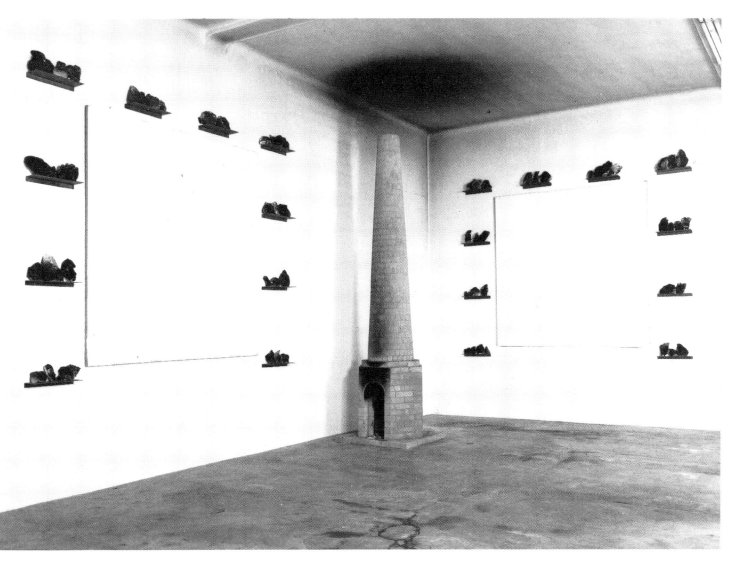

Untitled, 1981

Eliseo Mattiacci

Tubo giallo, 1967
(Yellow Tube)
1500 × ∅50 cm

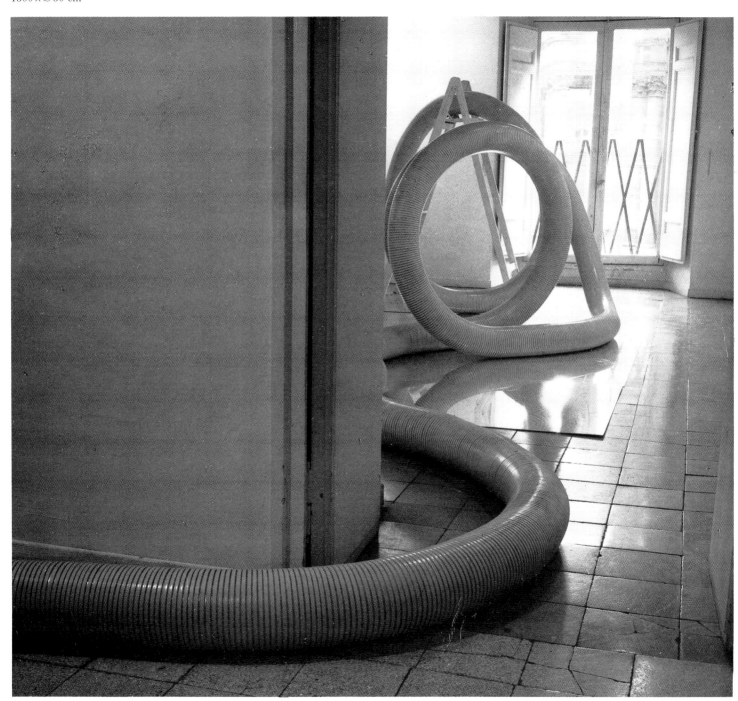

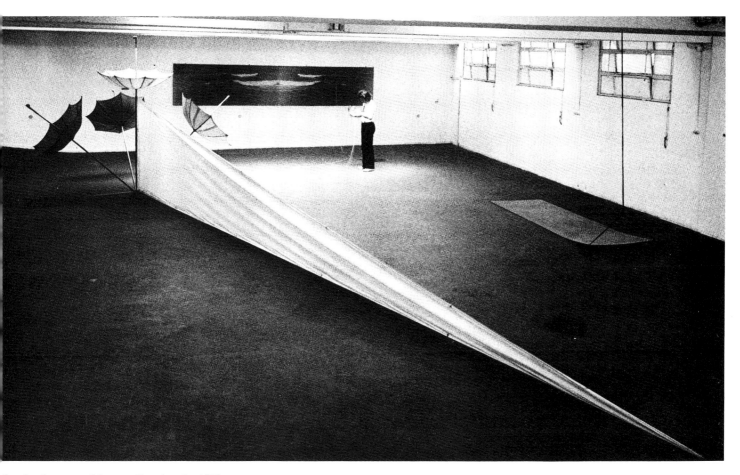

Sentire il rumore del mare, Grande vela, 1972
(Hearing the Noise of the Sea, Large Sail)

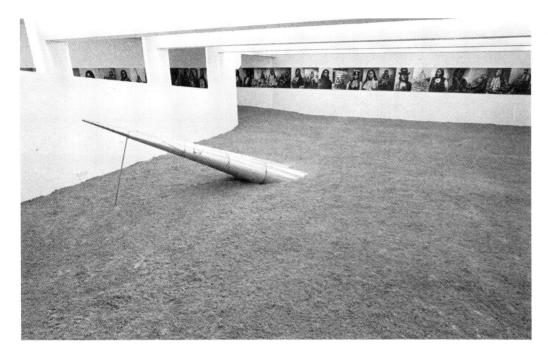

Recupero di un mito: Pellerossa, 1976
(Recovery of a Myth: Redskin)

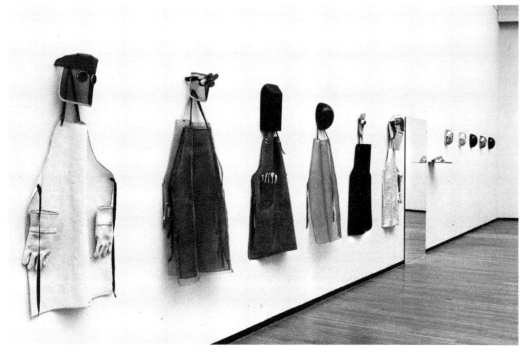

Untitled, 1981

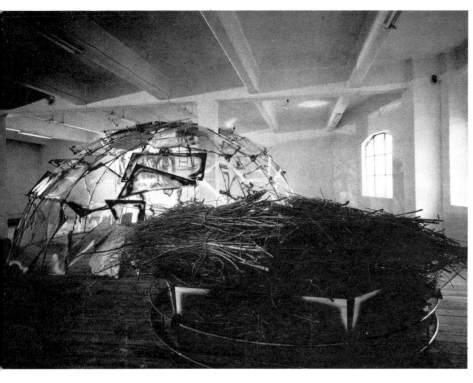

Installazione, 1981
(Installation)

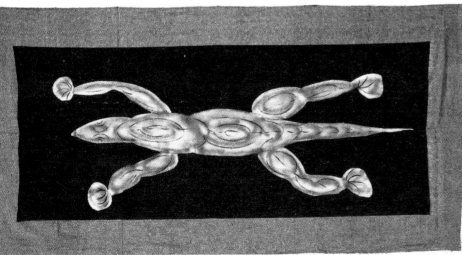

Untitled, 1981
250 × 400 cm

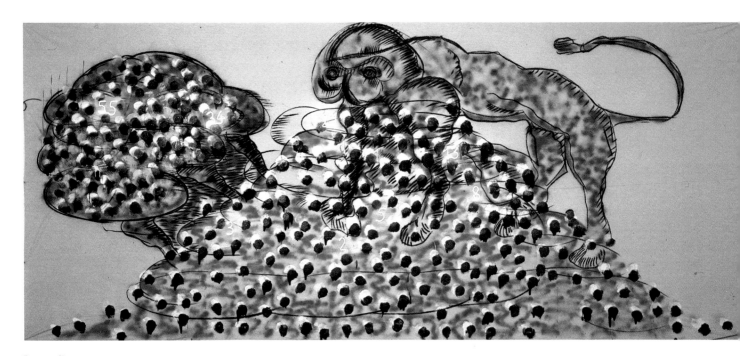

Leone di montagna, 1981
(Mountain Lion)
250 × 600 cm

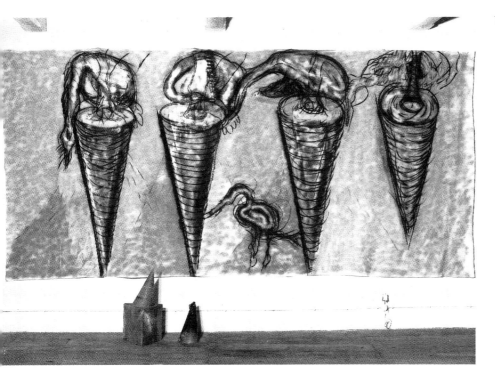

Untitled, 1981

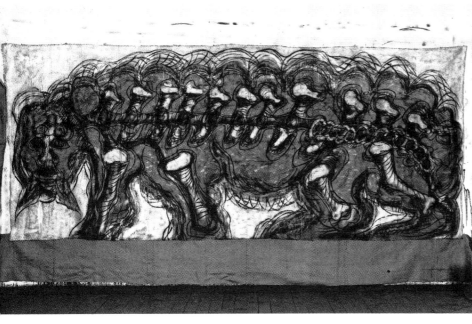

Animale feroce, 1981
(Ferocious Animal)
250 × 500 cm

Maurizio Mochetti

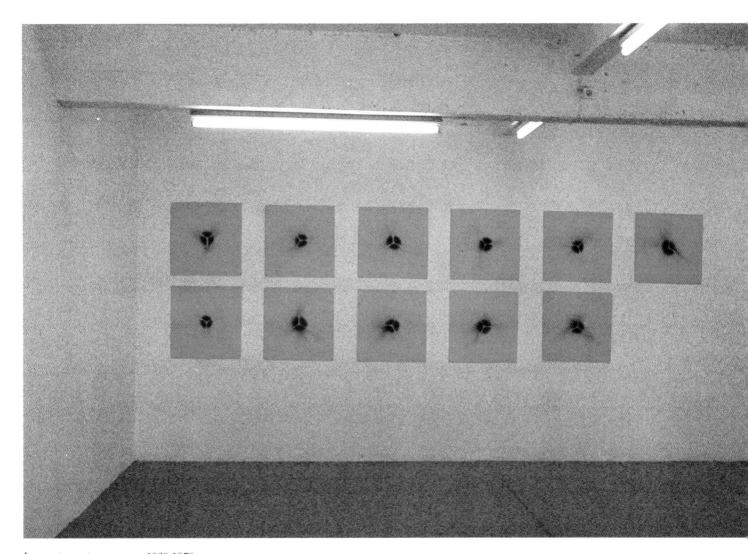

Impronte partenze razzo, 1969-1979
(Impressions of Rocket Launching)

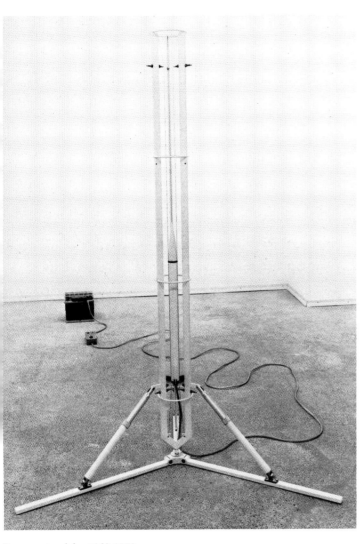

Razzo potenziale, 1969-1979
(Potential Rocket)

Aereo-razzo Natter Bachem BA 349B 1944,
1977
(Aereo-rocket Natter Bachem BA 349B, 1944)

Lotus Super Seven Model Series Three, 1977

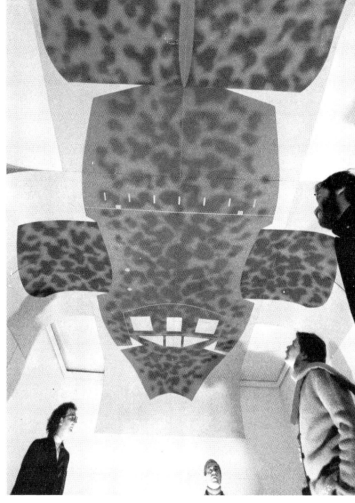

Bachem BA 349 Natter (Viper)/Camouflage
No. 1, 1979
520 × 800 cm

Giulio Paolini

Estelle Masselin — Orto Botanico, 1961
(Estelle Masselin — Botanical Garden)
40×60 cm

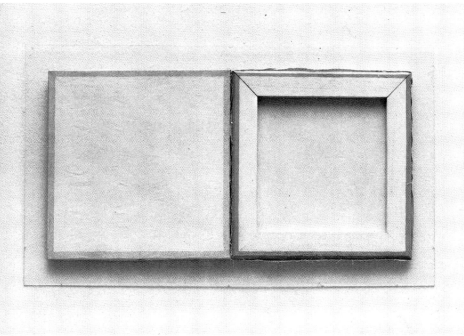

Untitled, 1962-1963
40×80 cm

173

GIOVANE CHE GUARDA LORENZO LOTTO, 1967

RICOSTRUZIONE NELLO SPAZIO E NEL TEMPO
DEL PUNTO OCCUPATO DALL'AUTORE (1505)
E (ORA) DALL'OSSERVATORE DI QUESTO QUA
DRO.

Giovane che guarda Lorenzo Lotto, 1967
(Youngster looking at Lorenzo Lotto)
30×24 cm

Averroè, 1967
200×65×65 cm

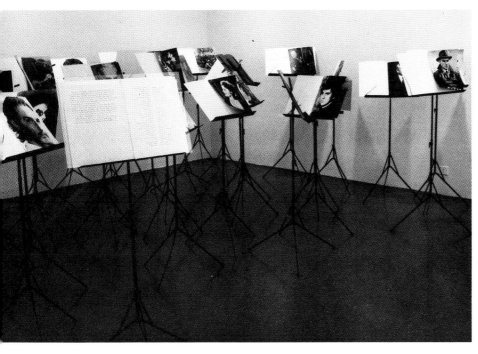

Apoteosi di Omero, 1970-1971
(Apotheosis of Homer)

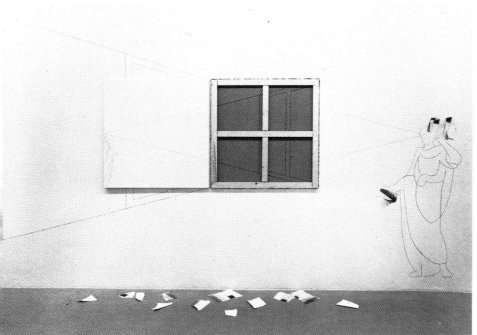

Liber Veritatis, 1979

Vettor Pisani

Il teatro del coniglio, 1976
(The Theatre of the Rabbit)

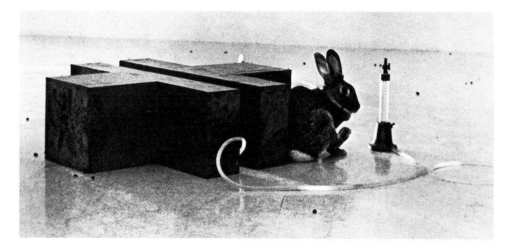

Artista che ama la natura, 1978
(Artist who Loves Nature)
70×100 cm

Il teatro sull'abisso, 1982
(The Theatre on the Abyss)

Labirinto, 1980
(Labyrinth)

I cipressi sul divano, 1980
(The Cypresses on the Divan)

Una tomba per Edipo, 1970-1982
(A Tomb for Oedipus)

Michelangelo Pistoletto

Il pozzo, 1966
(The Well)
170×170×100 cm

Un uomo, 1961
(A Man)
200×120 cm

Il bagno, 1966
(The Bath)
200×100×50 cm

179

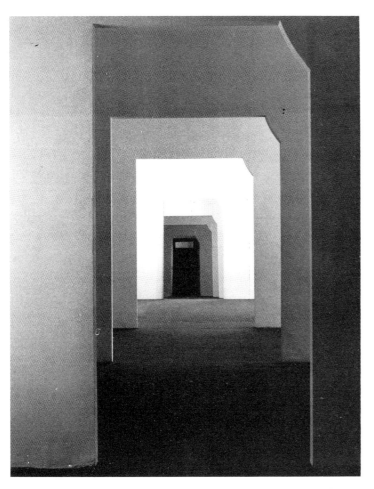

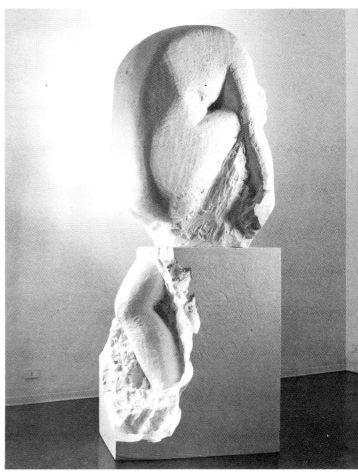

Le stanze, 1975
(The Rooms)

Il gigante bianco, 1982
(The White Giant)
100×75×240 cm

Venere degli stracci, 1967
(Venus of the Rags)

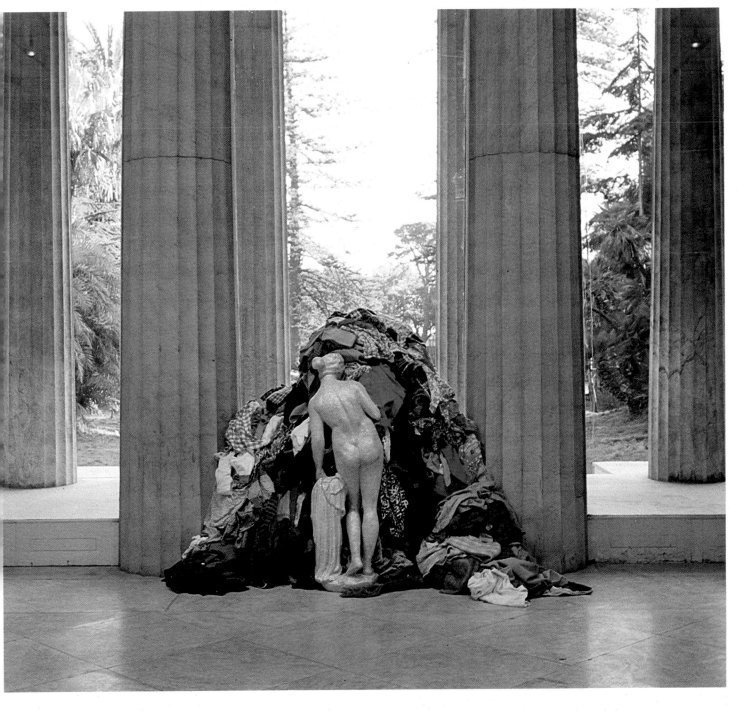

Franco Vaccari

Esposizione in tempo reale: "Lascia su queste
pareti una traccia fotografica del tuo
passaggio", 1972
(Exhibition in real time: "Leave a photographic
trace of your passing on these walls")

LASCIA SU QUESTE PARETI UNA TRACCIA FOTOGRAFICA DEL TUO PASSAGGIO

LASS AN DIESER WAND EINE FOTOGRAFISCHE ZEICHNUNG DEINES DURCHGANGS

LEAVE ON THE WALLS A PHOTOGRAPHIC TRACE OF YOUR FLEETING VISIT

LAISSE SUR CES MURS UN TEMOIGNAGE PHOTOGRAPHIQUE DE TON PASSAGE

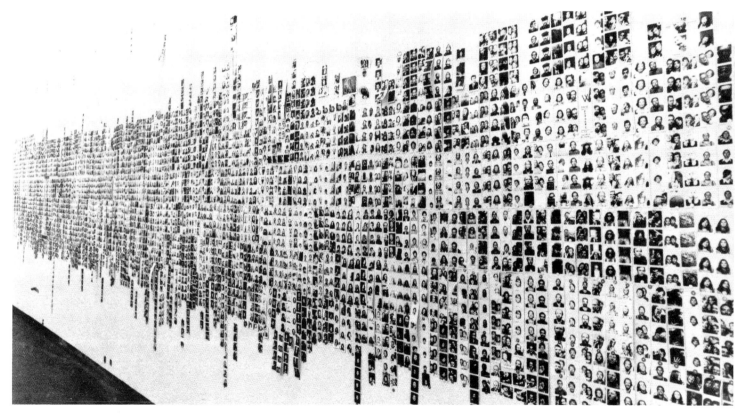

Esposizione in tempo reale: "Lascia su queste
pareti una traccia fotografica del tuo
passaggio", 1972
(Exhibition in real time: "Leave a photographic
trace of your passing on these walls")

L'autore dell'autore, 1973
(The Author of the Author)

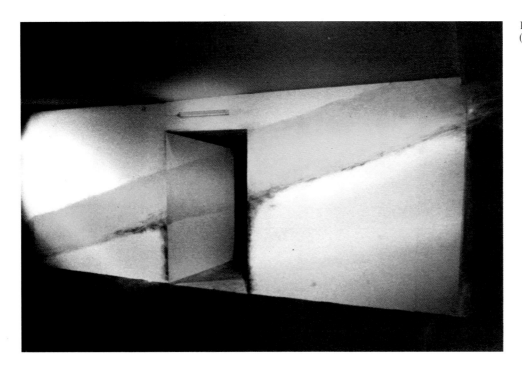

Installazione alla Biennale di Venezia, 1980
(Installation at the Venice Biennale)

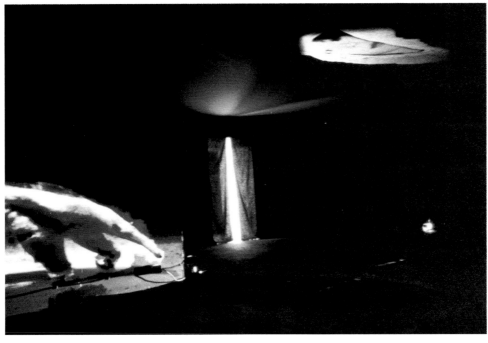

chele Zaza

Fantasia privata, 1976
(Private Fantasy)
44×54.5 and 21.5×27.5 cm

Anamnesi, 1976
(Anamnesis)
25×19 cm

185

Invaso dai profumi dell'anima, 1981
(Invaded by the Perfumes of the Soul)
114×210 cm

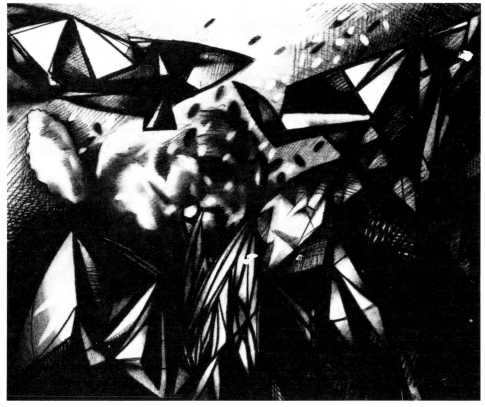

Lo spazio dell'anima, 1982
(The Space of the Soul)
66×80 cm

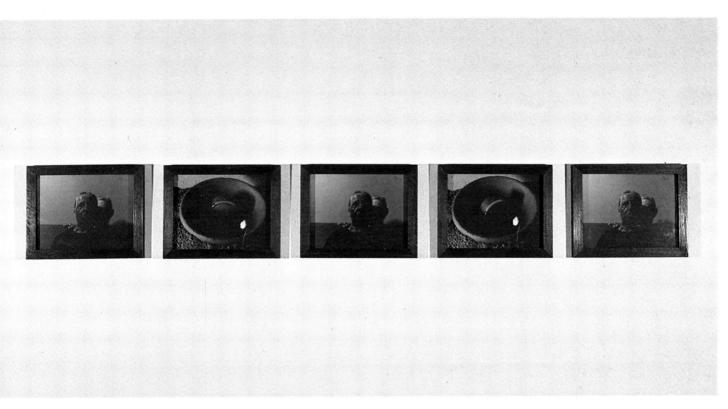

Neo-terrestre (particolare), 1979
(Neo-terrestrial) (detail)

Gilberto Zorio

Letto, 1966
(Bed)
170 × 170 × 30 cm

Untitled, 1967
170 × 100 × 100 cm

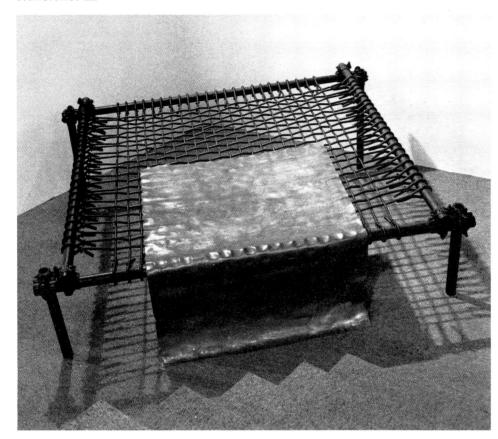

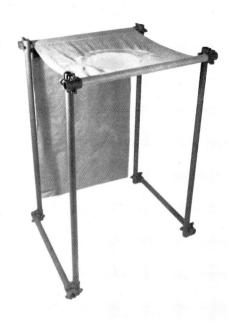

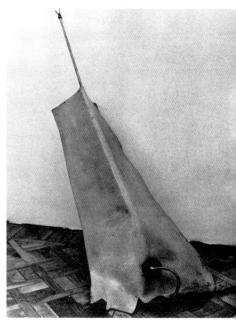

Arco voltaico, 1968-1969
(Voltaic Arc)

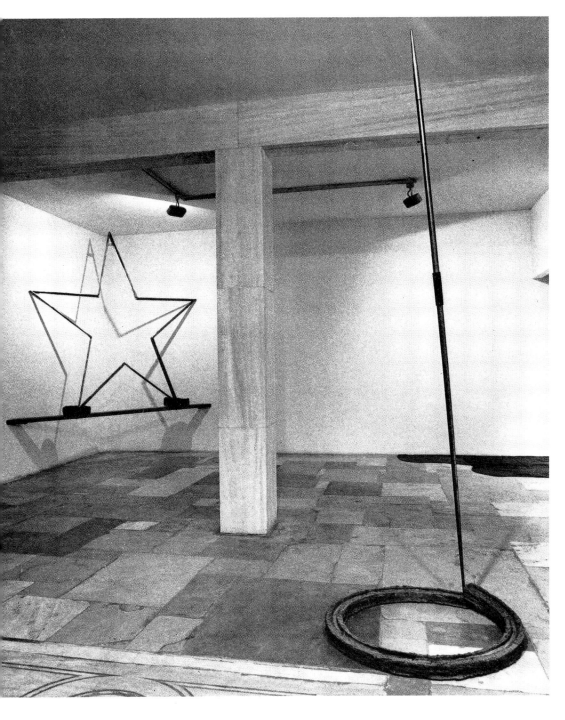

Stella di bronzo con acidi e
pergamena, Senza titolo, 1978
(Star of Bronze with Acids and
Parchment, Untitled)
260 × ⌀ 89 cm

Per purificare le parole, 1980-1981
(In Order to Purify Words)
520×400 cm

Pietro Coletta

Stanza, 1975
(Room)

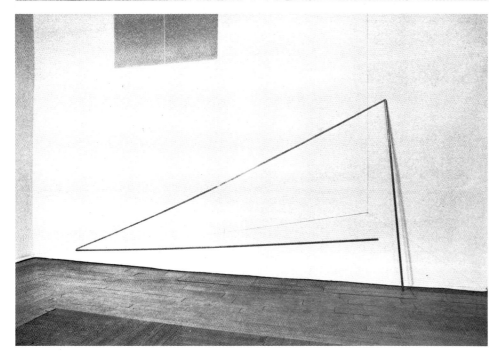

Fragile, 1980
220×230 cm

Stanza, 1981
(Room)

192

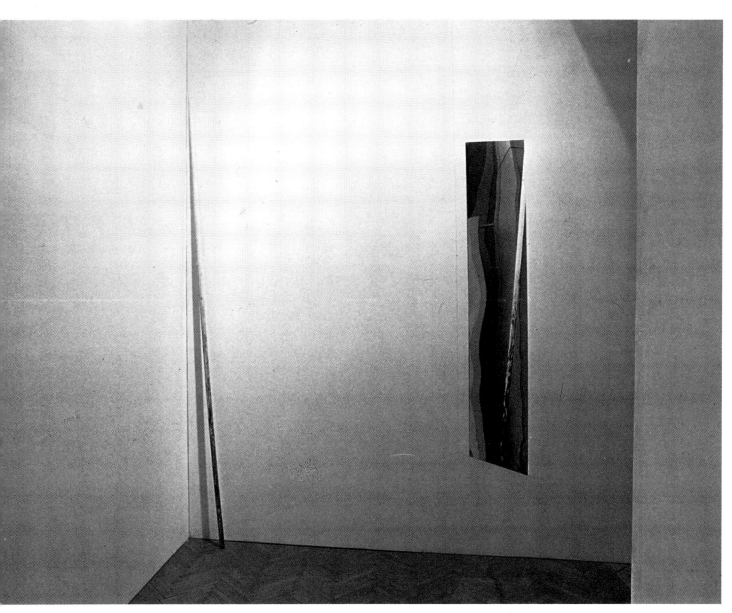

Stanza, 1981
Room)

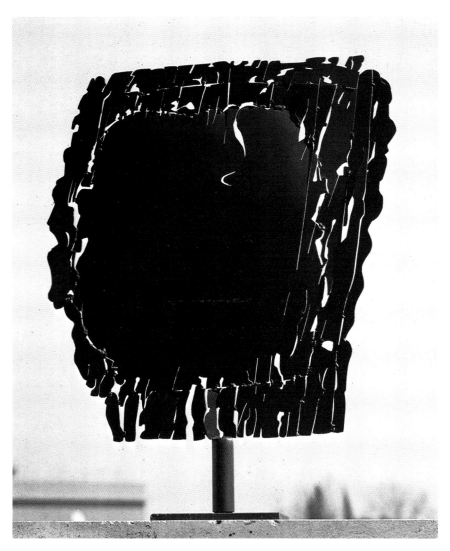

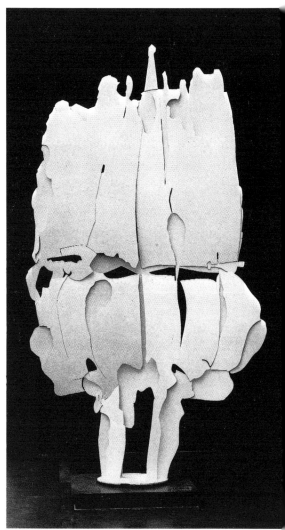

Ferro girevole, trasparente, 1964
(Revolving and Transparent Iron)
290 × 150 cm

Ferro bianco, 1966
(White Iron)
264 × 155 cm

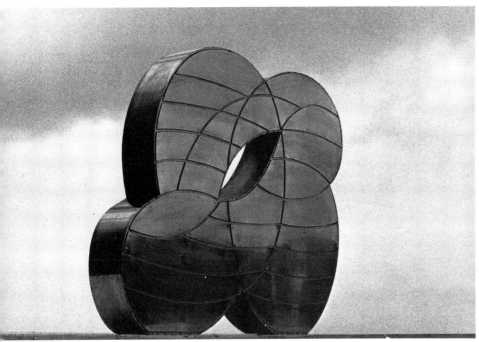

Città frontale, 1968
(Frontal City)

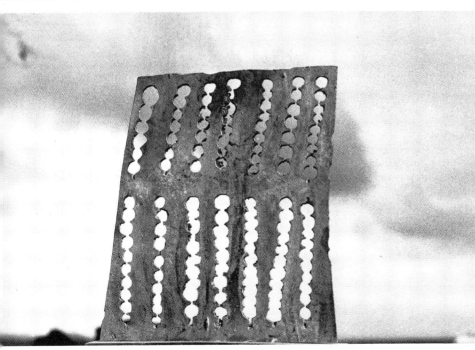

Solida n. 11, 1971
(Solid No. 11)
32×28 cm

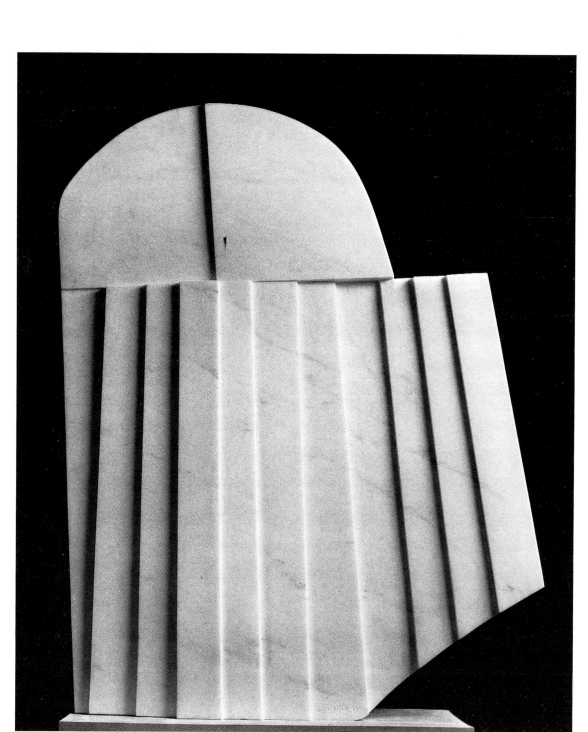

Marmo bianco, 1974
(White Marble)

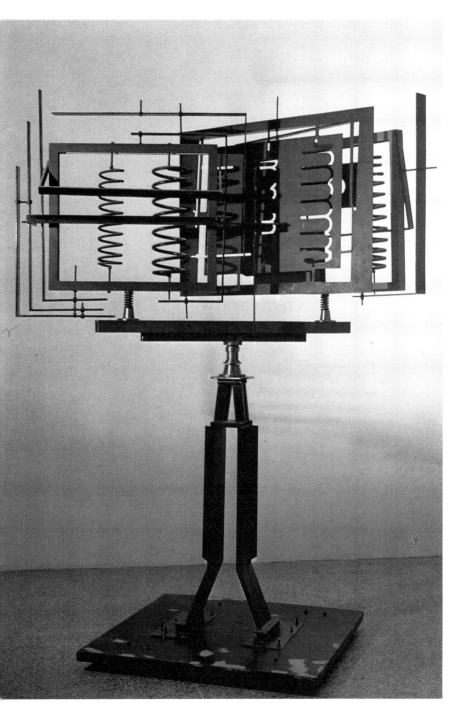

Componenti variabili luce ombra, 1965
(Variable Components Light Shadow)
350×230×230 cm

Da: I giochi del malessere, 1968
(From: The Games of Malaise)

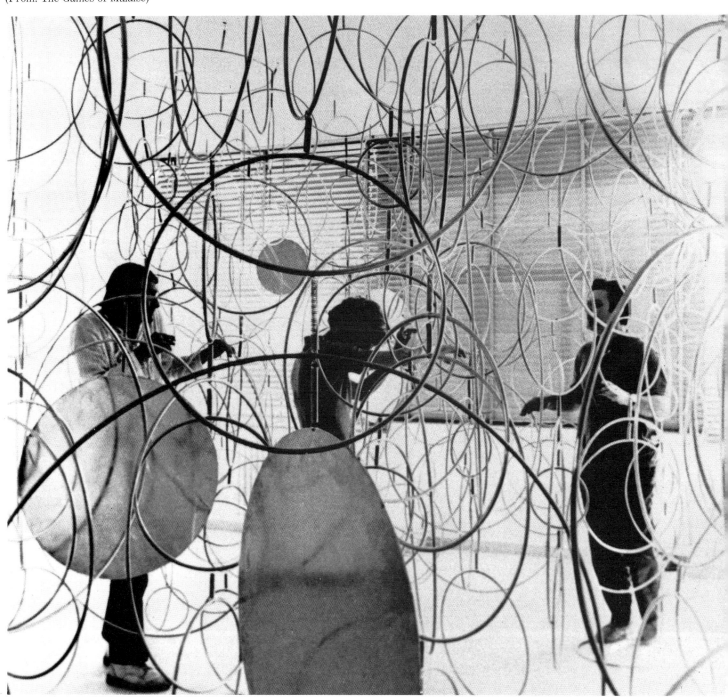

Lavoro continuo, 1970-1980
(Continuous Work)

Topologie, 1978-1979
(Topologies)

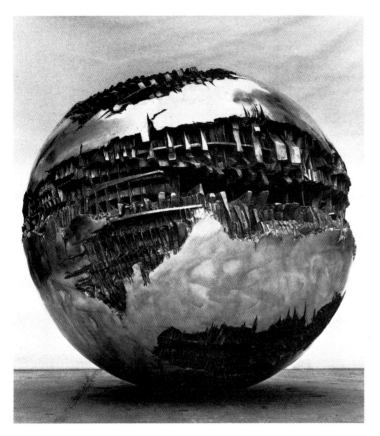

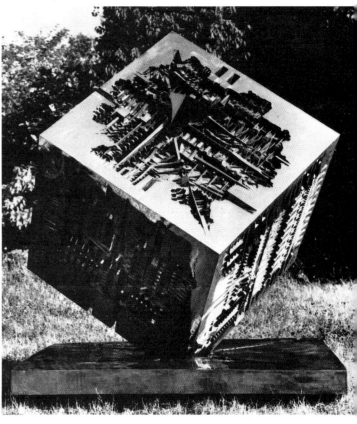

Sfera n. 1, 1963
(Sphere No. 1)
⌀ 120 cm

Cubo IV, 1965-1975
(Cube IV)
120×130×130; base 190×190 cm

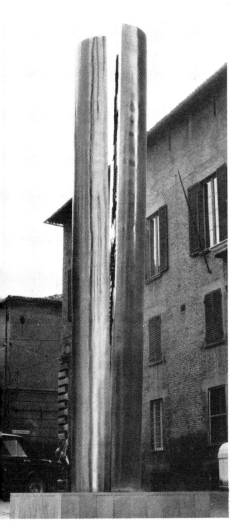

Movimento di crollo, 1970-1971
(Movement of Collapse)
20 × ∅ 70 cm

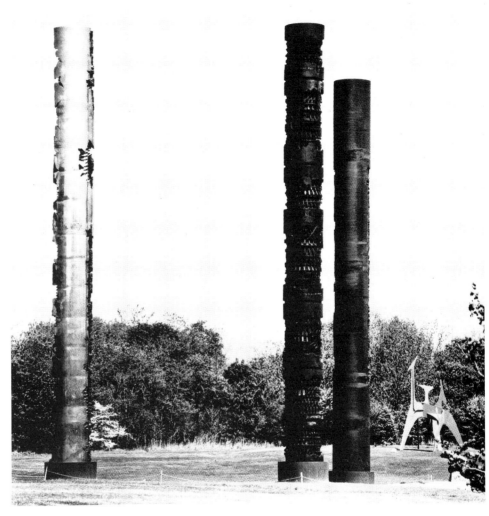

Tre colonne, 1979
(Three Columns)
1500 × ∅ 150 cm

201

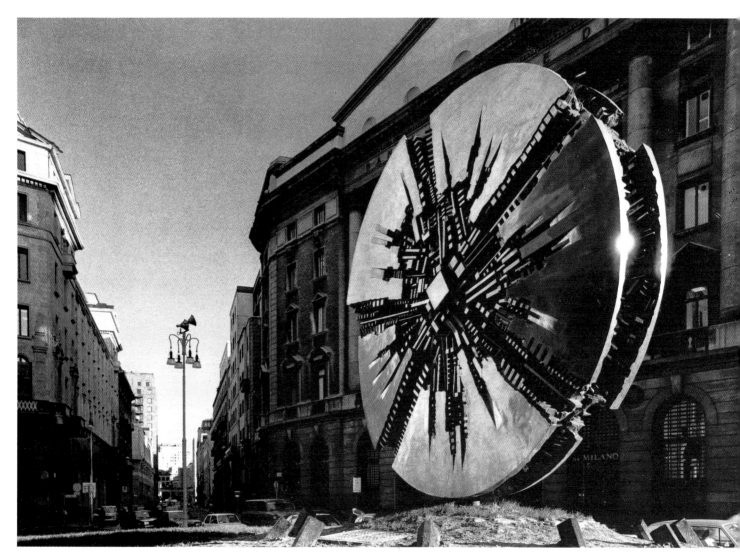

Disco, 1966-1973
(Disk)
⌀450 cm

Studio per Isla Negra, 1973-1975
(Study for Isla Negra)
138×87×87 cm

Piano d'uso collettivo: A Gramsci, Ales, 1977,
1977
(Plane of Collective Use: To Gramsci, Ales,
1977)
2800×3000×4000 cm

Tavola comune, 1973-1974
(Communal Table)
330×160×90 cm

Studio per luogo di misure, 1977
(Study for Place of Measures)
70×180×180 cm

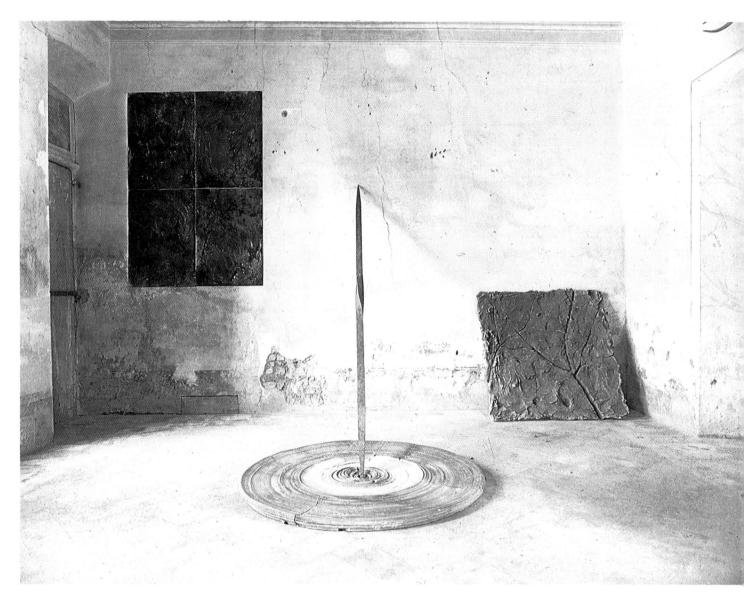

Le armi di Achille, 1980
(The Arms of Achilles)
500×300×300 cm

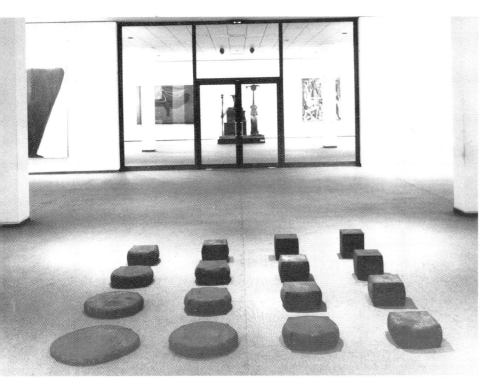

Archeologia, 1977
(Archeology)
28×300×300 cm

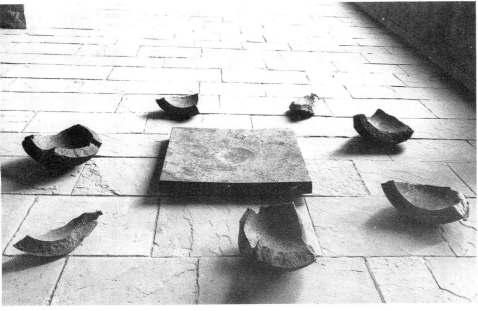

Archeologia, 1979
(Archeology)
20×160×160 cm

207

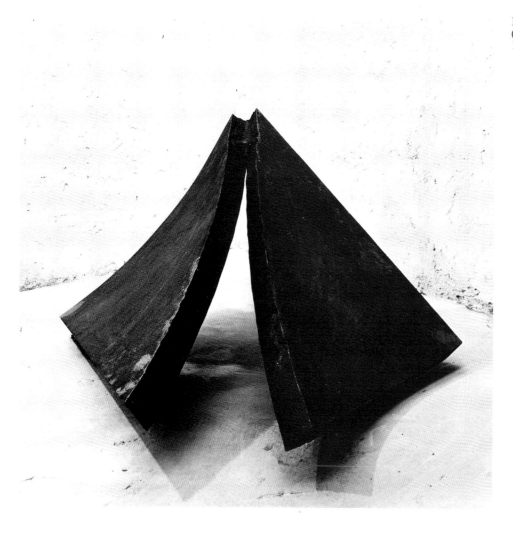

Ferro spezzato — grande curva, 1974
(Snapped Iron — Large Curve)
140×220×220 cm

Mauro Staccioli

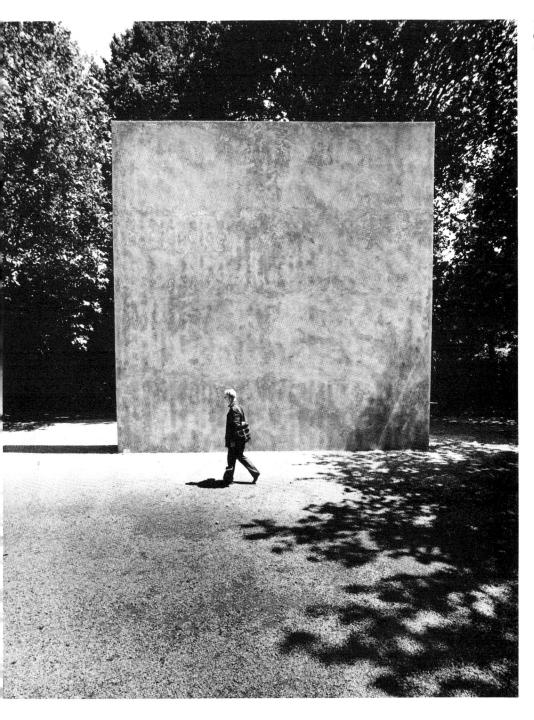

Muro, 1978
(Wall)
800×800×120 cm

Cemento, 1979
(Cement)

Scultura, 1982
(Sculpture)

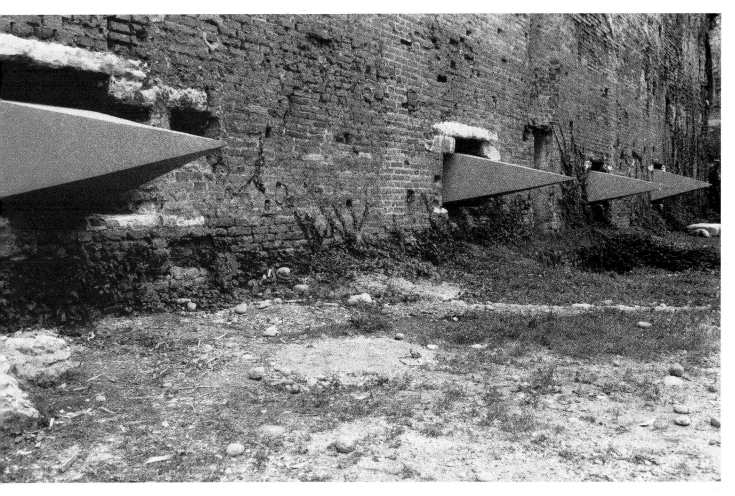

Scultura, 1981
(Sculpture)

16 racconti di fantasmi travestiti, 1981
(16 Stories of Ghosts in Disguise)

25 racconti autobiografici, 1981
(25 Autobiographical Stories)
275×225 cm

La porta del solstizio, 1981
(The Door of the Solstice)
125×210 cm

Looking into the Heart of Light, the Silence
(Oed und leer das Meer), 1982
175×225 cm

Self Portrait with Bird, 1980
40 × 30 cm

The Smoke in the Room, 1981
200 × 300 cm

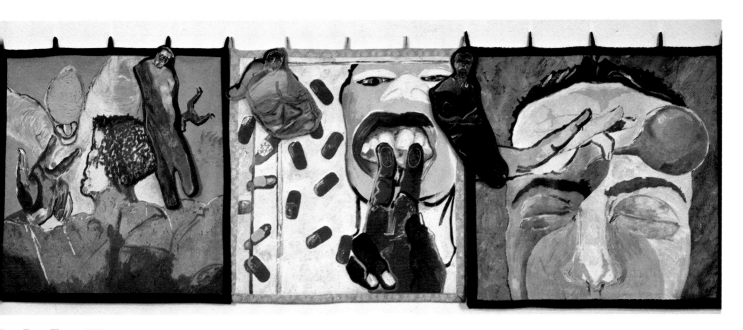

One, Two, Three, 1981
16×615 cm

Omar Galliani

Le tue macchie nei miei occhi, 1982
(Your Spots in My Eyes)
145×185 cm

Le tue macchie nei miei occhi,
1981-1982
(Your Spots in My Eyes)
95×105 cm

Le tue macchie nei miei occhi, 1982
(Your Spots in My Eyes)
145×185 cm

La ruota del Lotto, 1981
(The Wheel of Lotto)
200×400 cm

Marcello Jori

Forziere, 1981
(Strong-box)
120×50 cm

Disgelo, 1982
(Thaw)
170×300 cm

218

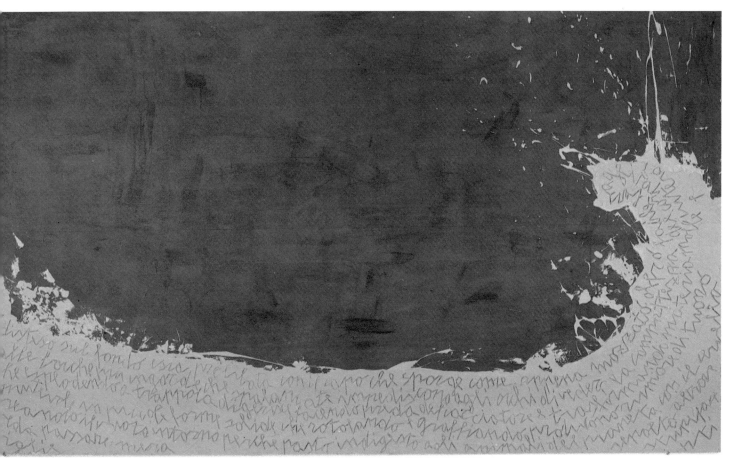

Disteso sul fondo con il petto pulsante, 1981
(Lying at the Bottom with Heaving Chest)
80×300 cm

Le due Gesine, 1981
(The Two Gesinas)
50×130×50 cm

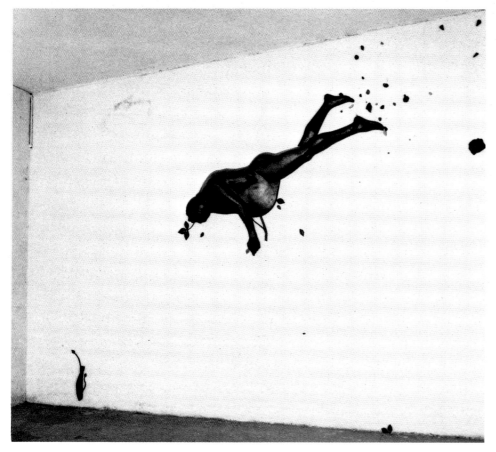

Orco fugge dalla Valle Candina, 1980
(Ogre Escapes from Valle Candina)

Lo stagno, 1982
(The Pond)
⌀250 cm

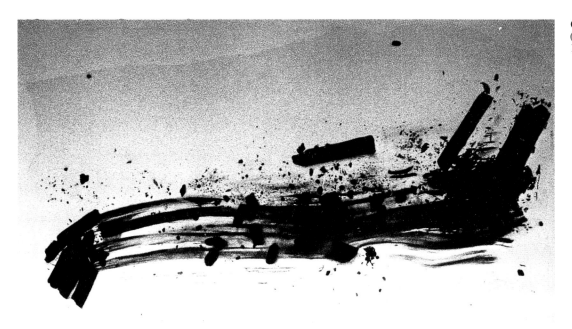

Carbone, 1980
(Coal)
140×240 cm

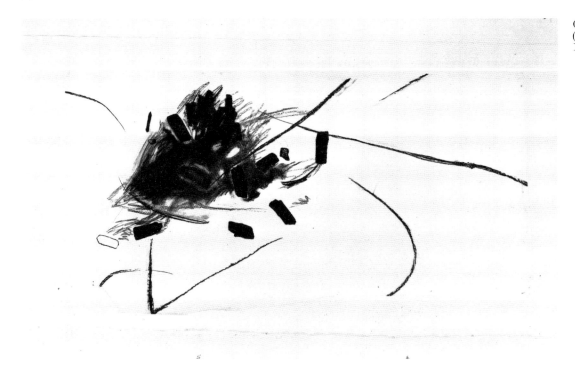

Carbone, 1981
(Coal)
140×250 cm

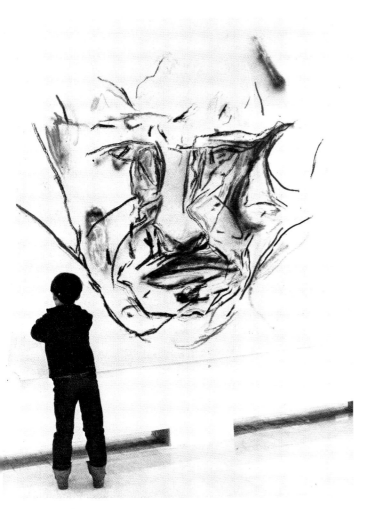

Testa, 1982
(Head)
270×300 cm

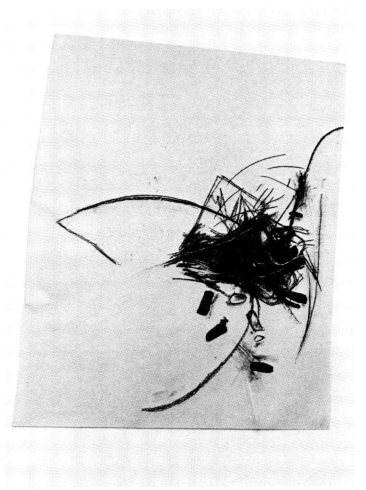

Carbone, 1982
(Coal)
270×300 cm

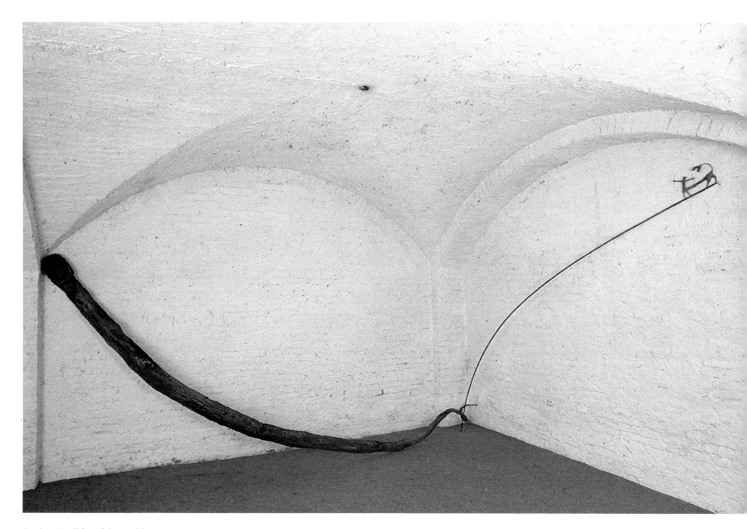

La barba, il bambino, 1981
(The Beard, the Child)
450×300 cm

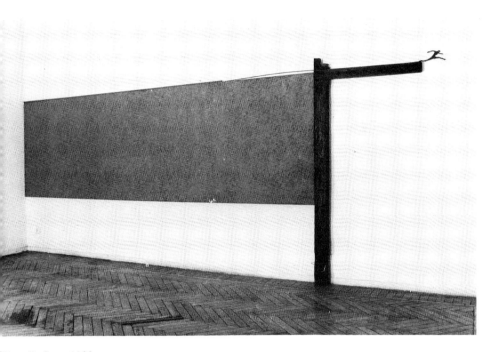

Tiro alla fune, 1980
(Tug-of-War)
180×500 cm

Altalena, 1981
(See-Saw)
280×160 cm

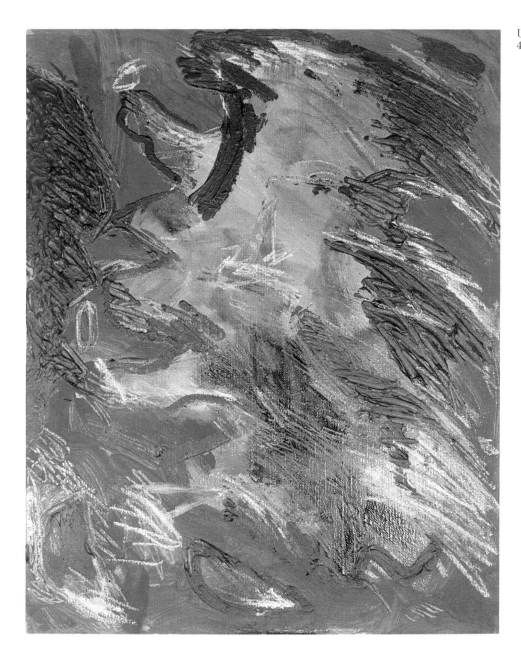

Untitled, 1982
40×30 cm

Le nostre divergenze, 1971
(Our Differences)

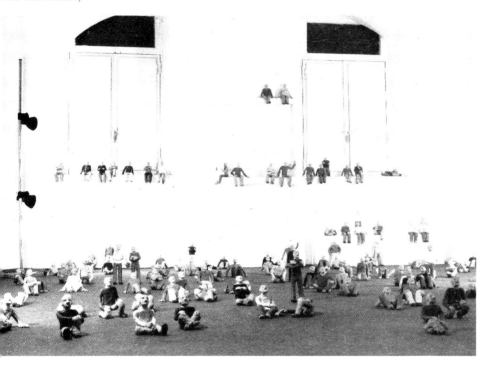

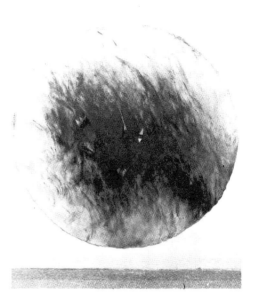

Untitled, 1981
⌀ 345 cm

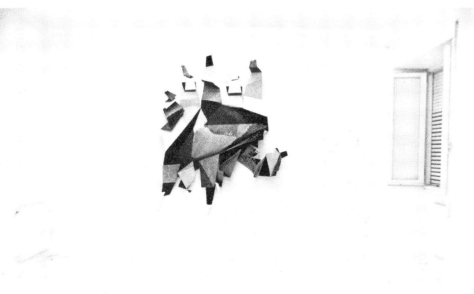

Takéte, 1979
250 × 250 cm

227

Luigi Ontani

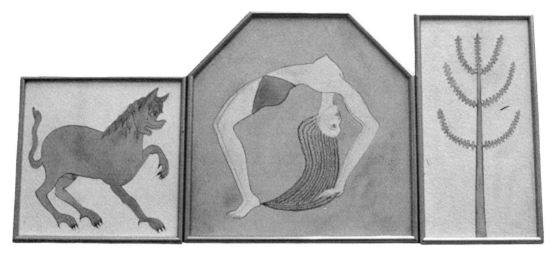

La casa dell'acrobata, 1980
(Acrobat's House)

Tondo Dante, 1974
(Dante Tondo)

Oggetti pleonastici, 1965-1968
(Pleonastic Objects)

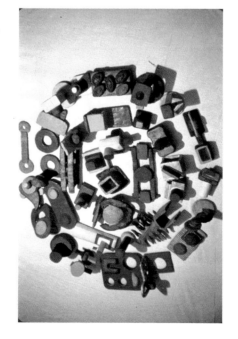

Per Eliogabalo, 1981
(For Heliogabalus)

Olimpo, 1980
(Olympus)

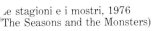
e stagioni e i mostri, 1976
(The Seasons and the Monsters)

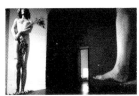

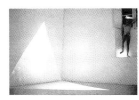

Fiat Lux, 1976

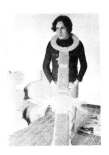

La stanza delle similitudini, 1969
(The Room of Similarities)

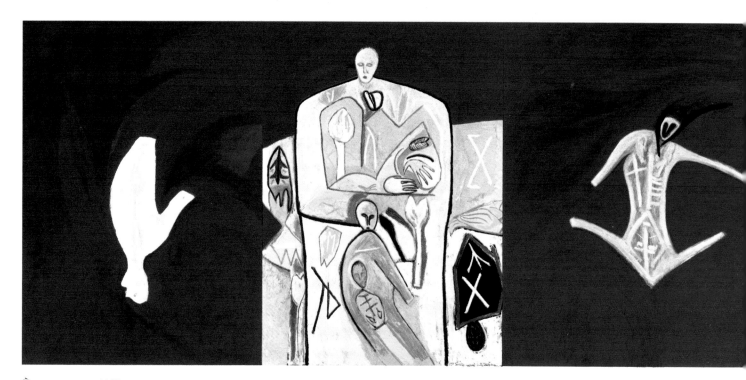

È sempre sera, 1982
(It's always Evening)
220×480 cm

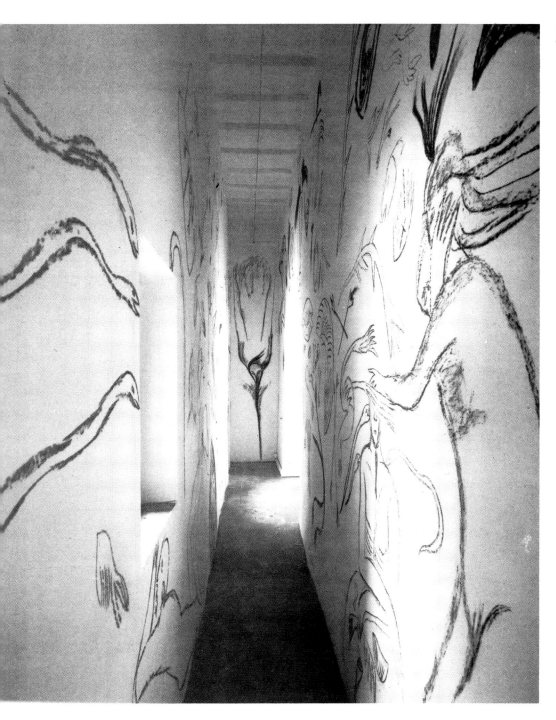

Passaggio di segreti, 1982
(Passage of Secrets)

231

Salvo

Autoritratto come S. Giorgio da Cosmè Tura.
1973
(Self-portrait as St. George from Cosmè Tura)
330×200 cm

Salvo tricolore, 1971
20×30 cm

Paesaggio, 1979
(Landscape)
35×50 cm

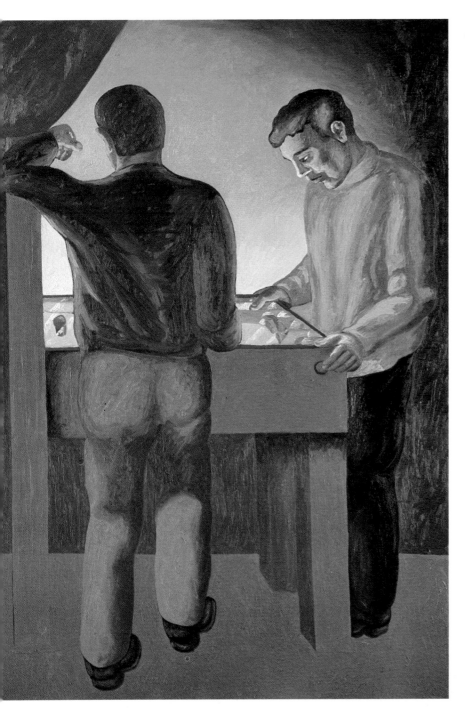

Flipper, 1982
(Pin-ball Table)
150×100 cm

Pensaci Giacomino, 1980
256×328 cm

Wilhelm Meister, 1980
160×220 cm

Le avventure di Gordon Pym, 1981
(The Adventures of Gordon Pym)
232×260 cm

Le avventure di Gordon Pym, 1981
(The Adventures of Gordon Pym)
146×214 cm

235

From "naked" to "clothed" performance
Renato Barilli

"Performance" is an English word almost untranslatable into Italian, although connected etymologically with a verb used freely in our language, "fornire", which one can use in the sense of "fornire una prestazione". It is a word that catches better than any other the spirit of the years around the turn of the Sixties and Seventies encompassing the artistic phase which I have previously defined as "explosive", that is to say breaking out from traditional spaces and means in the search for life and reality. Indeed, during that period, nearly all significant artists of that time had some involvement with performance activities. On this occasion we intend to give a very brief and basic résumé, concentrating above all on those who came to performance from fields other than the visual arts, but participate in the same cult of a "real" space and time and fully exploit the sensory potential of the body. It is worthwhile to add that in performance too there occurs a collaboration, typical of all forms of arte povera, between the naked and primal values of the body and electronic recording (sound and videotape) or photochemical means of projection (films and slides), whether or not these media are used directly in the performance or serve simply to document it for us.

What one would traditionally call the area of music or of sound research is here exemplified by Giuseppe Chiari, who combines destructive acts of protest and derision for conventional musical instruments with conceptual reflections on what "making music" today can mean. Chiari seems almost committed to demonstrating two general theories: that everything can give rise to a musical experience, and that consequently this is within reach of everybody (to take up one of his slogans, "music is easy"). Arrigo Lora Totino and Adriano Spatola come from the world of poetry but seem to have assumed the task of casting doubt on all its certainties. In their graphics they challenge the typographical format by submitting it to fragmentation and crossings out. For what concerns the sound, they reduce verbal flow to stammering, to elementary exercises of phonation, vindicating too the values of gesture, mime, intonation and onomatopaeia. Lora Totino does this activity either using texts of his own composition or rediscovering the works of previous avantgarde movements, like Futurism, of which he considers his own work to be a continuation.

But naturally the branch of the arts most directly concerned with research into performance is the theatre; a radical theatre which dares to criticize and destroy all its traditional privileges: text, plot, diction, the creation of an illusory time and space; thus becoming an exasperated affirmation of the present, of the presence of the body with all its gestural and acoustic immediacy, generally reinforced by technological aids (neon lighting, projections of slides, obsessive sound effects etc.). In this field Italy has seen the fertile flowering of various groups whom the critic Franco Quadri around 1977 dubbed the "theatre of the post-avantgarde" and on whom Giuseppe Bartolucci has contributed much interesting theoretical comment. Among these groups the most famous is undoubtedly the "Magazzini Criminali", who were initially known as "Il Carrozzone", and "Gaia Scienza". In addition to the latter, our selection includes somewhat more restricted groups such as the couples Dal Bosco-Varesco and Taroni-Cividin and also "Falso Movimento", a group of recent formation. It is interesting to note that in the area of theatre, as in the visual arts, there are alternating phases of explosion and implosion. For example, the most recent production of the "Magazzini Criminali", "Sulla Strada", no longer concentrates on brutal and "poveri" elements but on refined quotations from texts intended to create a climate of exoticism — even if the obsession for reiteration is still there, and in this respect the Florentine group continues to show its dependence from minimalism or "primary structures". Briefly speaking, one could say the performance, which began under a guise that was "povera" and naked, has recently developed a version that is "ornate" and "dressed up". In this latter phase it delights in assuming aspects thick with emotion and decorative value, as has also happened with the visual arts. A richness of handcraft has even reappeared in the staging and sets. The spirit of De Chirico has asserted itself in this field as well as in the visual arts and in architecture, thus confirming the general trend resurrecting the "presence of the past".

Through the media towards a new totality in art

Vittorio Fagone

Current developments have given the romantic aspiration towards a totality in art, the *Gesamtkunstwerk* of Wagner, a whole new dimension today.

There is a close link between the multiplication of media used by artists at the end of the Sixties and the crumbling of conventions in artistic communication. In Italy and France, the year 1968, with its socio-political ferment, introduced artists to the option of using the media of mass communication for a redefinition of language and even more for a negation of the art object as fetish. This operation had strong connexions with the strategy of the first explorations in conceptual art. The formalisation of the new genre was influenced by the use of film which intensified research into the moving image, its nexus and its temporal implications. In these activities the artists of the Seventies drew on the classic experience of the 20th century gained during the years of Cubism, Dada and Surrealism, making free use of the history of cinema while forcing the image, structure and sequence of the conventional cinema beyond the obligation to submit to a narrative code.

The artists' films in the years 1960-1980 cover two generations. The first came to the cinema in 1968 by way of painting (Baruchello, Schifano, Cioni Carpi, Nespolo, Gioli): the second, in the mid Seventies, chose film as a specific area of visual intervention (Gianikian and Ricci-Lucchi, Granchi, Berardinone, Martelli).

The use of video was also affected by the break with accepted methods of artistic communication and here explorations in the United States and Europe started at the same time, profiting from similar linguistic and social opportunities. It is since 1969 that video used by artists has been defined and investigated as a creative medium. This term indicates both supersession of conventional media in the visual arts and opposition to the schemata of mass television entertainment. The teaching of Marshall McLuhan, which saw the arts as countermedia, in contrast to conventional means, capable of widening perception and judgment, was obviously beginning to bear fruit. In the hands of artists, video is not a static medium. It is a versatile visual instrument, an immediately expandable architecture. The potentialities of video for creating a new fluid image are immense: — instantaneous reversal of space and image in the real time of duration, multiplication of the relationships of space-time in the environment. They have been usefully explored in various ways in Italy by four groups of artists (in Venice, Ferrara, Milan and Rome) whose work is being shown in this exhibition.

In fact, both film and video, as new artistic media, enlarge the visual field, realizing the possibility of origins, articulations and constructions. Film and video can establish complex images, accumulations of potential spaces, disembodied sculptures.

The Gesamtkunstwerk appeared at the end of the Seventies and was achieved in a different way to that originally envisaged. We know that Wagner, and Kandinsky too, when he put forward his hypothesis of a meeting and fusion of sound, colour and scene, was thinking of a synthesis of the arts when they were at the apogee of their individual disciplines. In reality, the new totality is now being realised when they are in a hypogeum of fragmentation. Every single fragment is a new, explosive, indivisible universe animated by inextricable relationships between colour, sound, space, movement.

The reference to performance in its two historical phases is clear here. The first phase is more directly related to body language and the physical duration of action time. The second concerns the dynamics of the staging itself, its appearances and abstractions and developments. Both are equally alive in Italy today, breaking down the confines between music and the visual arts, between poetry and image, between sound and colour. It is especially interesting to see today, at the start of the Eighties, the post-modern image exhibited by the "nuova spettacolarità" (Magazzini Criminali, Gaia Scienza, Falso Movimento, Antonio Syxty). McLuhan's countermilieu has materialized in an ambiguous game. The glittering image of video is the constant point of reference for a composite series of situations within an all-embracing, all-involving, continuous visual resonance. The artists move in this frenetic space, but the action is not theatre: it has no development, no catharsis. Before the viewer's eyes glide swift, liquid, vividly coloured, shadowless images. Bewildering images: planetary and domestic, cruel and tender. The artist at the centre of the scene does not offer us an image at the centre of the world but in a brilliant and obstinately focused perifery. Without background or foreground, each image dissolves and reappears as in a continuous film. The viewer is the first to tire. There is no end, only interruption.

Dense, disembodied images, the figures of the new epic spectacle indicate a way of seeing the world beyond the narrow confines of the television screen while exploiting its immediacy and clarity. At the same time, they proclaim the inexorable dominance of sound. Sound bestows order on the complex images, and enlarges through its repetition and expansion the perceptive mechanisms governing their recognition and structuring.

This exhibition has assembled a series of experiments on the boundary between sound and image. More precisely, it records the effect on images of sound and the spoken word. These images too belong to the artist of today. In small sounds he perceives grand figments, he questions the images of everyday, the words, the voices of us all, to give them back to us in an odd unity, in a *totality* that is impossible to overturn, disentangle or even duplicate.

Giuseppe Chiari

Concerto, 1974

Luisa Cividin/Roberto Taroni

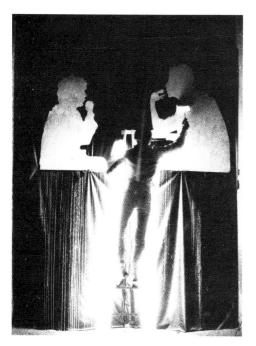

As diamond clearness, 1981

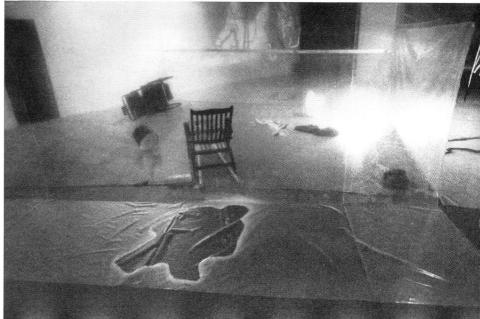

Decalage, 1982

La notte che vola, 1981

Cowboy esotico, 1981

Tango glaciale, 1982

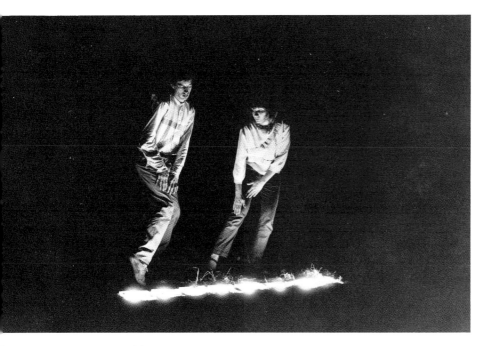
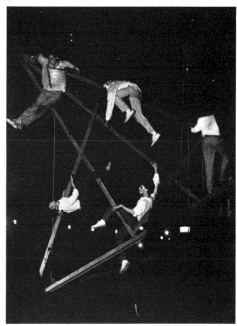

Gli insetti preferiscono le ortiche, 1982

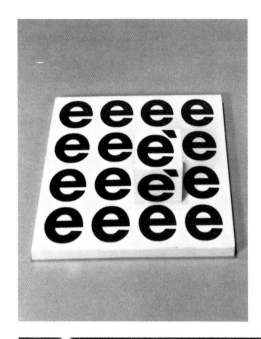

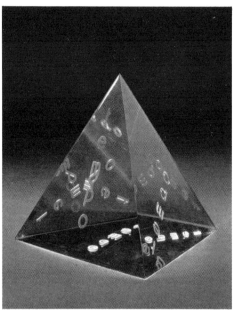

e è, 1967

Demagogia, 1976

Tempo, 1975

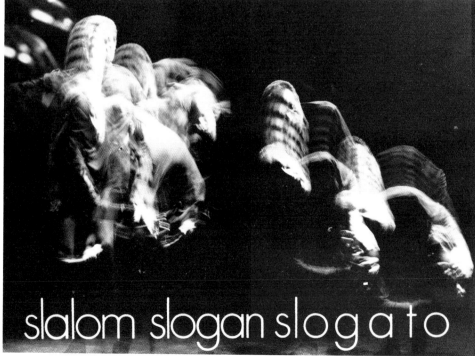

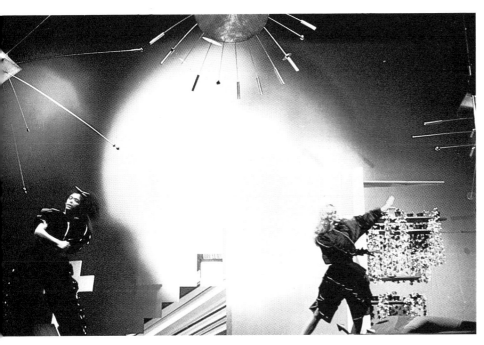

Famiglia Horror, 1981

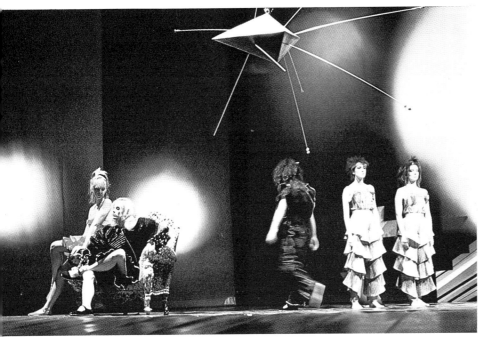

Adriano (Bruno) Spatola

Variazioni & varianti, 1980

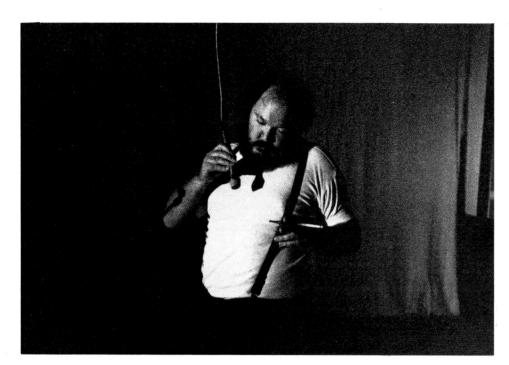

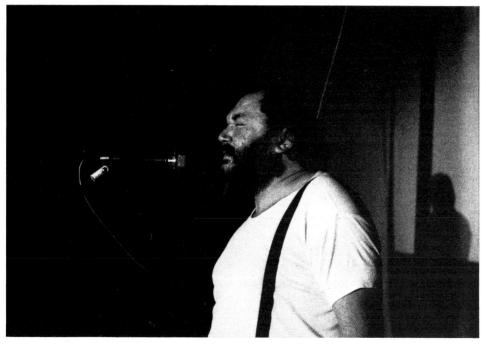

Ursonate di K. Schwitters, 1981

Ferruccio Ascari

Valentina Berardinone

Dispositivo, 1980

Superficiale, 1982

Nero + bianco fa legge, 1977

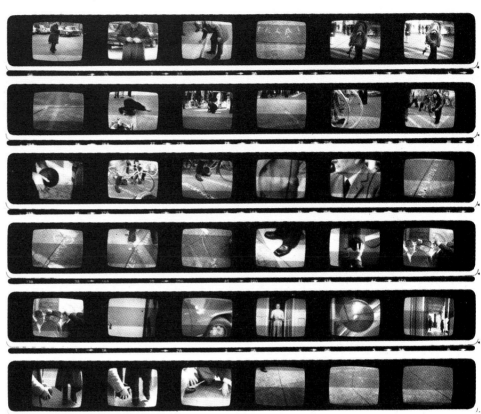

Il filo di Arianna, 1974

Fernando De Filippi **Fonosfera**

Sostituzione, 1974

New models of sound dramaturgy by way of experimentation, both specific and synesthetic, of the means is the goal proposed by "Fonosfera: segments, routes and sound dynamics in a laboratory experiment", by Armando Adolgiso and Pinotto Fava, directed by Leo Birzoli, which RAI, First Programme, has broadcast every two weeks since the 9th of November 1979.

The cycle set out as a series of individual items each of which proposes its own expressive module directed towards interpreting the present and future ferments of sound language by means of additions and subtractions, compositions and de-compositions, expansions and macerations of verbal, musical and sound materials.

A language research work which, in moving within a plurality of auditive geometries, travels in the dimension of the intercode, on that new path, that conceives a reality even before it is represented.

The works produced mirror the experiences and the signs of the various languages of the various fields of new expressiveness: from sound poetry to tape music, from the visual arts to the new spectacular, from mail art to cybernetic rock in an assiduousness of research of new forms of sound communication.

These listening performances are not limited to the experimentation in the radiophonic laboratory: besides being the fruit of the antenna they go out to meet the public — as is witnessed to by this exhibition — which is sensitive to the production of new expressive signals.

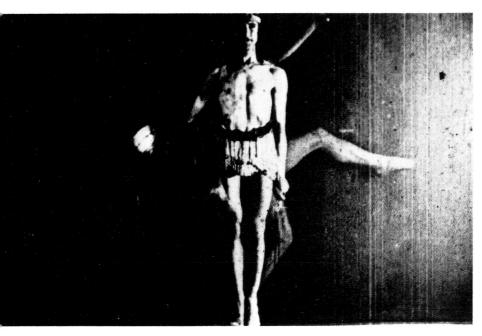

Karagoez, 1979-1981

Della presenza n. 1, 1974

Plinio Martelli

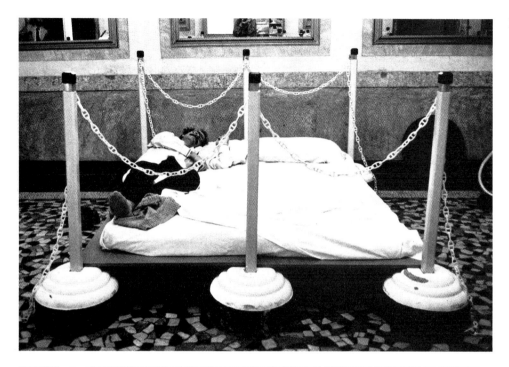

Interventi pubblici nella città di Milano, 1979

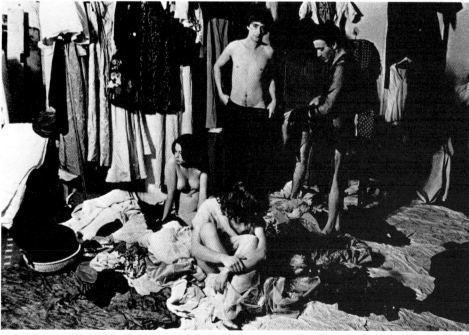

The End, 1979

Antonio Paradiso

Le porte girevoli, 1982

Teatro antropologico, 1978-1979

Luca M. Patella Fabrizio Plessi

Liquid Movie, 1982

SKMP2, 1968

Duo, 1979

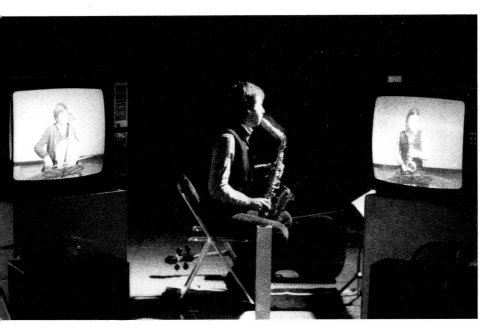

Teoria e pratica dell'architettura spontanea, 1970

Television as memory
Luciano Giaccari

In talking of television as memory — and that is of video-documentation — I would like to underline how this activity is only a moment in a very complex situation of relationships between art and television.

And in fact the practical activity of the Video Library directed by me is continually intersected with the theoretic elaboration on video which I did in 1972 and which was realised in the "classification of the methods of use of the videotape in art", a classification which in its own turn derived from the practical work previously carried out.

In this classification I distinguished two fundamental situations: the first in which the artist has a *direct* relationship of use within the television means — which gives place to the "videotape" understood as a work, to the video-performance and to the video-environment.

The second situation is, on the contrary, based on a *mediated* relationship between the artist and the television means: others use the video *on* the work of the artist.

This second situation gives rise to divers hypotheses which can more or less be taken back to information, and in particular to video-documentation, to video-criticism, to video-didactics, to video-history of art, to video-reportage etc.

Without entering into the details of these various classes, which after 1972 were also elaborated by others, I would very synthetically like to underline the most characteristic aspects of video-documentation.

Before anything else this work is born from the need/possibility of leaving a televisual memory of events, like the performance, the concert, the theatrical show and other situations of which, otherwise, no trace whatever would remain.

Video-documentation thus constitutes a form of expansion of the original phenomenon, as it is later being able to be seen by a much larger quantity of spectators than those of the original show. Technically the video, with the very simplified possibility of recording in "real time", has opened up perspectives which were unthinkable merely with the use of film or photography.

From the ideological point of view the main problem of video-documentation is that of objectivity, considering that it is a question of "reproducing" the work of others.

The same problem had already been posed for photography and the film, used for analogous ends, and faced by the characteristic "aberrations" of these means one had gradually concluded the impossibility of a real objectivity: photography being too often mystifying and cinema distorting the work with its own presence on the scene of the event.

Also for television, which while it operates in con-ditions of difficult lighting, "obstructs" less than the cinema, allowing the following of the proceeding of the work on a monitor, there is no doubt that it cannot be considered as total objectivity, both due to technical as well as to psychological factors.

From a technical point of view there first of all exists the morphological waste between the three-dimensional image of reality and the bidimensionalness of the televisual reproduction. From a "human" point of view it is clear that the vision of the person who carries out the video-documentation constitutes a filter between the work of the artist and his television public.

These factors may tend to a zeroing above all if the person who carries out the televisual documentation profoundly knows both the technical means as well as the work of the artist and, in second place, if he allows himself a faculty of "restitution" of the work of the artist.

In the impossibility of a total objectivity it is in fact evident that it is necessary to recognise a character of autonomy in video-documentation and, moreover, it is by now acquired that, according to the characteristics of the work and the persons for whom it is destined, it is possible to carry out various types of documentative interventions and here, in fact, are the various aspects of the classification like video-criticism, video-didactics etc.

These diversifications have some very important technical aspects and in fact depending on the various objectives it is possible to effect documentations with a single camera — fixed or in action — with the simultaneous direction of various telecameras, with multiple recordings and post-production phase edition.

In order to complete this extremely synthetic discussion on video-documentation the determining importance of the vision of the "finished product" should be underlined, precisely from the perceptive point of view, given the large range of the same which goes from monitors of a few inches up to gigantic telescreens.

Notwithstanding these wide technical possibilities one very often finds oneself verifying a situation which is still very limited on the "circuit" level for which it is to be hoped that as soon as possible television transmitters, museums and universities can consider themselves as being more fluid channels of diffusion of a work which, by definition, has an essential need of circulation.

Video-installazione, 1975

1960

Group Exhibitions in Italy

"La Nuova Concezione Artistica", Milan, Galleria Azimuth. The catalogue which is inserted in the *Azimuth* review of January 1960 contains statements by E. Castellani, U. Kultermann, P. Manzoni and Piene. Exhibitors: Breirer, E. Castellani, Holweck, Y. Klein, Mack and P. Manzoni (who exhibited two *Achromes*, a *linea* and, for the first time, *Un corpo d'aria*, whilst with his text, *Libera dimensione*, he claimed the artist's right to act within a full spatial-temporal dimension outside of the traditional limits of the painting).

"Miriorama 1", Milan, Galleria Pater. Exhibition-manifesto of the Gruppo T. It was formed in 1959 and comprised G. Anceschi, D. Boriani, G. Colombo, G. De Vecchi (in March of the same year G. Varisco also joined the group). The problem of the space-time relation is raised in the catalogue. One-man exhibitions of the members of the group followed in the various Miriorama editions.

"Les Nouveaux Réalistes", Milan, Galleria Apollinaire. First manifesto and exhibition of the group promoted and organised by P. Restany. (The Italian, Mimmo Rotella, was also to form part of the group.)

"Possibilità di Relazione", Rome, Galleria L'Attico. Prepared by E. Crispolti, R. Sanesi, E. Tadini. This is the first group exhibition which brought together the exponents of the New Figuration. Exhibitors: V. Adami, R. Aricò, V. Bendini, M. Ceretti, G. Dova, C. Peverelli, C. Pozzati, B. Romagnoni, P. Ruggeri, E. Scanavino, M. Strazza, S. Vacchi, T. Vaglieri. The exhibition meant to find an alternative to the Informal.

Venice Biennale. E. Vedova was awarded the prize for Italy; Hartung for the foreign exhibitors.

"5 Pittori Roma '60", Rome, La Salita. Catalogue preface by P. Restany. Exhibitors: F. Angeli, F. Festa, F. Lo Savio, M. Schifano, G. Uncini.

"Arte Italiana del XX Secolo da Collezioni Americane", Rome, Galleria Nazionale d'Arte Moderna. Organised by J. Throll Soby, P. Bucarelli and B. Parkinson.

International References

Exhibition of visual research organised at the National Gallery of Modern Art in Basel. E. Castellani, P. Manzoni, Mack, Piene and others launched the "Nul bei Nul" manifesto.

"Monochrome Malerei", Leverkusen, Städtisches Museum. International exhibition organised by U. Kultermann. The Italians invited were: L. Fontana, P. Dorazio, S. Scarpitta, Bordoni, E. Castellani, F. Lo Savio, P. Manzoni.

Books and Reviews

C. Brandi, *Segno e immagine*, Milan.
M. Calvesi, *Struttura italiana al XXX Biennial*, in "Art International".
B. Munari, *Il Quadrato*, Milan.
C. Vivaldi, *Crack*, Milan. Documentation of the Crack group made up of A. Cascella, P. Dorazio, G. Marotta, Mauri, G. Novelli, A. Perilli, M. Rotella, G. Turcato.

1961

Group Exhibitions in Italy

"Continuità", Rome, Galleria Odyssia. Organised by G.C. Argan. Exhibitors: P. Consagra, P. Dorazio, G. Novelli, A. Perilli, G. Turcato; these artists were joined by L. Fontana, Benporad, A. and G. Pomodoro in the successive exhibitions in Turin, Paris, San Francisco, New York and Milan (in 1962).

"Mostra della Critica Italiana", Milan, Galleria Civica d'Arte Moderna. The catalogue was edited by the following critics: M. Valsecchi, F. Russoli, R. De Grada, M. Calvesi. The exhibition had the aim of focussing on the orientations of militant criticism.

"L'oggetto nella Pittura", Milan, Galleria Schwarz. International exhibition in which the Italians E. Baj, A. Biasi and L. Del Pezzo exhibited, from amongst others.

"XII Premio Lissone", Lissone. Catalogue with contributions by G.C. Argan, U. Apollonio, P. Restany. International exhibition divided into four sections, one of which was entitled "Informativa Sperimentale" dedicated to Italian artists of the young generation.

International References

"Bewogen-beweging", Amsterdam, Stedelijk Museum. Catalogue preface by K.G. Hultén. Exhibition of international artistic avant-garde tendencies. The Gruppo N and Gruppo T participated.

"Nove Tendencije", Zagreb, Galerja Suvremene Umjetnosti. Catalogue with contributions by M. Mestrovic and R. Rutar. International exhibition of visual art experiences. Present for Italy were: A. Biasi, E. Castellani, Chiggio, I. Costa, E. Landi, M. Massironi, P. Manzoni, P. Dorazio.

VI Biennial, Sao Paolo, Brazil. The Italian Pavilion was organised by the Venice Biennale.

II Biennial, Paris. F. Bellonzi was the organiser of the Italian Pavilion. Exhibitors: P. Dorazio, S. Dangelo, P. Ruggeri.

"Merda d'Artista e Opere Viventi", by P. Manzoni, Copenhagen, Galerie Kopcke.

"The Art of Assemblage", New York, Museum of Modern Art. Exhibition organised by W.C. Seitz. The Italians present were: A. Burri, E. Colla, R. Crippa, E. Baj, A. Magnelli, E. Prampolini, C. Carrà, M. Rotella, G. Severini.

Books and Reviews

G. Dorfles, *Ultime tendenze nell'arte oggi*, Milan. Special number of *Il Verri*, V, 3, dedicated to the Informale with articles by: G.C. Argan, R. Barilli, U. Eco, E. Crispolti, F. Ponge, M. Calvesi, E. Sanguineti, S. Becket, H. Rosemberg, F. Bacon and numerous other authors.

1962

Group Exhibitions in Italy

"Nuove Prospettive della Pittura Italiana", Bologna, Palazzo di Re Enzo. Catalogue preface by F. Arcangeli. The exhibition was organised by R. Barilli, M. Calvesi, Courir, E. Crispolti, A. Emiliani, Ferrari, E. Tadini, R. Tassi. Also present in the catalogue with critical texts were U. Eco, C. Vivaldi, E. Sanguineti. Exhibitors: V. Bendini, S. Vacchi, Pancaldi, Ruggeri, Brunoni, Strazza, Zigaina, E. Scanavino, V. Adami, R. Aricò, T. Festa, F. Angeli, E. Baj, F. Lo Savio.

"Sculture nelle Città", Spoleto, on the occasion of the "Festival dei Due Mondi". Exhibition organised by G. Carandente. Exhibitors, from amongst others: E. Colla, Calder, L. Fontana, P. Consagra.

Venice Biennale. Winners, *ex aequo*, for Italy: G. Capogrossi and E. Morlotti; Manessier for foreign artists.

"Alternative Attuali", L'Aquila, Castello Cinquecentesco. Catalogue prepared by E. Crispolti and A. Barbera with writings by: R. Barilli, A. Boatto, F. Menna, E. Jaguer. International exhibition of young artists of every tendency.

"Arte Programmata", Milan, Olivetti Showroom. Organised by B. Munari and G. Soavi, presented by U. Eco. Works presented of kinetic art, multiple works and open works.

International References

"Tentoostelling Nul", Amsterdam, Stedelijk Museum, International exhibition of visual art. The Italians who participated were: E. Castellani, P. Dorazio, L. Fontana, P. Manzoni, F. Lo Savio, Dadamaino.

"New Realists", New York, Sidney Janis Gallery. International exhibition on the theme of "factual art", organised by J. Ashbery and P. Restany. The Italians invited were: E. Baj, G. Baruchello, T. Festa, M. Rotella, M. Schifano.

Books and Reviews

U. Eco, *Opera aperta*, Milan.
U. Eco, "La forma del disordine", in *Almanacco Letterario Bompiani*, Milan.
F. Lo Savio, *Spazio-Luce*, Rome.

1963

Group Exhibitions in Italy

"13 Pittori a Roma", Rome, Galleria La Tartaruga. Catalogue texts by: N. Balestrini, G. Dorfles, U. Eco, A. Giuliani, E. Pagliarini, A. Porta, E. Sanguineti, C. Vivaldi. Exhibitors: F. Angeli, U. Bignardi, T. Festa, G. Fioroni, J. Kounellis, R. Mambor, F. Mauri, G. Novelli, A. Perilli, M. Rotella, P. Saul, C. Tacchi, C. Twombly.

"Visione e Colore", Venice, Palazzo Grassi. From among the Cobra group, of J. Dubuffet and other artists having the materic use of colour in common there were works by E. Baj, the only Italian present.

"La Nuova Figurazione", Florence, La Strozzina. International exhibition of painting. Various critics presented the works of artists operating within the area of figuration.

"Oltre l'Informale", IV Biennial, San Marino, Palazzo del Kursal. International exhibition organised by G.C. Argan, P. Restany, U. Apollonio, G. Gatt. This exhibition dealt with visual and neo-constructivist research, new realism and new figuration as the surpassing of the Informal.

International References

"Schrift und Bild", Amsterdam, Stedelijk Museum. The exhibition examined the relationships between art and writing and was organised by D. Mahlow. From amongst the Italian artists present: C. Accardi, E. Baj, A. Biasi, G. Capogrossi, J. Kounellis, R. Crippa, G. Novelli, M. Rotella, E. Vedova.

III Biennial, Paris, Musée Municipal d'Art Moderne. The Italian section was organised by the Rome Quadriennale. Exhibitors: G. Biasi, F. Bodini, N. Cassiani, L. Del Pezzo, A. Recalcati, L. Sguanci, V. Trubbiani.

"Nove Tendencije 2", Zagreb, Galerija Souvremene Umjetnosti. International exhibition of kinetic, programmed and visual art organised by M. Mestovic. The Italian artists present: G. Alviani, E. Castellani, P. Dorazio, E. Mari, Gruppo N, Gruppo T.

"VII Biennial", Sau Paolo, Brazil. The Italian Pavilion was organised by the Venice Biennale (Organiser: G.C. Argan). The international sculpture prize was awarded to A. Pomodoro.

Symposia

"XII Convegno Internazionale Artisti, Critici e Studiosi d'Arte", Rimini-Verrucchio-Riccione. The symposium was divided into three sections: A (Critics and Artists); B (Philosophers, Scholars of Aesthetics and Sociologists); C (Psychologists and Scientists). Numerous speakers, amongst which: G.C. Argan, P. Restany, R. Assunto, N. Ponente, I. Tomassoni, F. Menna.

Books and Reviews

AA.VV., "Le problematiche di gruppo", in *Arte Oggi*, No. 17.
G.C. Argan, "Il rapporto arte società nella condizione storica attuale" in *De Homine*, Nos. 5-6.
R. Barilli, A. Boatto, E. Sanguineti, "Oltre l'Informale", in *Il Verri*, No. 12.
G. Dorfles, *Ultime tendenze dell'arte d'oggi*, Milan.
G. Politi, "La funzione della critica", in *La Fiera Letteraria*, No. 43.
I. Tomassoni, "Appunti per un criterio critico", in *Arte Oggi*, Nos. 15-16.

1964

Group Exhibitions in Italy

"Collettiva", Milan, Galleria Profili. Catalogue edited by E. Tadini who defined the works exhibited as examples of "figural narration". Exhibitors: V. Adami, L. Del Pezzo, B. Romagnoni, R. Volpini.

"Pittura a Milano dal 1945 al 1964", Milan, Palazzo Reale. Catalogue texts by L. Alloway, V. Agnetti, F. Biamonti, R. Birolli, R. De Grada, M. De Micheli, G. Dorfles, G. Kaisserlian, A. Martini, D. Morosini, A. Natali, M. Valsecchi, Exhibitors: G. Ajmone, E. Baj, R. Birolli, R. Brindisi, B. Cassinari, A. Ghighine, R. Crippa, G. Dova, L. Fontana, F. Francese, P. Manzoni, G. Meloni, G. Migneco, E. Morlotti, C. Paverelli, E. Scanavino, E. Treccani.

Venice Biennale. A. Cascella and A. Pomodoro were awarded, *ex aequo*, the prizes for Italy; R. Rauschenberg for the foreign artists.

"Proposte Strutturali Plastiche e Sonore", Florence, Centro Proposte. Conceived by U. Apollonio and organized by G. Celant. Catalogue text by L. Vinca Masini. Exhibitors: G. Alviani, G. Anceschi, R. Borella, D. Boriani, E. Castellani, G. Colombo, G. De Vecchi, E. Mari, P. Scheggi, G. Varisco, Gruppo 1.

International References

Documenta 3, Kassel. Exhibited in the "Aspekte 1964" section were works by V. Adami, P. Dorazio, C. Pozzati, Pierluca, B. Romagnoni, I. Valenti.

"Arte Programmata, Kinetic Art", New York, Loeb Student Center. Catalogue text by B. Munari. Exhibitors: G. Anceschi, D. Boriani, G. Colombo, G. De Vecchi, E. Mari, B. Munari, G. Varisco, Gruppo N.

"Arte Programmata", London, Royal College of Art. From among the exhibitors: Gruppo T and Gruppo N.

Books and Reviews

G.C. Argan, *Salvezza e caduta dell'arte moderna*, Milan.

G.C. Argan, "Aleatorio e programmato", in *Terzo Programma*, No. 1.
G. Ballo, *La linea dell'arte italiana dal simbolismo alle opere moltiplicate*, Rome.
R. Barilli, *Per un'estetica mondana*, Bologna.
R. Barilli, *L'informale e altri studi di arte contemporanea*, Milano.
G. Gatt, I. Tomassoni, "Dopo e oltre l'Informale", in *Pensiero e arte*, Nos. 8-9.

1965

Group Exhibitions in Italy

"Poesie Visive", Rome, Galleria Arco d'Alibert. Poetry by N. Balestrini, A. Giuliani, A. Porta.

"Aspetti dell'Arte Contemporanea", Rome, Galleria Nazionale d'Arte Moderna. Organised by P. Bucarelli e G. De Marchis. Exhibitors: C. Accardi, V. Adami, G. Alviani, F. Angeli, R. Aricò, E. Baj, D. Boriani, A. Burri, C. Capogrossi, E. Castellani, M. Ceroli, E. Colla, L. Del Pezzo, G. De Vecchi, T. Festa, L. Fontana, M. Gandini, P. Manzoni, G. Novelli, P. Pascali, A. Perilli, M. Rotella, M. Schifano, C. Tacchi, G. Turcato, G. Varisco, Gruppo N.

"Perpetuum Mobile", Rome, Galleria dell'Obelisco. Exhibition an OP art prepared by F. Menna. Catalogue texts by: G.C. Argan, R. Assunto, E. Battisti, R. Lazzari, F. Menna, P. Portoghesi. Exhibitors: G. Alviani, G. Anceschi, A. Biasi, D. Boriani, C. Carlucci, G. Colombo, T. Costa, G. De Vecchi, R. Fasola, E. Landi, F. L. Savio, Lupo, E. Mari, M. Massironi, B. Munari, G. Varisco.

"Una generazione", Rome, Galleria Odyssia. Catalogue texts by: R. Barilli, A. Boatto, M. Calvesi, G. Dorfles, M. Volpi. Exhibitors: V. Adami, R. Aricò, F. Angeli, E. Castellani, L. Del Pezzo, T. Festa, E. Mari, C. Pozzati, A. Recalcati, M. Schifano.

IX Quadriennale, Rome, Palazzo delle Esposizioni. From amongst the participants: F. Angeli, M. Ceroli, T. Festa, M. Rotella, Gruppo 1, Gruppo T.

International References

"The Responsive Eye", New York, Museum of Modern Art. Travelling exhibition of Optical Art organised by W. Seitz. Articulated in different sections among which: *The Color Image. "Invisible" Painting, Optical Paintings*. From among the Italians present: G. Alviani, F. Costa, P. Dorazio, E. Mari, Gruppo N.

Books and Reviews

G.C. Argan, *Progetto e destino*, Milan.
E. Crispolti, "Neoconcretismo, arte programmata, lavoro di gruppo", in *Il Verri*, Nos. 1-2.
G. Dorfles, *Nuovi riti, nuovi miti*, Turin.
AA.VV., *Arte d'oggi*, Rome.

roup Exhibitions in Italy
Tendenze a Confronto", Naples, il Centro. Exbition organised by A. Boatto and F. Menna. he exhibition intended to document two reearch orientations: objectual figuration and sual art.

Poesia Visiva", Naples, Libreria-Galleria Guida. exts by E. Miccini, L. Pignotti, A. Bonito Oliva. xhibitors: A. Bonito Oliva, E. Isgrò, L. Marcuc-, E. Miccini, L. Ori, Nazzaro, Piemontese, usso, L. Pignotti.

Mostra di Poesia Visiva", Milan, Libreria eltrinelli. Organised E.R. Sampietro Editore d E. Isgrò.

Aspetti dell'Arte Italiana Contemporanea", ome, Galleria Nazionale d'Arte Moderna. rganised by G. De Marchis. Exhibitors: C. Acardi, V. Adami, G. Alviani, F. Angeli, R. Aricò, . Baj, A. Biasi, E. Landi, A. Bonalumi, D. oriani, A. Burri, G. Capogrossi, E. Castellani, . Ceroli, E. Colla, G. Colombo, P. Consagra, T. osta, L. Del Pezzo, T. Festa, L. Fontana, M. andini, J. Kounellis, S. Lombardo, F. Lo Savio, . Manzoni, E. Mari, A. Moricone, G. Novelli, P. ascali, A. Perilli, P. Raspi, M. Rotella, P. Sanro, E. Scanavino, S. Scarpitta, M. Schifano-C. acchi, G. Turcato.

Pittura-Oggetto a Milano", Rome, Galleria Arco 'Alibert. Catalogue texts by G. Dorfles, G. elant. Among the artists: A. Bonalumì, E. astellani, P. Scheggi.

Cinquant'Anni a Dada. Dada in Italia 1916-966", Milan, Civico Padiglione d'Arte Conmporanea. Exhibition organised by Schwarz D. Palazzoli. Exhibitors: L. Fontana, E. Colla, . Crippa, R. Crippa, E. Baj, S. Dangelo, M. otella, L. Del Pezzo, G. Baruchello, G.E. Simonetti, T. Festa.

irst edition of the "Incontri Internazionali di malfi" directed by Marcello Rumma. "The eturn to Things" organised by R. Barilli (thirty talian artists representing Objectual and Pop ndencies).

Metafora 66", Milan, Studio Marconi; Venice, alleria del Canale. Catalogue text by M. Fagiolo ell'Arco. Exhibitors: V. Adami, E. Baj, L. Del ezzo, M. Schifano, E. Tadini.

enice Biennale. L. Fontana and A. Viani won he Grand Prix for Italy.

nternational References
rt Biennial, Nagooka, Tokyo, Museum of Iodern Art. Among the members of the jury, Jello Ponente. Italian artists: G. Alviani, R. ianco, A. Bonalumi, E. Castellani, L. Del Pezzo, . Dorazio, E. Scanavino. E. Castellani won the rize with the work *Superficie bianca*.

"The 5th International Biennial Exhibition of Prints in Tokyo 1966", Tokyo, National Museum of Modern Art. Curator for Italy: G.C. Argan. Italian artists: G. Alviani, A. Burri, A. Calderara, G. Capogrossi, L. Fontana, L. Patella, G. Pomodoro, E. Vedova, A. Virduzzo.

Books
G. Ballo, *Occhio Critico*, Milan.
G. Brandi, *Le due vie*, Bari.
M. Calvesi, *Le due avanguardie*, Milan.
E. Crispolti, *La Pop Art*, Milan.
M. Fagiolo dell'Arco, *Rapporto 60*, Rome.
B. Munari, *Libro illeggibile*.

1967
Group Exhibitions in Italy
"Realtà dell'Immagine e Struttura della Visione", Rome, Galleria Il Cerchio. Organised by M. Calvesi and G. Gatt. Exhibitors: U. Bignardi, M. Ceroli, P. Pascali, M. Schifano, C. Tacchi, G. Alviani, E. Castellani, G. Colombo, M. Massironi, P. Scheggi.

"Salone Internazionale dei Giovani", Milan, Civica Galleria d'Arte Moderna, Padiglione d'Arte Contemporanea. Amongst other exhibitors: V. Adami, F. Dangeli, A. Bonalumi, D. Boriani, M. Ceroli, G. Colombo, B. Devalle, P. Gilardi, G. Pardi, P. Pascali, G.E. Simonetti, E. Tadini.

"Situazione 67", Turin, Galleria Civica d'Arte Moderna. Catalogue texts by E. Battisti, G. Celant, A. Passoni. Among the artists: V. Adami, E. Baj, A. Boetti, E. Castellani, L. Fontana, J. Kounellis, M. Merz, M. Rotella.

"Lo Spazio dell'Immagine", Foligno, Palazzo Trinci. Organising Committee: G. Marchiori, B. Alfieri, G. De Marchis, G. Marotta, S. Ponti, L. Radi, L. Radi. Artists invited: G. Alviani, A. Biasi, A. Bonalumi, D. Boriani, E. Castellani, M. Ceroli, G. Colombo, G. De Vecchi, G. Fabro, T. Festa, P. Gilardi, G. Marotta, E. Mattiacci, R. Notari, P. Pascali, M. Pistoletto, P. Scheggi, Gruppo MID, Gruppo N. Special invitations: E. Colla; L. Fontana, who exhibited *Ambiente Spaziale Nero* of 1949.

"Nuove Tecniche di Immagine", VI Biennial, San Marino, Palazzo dei Congressi.

"Arte Povera" e "Im Spazio", Genoa, Galleria La Bertesca. Catalogue text by G. Celant. Exhibitors: (Arte Povera) A. Boetti, L. Fabro, J. Kounellis, G. Paolini, P. Pascali, E. Prini; (Im Spazio) U. Bignardi; M. Ceroli, R. Mambor, E. Mattiacci, C. Tacchi.

"Contemplazione", Turin, Gallerie Sperone e Stein, Il Punto. Organiser: D. Palazzoli. The exhibition took place both in the environments of the three galleries and in the streets connecting them.

International References
"Le Dimensioni del Reale", Belgrade, Galerie Du Foyer de Jeunesse. Organised by E. Crispolti. International exhibition intended to document the relationship between artistic creation and new aspects of the real, divided into many sections. From the Italian artists: L. Del Pezzo, C. Pozzati, E. Baj, A. Biasi.

"Exhibition of Contemporary Italian Art", Tokyo, National Museum of Modern Art. Exhibition organised in collaboration with the Galleria Nazionale d'Arte Moderna in Rome. Catalogue text by J. Kobayaschi and P. Bucarelli. Among the artists: V. Adami, R. Aricò, E. Baj, A. Bonalumi, E. Castellani, M. Ceroli, G. Colombo, L. Del Pezzo, P. Pascali, M. Rotella, M. Schifano.

IX Biennial, Sao Paolo in Brazil. The Italian section was organised by the Venice Biennale. The prize was won by M. Pistoletto.

V Biennial, Paris, Musée Municipal d'Art Moderne General curator for the Italian section: P. Bucarelli. The Italian contribution was divided into different sections: painting, sculpture, photography, scenography, art films and research.

Books
AA.VV., *Pop Art*, Milan.
A. Boatto, *Pop art in USA*, Milan.

1968
Group Exhibitions in Italy
"Arte Povera", Bologna, Galleria De' Foscherari. Organiser: G. Celant. Catalogue texts by G. Celant, R. Barilli, P. Bonfiglioli. Exhibitors: G. Anselmo, A. Boetti, M. Ceroli, L. Fabro, M. Merz, G. Paolini, P. Pascali, G. Piacentino, M. Pistoletto, E. Prini, G. Zorio.

"Il Teatro delle Mostre", Rome, Galleria La Tartaruga. Organiser: P. De Martis. The artists were invited to realise a behaviour-exhibition each day.

Venice Biennale. The edition was contested by both the artists invited to participate as well as by the public.

"Arte Povera. Azioni Povere", Amalfi, Arsenale dell'Antica Repubblica. Organised by G. Celant. Divided into three sections: "Arte Povera, Azione di Gruppo, I Guitti dello Zoo". Exhibitors: G. Anselmo, A. Boetti, L. Fabro, M. Merz, G. Paolini, G. Piacentino, M. Pistoletto, G. Zorio. During the exhibition a debate on various themes was held: arte povera, azione povera, repressive criticism, the prophecy of an aesthetic society. Numerous contributions from critics and artists.

"Ricognizione Cinque", Milan, Einaudi 691 and New design. Five critics presented five artists: A. Bonito Oliva-A. Bonalumi, M. Fagiolo-A. Gan-

dini, R. Barilli-G. Ruffi, A. Boatto-G. Zorio, G. Celant-A. Mondino.

International References
"Music, Painting, Poetry", Peking. Participants: G. Chiari, S. Bussotti, A. Bueno, A. Moretti, L. Marcucci, L. Pignotti.

Documenta 4, Kassel. Curator: A. Bode. From amongst the Italians: M. Pistoletto, G. Alviani, G. Colombo, L. Fontana.

"Prospekt 68", Düsseldorf, Kunsthalle. Exhibition of the movements absent from Kassel, among which funk art and psychedelic art. From amongst the Italians present: G. Anselmo, M. Merz, G. Zorio.

Books and Reviews
M. Calvesi, *Teatro delle mostre*, Rome.
E. Crispolti, *Ricerche dopo l'Informale*, Rome.
G. Dorfles, *L'estetica del mito*, Milan.
F. Menna, *Profezia di una società estetica*, Rome.
G. Politi, "Mostre a Venezia", in *Flash Art*, No. 8.
G.C. Argan, "La Fronda", in *Metro*, No. 18.

1969

Group Exhibitions in Italy
"Arte Povera", Bologna, Galleria De' Foscherari; Genoa, Galleria La Bertesca. Exhibitors: G. Anselmo, A. Boetti, Icaro, M. Merz, M. Pistoletto, E. Prini, G. Zorio.

"Mec Art 10", Rome, Galleria Ciak. Organiser: G. Di Genova. Works by artists involved in Mechanical Art.

"Al di là della Pittura", VII Contemporary Biennial, San Benedetto del Tronto. Organisers: G. Dorfles, F. Menna, L. Marucci. The exhibition was divided in four sections: 1) "Research of the new generation"; 2) "Independent cinema section"; 3) "Multiple international section"; 4) "Section of new sound experiences". A debate was also held, conducted by G. Dorfles, with contributions from numerous critics and artists.

"Campo Urbano", Como. Organisers: L. Caramel, U. Mulas, B. Munari. The catalogue has texts by L. Caramel and the artists invited. Contributions and manifestations in a single day (21, of September) at various points of the town. A debate followed conducted by L. Caramel.

International References
"5 Italiener", Karlsruhe, Badischer Kunstverein. Catalogue edited by G. Bussmann. Exhibitors: A. Bonalumi, M. Ceroli, P. Manzoni, B. Munari, M. Pistoletto.

"Mostra Internazionale di Arte Povera — Op Losse Schereevan", Amsterdam, Stedelijk Museum. From among the Italians: G. Anselmo,

P.P. Calzolari, Icaro, Mario e Marisa Merz, E. Prini, G.E. Simonetti, G. Zorio, J. Kounellis.

"Live in your head — When attitudes became form", Berne, Kunsthalle. Catalogue editors: H. Szeeman, S. Burton, C. Müller, T. Trini. Exhibitors: G. Anselmo, A. Boetti, P.P. Calzolari, Icaro, J. Kounellis, M. Merz, P. Pascali, M. Pistoletto, E. Prini, G. Zorio.

"Ceroli, Kounellis, Marotta, Pascali, 4 artistes italiens plus que nature", Paris, Musée des Arts Décoratifs. Organiser M. Calvesi who also wrote the catalogue text.

VI Biennial Paris, Italian section organised by the Galleria Nazionale d'Arte Moderna with catalogue text by P. Bucarelli. From among the artists: S. Lombardo, G. Paolini, M. Mochetti.

Symposia
International symposium on aesthetic methodology: *Open institution and closed institution*. All of the contributions are published in *D'Ars Agency*, Nos. 48-49.

Books
G. Celant, *Arte Povera*, Milan.
M. Volpi, *Arte dopo il 1945*, Bologna.

1970

Group Exhibitions in Italy
"Gennaio '70. Comportamenti, Progetti, Mediazioni", Bologna, Museo Civico. Mixed exhibition of arte povera, pop art, conceptual and process art organised by R. Barilli, M. Calvesi, A. Emiliani, T. Trini. Catalogue texts by R. Barilli, M. Calvesi, T. Trini. Exhibitors: G. Anselmo, A. Boetti, P.P. Calzolari, L. Fabro, J. Kounellis, M. e M. Merz, G. Paolini, G. Penone, M. Pistoletto, E. Prini, G. Zorio (arte povera section); V. Bendini, C. Bonfà, M. Ceroli, C. Cintoli, G. Colombo, G. De Dominicis, G. Del Franco, L. Del Pezzo, B. Devalle, A. Dias, C. Gajani, G. Marotta, L. Marzot, E. Mattiacci, M. Mochetti, M. Nanni, U. Nespolo, L. Patella, C. Pozzati, G. Ruffi, G.E. Simonetti, G. Uncini.

"Conceptual Art — Arte Povera — Land Art", Turin, Galleria Civica d'Arte Moderna. International exhibition. Organiser: G. Celant. Catalogue texts by G. Celant, L. Lippard, L. Mallé, A. Passoni.

"Amore mio", Montepulciano, Palazzo Ricci. Organiser: A. Bonito Oliva. Arrangement and catalogue were directly entrusted to the artists exhibiting. Artists: C. Alfano, G. Alviani, M. Ceroli, L. Fabro, J. Kounellis, R. Mambor, G. Marotta, F. Mauri, M. Merz, M. Nanni, M. Nannucci, M. Pistoletto, P. Scheggi, V. Tacchi.

Venice Biennale. Italian artists present: C. Battaglia, A. Bonalumi, N. Carrino, S. Lombardo, M. Mochetti, G. Paolini, C. Verna.

"Pittura 70. L'Immagine Attiva", Mantua, Casa

del Mantegna. Organiser: V. Fagone. Catalogue texts by F. Bartoli, V. Fagone, R. Beltrame. Artists: G. Bonora, A. Forgioli, G. Madella, C. Olivieri, G. Ossola, F. Picenni, M. Raciti, S. Sermidi, V. Vago.

"Due decenni di eventi artistici in Italia 1950-70", Prato, Palazzo Pretorio. Organisers: G. De Marchis, S. Pinto.

"Vitalità del negativo nell'arte italiana 1960-1970", Rome, Palazzo delle Esposizioni. Exhibition arranged by Incontri Internazionali d'Arte. Organiser: A. Bonito Oliva. Catalogue texts by A. Bonito Oliva, G.C. Argan, A. Boatto, M. Calvesi, G. Dorfles, F. Menna, C. Vivaldi. Exhibitors: V. Agnetti, G. Anselmo, A. Boetti, D. Boriani, M. Ceroli, G. Colombo, L. Fabro, J. Kounellis, P. Manzoni, G. Marotta, E. Mattiacci, M. Merz, M. Pistoletto, M. Rotella, G. Uncini, G. Zorio and others.

"Arte e critica 70, Segnalazioni", Modena, Galleria della Sala di Cultura del Comune. Twenty-seven critics made up a committee and chose four works as being the most indicative of 1968-1969. The artists invited exhibited in various parts of the town with works realised in 1970.

International References
"Processi di Pensiero Visualizzati", Lucerne, Kunstmuseum. Organisers: J.C. Amman and G. Celant. Exhibition of the young Italian avant-garde. Artists: G. Griffa, M. Merz, G. Paolini and others.

"10th Tokyo Biennale '70", Tokyo, Metropolitan Art Gallery. General organiser of the exhibition: Yusure Nakahara. International exhibition by invitation: 40 artists were chosen who worked in the area of arte povera, conceptual art and land art. Italian artists: L. Fabro, J. Kounellis, M. Merz, G. Penone, G. Zorio.

"3e Salon International des Galeries Pilotes", Lausanne, Museo cantonale di Belle Arti; Paris, Musée d'Art Moderne de la Ville de Paris. On invitation to sixteen galleries throughout the world. Italian artists: V. Adami, E. Baj, P.P. Calzolari, G. Griffa, G. Anselmo, P. Manzoni, M. Merz, L. Fontana, L. Del Pezzo, M. Schifano, G. Zorio.

Books and Reviews
G.C. Argan, *L'Arte Moderna 1770-1970*, Florence.
G. Celant, *Conceptual art, arte povera, land art*, Turin.
G. Dorfles, *Le oscillazioni del gusto, l'arte d'oggi tra tecnocrazia e consumismo*, Turin.
C. Maltese, *Semiologia del linguaggio concettuale*, Milan.
F. Menna, *La regola e il caso*, Rome.
L. Vergine, *L'arte avviene nello spazio di tutti*, Milan.

"Italie 70", special number (March) of *Opus* dedicated to Italian art.

1971

Group Exhibitions in Italy
"L'Immagine Attiva", Milan, Rotonda della Besana. Texts by F. Bartoli, R. Beltrame, V. Fagone. Artists: A. Forgioli, R. Guarnieri, G. Madella, C. Olivieri, M. Raciti, V. Vago.
"L'Azione Concreta", Como, Villa Olmo. Organiser: P. Fossati. Artists: M. Gastini, G. Griffa, M. Nannucci, C. Parmiggiani.

International References
"Elf Italiener Heute", Dortmund, Museum am Ostwall. Organiser: G. Dorfles. Artists: G. Alviani, A. Bonalumi, E. Castellani, M. Ceroli, L. Del Pezzo, U. La Pietra, G. Marotta, G. Paolini, G. Piacentino, M. Pistoletto, G. Spagnulo.
"New Multiple Art", London, Whitechapel. Exhibition organised by the Arts Council of Great Britain. International exhibition on multiple art. Italian artists: G. Alviani, E. Castellani, M. Ceroli, G. Colombo, G. De Vecchi, U. La Pietra, L. Fontana, B. Munari, M. Pistoletto, P. Scheggi and others.
"New Italian Art 1953-71", Liverpool, Walker Art Gallery. Catalogue introduction by G. Carandente. Artists: A. Burri, L. Fontana, M. Rotella, P. Pascali, M. Ceroli, E. Mattiacci, G. Paolini, L. Patella, M. Pistoletto, L. Fabro.
VII Biennial, Paris, Bois de Vincennes. Organiser of Italian section: A. Bonito Oliva. Italian artists: A. Boetti, P.P. Calzolari, G. De Dominicis, L. Fabro, M. Germanà, G. Penone, V. Pisani, E. Prini, G. Zorio. A section dedicated to the cinema was also presented.
"Artisti italiani d'oggi alla II Biennale del Museo d'Arte Moderna di Sao Paolo", Brazil. Exhibition organised by the Venice Biennale.
"Pérsona", Belgrade, International Theatre Festival. Catalogue text by A. Bonito Oliva. Artists: A. Boetti, P.P. Calzolari, G. De Dominicis, L. Fabro, M. Germanà, J. Kounellis, M. Merz, G. Paolini, G. Penone, V. Pisani, M. Pistoletto, E. Prini.

Books
AA.VV., *L'arte contemporanea in Italia*, 2 vols. Rome.
AA.VV., *Fotomedia* (Italian artists who work with photography and videotape), Dortmund.
R. Barili, *Dall'oggetto al comportamento*, Rome.
A. Bonito Oliva, *Persona*, Florence.
A. Bonito Oliva, *Il territorio magico*, Florence.
G. Dorfles, *Senso e insensatezza nell'arte d'oggi*, Rome.
P. Fossati, *L'immagine sospesa*, Turin.
I, Tomassoni, *Arte dopo il 1945 in Italia*, Bologna.

1972

Group Exhibitions in Italy
"Progetto, Intervento e Verifica". Milan, Sala delle Cariatidi. Sculptures by N. Carrino, G. Pardi, P. Spagnulo, G. Uncini.
"I denti del drago", Milan, Galleria l'Uomo e l'Arte. Organiser: D. Palazzoli. Artists: V. Agnetti, G. Baruchello, C. Costa, C. Parmiggiani, K. La Rocca, M. Diacono, F. Vaccari, E. Isgrò, M. Bentivoglio, P. Manzoni, B. Munari, U. Nespolo, A. Spatola.
Venice Biennale. Sections: "Opera e comportamento", organised by F. Arcangeli, R. Barilli, M. Valsecchi (participants in "Opera": Guerreschi, Mandelli, M. Moreni, E. Morlotti, G. Turcato; in "Comportamento": V. Bendini, G. De Dominicis, L. Fabro, M. Merz, C. Olivotto, F. Vaccari); "Aspetti internazionali della scultura", organised by G. Carandente, A. Cascella, Q. Ghermandi, G. Marchiori; "Il libro come luogo di ricerca", organised by R. Barilli and D. Palazzoli.
"Fluidità del Reale", Forte dei Marmi, Liceo Scientifico. Exhibition organised by: R. Barilli, E. Corradini, E. Crispolti, G. Dorfles, F. Russoli, C. Vivaldi.

International References
Documenta 5, Kassel. The exhibition on the theme "Inquiry Regarding Reality-Visual Languages Today" was articulated in 4 sections. General Secretary of the exhibition: H. Szeemann. Artists: V. Pisani, J. Kounellis, G. Paolini, V. Agnetti, G. Anselmo, A. Boetti, P.P. Calzolari, G. De Dominicis, L. Fabro, M. Merz, G. Penone, G. Zorio.

Symposia
"Critica in Atto", Rome, Palazzo Taverna. Symposium promoted by Incontri Internazionali d'Arte coordinated by B. Corà. The contributions were published in *Critica in atto*, Rome 1973.

Books and Reviews
G. Dorfles, *Introduzione al disegno industriale*, Turin.
P. Fossati, *Il design in Italia (1945-1972)*, Turin.
E. Migliorini, *Conceptual Art*, Florence.
I. Mussa, *Iperrealismo*, Rome.
"Il futuro dell'arte", round table with R. Barilli, V. Fagone, E. Tadini, M. Volpi Orlandini, in *Nac*, No. 5, May.

1973

Group Exhibitions in Italy
"Combattimento per un'immagine", Turin, Galleria Civica d'Arte Moderna. International-exhibition on the relationship between photographic and pictoric language from the origins until today. Organisers: L. Carluccio, D. Palazzoli, L. Mallé. Italian artists: A. Carena, T. Festa, G. Fioroni, P.V. Fogliati, Gruppo Fluxus,

U. Mulas, G. Paolini, C. Parmiggiani, G. Penone, M. Pistoletto, E. Prini.
"La Ricerca Estetica 1960-1970", Rome, Palazzo delle Esposizioni. Organiser: F. Menna. Exhibition revealing ten years of Italian artistic research, divided in various sections: a) analysis of the components of aesthetic communication; b) recognition, appropriation of the urban scene; c) reconstruction of the universe; d) involvement in environmental space; e) language as mediation; f) ideological proposition.
"Un Futuro Possibile, Nuova Pittura", Ferrara, Palazzo dei Diamanti. Organiser: G. Cortenova. Large international exhibition on new painting. Amongst the Italian artists: R. Aricò, C. Battaglia, M. Gastini, G. Griffa, C. Verna.
"Scrittura Visuale in Italia 1912-1972", Turin, Galleria Civica d'Arte Moderna. Historical exhibition covering visual writing from the avantgarde to the present day. Organiser: L. Ballerini. Catalogue text by A. Passoni.
"La Riflessione sulla Pittura". Acireale, Palazzo Comunale. International exhibition on the new painting. Organisers: F. Menna, I. Mussa, T. Trini. Italian artists: C. Battaglia, P. Cotani, D. Esposito, M. Gastini, G. Griffa, M. Nigro, V. Palermo, L. Pozzi, V. Vago, C. Verna.
"Contemporanea", Rome, Parking Area of Villa Borghese. Organised by Incontri Internazionali d'Arte. International exhibition divided into sections covering visual arts. cinema, theatre, music, dance, architecture, design, photography, books, records, visual and concrete poetry, alternative information. Organiser of the visual arts section: A. Bonito Oliva; P. Berterto for the cinema section; G. Bartolucci for the theatre section; A. Mendini for the architectural section; D. Palazzoli for the photography section; F. Sargentini for the dance section; M. Diacono for the visual poetry section.

International References
VIII Biennial, Paris, Musée National d'Art Moderne. International exhibition. divided into five sections. Organiser: A. Bonito Oliva. Italian artists: C. Costa, G. Paolini, C. Parmiggiani, R. Salvadori, P. Adriano, U. Bartolini, P.P. Calzolari, B. Di Bello, G.E. Simonetti, E. Tatafiore, F. De Filippi, G. Notargiacomo, G. De Dominicis, V. Pisani.
"Prospekt 73", Düsseldorf, Kunsthalle. Wide selection dedicated to the new painting. Italian artists: C. Battaglia, G. Griffa, C. Verna.
"Italy Two, Art Around 70", Philadelphia, Museum of Civic Center. Exhibition of documentation of aesthetic research from 1960 to 1970. Catalogue texts by: A. Boatto, F. Colombo, F. Menna.

Biennial of Sao Paolo, Brazil. Italian section: V. Agnetti, M. Ballocco, M. Bentivoglio, P.P. Calzolari, A. Del Ponte, G. Paolini, P. Tovaglia, G. Zen. Honorary mention made of G. Paolini.

Conferences

Rome, Galleria Nazionale d'Arte Moderna, 13th May conference by R. Barilli on the theme "Il comportamento" (published in *Tra presenza e assenza*, Bompiani, Milan, 1974).

Books and Reviews

A. Abruzzese, *Forme estetiche e società di massa*, Venice.

R. Barilli, "Le due anime del concettuale", in *Op. Cit.* n. 26.

G. Dorfles, *Dal significato alle scelte*, Turin.

G. Dorfles, *Ultime tendenze dell'arte d'oggi*, Milan.

Data, n. 10, the entire issue is dedicated to Nuova Pittura.

1974

Group Exhibitions in Italy

"Presenze e Tendenze della Giovane Arte Italiana", Milan, Palazzo della Permanente. Organiser: V. Fagone.

"Della Falsità", Parma, Istituto di Storia dell'Arte. Exhibition on the research of conceptual artists. Organiser: A.C. Quintavalle. Artists: L. Fabro, E. Isgrò, E. Marcheggiani, P. Martelli, F. Mauri, H. Nagasawa, F. Tonello, A. Trotta.

"La Ripetizione Differente", Milan, Studio Marconi. International exhibition on the theme of citation and the revisiting of the classics, in the new tendencies. Organiser: R. Barilli. Artists: V. Adami, E. Baj, U. Nespolo, B. Di Bello, L. Fabro, G. Paolini, Salvo, G. Croce, J. Kounellis, P. Martelli, L. Ontani.

Venice Biennale. Inaugurated on October the 5th with the exhibition "Testimonianze contro il fascismo". There were two exhibitions for the visual arts section: murals by Chilean artists and an exhibition of photography by U. Mulas taken at previous Biennales.

"La Ricerca dell'Identità", Milan, Palazzo Reale, Organisers: G. Bruno and G.A. Dell'Acqua. Comprehensive international exhibition on the theme of the identity of art in mass society, from the historic avant-gardes to the present day.

International References

"Projekt 74", Cologne, Kunsthalle. Organisers: Horst Keller and Von der Moster. International exhibition of the avant-garde of the 70's from which painting was excluded. Italian artists: G. Anselmo, G. Chiari, C. Costa, L. Fabro, M. Mochetti, M. Merz, Palermo, G. Penone, G. Paolini, Salvo.

"Pittura Italiana a Montreal", Galerie Espace 5. Artists: P. Dorazio, M. Nigro, R. Aricò, C. Bat-

taglia, D. Esposito, M. Gastini, G. Griffa, C.G. Morales, C. Olivieri, C. Verna.

"Italian avantgarde", New York, Max Protetch Gallery. Organiser: L.M. Venturi. Artists: F. Clemente, D. Esposito, P. Lunanova, L. Ontani, M. Zaza.

Books and Reviews

Renato Barilli, *Tra presenza e assenza*, Milan.

G. Celant, *Senza titolo*, Rome.

A. Del Guercio, *L'oggetto, l'immagine, il tempo*, Naples.

G. Dorfles, *Simbolo, comunicazione e consumo*, Turin.

P. Fossati, *La pittura a programma*, Venice.

T. Maldonado, *Avanguardia e razionalità (1946-1974)*, Turin.

L. Vergine, *Il corpo come linguaggio*, Milan.

"Italie', special issue of *Opus* entirely dedicated to the artists of the most recent tendencies in Italy. Paris, November-December.

1975

Group Exhibitions in Italy

"Artevideo Multivision", Milan, Rotonda della Besana. International exhibition of videotapes and multivision projection. Organiser: T. Trini.

"Progetto-Struttura", Livorno, Museo progressivo d'Arte Contemporanea. Exhibition on design. Organisers: F. Fagone and L. Vinca Masini.

"Fotomedia", Milan, Rotonda della Besana. Exhibition of Italian artists who use photography and videotape: D. Palazzoli. Presented in 1973 at Dortmund, new sections were added here. Amongst the artists: V. Agnetti, V. Berardinone, G. Chiari, G. Colombo, B. Di Bello, E. Mattiacci, U. Nespolo, L. Ontani, G. Paolini, A. Paradiso, L. Patella, M. Schifano, F. Vaccari.

"Parlare e Scrivere", Rome, Galleria La Tartaruga. Exhibition arranged in two sections: one dedicated to writing with exhibition of works; the other to the oral element with performances which continued over the five evenings. Organiser: R. Barilli.

"Empirica-l'Arte Fra Addizione e Sottrazione", Rimini, Palazzo del Comune. International exhibition of artists involved in minimal, conceptual, new painting and narrative research. Organiser: G. Cortenova.

International References

"Sempre Nuove Cose Pensando", Antwerp, International Cultureel Centrum. Exhibition on artistic research in Italy arranged according to two different lines of tendency: conceptual art and behavioural art. Organiser: V. Fagone.

"Pittura Italiana d'Oggi", Montreal, Galerie Espace 5, Paris, Galerie Templon. Organiser: G. Politi. Artists: R. Aricò, C. Battaglia, P. Dorazio,

D. Esposito, M. Gastini, G. Griffa, R. Gurnieri G.C. Morales, M. Nigro, C. Olivieri, C. Verna.

X Biennial, Paris, Musée d'Art Moderne de la Ville de Paris. Organisers: G. Boudaille, J Lassaigne, P. Hulten. From the Italians: P Cotani, F. Plessi, M. Zaza.

Symposia

Round table on the theme "Problemi del mercato dell'arte, legislazione organizzazione e implica zioni socio-culturali", Bologna, Galleria Civica d'Arte Moderna. From the speakers: T. Trini, G Marconi, A. Schwarz, U. Allemandi, F. Solmi, G Panza di Biumo:

Books and Reviews

AA.VV., *Pittura italiana d'oggi*, Milan.

E. Crispolti, *Sociologia e iconologia della Pop art e altri studi*, Naples.

G. Dorfles, *Il divenire delle arti*, Turin.

M. Fagiolo, *La pittura come disciplina*, Turin.

F. Menna, *La linea analitica dell'arte*, Turin.

E. Migliorini, *L'arte e la città*, Florence.

F. Poli, *Produzione artistica e mercato*, Turin.

The Guardian, London, 22nd January 1975. Caroline Tisdall published an analysis on the Italian artistic avant-garde in the light of the economic crisis and of its consequences on art and the market.

1976

Group Exhibitions in Italy

"Ricerche a Milano agli Inizi degli Anni 60", Milan, Galleria L. Palazzoli. Organiser: G. Ballo. Artists: G. Alviani, L. Anceschi, A. Bonalumi, D. Boriani, E. Castellani, G. Colombo, Dadamaino, P. Scheggi, G. De Vecchi, P. Manzoni, E. Mari, G. Varisco, N. Vigo.

"Arte e Cinema in Italia", Milan, Centro Internazionale di Brera. Catalogue text by V. Fagone: *Per un catalogo del cinema d'artista in Italia*.

"Europa-America, l'Astrazione Determinata", Bologna, Galleria Civica d'Arte Moderna. Historical exhibition centred on the relationships between the aesthetic object and environmental space according to the path of a reduction of the image to minimal linguistic and structural terms. Organiser: F. Caroli. Collaboration: G. Panza di Biumo.

Venice Biennale: a) "Arte ambiente 1915-1976"; b) padiglione italiano, "L'ambiente come sociale"; c) "Attualità internazionali 1972-1976"; d) "Attivo" (selection of performances).

"I Colori della Pittura, una Situazione Europea", Rome, Istituto Italo-latino americano. Exhibition which assessed the new painting. Organiser: I. Mussa. Catalogue preface by G.C. Argan and critical anthology of writings.

"Blow Up, i Viaggi di Gulliver nel Regno della Percezione", Milan, Dov'è la tigre. Exhibition on

he theme of the disconcertment obtained by way of a dimensional manipulation of the image, in the line of primary emergence of the technical factor of the creative process. Organiser: R. Barilli.

"La Cosa Disegnata", Milan, Studio Marconi. 16 mini one-man exhibitions. Organiser: T. Trini.

Seminars and Symposia
"L'istituzione espositiva dal 1964 ad oggi", Turin, Aula Magna dell'Accademia di Belle Arti. Speakers: L. Caramel; F. Vincitorio, R. Barilli, F. Menna.

International meeting of art reviews on the theme "Funzione culturale ed incidenza sul mercato, rapporti con artisti e gallerie, problemi di finanziamento e diffusione", Bologna, Galleria Comunale d'Arte Moderna.

Books
AA.VV., 1966-1976 Dieci anni in Italia, Milan.
AA.VV., Situazione dell'arte contemporanea, Rome.
G. Ballo, La mano e la macchina, dalla serialità artigianale ai multipli, Milan.
R. Barilli-A. Socal, Aspetti del comportamento, Padua.
A. Bonito Oliva, Europe America, the different avant gardes, Milan.
G. Celant, Precronistoria 1966-1969, Florence.
G. Dorfles, Il divenire della critica, Turin.
L. Vergine, Attraverso l'Arte: pratica/politica/pagare il 68, Rome.

1977

Group Exhibitions in Italy
"Le Contraddizioni del Segno", Turin, Teatro Gobetti, Organiser: M. Vescovo. On the different semantic directions of the sign in present artistic research.

"Ipotesi 80", Bari, Expo Arte. The exhibition was arranged within the ambit of the International Fair of Contemporary Art. It was entrusted to various curators and took the form of an investigation into the developments of artistic research in Italy.

"1960-1970: Arte in Italia", Turin, Galleria Civica d'Arte Moderna. The exhibition was arranged into three sections covering three areas of research: "From the work to commitment" (R. Barilli); "The work, symbols and images" (A. Del Guercio); "The analytical line" (F. Menna). Catalogue texts by the three organisers and an accurate chronological list with a bibliography by F. Alinovi, B. Tosi, S. Sinisi.

"Pratica, Milano 1977", Milan, Studio Marconi. Series of nine exhibitions on aesthetic research in Milan, organised by the artists.

"I Settimana Internazionale della Performance", Bologna, Galleria Comunale d'Arte Moderna. A

meeting of actions, music, dance, oral poetry, gestual, phonetic, eat art. Organisers: F. Alinon; R. Barilli, R. Daolio, A. Tosarelli, M. Pasquali, F. Solmi.

International References
Documenta 6, Kassel. Amongst the Italian artists: J. Kounellis, C.G. Morales, C. Olivieri, V. Adami, C. Alfano, M. Merz, G. Paolini and others.

X Biennial, Paris. Italian artists: M. Del Re, N. De Maria, D. Rabito, C. Parmiggiani, F. Clemente, S. Chia, F. Avalle, M. Bagnoli. C. Kubish.

"Europe in the Seventies, Aspects of Recent Arts", Chicago, Art Institute. The Italian section: G. Anselmo, M. Merz, G. Paolini, G. Zorio.

Seminars and Symposia
"Arte e Ideologia", Rome, Palazzo Taverna. Series of debates on art and ideology, cultural policy, artistic institutions.

Books and Reviews
V. Accame, Il segno poetico.
R. Barilli, G. Dorfles, F. Menna, L'arte contemporanea III, series "L'Arte Moderna", vol. XIV, Milan.
A. Bonito Oliva, Autocritico Automobile — Attraverso le Avanguardie, Milan.
G. Celant, Offmedia, Bari.
G. Dorfles, Artificio e natura, Turin.
G. Dorfles, Nuovi riti, nuovi miti, Turin.
V. Fagone, Per un catalogo del cinema d'artista in Italia 1965/1977, Venice.
D. Palazzoli, Fotografia, cinema, videotape, collana Arte e Società, Milan.
F. Quadri, L'avanguardia teatrale in Italia, Turin.
R. Sanesi, La cosa scritta, Milan.
I. Tomassoni, O grande, Rome.
Data, Nos. 28-29, Investigation dedicated to Moderno, postmoderno, millenario.
Flash Art, Nos. 78-79, monographical issue on the theme of Romanticismo postconcettuale.

1978

Group Exhibitions in Italy
"Aphoto", Milan, Studio Marconi. Organiser: R. Peccolo. Exhibition on the theme of the analytical and reflective contribution raised by photography which affect the painter.

"Le Figure del Tempo", Bologna, Galleria De' Foscherari. Organised by P.G. Castagnoli. Exhibition concerning the notion of time in present research.

"II Settimana Internazionale della Performance", Bologna, Palazzo dei Congressi. Curated by F. Alinon, R. Barilli, R. Daolio.

"Cara Morte", Gavirate, Seminari di Gavirate, Chiostro di Voltorre. Organiser: T. Trini. The ex-

hibition, which covered various disciplines, is documented in the catalogue of the exhibition, Metafisica del Quotidiano, Bologna 1978. The theme was that of the relation between art, rejoicing and death.

"Artisti e Cinema negli Anni 70", Ravenna, Pinacoteca Comunale. An exhibition of art films. Organiser: V. Fagone.

"1, 2, 3", Milan, Studio Ennesse. Exhibition organised by F. Menna. Within the ambit of the new painting the choice was made of research which questioned one of the fundamental statutes of the work, the unitary surface, preferring the serial contiguity of the elements.

"Metafisica del Quotidiano", Bologna, Galleria Comunale d'Arte Moderna. Organiser: F. Solmi who as a work hypothesis chose that of ambiguity in that it is the privileged dimension of the aesthetic with the result of preparing an exhibition which was open in every sense, neither a trial nor didactic. Catalogue texts by F. Farina, A.C. Quintavalle, F. Solmi. The individual sections were run by the respective organisers in complete autonomy. Sections: "Ritual ambiguity" (F. Solmi and M. Pasquali); "Dear death" (T. Trini); "Ianua coeli" (E. Spera and P.E. Novielli); "Sign, Labyrinth" (M. Vescovo); "Close-up meetings of architecture" (A. Mendini); "The water and the ecstasy" (L. Bortolotto); "With the pretext of the icon" (F. Menna and B. Lamache-Vadel); "The adventure of the object" (P. Restany); "The geometrical imaginary" (I. Mussa and S. Sinisi); "Painting of hyperrealism" (R. Bossaglia); "The doppel and the intellect" (R. Dalmonte); "Fluxus as Fluxus" (A. Bonito Oliva). From among the numerous Italian and foreign artists invited: A. Cavaliere, J. Beuys, E. Tadini, M. Merz, P. Spagnulo, M. Zaza, L. Del Pezzo, A. Branzi, E. Sottsass, Christo, César, F. Lo Savio, J. Tilson, M. Pistoletto and others.

Venice Biennale. Theme: "From nature to art, from art to nature". International critical-historical exhibition.

Seminars and Symposia
"Critica 0", Montecatini Terme. International symposium of art criticism today. Scientific committee: J.C. Amman, G.C. Argan, R. Barilli, M. Calvesi, G. Dorfles, U. Eco, L. Pignotti, The numerous contributions were divided into three groups: theories relative to the definition and methodologies of the critical investigation; methodological practices and of the reading of the problems emerging in the art system; the rôle and function of the art critic. The contributions and debates were collected into the volume Teoria e pratiche della critica d'arte by E. Mucci and P.L. Tazzi, Milan, 1979.

"Milano 80", Milan, Palazzo Reale. Series of

events promoted by the City Council and organised by R. Barilli, F. Caroli, V. Fagone, M. Garberi, A. Morello on the themes of art today, with numerous contributions from critics, art scholars and artists.

"Dell'Arte... i Bordi", Milan, Museo della Scienza. Symposium organised by the Italian Psychoanalytical Association and by the review *Spirali* with numerous contributions by Italian and foreign scholars.

Books
AA.VV., *La performance oggi*, Macerata. Presentation by R. Barilli; texts by F. Alinovi, R. Daolio, M. Pasquali.
AA.VV., *Fine dell'avanguardie?*, Florence.
A. Bonito Oliva, *Un passo dello strabismo, sulle arti*, Milan.
M. Calvesi, *Avanguardia di massa*, Milan.

1979

Group Exhibitions in Italy
"Words, The Use of Language in Art in the Last Ten Years", Genoa, Palazzo Ducale. An exhibition previously held in Bochum and organised in Genoa by I. Puliafito. Amongst the artists: V. Agnetti, A. Boetti, G. Chiari, G. Paolini.

"L'Estetico e il Selvaggio", Modena, Galleria Civica d'Arte Moderna. Organiser: G. Cortenova who in the sub-title *Associazione, dissociazione, dissezione: l'obliquità dell'arte* intended to indicate the elusiveness, the presence-absence of the artistic fact.

"Pittura-Ambiente", Milan, Palazzo Reale. Organisers: R. Barilli and F. Alinovi. On the theme of painting which extends in space according to two lines: that deriving from Funk Art in the maximum relief given to the support; that which derives from the research of Californian artists like R. Irwin in the relief given to the single colour become pure spatiality. Participation of numerous artists from Italy and abroad.

"Testuale, le Parole e le Immagini", Milan, Rotonda della Besana. Organisers: F. Caroli and L. Caramel. International exhibition which covered the writing image relationship in the decade 1970-1980. It was divided into 5 sections: "Parallelismi, Interferenze, Identità, Sostituzioni" (where the words substitute the image) and "Proposizioni" (where the words and images are used in a propositive function in order to stimulate the reply of the user).

"Ars Combinatoria", Bologna, Galleria Civica d'Arte Moderna. Organisers: R. Barilli and F. Solmi. Exhibition in homage to Fahlström. From amongst the artists present: A. Boetti, T. Pericoli, G. Piacentino, G.F. Baruchello, E. Tadini.

"Sistina Società per Arte", Bologna, Arte Fiera.

Organiser: T. Trini, on the theme of art on public commission and for collective spaces.

"La Section d'Or o della Restaurazione", Ravenna, Pinacoteca Comunale. Organisers: F. Caroli and G. Guberti, on the conceptual, reductive, fantastic use of manuality. The catalogue is contained in the review *La Tradizione del Nuovo*.

"The Art of Performance", Venice, Palazzo Grassi. Organised by the New York University Art Department and by the Centre of Arts & Communication, Buenos Aires. A symposium was organised on the theme with the participation of numerous critics and scholars from Italy and abroad.

"Pittura Teatrica", Milan, Studio Cannaviello. Artists: D. Benati, V. Cassano, A. Spoldi, Wal.

"Opere Fatte ad Arte", Acireale, Palazzo di Città. Organiser: A. Bonito Oliva. Artists: S. Chia, F. Clemente, E. Cucchi, N. De Maria, M. Paladino.

"Le Stanze", Genazzano, Castello Colonna. Organiser: A. Bonito Oliva, with contributions especially studied for the destined environments. Amongst the artists: A. Boetti, S. Chia, E. Cucchi, M. Merz, M. Paladino, V. Pisani and others.

"Il Nuovo Contesto", Milan, Studio Marconi. Organiser: F. Caroli. Artists: D. Benati, M. Carone, R. Caspani, A. Faggiano, O. Galliani, L. Giandonato, M. Landi, A. Spoldi.

"Cine Qua Non", Florence, Cappella di S. Apollonia and Il Concertino of Palazzo Capponi. International days of art cinema.

International References
"Giovani Artisti Italiani", Basel, Kunst Museum. Organiser: J.C. Amman. Artists: S. Chia, M. Bagnoli, F. Clemente, N. De Maria, L. Ontani, M. Paladino.

Symposia
"Autonomia Critica dell'Artista", Bologna. International symposium of artists promoted by Arte Fiera.

Books
AA.VV., *L'arte in Italia nel secondo dopoguerra*, Bologna, with introduction by R. Barilli.
G. Ballo, *Le origini dell'astrattismo, verso altri orizzonti del reale*.
R. Barilli, *Informale, oggetto comportamento (La ricerca artistica negli anni cinquanta e sessanta*, vol. 1, *La ricerca artistica negli anni settanta*, vol. 2), Milan.
C. Brandi, *Scritti sull'arte contemporanea*, vol. II, Turin.
L. Caramel-F. Poli, *L'arte bella. La questione delle Accademie di Belle Arti in Italia*, Milan.
F. Caroli, *La politica dell'arte. Fra creatività ed istituzione: l'arte e l'artista nella società dei consumi*, Milan.

F. Caroli, *Parola e Immagine*, Milan.

1980

Group Exhibitions in Italy
"Fiat Lux", Alessandria, Galleria Civica. Organiser: M. Vescovo. Collective exhibition of young Italian artists.

"Italiana. Nuova Immagine", Ravenna, Pinacoteca Comunale. Organiser: A. Bonito Oliva. The catalogue, with an introduction by the organiser and statements by the artists, is contained in the review *La Tradizione del Nuovo*.

"Dieci Anni Dopo — I Nuovi Nuovi", Bologna, Galleria Comunale d'Arte Moderna. Organisers: R. Barilli, F. Alinovi, R. Daolio. Like the previous ones this was an exhibition of the most recent tendencies grouped on the basis of the ascendancy of different currents: the pauperism from the return to the origins and the quoting practice until arriving at a mythical and cultural thickness. Narrative Art from which derives that freedom of the cut of the painting with the substitution to the photograph of the manual trace in a renewed freedom of the gesture and the techniques, void of the previous theoretical preoccupation, as in the prohibition of recovering the means of traditional figuration: the neosymbolism. Artists: Salvo, L. Ontani, L. Mainolfi, G. Maraniello, L. Bartolini. A. Faggiano, A. Spoldi, Wal, B. Benuzzi, G. Pagano, E. Barbera, F. Levini, G. Salvatori, M. Jori.

"Camere Incantate", Milan, Palazzo Reale. Exhibition, prepared by V. Fagone, on photography, artists' films, installations, videotapes, recording of performances.

"Nuova Immagine/New Image, una generazione e mezzo di giovani artisti internazionali", Milan, Palazzo della Triennale. Organiser: F. Caroli who arranged the exhibition in 4 sections: "Archetipi", Italian artists: R. Camoni, V. Cassano, F. Dellerba, G. Gori, L. Mainolfi; "Alchymia": L. Bartolini, R. Caspani, V. D'Auguata, O. Galliani, L. Giandonato, M. Landi, C. Parisot, G. Zucchini; "Eventi": M. Carone, M. Cresci, C. Di Leo Ricatto, N. Longobardi, P. Lunanova; "Introiezioni": A. Altamira, A. Faggiano, P. Manai. A. Spoldi. In his catalogue introduction Caroli indicated the values emerging from this research: art as metaphor or episteme of a sensual-mythical type, the re-semanticising of the image, hedonism and proclaiming of the private in artistic practice. Catalogue texts by G.M. Accame, F. Gualdoni, M. Pleynet, M. Vescovo, C. Cerritelli, A. D'Elia, D. Paparoni, L. Parmesani.

Venice Biennale. Director of the visual arts section: L. Carluccio, "L'arte negli anni 70". Historical-critical international exhibition. "Padiglione Italiano", organised by V. Fagone.

"Aperto 80", organised by A. Bonito Oliva and I. Szeemann, international exhibition of young artists.

"Arte e Critica 1980", Rome, Galleria Nazionale l'Arte Moderna. Organiser. Ida Panicelli. 25 critics chose two works exhibited or published for the first time in 1979: the artists chosen in this way exhibited works done in 1980, if possible new works.

International References
"The Italian Wave", New York, Holly Solomon Gallery. Organiser: F. Alinovi. Exhibitors: L. Bartolini, B. Benuzzi, E. Esposito, M. Jori, L. Ontani, Salvo, A. Spoldi, G. Zucchini.

"Una Mostra di Sette Artisti", Basel, Essen, Amsterdam. Artists: S. Chia, F. Clemente, E. Cucchi, N. De Maria, L. Ontani, M. Paladino, E. Tatafiore.

XI Biennial, Paris, Musée d'Art Moderne de la Ville de Paris. Italian Pavilion organised by the Galleria Nazionale d'Arte Moderna of Rome. Organisers G. De Marchis and B. Mantura. Artists: L. Bartolini, D. Bianchi, B. Ceccobelli, E. Cucchi, D. Degli Angeli, C. Diamantini, A. Faggiano, G. Notargiacomo, M. Paladino, A. Spoldi, O. Mazza, M. Perazza.

Books and Reviews
G. Ballo, *Origini dell'astrattismo 1885-1919*, Milan.
A. Bonito Oliva, *La transavanguardia italiana*, Milan.
F. Caroli, *Nuova Immagine*, Milan.
G. Dorfles, *L'intervallo perduto*, Turin.
G. Dorfles, *Simbolo, comunicazione, consumo*, Turin.
F. Menna, *Critica della critica*, Milan.

A comprehensive service entitled "Dove va l'arte/Inchiesta sugli anni 80" appeared in three numbers of *Bolaffi Arte*. March number: "La mamma mi ha regalato una scatola di colori", texts by R. Barilli, F. Alinovi and R. Daolio. April number: "Gli anni 80 ci portano l'arte Casual", by A. Bonito Oliva. May number: "Monumento al giovane ignoto", by F. Caroli.

Number 37 of *Art Press* is almost entirely dedicated to Italian art.

1981
Group Exhibitions in Italy
"Genius Loci", Acireale, Palazzo di Città. Organiser: A. Bonito Oliva.

"Magico Primario", Ferrara, Palazzo dei Diamanti, Organiser: F. Caroli. Artists: L. Bartolini, O. Galliani, L. Giandonato, G. Notargiacomo, A. Spoldi.

"Enciclopedia: Il Magico Primario in Europa", Modena, Galleria Civica d'Arte Moderna. Organiser: F. Caroli. International exhibition of

artists grouped by Caroli under the label of Primary-Magical.

"Spazio Giovani", Bari, Expo Arte. The galleries identified indicate artists of the new generation.

"La Qualità (Development of the New New)", Ferrara, Padiglione d'Arte Contemporanea del Parco Massari. Organisers: R. Barilli, F. Alinovi, R. Daolio. Artists: Salvo, L. Ontani, L. Bartolini, A. Faggiano, L. Mainolfi, G. Maraniello, A. Spoldi, E. Barbera, B. Benuzzi, V. D'Augusta, G. Del Franco, E. Esposito, M. Jori, F. Levini, G. Pagano, G. Salvatori, Wal, G. Zucchini.

"Bestiario", Terni, Palazzo Mazzancolli. Organiser: S. Sinisi. Artists: Baretta, L. Bartolini, Camorani, B. Ceccobelli, F. Corneli, O. Galliani, M. Jori, Moretti, L. Ontani, R. Ranaldi, M. Tanganelli.

"Tutte le Arti Tendono alla Performance", V settimana internazionale della performance. Organisers: R. Barilli, F. Alinovi, R. Daolio. The exhibition was held in May and June, not only in Bologna but also in other towns of Emilia.

"Arti Teatro: Paesaggio Metropolitano", Rome, Galleria Nazionale d'Arte Moderna. Organiser: G. Bertolucci. Exhibition of Nuova Spettacolarità and Nuova Performance, with seminars and debates by scholars and artists.

"Umanesimo, Disumanesimo nell'Arte Europea 1890/1980", Florence. Organiser: L. Vinca Masini. Arranged in various sections including historical and contemporary works.

"Alternative Italiane alla Pop Art e al Nouveau Realisme", Verona, Palazzo della Gran Guardia. Works exhibited by 37 artists. Organisers: L. Meneghelli and A. Mozzambini.

"Linee della Ricerca Artistica in Italia 1960-1980", Rome, Palazzo delle Esposizioni. Exhibition onItalian art of the last twenty years comprising about three hundred works by about two hundred artists. Selection committee: G. Ballo, M. Calvesi, C. Dardi, V. Fagone, F. Menna, A. Quintavalle, F. Solmi, C. Terenzi.

Begun at te PAC in Milan a series of two-man exhibitions conceived by Z. Birolli and M. Garberi.

Begun at the Galleria Comunale d'Arte Moderna, Bologna, a series of *excises in reading* involving critics and artists.

International References
"Art International d'Aujourd'hui", Brussels, Palais des Beaux Arts. 8 Belgian critics chose 8 international artists. The only Italian, A. Spoldi, was chosen by W. Van Mulderns.

"Westkunst", Cologne. International selection committee under the Chairmanship of K. Koenig. From amongst the Italians: S. Chia, E. Cucchi, F. Clemente, N. De Maria, M. Paladino, M. Merz, G. Paolini, P. Pascali and others.

"identité Italienne", Paris, Centre Pompidou. Organiser: G. Celant. The exhibition was organised in collaboration with the Incontri Internazionali d'Arte and comprised 18 artists: Anselmo, Bagnoli, Boetti, Castellani, De Dominicis, De Maria, Fabro, Kounellis, Lo Savio, Manzoni, Mario & Marisa Merz, Paolini, Pascali, Penone, Pistoletto, Schifano, Zorio.

Books and Reviews
F. Alinovi-C. Marra, *La fotografia. Illusione o rivelazione?*, Bologna.
R. Barilli, *Viaggio al termine della parola; La ricerca introvabile*, Milan.
A. Boatto, *Sguardo dal di fuori (nuove frontiere dello spazio e dell'immaginario)*, Bologna.
A. Bonito Oliva, *L'ideologia del traditore — Arte, maniera, manierismo*, Milan.
A. Bonito Oliva, *Il sogno dell'arte*, Milan.
R. Sanesi, *Recitazione obbligata*, Milan.

"Negli anni ottanta", No. 21 of *Iterarte*. Ten young critics testify to the situation of art today.

1982
Group Exhibitions in Italy
"La Ruota del Lotto", Jesi, Palazzo dei Convegni. Organiser: F. Caroli. Related to the V Centenary of the birth of Lorenzo Lotto the works of seven artists were presented: O. Galliani, L. Giandonato, G. Notargiacomo, L. Ontani, G. Paolini, M. Pistoletto, Salvo.

"Generazioni a Confronto", Rome, Facoltà di Lettere of the University of Rome. "Second Symposium on Work Communications of Contemporary Artists" dedicated to N. Ponente, and organised by M. Calvesi with the collaboration of S. Lux, the exhibition begins with C. Accardi, A. Burri, P. Consagra, L. Fontana, G. Turcato, G. Fioroni, J. Kounellis, G. Paolini and V. Pisani and progresses to the work of B. Ceccobelli, F. Clemente, O. Galliani, G. Notargiacomo and F. Piruca.

"La Sovrana Inattualità, Ricerche Plastiche in Italia negli Anni 70", Milan, Padiglione d'Arte Contemporanea. Organiser: F. Gualdoni. Artists: P. Icaro, L. Mainolfi, H. Nagasawa, G. Spagnulo, A. Trotta, G. Zorio.

"Registrazione di Frequenze (Regstrzn Freqnz)", Bologna, Galleria Comunale d'Arte Moderna. Organisers: F. Alinovi, C. Cerritelli, F. Gualdoni, L. Parmesani, B. Tosi. An exhibition with five sections prepared by five critics. Alinovi: "Frontiere di Immagini" (G. Carpinteri, N. Corona, M. Jori, M. Mattioli, L. Ontani, A. Pazienza, A. Spoldi); Cerritelli: "Immagini del Cuore" (P.A. Cuniberti, D. Degli Angeli, M. Landi, P. Manai, V. Mascalchi, G. Partisani, G. Pintori, G. Sartelli, V. Satta); Gualdoni: "Pittura di Valori" (P. Dorazio, A. Garutti, M. Gastini, G.

Griffa, V. Matino, M. Nigro, C. Olivieri, G. Turcato); Parmesani: "Dall'Opera Aperta all'Operetta" (E. Baj, P. Gilardi, J. Kounellis, G. Paolini, P. Pascali, G. Pardi, M. Rotella, E. Tadini); Tosi: "Perle" (M. Del Re, F. Di Sambuy, P. Fortuna, Pinot Gallizio, M. Germanà, N. Longobardi, A. Nelli, V. Messina, E. Montessori).

"Transavanguardia: Italia/America", Modena, Galleria Civica d'Arte Moderna. Organiser: A. Bonito Oliva. A confrontation between the works of S. Chia, P. Clemente, A. Cucchi, N. De Maria, M. Paladino and the works of American artists.

"Avanguardia Transavanguardia", Rome, Mura Aureliane. Organiser: A. Bonito Oliva. From amongst the Italians: S. Chia, P. Clemente, E. Cucchi, N. De Maria, M. Paladino, A. Boetti, M. Schifano, E. Vedova, G. Turcato and others.

"Forma Senza Forma", Modena, Galleria Civica d'Arte Moderna. Organiser: E. Bargiacchi. Exhibitors: P.P. Calzolari, Cremaschi, E. Cucchi, G. Dessì, F. Di Sambuy, Gattuso Lo Monte, Guberti, J. Kounellis, M. Landi, L. Mainolfi, G. Maraniello, M. Merz, M. Paladino, M. Pistoletto, Raffaele, M. Ragusa, D. Ranaldi, Ruffa, M. Tirelli, W. Vaccari.

"Arti Teatro Città — Ultimi Segnali", Varese. Organisers: G. Bartolucci and V. Fagone; with shows, performances and contributions from F. Alinovi, R. Bonfiglioli, F. Bolelli, S. Sinisi, L. Mango, G. Verzotti, P. Landi.

"Babele — Esperienze Artistiche in Italia. Anni 50, Anni 70", Palma Campania. Organised by C. Benincasa. The exhibition is divided into four sections.

Venice Biennale. International Pavilion dedicated to painting. Curator of the Italian Pavilion: L. Caramel. Organiser of "Aperto 82" T. Trini. Exhibition divided into two sections: "Space" and "Time".

"Celle, Arts Spaces", Pistoia, Villa di Celle. Organiser: A. Barzel. Works by N. De Maria, M. & M. Merz, M. Paladino, M. Staccioli, A. Spoldi, etc.

International References

"Phoenix", Germany. Exhibiting artists: C. Accardi, M. Affinati, E. Castellani, P. Dorazio, P. Manzoni, C.G. Morales, G. Spagnulo, G. Zappettini.

"Baroque 81", Paris, A.R.C. organised by Catherine Millet. International exhibition. From amongst the Italians: F. Clemente, E. Esposito, N. Longobardi, M. Paladino.

XVI Biennal, Sao Paolo, Brazil. Italian selection by B. Mantura. Italian artists are also present in the historic pavilion: A. Burri, P. Guccione, R. Guttuso, J. Kounellis, C.M. Mariani, G. Turcato.

"Aspects of Italian Art Now", New York, Guggenheim Museum. Selection by D. Waldman. Exhibitors: S. Chia, E. Cucchi, N. Longobardi, L. Ontani, G. Penone, V. Pisani, G. Zorio.

Documenta 7, Kassel. From amongst the Italians: G. Anselmo, M. Bagnoli, A. Boetti, A. Burri, E. Castellani, S. Chia, F. Clemente, E. Cucchi, G. De Dominicis, N. De Maria, L. Fabro, J. Kounellis, L. Mainolfi, C.M. Mariani, M. & M. Merz, M. Paladino, G. Paolini, G. Penone, A. Rossi (architect), R. Salvadori, E. Spalletti, E. Vedova, A. Violetta, M. Zaza.

Books

AA.VV., *Paesaggio metropolitano*, Milan.
R. Barilli, *Culturologia e fenomenologia degli stili*, Bologna.
A. Bonito Oliva, *Manuale di Volo*, Milan.
M. Calvesi, *La metafisica schiarita*, Milan.
F. Caroli, *Magico Primario*, Milan.

Biographies
Information supplied by the artists

Spazialismo

Lucio Fontana
Born in Rosario di Santa Fé (Argentina) in 1899. Died in Comabbio (Varese) in 1968.

He began his artistic activity as a sculptor and ceramicist. During the 30's he produced ceramics of an expressionist type while, later, he also turned his attention to a language of an abstract type. He adhered to the French Abstraction-Creation movement. In 1946 he signed the *Manifesto Blanco* in Argentina beginning the discussion which he was to develop in Milan in the years after the war with the founding of Spazialismo in 1947. Art, for Fontana, was an attempt at opening space to vaster, cosmic dimensions. It is from this point of view that his spatial environments from 1948 onwards should be seen. The *Concetti Spaziali* follow on from 1957, where the material of the sculpture or of the painting is lacerated, opened up by the gesture-cut of the artist. The cut of truth against the fiction of art and, contemporaneously, the opening of artistic space to intra-world space, and vice versa. In 1966 he was awarded the Gran Premio Internazionale for painting at the Venice Biennale. He has been given numerous one-man and retrospective exhibitions have been dedicated to him in museums, both in Italy and abroad. For more detailed bio-bibliographical information see the monograph-catalogue prepared by the Milan Commune.

From Azzeramento to Modulazione oggettuale

Agostino Bonalumi
Born in Vimercate in 1935. Lives and works in Milan.

1956 — First one-man exhibition at the Galleria Totti, Milan, 1960 — With Manzoni and Castellani he founded the magazine *Azimuth*. Gillo Dorfles presented Bonalumi's exhibition at the Galleria Il Prisma in Milan. 1961 — He was among the founders of the Gruppo Nuova Scuola Europea (New European School Group) at the Kaspar Gallery in Lausanne. 1966 — He participated for the first time at the Venice Biennale. 1967 — He stayed for a long period in New York where he exhibited at the Bonino Gallery. He realised the work *Blu abitabile* for the exhibition "Lo spazio dell'immagine" at Foligno. He was invited to exhibit at the IX Biennial of Sao Paulo and to the Paris International Biennial. 1968 — Retrospective exhibition from 1964 to 1968 at the Museum am Ostwall in Dortmund. For this occasion he realised the work *Grosse Environnement*. 1969 — His own room at the exhibition "Arte Italiana dal '200 ad oggi" at the Palais des Beaux-Arts in Brussels. 1970 — His own room at the XXXV Venice Biennale. 1979 — "Pittura-Ambiente" at the Palazzo Reale in Milan.

Dadamaino
Born in Milan in 1935. Lives and works in Milan.

One-man exhibitions: 1958 — Galleria dei Bossi, Milan. 1959 — Galleria del Prisma, Milan. 1961 — Galleria Montenapoleone, Milan. 1962 — Galleria Senatore, Padua. 1970 — Galleria Diagramma, Milan. 1971 — Whyte Gallery, Lausanne. 1973 — Galleria del Cavallino, Venice. 1975 — Salone Annunciata, Milan. 1979 — Galerie Walter Storms, Munich. 1979 — Studio Grossetti, Milan. 1980 — XXXIX Venice Biennale: "Arte e Critica", Galleria Nazionale d'Arte Moderna, Rome; Maggie Kress Gallery, Taos (USA). 1981 — Galleria 3 Tre, Rome; Institut für Moderne Kunst, Nuremberg; Galerie Walter Storms, Villingen; Künstler Werkstätten, Munich.
Group exhibitions: 1968 — Kunsthalle, Hamburg. 1969 — Campo Urbano, Como; Centre National d'Art Contemporain, Paris; New Goodman Gallery, Johannesburg. 1972 — Museo Poldi Pezzoli, Milan. 1977 — Museo Civico, Modena; Palazzo della Permanente, Milan; Civic Museum, Graz. 1978 — Museo Civico, Bologna; Cara Morte, Gavirate; Drawing Biennial, Cracow; Civic Museum, Gelsenkirchen. 1979 — Sistina Società per Arte, Bologna. 1981 — Palazzo delle Esposizioni, Rome. 1982 — Centre Pompidou, X Manifestation du Livre d'Artist/Livre Objet, Paris.

Francesco Lo Savio
Born in Rome in 1935. Died in Marseilles in 1963.

He held his first one-man exhibition of paintings in Rome, in 1960, at the Galleria Selecta. In 1961 and 1962 he exhibited at the Galleria La Salita in Rome; in 1961 at the Städtisches Museum, in Leverkusen; in 1963 the monograph *Spazio-Luce*, vol. I, Ed. De Luca, was presented at the Libreria Einaudi in Rome. He participated at numerous Italian and foreign group exhibitions, in particular at the Galleria La Salita in Rome, at the Städtisches Museum in Leverkusen, at the Städtisches Museum in Trier, the Stedelijk Museum in Amsterdam and at the Galleria Comunale d'Arte Moderna in Bologna. Since his death numerous retrospective exhibitions have been dedicated to Lo Savio, including 1965 — Palazzo delle Esposizioni, Rome; 1967-1969 — Galleria La Salita, Rome; 1972 — XXXVI Venice Biennale; 1974 — Galerie Dénise René-Hans Mayer, Düsseldorf; 1979 — Padiglione d'Arte Contemporanea (PAC), Milan. He was also included in the following exhibitions: 1967 — National Museum of Modern Art of Tokyo; 1968 — The Jewish Museum, New York; XXXIV Venice Biennale; Documenta 1 and 2, Kassel, as well as numerous exhibitions at the Galleria Nazionale d'Arte Moderna of Rome where, in 1968, a permanent room was installed.

Piero Manzoni
Born in Soncino in 1933. Died in Milan in 1963.

He began to be interested in painting in 1957, concerning himself within spatial and nuclear problematics and exhibiting in group exhibitions. His work underwent a radical change and from canvases of an informal-automatic type he passed to "Achrome" paintings, large white surfaces realised with non-traditional non-artistic materials. In 1959, together with Castellani and Bonalumi, he founded the Azimuth movement as well as the magazine of the same name. In the same year he held his first one-man exhibition at the Galleria Azimuth in Milan where he presented the *Percorsi*, kilometrical lines drawn on strips of paper, rolled up and contained in a cardboard tube. In 1959, 1960 and 1961 Manzoni's interest was directed towards the body and its possibilities. He realised the work *Corpi in aria sferici*, balloons containing his breath, the *Divorare l'arte* happening at the Galleria Azimuth where he fed the public, *Eggs* with the impression of his finger prints; the *Sculture viventi* at the Galleria La Tartaruga in Rome, signed pedestals everyone who climbs onto which can become a work of art. He placed his *Merde d'Artiste* on sale.
During his short life Manzoni participated at important national and international exhibitions and held numerous one-man exhibitions. Numerous retrospective exhibitions have been dedicated to his work, in particular in Milan in 1964, in Paris in 1969 and at the Galleria Nazionale d'Arte Moderna in Rome in 1971.

Arte cinetica and Arte programmata

Gruppo T (Giovanni Anceschi, Davide Boriani, Gianni Colombo, Gabriele De Vecchi, Grazia Varisco)

Giovanni Anceschi
Born in 1939 in Milan where he lives and works.

His artistic development took place within the Milanese post-informal climate. He contributed to the formation of the kinetic, programmed and perceptive art currents which flowed into the large international movement of the New Tendencies. In fact, with Boriani, Colombo and De Vecchi he founded the Gruppo T in 1959 and participated at all the "Miriorama" events and exhibitions in Italy and abroad. He also participated at: 1961 — "Bewogen beweging", Amsterdam; "Rorelse i Konset", Stockholm. 1962 — "Anti-peinture", Antwerp. 1962 — 1965 — "Arte programmata", travelling exhibition, Milan, Venice, Rome, Trieste, Düsseldorf, London and New York. 1963 — "Nova Tendencija 2", Zagreb; Biennial of S. Marino; "Nuove Tendenze", Venice. 1964 — "Nouvelles Tendences", The Louvre, Paris; "Premio Avezzano". He

was invited to show at the 1964 Venice Biennale. His artistic activity ended with his participation at "Nova Tendencija 3" in Zagreb in 1965. In 1966 he completed his studies at the Visual Communications Department of the Ulm School. Since then he has been professionally active as a visual designer. He now teaches Graphic Systems at the D.A.M.S. in Bologna.

Davide Boriani
Born in 1936 in Milan where he lives and works.

He began exhibiting in 1957. In 1959 in Milan, with Anceschi, Colombo and De Vecchi, he founded the Gruppo T with which he began and continued research work within the area of kinetic and programmed art. He also took an active part in the organisation of exhibitions and of the grouping of artists working within the area of visual research (Galleria Azimuth, Milan 1959; activity of the Gruppo T 1959-1967; Arte Programmata 1961-1965; Movimento Internazionale della Nuova Tendenza 1962-1967). From 1968 onwards he has concentrated on research and its application to the context of the environment and collective communication, rather than exhibition activity. He has realised works which utilised different techniques, traditional and experimental, which have been exhibited in national and international exhibitions. 1962, 1964, 1970, 1976 — Venice Biennale. 1964, 1979, 1980 — Milan Triennale. 1966, 1973 — Rome Quadriennale. 1982 — Tokyo Biennial. His works are to be found in numerous private and public collections, both in Italy and abroad.

Gabriele De Vecchi
Born in 1938 in Milan where he lives and works.

His experience and exhibitions are in the area of materic, monomateric and "opera aperta" research work, 1956-1958 (Fontana, Castellani, Manzoni, Gruppo O). He took part in the constitution of the Gruppo T, 1959, with Anceschi, Boriani, Colombo and Varisco; he exhibited in group kinetic works and kinetic, visual and tactile experiences for the "Miriorama" exhibitions of 1959-1965. From 1962 he held exhibitions of "programmed art" with Alviani, Mari, Munari, GRAV, Gruppo N and Gruppo T. From 1963 he participated in the organisation of the international Nouvelle Tendence movement and its relative exhibitions. From 1963 he realised kinetic environments by way of the manipulation of light and of the virtual dimensions determined by it. Events in the urban context and in urban decoration (1968-1975) and design activity are both areas to which he referred in his teaching of "theory of perception" at the Accademia di Brera from 1971 to 1975. He is an architect and is also concerned with handicrafts. He is at present the Secretary of the Italian World Crafts

Council. His works are to be found in private and public collections in both Italy and abroad.

Grazia Varisco
Born in 1937 in Milan where she lives and works.

In 1960, she joined the Gruppo T, founded by Anceschi, Boriani, Colombo and De Vecchi. Within this group, she conducted research into the areas of visual communication, concerning the possibilities of the programming and variation of images involving the participation of the spectator. She participated in the international group Nouvelle Tendence and exhibited at the organised exhibitions. She then concluded her experience with the Gruppo T, continuing her artistic activity with one-man exhibitions. At present she is a teacher of Visual Design at the Istituto Europeo and of Theory of Perception at the Accademia di Brera in Milan. Works by Grazia Varisco are to be found in both Italian and foreign public galleries and museums, including the Galleria Nazionale di Arte Moderna in Rome and the Museum of Modern Art in New York.

Alberto Biasi
Born in 1937 in Padua where he lives and works.

He initially undertook classical studies at Padua and from 1957 until 1962, studying at the Istituto di Architettura, Venice and with the "Corso Superiore" of industrial design. More suitable for Biasi, however, was the study and knowledge of the Neo-plastic movement, of Futurism and dadaism. In 1959 he formed the Gruppo N and from 1961 he was active in the international new tendencies movement. Belonging to this period are his black and grey paintings as well as his "closed" exhibitions carried out contemporaneously with the first optical surveys. He participated in exhibitions of programmed art and, up until 1970, he experimented with kinetic images, constructed dynamic structures and photo-reflection and realised instable perception projects of environments. He later began research on spatiality with the series *Politipo*. From 1960 until 1967 he participated at twelve exhibitions of the Gruppo N. He later held 33 one-man exhibitions. He has been included in numerous group exhibitions including the Venice Biennale, the Biennial of Sao Paulo as well as the most well known graphic Biennials.

Gianni Colombo
Born in 1937 in Milan where he lives and works.

He began to exhibit works of painting, sculpture and ceramics in 1954. In 1958-1959 he realised his first monochrome reliefs in cotton wadding which he exhibited at the Galleria Azimuth in Milan. In 1959, he executed reliefs which could be altered by spectator participation, and he founded the Gruppo T with Anceschi, Boriani

and De Vecchi. In 1962 he participated in the organisation of the "Arte Programmata" exhibition and in 1963 in that of the international Nouvelle Tendence movement. In 1964, at the Palais du Louvre, he realised his first habitable environment using artificial light. In the same year he was awarded the Gold Medal for Design at the XIII Milan Triennale. 1965 — "Nul 65", Stedelijk Museum of Amsterdam and contacts with the Gruppo O, "Nova Tendencija 3", Zagabria: he realised the *Tre zone contigue* environment. 1967-1970 — topological alterations of geometric volumes and the first realisation of the *spazio elastico* environment at the "Trigon 67" exhibition in Graz. 1968 — First Prize at the XXXIV Venice Biennale. 1970 — With De Vecchi he carried out *Ingombri estetici* for the "Amore Mio" exhibition at Montepulciano. 1973 — He formed part of the selection committee for the X Rome Quadriennale. In collaboration with Pardi and Tadini he realised "Borgotondo". In 1980 he won the Premio Giolli and in 1981 the competition "Kunst am Bau", in Berlin.

Enzo Mari
Born in Novara in 1932. Lives and works in Milan.

Through his writings Enzo Mari shows the contradictions and compromises of the intellectual in capitalist society and proposes spaces for action within which the artist can work, by unmasking the ambiguities of the system, by questioning the very concept of planning and by proposing examples in which the project, although becoming a manufactured article, does not lose its eversive function... If the philosopher is a person who looks for reasons and the planner is a person who suggests how to do something then Enzo Mari can be defined as a philosopher planner. In not being a recognised profession, and thus one which does not create boundaries and divisions, he each time proves to be designer, artist, poet, researcher and alchemist. These different activities are the answers to a single question on the part of the philosopher: how, on an individual level and on a collective level, to overcome the growing alienation of doing and of thinking — which, in practice, is the function of the artist in contemporary society.

Poesia visiva and Nuova scrittura

Vincenzo Accame
Born in Loano in 1932. Lives and works in Milan.

He has collaborated with magazines such as *Il Verri, Malebolge, Marcatrè, Uomini e idea, Le Arti, Quaderni Tool, D'Ars*, etc. His writings have appeared in *Tre Rosso, Approches, Ex, Phantomas, Ovum 10, Tam Tam, Gala, Almanacco letterario Bompiani*, etc. He has translated

various poets including Eluard, Arp and Jarry. He has also written a monograph on Jarry. He began to be interested in poetic-visual research, as both operator and "commentator", at the beginning of the 1960's within the area of the Gruppo Tool with which he participated at a large number of international exhibitions. He has published numerous poetic volumes. Amongst the most important exhibitions at which he has participated within the specific area of visual painting are: "Nuove tecniche poetiche in Italia", Milan, 1967; "Italian Visual Poetry", New York, 1973; "Scrittura visuale in Italia 1912-1972", Turin, 1973; "Testuale", Milan, 1979 etc. Together with others he signed the manifesto of "Nuova scrittura".

Mirella Bentivoglio
Born in Klagenfurt (Austria) in 1922. Lives and works in Rome.

Active in the fields of art criticism, verse poetry, visual poetry, objectual poetry, artist's theatre, she has recently concerned herself with symbolic structures of alphabetic original urban contexts. She is the author of several volumes, including: (verse poetry) *Giardino*, Scheiwiller 1943; *Calendario*, Vallecchi 1968; *Jet P 68*, Edikon 1976; (art criticism) *H. Rousseau*, Scheiwiller 1943; *Ben Shahn*, De Luca 1968; *La Collezione Astaldi*, De Luca 1971; (visual poetry) *Monumento*, De Luca 1968; *Punto ambiguo*, Geiger 1973; ecc. She organized several group shows and wrote introductions for them: for the Italian Cultural Institute, Tokyo, 1976; Venice Biennale, 1978; Palazzo delle Esposizioni, Rome, 1978; Columbia University, New York, 1979; Art Biennial, Colombia, 1980; Biennial of Sao Paulo, Brazil, 1981; Italian Consulate, Perth, Australia, 1981.
Principal one-man exhibitions: Galleria Schwarz, Milan, 1971; Pictogramma, Rome, 1973; XII Biennial Sao Paulo, Brazil, 1973 (personal room); Klingspor Museum, Offenbach a. M., West Germany, 1974; Studio Santandrea, Milan, 1975; Casa Italiana, Rochester, 1978; Other Books and So, Amsterdam, 1978; Spazio Alternativo, Rome, 1978; Coop. Alzaia, Rome, 1979; Italian Cultural Institute, New York, 1980; Metronom, Barcelona, Spain, 1982.

Ugo Carrega
Born in Genoa in 1935. Lives and works in Milan.

One-man exhibitions: 1970 — Galleria Schwarz, Milan; Galerie Senatore, Stuttgart. 1971 — Galerie Reckermann, Cologne. 1972 — Galleria Blu, Milan. 1973 — Galleria La Bertesca, Genoa. 1974 — Mercato del Sale, Milan. 1978 — Studio Marconi, Milan. 1979 — Studio Santandrea, Milan. 1980 — Multimedia, Brescia.
Group exhibitions: 1965 — "La lettura del linguaggio visivo", Castello del Valentino, Turin.

1966 — "TOOL e la Scrittura Simbiotica", Galleria Rotta, Genoa. 1968 — "Ausstellung und Dokumentation Visueller Poesie", Vienna, Innsbruck. 1969 — "Expo International de novissima poesia", Buenos Aires; "TOOL ETC. 3", Brno. 1970 — "Vou Exhibition", Tokyo; "Konkrete Poesie", Stedelijk Museum, Amsterdam. 1973 — "Italian Visual Poetry", The Inch College Museum of Art, New York; "Contemporanea", Rome. 1974 — XXVIII National Art Biennial, Milan. 1979 — "Testuale", Milan. 1980 — "Il tempo del museo Venezia", Venice Biennale. He has published numerous books and articles.

Vincenzo Ferrari
Born in 1941. Lives and works in Milan.

One-man exhibitions: 1971 — Galleria La Bertesca, Genoa. 1972 — Galleria Modulo, Milan; Galleria Blu, Milan, 1973 — Galleria Centro TOOL, Milan. 1974, 1976, 1980, 1981 — Mercato del Sale, Milan. 1975 — Galleria Il Canale, Venice. 1978 — Galleria Solferino, Milan.
International exhibitions: 1972 — XXXVI Venice Biennale. 1973 — Milan Triennale. 1974 — Museum of Stockholm; "Prospettiva 74", Gallery of Modern Art, Sao Paulo. 1975 — Museum of Helsinki. 1976 — Documenta 6, Kassel. 1978 — "La Metafisica del Quotidiano", Galleria d'Arte Moderna, Bologna; "Formato libro", Palazzo Vecchio, Florence. 1979 — XVI Milan Triennale; with Alik Cavaliere at the Sala Comunale d'Arte Contemporanea, Alessandria. 1980 — Bibliothèque Nationale, Paris; "Cronografie", Venice Biennale and the Rotonda della Besana, Milan (1981); "Testuale", Rotonda della Besana, Milan. Ferrari has published numerous books and realised films and scenographies. He has also been involved in publishing and in the organisation of exhibitions. In 1972, with Carrega and Salocchi, he founded the "Centro di ricerca non finanziata".

Eugenio Miccini
Born in 1925 in Florence where he lives and works.

Journalist and scholar of semiotics and rhetoric of photography in 1962/63, together with Pignotti, he created "poesia visiva" and has contributed to its diffusion by way of numerous publications and organised events. He formed part of the Gruppo 63 and founded the Gruppo 70 (together with Chiari, Bussotti and others). He directed the Centro Téchne for the magazine of the same name and the underground *Quaderni*. He has held lectures in numerous Italian and foreign universities. In 1961 he won the "Città di Firenze" poetry award. He has written more than thirty books (poetry, visual poetry, monographs, essays, anthologies...). He has

taken part in all of the most important international exhibitions of "nuova scrittura" and "poesia sperimentale". He has realised three films and three tapes, some video-tapes and actions. His works are to be found in the museums of Parma, Mantua, Céret, Kyoto, Portofino, Melbourne and at the Venice Biennale.

Magdalo Mussio
Born in Florence in 1925. Lives and works in Pollenza di Macerata.

He has been involved in various forms of artistic activity. He has collaborated with numerous publishing houses and has been particularly concerned with the cinema and animated cartoons. He was an editor of the magazine *Marcatrè*, from 1963 until 1970, which was important in Italy for its openness towards the avant-garde and for its interest in interdisciplinary research.
Mussio had dedicated to the research of "Nuova Scrittura" and "Poesia visiva". He has written a large number of books, including *Il fastidio delle parole*, 1960; *In pratica*, 1968; *Il corpo certo o il luogo di una perdita*, 1974. He has exhibited in numerous one-man exhibitions in Florence, Genoa, Milan, Paris, Montreal, New York and Tokyo and in the most important exhibitions of new writing.

Anna Oberto
Born in Ajaccio (Corsica) in 1934. Lives and works in Genoa and Varigotti.

She participated in the founding and editing in Genoa, from 1958, of the magazine of interlinguistic research *Ana eccetera*. Since 1963 she has participated at the most significant Italian and foreign exhibitions of visual writing. Since 1969 she has been committed to the feminist movement, with visual works and manifestos, presenting the first international survey of female visual operators with a theoretical and ideological text on the theme of the creativity and freedom of the woman. In 1975 she exhibited the diary *Scrittura al femminile* at the Mercato del Sale gallery in Milan and has formed part of the "Nuova scrittura" group of the same gallery. In 1978 she exhibited at the Venice Biennale. In 1979 she published *Segnificare la scrittura* in the "Lessico politico delle donne", Ed. Gulliver, Milan. In 1980 she organised the exhibition "Scrittura Visuale a Genova" at the Teatro del Falcone and the installation-performance "Scrittura d'amore" at Palazzo Bianco, both for the cultural department of the Genoa City Council. In 1981 the third RAI television channel of the Marche presented a documentary about her entitled *La parola delle donne*.

Martino Oberto (OM)
Born in 1925 in Genoa where he lives and works.

Around the 1950's he remained at Genoa Pegli, in the cultural suburbs, where he began research on aesthetics, philosophy and political economy at the University, and then at the linguistic Accademia. He founded *Ana eccetera* in 1958. He filmed *Cogito ergo zoom* in 1967 and *Prima dell'anarchia* in 1968. He also participated in international artist-organized exhibitions of visual writing; he inaugurated the Mercato del Sale, in 1974, with his first one-man exhibition. He formed part of the Nuova scrittura group, then of the Unione Culturale. On his own he published *Aefutura*, producing the first Anaphilosophia book-work in 1977. He is an expert analyst of works of art and is active concerning anacultural positions.

Lamberto Pignotti
Born in Florence in 1926. Lives and works in Rome.

His first artistic experiences which simultaneously used verbal and visual codes date back to 1945. His first book, *Odissea*, which was cyclostyled, was produced in 1954. He has published various books of poetry, essays, anthologies of experimental art and visual poetry for Mondadori, Lerici, Einaudi, Marsilio etc. He took part in the Gruppo 63 and the Gruppo 70. He has taught at the Faculty of Architecture at the University of Florence and teaches at the Faculty of Literature and Philosophy at the University of Bologna. He is a contributor to the daily papers *Paese Sera* and *L'Unità*, to numerous reviews and magazines and to the cultural programmes of the Italian National Television (RAI). Since the beginning of the 1960's he has participated at national and international avant-garde group exhibitions, including the Venice Biennale of 1968, 1972 and 1978. He has held various one-man exhibitions in both public and private exhibition spaces, including the Galleria Civica in Modena, the Galleria d'Arte Moderna in Mantua, the Literature Museum in Warsaw, Il Mercato del Sale in Milan and the Studio Santandrea, also in Milan. On a continuous basis, from the beginning of the 1960's, he has worked in the field of art-entertainment, both as an actor and reader as well as with audio-visuals.

Oggetto popolare, Immagine

Valerio Adami
Born in Bologna in 1935. Lives and works in Paris.

One-man exhibitions: 1959 — Galleria del Naviglio, Milan. 1961 — Galleria L'Attico, Rome, 1962 — Institute of Contemporary Art, London. 1965 — Galerie Ad Libitum, Antwerp; Galleria Schwarz, Milan. 1967 — "Pictures with Connection", Galleria Schwarz and Studio Marconi, Milan. 1968 — Galerie With-ofs, Brussels; Museo de Bellas Artes, Caracas. 1969 — Galleria Schwarz and Studio Marconi, Milan. 1970 — Hansen Gallery, San Francisco; A.R.C. Musée d'Art Moderne de la Ville de Paris; Kunstverein, Ulm; 1970, 1973, 1975, 1976, 1980 — Galerie Maeght, Paris. 1971, 1976, 1980 — Studio Marconi, Milan. 1972, 1976, 1981 — Galerie Maeght, Zurich. 1972 — Galerie Schmela, Düsseldorf; Galerie Lowenadler, Stockholm. 1973 — Kunstverein, Hamburg. 1976 — Kunst Kabinet, Frankfort; Galerie Micha, Brussels; Design Center, Lugano; Galerie Maeght, Barcelona. 1977 — Musée Cantini, Marseilles; N.G. Gallery, Antwerp. 1978 — Centro La Serra, Ivrea; Kulturhuset, Hellerup; Palais des Beaux Arts, Charleroi. 1979 — Museo de Bellas Artes, Mexico D.F.; Israel Museum, Israel. 1982 — Lens Fine Arts, Antwerp.

Enrico Baj
Born in Milan in 1924. Lives and works in Vergiate.

In 1951, with Sergio Dangelo, he was the promoter of the "Movimento nucleare". His first one-man exhibition was held in Milan at the Galleria San Fedele in 1951. In 1953 he met Asger Jorn with whom he organized the "Mouvement pour un Bauhaus Imaginiste". Asger Jorn wrote the catalogue introductions for his one-man exhibitions at the Galleria Asterisco in Rome, in 1954, and at the Galerie Kunstkredsen in Copenhagen in 1956. In 1957, with other artists, Bay published the "Contro lo Stile" manifesto.
At that time Baj held his first one-man exhibitions abroad, in 1957-1959 at the Gallery One in London and in 1958 at the Galerie Cordier in Paris. He also participated in exhibitions of the Surrealist Movement in New York and Paris. In 1961 he was invited to show at the exhibition "The Art of Assemblage" at the Museum of Modern Art in New York and in 1963, once again in New York, he had a one-man exhibition at the Cordier and Ekstrom Gallery.
He entered the College de Pataphisique de France and founded the Institutum Pataphisicum Mediolanense. In 1964 he had his own room at the Venice Biennale and at the Milan Triennale. The following years saw numerous retrospective exhibitions dedicated to him including those of 1971, at Palazzo Grassi in Venice and at the Museum of Contemporary Art in Chicago, Palazzo Reale in Milan in 1974 and at the Indianapolis Museum of Art in 1978. At the Studio Marconi in Milan in 1979 he exhibited the large work *Apocalisse* with a monograph by Umberto Eco, ed. Mazzotta.
Baj has always combined his artistic work with writings of a varied nature and has published numerous articles and books.

Alik Cavaliere
Born in Rome in 1926. Lives and works in Milan.

After completing an art course at the Accademia di Brera he continued classical studies at the Faculty of Arts of the University of Milan. For many years he worked in a studio situated in the very centre of the city — in bad repair and which has since been demolished — in a space which was almost a labyrinth between doors, windows and skylights, incorporating an abandoned shop. Later he worked for twenty years in a sort of oasis (even in an industrial city like Milan) with his studio surrounded by a garden, cultivated flowers and trees and breeding animals. Today, with "culture" advancing the studio has been demolished and a new and different experience began concerning the organisation of his work.
Since May 1945, the date of his first exhibition, he has taken part in artistic events in many countries. These include the Venice Biennale with his own room in 1964 and 1972; retrospective exhibitions at the Gemeentemuseum, The Hague and at the Museo de Bellas Artes in Caracas, etc.

Mario Ceroli
Born in Castelfrentano in 1938. Lives and works in Rome.

He started his artistic activity in 1954, combining his work as a sculptor with that of theatrical designer, producing, for example, the sets for *Riccardo III*, for *Orgia* by Pasolini and for the *Candelario* by Giordano Bruno at the Theatre Festival of the Venice Biennale. His interest is directed towards the objective world and to man reduced to a type, a series. He held his first one-man exhibition in 1958 at the Galleria San Sebastiano where he exhibited ceramic sculptures; then he exhibited wooden sculptures in 1964 and 1965 at the Galleria La Tartaruga in Rome, in 1967 at the Bonino Gallery in New York and in 1968 at the Galerie Schmela in Düsseldorf. He has held numerous one-man exhibitions in the most important Italian and foreign galleries and has participated at the most important artistic events in Italy and abroad, including the V Paris Biennial, the Venice Biennale of 1966 (winning the Premio Giollini) and in 1982. The following should be consulted for more detailed information: G. Dorfles, *Galleria del Naviglio*, catalogue, Milan 1966; M, Calvesi, "I legni di Ceroli", in *Le due avanguardie*, Laterza, Bari 1971; *Premio Bolaffi 1972*, monograph.

Lucio Del Pezzo
Born in Naples in 1933. Lives and works in Milan.

One-man exhibitions: 1960-1963 — Galleria Schwarz, Milan. 1965 — Schloss Morsbroich Museum, Leverkusen; Kroller-Müller Museum,

tterlo. 1966 — Studio Marconi, Milan; XXXIII enice Biennale. 1967 — Studio Marconi, Milan; alerie D'Aujourd'hui, Palais des Beaux Arts, russels. 1968 — Galerie Blumenthal-Iommanton, Paris. 1969 — Studio Marconi, Iilan. 1970 — Galerie Brusberg, Hannover; alerie Foncke, Gand; Palais des Beaux Arts, russels; University of Parma. 1971 — Studio Iarconi, Milan; Galleria Marlborough, Rome; .R.C. Musée d'Art Moderne de la Ville de Paris, 'aris. 1972 — Galerie Ostermalm, Stockholm. 973 — Galerie Lucien Durand, Paris; Galerie isat, Paris. 1974 — Rotonda Besana, Milan. 974 — Galerie Paul Facchetti, Paris; Galleria Il 'entro, Naples; Galerie Ostermalm, Stockholm. 976 — Galleria Il Tritone, Biella; Galleria Ronanini, Rome. 1977 — Galleria Marin, Turin. 978 — Studio Marconi, Milan. 1979 — Galleria .izzardi, Milan; EXPO Levante, Bari; FIAC, 'aris; Galleria Il Disegno, Rome. 1981 — Studio Iarconi, Milan. 1982 — XL Venice Biennale.

Fiosetta Fioroni
Born in Rome in 1932. Lives and works in Rome.

n 1956 she exhibited at the Venice Biennale and 1 1958 she held her first one-man exhibition at ne Galleria Montenapoleone in Milan. In the ame year she moved to Paris where she exibited in various Salons des Réalités Nouvelles, t the Galerie Paul Facchetti and in Germany at he Modern Art Museum in Leverkusen. In 1961 1 Italy she exhibited at the Galleria La Tararuga and at La Salita in Rome. Since then she as held numerous one-man exhibitions and paricipated at a large number of group exhibitions 1 Italy and abroad, including the Venice Bienale of 1964; "Vitalità del Negativo" in 1970, in .ome, with her own room; the Rome Quadrienale of 1973; at the A.R.C. Musée d'Art Moderne e la Ville de Paris; "Testuale" at the Rotonda ella Besana in Milan; "Künstlerinnen Interna-ional" in Berlin; "Linee della Ricerca Artistica 1 Italia 1960-1980" in Rome; "Ars Cominatoria" at the Galleria Civica in Bologna; Generazioni a Confronto" at the University of .ome. She has been the subject of large etrospective exhibitions: 1972 — at the Palazzo ei Diamanti in Ferrara; 1978 — at the Galleria 'omunale in Alessandria; 1979 — at the Casa del Iantegna in Mantua and at the Galleria Civica 'Arte Moderna in Suzzara.

Igo Nespolo
Born in Vercelli in 1941. Lives and works in 'urin.

Dne-man exhibitions: 1966 — Il Girasole, Rome. 966, 1968 — Il Punto, Turin. 1968 — Galleria chwarz, Milan. 1971 — La Nuova Loggia, ologna. 1972, 1974, 1975, 1980 — Galleria Blu, 1ilan. 1972 — Galerie Le Chat Bernard,

Chicago. 1973, 1975 — La Nuova Città, Brescia; Galleria Christian Stein, Turin; Studio G7, Bologna. 1974, 1975 — Studio Corsini, Intra. 1974 — Camden Arts Center, London. 1975 — Galleria Etrusculudens, Rome; Galleria Ricerche, Turin; he won the Bolaffi award. 1976 — Galleria La Bussola, Turin; Galleria Plura, Milan. 1976, 1977 — Museo Progressivo d'Arte Contemporanea, Livorno. 1976 — Galleria Palazzo Galvani, Bologna. 1977 — Galleria Cavour, Milan. 1979 — Studio Marconi, Milan; Castello di Torre Canavese (Turin). 1980 — Stufidre, Turin. 1981 — Arras Gallery, New York; Galleria Civica d'Arte Moderna, Ferrara (retrospective exhibition).

Group exhibitions: 1971 — Akademie der Künste, Berlin and Cologne. 1974 — "Fotomedia", Museum am Ostwall, Dortmund. 1975 — Rotonda Besana, Milan; Cayc, Buenos Aires. 1976 — International Cultural Centrum, Antwerp; Venice Biennale, 1977 — Mirò Foundation, Barcelona; "Arte e Cinema", Centro Internazionale di Brera, Milan. 1978 — Venice Biennale; "Cinéma d'Artiste", Centre George Pompidou, Paris.

Pino Pascali
Born in Bari in 1935. Died in Rome in 1967.

Besides being a painter and sculptor Pascali also worked in the field of advertising graphics and theatre design. This interest in theatre design is to be found in all of his works directed towards a total involvement of nature and space, using artificial materials united to primordial elements like water and earth. In 1965 at the Galleria La Tartaruga in Rome he held his first one-man exhibition, exhibiting the *Ruderi romani* and the series of *Armi*. From 1966 nature becomes the central theme of all of his works, of which *Il mare* forms a part. Pascali's work is characterized by an interest in the Neo-dadaist experience, by a position of irony detached from reality and by experimentation of new materials and new techniques such as stretching the canvas over hoops of wood, steel blades, plastic and acrylic pastes.

Pascali participated at numerous exhibitions including the Biennial of Sao Paolo of Brazil and the Biennial of San Marino. In 1968 and 1972 he was given his own room at the Venice Biennale.

Concetto Pozzati
Born in Vò di Padova in 1935. Lives and works in Bologna.

Besides other things he is interested in architecture and advertising graphics. In 1960 in Bologna, with Sepo, he founded the Scuola d'arte pubblicitaria dedicated to his father, Mario Pozzati. In 1962 and 1964 he produced some theatre sets for civic theatres. Since 1955 he has participated in all of the main national and interna-

tional artistic events. He has exhibited in the Rome Quadriennale, at the Venice Biennale of 1964, 1972 and 1982, at the Biennial of Sao Paolo and the Tokyo Biennial, both in 1963, at the Paris Biennial in 1969 and at Documenta in Kassel in 1964. In 1968 the Pinacoteca and the University of Parma held a retrospective exhibition, "Pozzati 1958-1968", at the Palazzo della Pilotta in Parma. In 1974 the Centro Internazionale delle Arti e del Costume invited him to hold a large retrospective exhibition at Palazzo Grassi in Venice. In 1976 he held a retrospective exhibition at Palazzo delle Esposizioni in Rome and he inaugurated the Padiglione d'Arte Contemporanea of the Commune of Ferrara. In 1980 he had a retrospective exhibition at the Galleria Civica d'Arte Moderna di Suzzara in Mantua.

Bepi Romagnoni
Born in Milan in 1930. Died in Villasimius in 1964.

One-man exhibitions: 1955 — Galleria Schettini, Milan. 1956 — Galleria S. Fedele, Milan; Galleria Alibert, Rome; Galleria del Cavallino, Venice. 1957 — Galleria Bergamini, Milan; Galleria La Bussola, Turin. 1959 — Galleria Bergamini, Milan. 1960 — Salone Annunciata, Milan. 1961, 1962 — Galleria Bergamini, Milan. 1963 — Galleria Il Punto, Turin; Galleria Il Leone, Venice. 1964 — Galleria La Polena, Genoa; Premio Città di Lucca: Exhibition in Homage of Bepi Romagnoni. 1965 — Retrospective exhibition at the Galleria Bergamini, Milan; Premio Scipione, Macerata: Homage to Bepi Romagnoni; "Alternative Attuali 2": Exhibition in Homage to Bepi Romagnoni, L'Aquila; Galleria S. Fedele, Milan. 1966 — Studio Marconi, Milan; Galleria del Minotauro, Brescia. 1968 — Galleria Solarina, Milan; Galleria Ferrari, Verona. 1971 — Galleria dei Lanzi, Milan; Galleria Fante di Spade, Rome; "Le Incisioni 1954-1955", presentation by Mario De Micheli, Galleria dell'Orso, Milan. 1972 — Studio 3Bi, Bolzano.

Mimmo Rotella
Born in Catanzaro in 1918. Lives and works in Paris and Milan.

In 1954-1955 he exhibited publicly for the first time in Rome the lacerated poster as a work of art. In 1961 Pierre Restany invited him to join the group of the Nouveaux Realistes. In 1963 he realised the first Mec-Art works, a term which he defined in 1955. He has held numerous one-man exhibitions in Italy and abroad, including 1952 — Rockill Nelson Gallery, Kansas City. 1955, 1957, 1966, 1969 — Galleria del Naviglio, Milan. 1957 — I.C.A., London. 1959, 1961 — Galleria La Salita, Rome. 1962 — Galérie "J", Paris; Seven Arts Gallery, London; Galleria Bonino, Buenos Aires. 1963 — Galleria Apollinaire, Milan. 1964

— Venice Biennale. 1971 — Galerie Mathias Fels, Paris. 1974 — Galleria Ariete Grafica, Milan. 1975 — Rotonda della Besana, Milan. 1978 — Galleria Civica, Portofino; Padiglione d'Arte Contemporanea, Ferrara. 1981 — Studio Marconi, Milan; Galerie Denise Renée, Paris.

He has been invited to participate in numerous international exhibitions, including: 1949 — Salon des Réalités Nouvelles, Paris. 1958 — Whitney Museum, New York. 1961 — Festival de Nouveau Réalisme, Nice. 1961 — Museum of Modern Art, New York. 1963 — Tokyo Biennial. 1963 — Biennial of Sao Paolo. 1964 — Museum of Modern Art in Vienna and Berlin. 1964 — Palais des Beaux Arts in Brussels. 1968 — Jewish Museum, New York. 1970 — "Festival del Nuovo Realismo", Milan. 1981 — Palazzo delle Esposizioni, Rome.

Mario Schifano
Born in Homs (Libya) in 1934. Lives and works in Rome.

One-man exhibitions: 1959 — Galleria Appia Antica, Rome. 1961, 1967 — Galleria La Tartaruga, Rome. 1963, 1964 — Galleria dell'Ariete, Milan. 1963 — Galerie Sonnabend, Paris. 1963, 1964, 1965 — Galleria Odyssia, Rome. 1964, 1966, 1973 — Galleria Il Punto, Turin. 1965, 1967 1968, 1970, 1974 — Studio Marconi, Milan. 1966 — Galleria Il Canale, Venice. 1967 — Galleria Christian Stein, Turin. 1969, 1974 — Galleria La Chiocciola, Padua. 1970 — Galleria La Città, Verona. 1972 — Galleria L'uomo e l'arte, Milan; Galleria Soligo, Rome. 1973 — Galleria Il Gabbiano, Rome; Galleria La Steccata, Parma. 1974 — Galleria Lia Rumma, Naples; Istituto di Storia dell'Arte of the University of Parma. 1975 — Galleria Il Centro, Naples. 1977 — Galleria Pinuccia Pero, Milan.

He has participated in numerous group exhibitions in Italy and abroad including several of the Venice Biennales.

Emilio Tadini
Born in 1927 in Milan where he lives and works.

One-man exhibitions: 1961 — Galleria del Cavallino, Venice. 1967, 1970, 1971, 1974, 1978 — Studio Marconi, Milan. 1968, 1970, 1972 — Galerie Foncke, Gand. 1972 — A.H. Gallery, Stockholm. 1974 — Studio Actuals, Caracas. 1975 — Galerie Rencontres, Paris; Istituto di Storia dell'Arte, University of Parma; Studio G7, Bologna; Galerie Micha, Brussels. 1976 — Galleria Rondanini, Rome. 1977 — Museo Civico of Alessandria. 1977, 1982 — Galleria Civica di Suzzara. 1978 — Galerie C, Paris. 1979 — Centro Culturale Olivetti, Ivrea. 1980 — Galerie Pieter V Coecke, Alst, Belgium; Galerie Atmosphère, Brussels.
Group exhibitions: 1967 — "Art Contemporain

de l'Italie", The Hague. 1968 — Salon de Mai, Paris. 1969 — "Aspekte aus Italien", Vienna. 1970 — "Neue Italienische Kunst", Rolandseck. 1971 — "20 Artisti Italiani", Museum of Modern Art, Mexico City. 1974 — "La Ripetizione Differente", Studio Marconi, Milan. 1977 — Galleria d'Arte Moderna, Turin. 1978 — Venice Biennale. 1979 — "Testuale", Rotonda della Besana, Milan. 1981 — "Linee della Ricerca Artistica in Italia 1960-1980", Palazzo delle Esposizioni, Rome. 1982 — "L'Opera Dipinta", La Pilotta, Parma and at the Rotonda della Besana, Milan; Venice Biennale.

Astrazione lirica and Nuova astrazione

Gastone Novelli
Born in Vienna in 1925. Died in Milan in 1968.

He began his artistic career with works of an abstract geometrical type, partly under the influence of Max Bill. After his trip to Brazil in 1948-1949 his interests were directed towards research of a lyrical-poetic-visual type. This characteristic of his work was later to be reinforced by his meetings, which took place in Paris in 1957, with the historic leaders of Dadaism. His works present themselves as an emotional yet erudite writing, the sign obeys the internal rhythms capable of reconstructing a new alphabet, a kind of stammering alphabet where the letters, the fragments, form a new universe. He has participated in numerous Italian and international exhibitions including many of the Biennals of Sao Paolo; in 1958 at the exhibition "Pittori Italiani d'Oggi" in Tokyo; in 1961 at the Pittsburg International, as well as several of the Venice Biennales. In 1976 the Marlborough Gallery, in Rome organized a large commemorative exhibition of his work. For more detailed information see N. Ponente & Z. Birolli, *Gastone Novelli*, Milan, 1976.

Tancredi
Born in Feltre in 1927. Died in Rome in 1964.

His artistic experience was gained within the environment of the young Venetian painters of the 1950's, especially Emilio Vedova. Through Peggy Guggenheim he came into contact with American abstract expressionism. By means of his works he attempted a response to the Americans, realising works marked by the aesthetics — as he himself defined it — of the "spatial infinite", where fragments of sign and colour create a mental tension which organises itself in a logic within the painting. His work underwent numerous metamorphoses. From the painting of sign-gesture — after 1960 — he produced collages in which the drama of the individual finds its transcription lacerated in the same image of alienation. *Tam Tam per Brigitte*

Bardot is one example. He participated i numerous national and international exhibition His works are to be found in public collection such as the Museum of Modern Art in New Yor For more detailed information see the catalogu of the retrospective exhibition held at the Roto da della Besana in Milan in 1973.

Piero Dorazio
Born in Rome in 1927. Lives and works in To

Studied painting and architecture after classical training. During the war worked as voluntary interpreter for the British Arm RASC and Red Cross. In 1947 he promoted, wit the group "Forma 1", a manifesto against Italia provincialism and social realism.
He lived in Paris and New York as well as Rom in the 1950's, where he became acquainted wit the leading artists of the International abstra tionist school. He published the first book o "modern art" in postwar Italy in 1955. His on man exhibition in 1960 at the Venice Biennal was the first crucial reaction to "informale, info mal style, textures and signs before form" an opened the way to what became known later a "optical painting". Yet his paintings do no belong to the "optical geometrical" style. He wa Chairman and Professor of Art at the School c Fine Arts, University of Pennsylvania fror 1960-1969. He is a leading figure in Europea abstract painting and has had many one-man e hibitions in Venice, Berlin, London, New Yor Düsseldorf, Paris, Rome, etc. Represented by th André Emmerich Gallery, New York; Galleri Lorenzelli, Milano; Erker Galerie, St. Galler Switzerland; Galerie Springer, Berlin.

Rodolfo Aricò
Born in 1930 in Milan where he lives and works

From 1950-1955 he attended the Faculty of A chitecture, Politecnico of Milan. In 1962 he wa invited to show in "Nuove Prospettive della Pit tura Italiana" at the Palazzo di Re Enzo i Bologna where he exhibited a large painting divided by two vertical bands; in 1964 he was in vited to show in the XXXII Venice Biennal where he exhibited a work formed by three larg canvases in which the rhythmical division an nounced his temporal research. In 1967 he hel an exhibition at the Galleria Attico in Rome organized by Giulio Carlo Argan. In 1968 he ha his own room at the XXXIV Venice Biennal where he revealed the structural character of hi research. In 1970 contemporaneously, at the Salone Annunciata and at the Studio Marconi, i Milan, he held an exhibition where he presente works realised by painting with minute drops o colour which offer a monochromatic final result He developed his humanistic theme with work entitled *Arco, A Paolo Uccello, Quattrocento*. He

egan studies on ambiguous perspective. 1974 — etrospective exhibition at Palazzo Grassi in ʻenice. 1977 — retrospective exhibition at the ʻalazzo dei Diamanti in Ferrara. 1980 — ʻetrospective exhibition at the Casa del ʻlantegna in Mantua. 1982 — invited to show at ʻle Milan Triennale and the Venice Biennale.

arlo Battaglia
ʻorn in La Maddalena in 1933. Lives and works ʻ New York and Rome.

ʻne-man exhibitions: in Rome, 1964 — Galleria ʻa Salita. 1968 — Arco d'Alibert. 1968, 1969, ʻ972 — Galleria Editalia. 1973 — Galleria Godel. ʻ974 — Galleria La Bertesca. 1978, 1980 — ʻalleria E Tre; in Milan, 1966, 1968, 1970, 1971, ʻ974, 1976 — Salone Annunciata. 1974, 1977 — ʻtudio Ennesse. 1980 — Studio Grossetti. In ʻ970 and 1980 he had his own room at the Venice ʻiennale and in 1974 he had a retrospective ex-ʻbition at the Palazzo Grassi, Venice.
ʻetrospective exhibitions: 1976 — Palazzo dei ʻiamanti, in Ferrara. 1978 — Kunsthalle, ʻüsseldorf. 1980 — Galleria Civica, Alessandria; ʻergio Tosi Gallery, New York; Ann Jacob ʻallery, Atlanta. 1976, 1977 — Galerie Arnesen, ʻopenhagen. 1975 — Galerie Templon, Paris.
ʻlain group exhibitions: 1965 — Lund Museum, ʻweden. 1972 — Art Institute, Chicago. 1973 — ʻome Quadriennale. 1974 — Milan Biennale. ʻ977 — Galleria Civica, Turin. 1978 — Venice ʻiennale. 1980 — "Arte e Critica 1980", Galleria ʻlazionale d'Arte Moderna, Rome.

ʻicola Carrino
ʻorn in Taranto in 1932. Lives and works in ʻlome.

ʻrom 1962 until 1976 he formed part of the ʻlome Gruppo 1 and carried out plastic-ʻonstructive research. From 1969 he realised ʻostruttivi trasformabili, modular organisms in ʻon or steel and has carried out *Interventi di ʻrasformazione* in galleries and urban spaces, ʻroposing a projectural sculpture, transformable ʻl time, of an environmental and participatory ʻrder. From 1978 he realised environments like ʻrasformazione dello Spazio* and events like ʻuogo-Scultura. He participated at the Venice ʻiennale in 1966, 1970, 1976; at the Paris Bien-ʻial in 1967; at the Biennial of Sao Paolo in 1971, ʻ979.
ʻne-man exhibitions: 1970, 1975, 1978 — Salone ʻlnnunciata, Milan. 1976 — Galleria ʻlarlborough, Rome; Bochum. 1977 — Denise ʻlené Hans Mayer, Düsseldorf. 1978 — Denise ʻlené, New York. 1981 — Studio Grossetti, ʻlilan. In 1971 he received the International ʻrize at the XI Biennial of Sao Paolo. His works ʻre to be found at the Galleria Nazionale d'Arte ʻloderna in Rome, at the Museum of the Ruhr

Universität in Bochum and at the Museum Boymans-Van Reuningen in Rotterdam.

Marco Gastini
Born in 1938 in Turin where he lives and works.

One-man exhibitions: 1968 — Galleria Il Punto, Turin. 1969, 1971, 1972, 1975 — Salone Annunciata, Milan. 1971 — Galerie Wspolczesna, Warschau. 1971, 1973 — Galerie Arges, Brussels. 1972 — Les Halles, Bruges. 1973, 1976 — Galleria Primo Piano, Rome. 1973, 1976, 1980 — Galerie Annemarie Verna, Zurich. 1974 — Banco, Brescia; Galerie M, Bochum; Galerie Swart, Amsterdam. 1974, 1977 — Galerie Müller-Roth, Stuttgart. 1975 — Cirrus Gallery, Los Angeles; Galleria Peccolo, Livorno. 1976 — Galleria Sperone, Rome; Venice Biennale. 1976, 1979 — Gallery Baronian, Brussels. 1977 — Galleria Christian Stein, Turin; Galleria Forma, Genoa; Galleria E Tre, Rome. 1977, 1979, 1982 — John Weber Gallery, New York. 1978 — Galerie Walter Storms, Munich; Studio Grosset-ti, Milan. 1979, 1982 — Studio G7, Bologna. 1980 — Centre d'Art Contemporain, Geneva. 1981 — Galleria Martano, Turin; Galleria Apper Fertsch, Frankfurt; Salone Villa Romana, Florence. 1982 — Galleria d'Arte Moderna, Bologna; Städtische Galerie im Lenbachhaus, Munich.
Group exhibitions: 1974 — "Contemporanea-area Aperta", Rome; "Italia 1950-1970", Kunstmesse, Basel. 1975 — "Tendencies of Con-temporary Art", Aalborg, Copenhagen, Odensee. 1977 — "1960-1977: Arte in Italia", Galleria Civica, Turin. 1979 — "Pittura-Ambiente", Palazzo Reale, Milan; Sistina Società per Arte, Bologna. 1981 — "Linee della Ricerca Artistica in Italia 1960-1980", Rome. 1982 — "Registrazione di Frequenze", Galleria Civica d'Arte Moderna, Bologna; "11 Italienische Künstler in München", Munich; Venice Biennale.

Giorgio Griffa
Born in 1936 in Turin where he lives and works.

One-man exhibitions: 1968 — Galleria Martano, Turin. 1969 — Galleria Sperone, Turin. 1970 — Sonnabend Gallery, New York and Paris. 1971 — Galerie Ricke, Cologne; Galleria Toselli, Milan. 1972 — Galleria Sperone, Turin. 1973 — Galerie Verna, Zurich; Galerie Templon, Paris. 1974 — Mikro Gallery, Berlin; Galleria Lia Rumma, Naples; Galleria Templon, Milan and Paris. 1975 — Galleria Sperone, Rome; Galerie Verna, Zurich; Kunstraum, Munich. 1976 — Banco, Brescia; Art in Progress, Munich and Düsseldorf. 1977 — Samangallery, Genoa; Marlborough, Rome. 1978 — Galleria Verna, Zurich; Galleria Lorenzelli, Milan; Kunsthalle, Düsseldorf. 1980 — Galleria Martano, Turin; Samangallery, Genoa. 1981 — Galleria Lorenzelli, Milan; Studio G7, Bologna; Taide, Salerno; Galerie Verna,

Zurich; Galerie Walter Storms, Munich.
Group exhibitions: 1969, 1973 — "Prospect", Düsseldorf. 1970 — "Processi di Pensiero Visualizzati", Lucerne. 1973 — "Une Exposition de Peinture...", Paris, Mönchengladbad, Ant-werp; "Contemporanea", Rome. 1978, 1980 — Venice Biennale.

Vittorio Matino
Born in Tirana (Albania) in 1943. Lives and works in Milan.

One-man exhibitions: 1967 — Galleria Adelphi, Padua. 1969, 1970, 1972, 1974 — Galleria Tino Ghelfi, Vicenza. 1971, 1972, 1974 — Galleria Morone 6, Milan. 1972 — Galleria del Cavallino, Venice. 1974 — Galleria Civica, Valdagno. 1975 — Galleria La Piramide, Florence; Galleria Il Milione, Milan. 1976, 1978, 1980, 1982 — Galleria Lorenzelli, Milan. 1977 — Museo Civico Palazzo Chiericati, Vicenza. 1978 — Galerie Schröer, Krefeld; Galerie Suzanne Bollag, Zurich; Galleria Annunciata, Milan. 1979 — Galleria Il Centro, Naples. 1980 — Galleria Wurz, Milan. 1981 — Museo Civico di Castelvecchio, Verona. 1982 — Ghelfi Palazzo Bonin, Vicenza.
Group exhibitions: 1967 — Premio San Fedele. 1971, 1972 — XXV Salon des Realistes Nouvelles, Paris. 1973 — XXVIII Milan Bien-nale. 1975 — X Rome Quadriennale; VII Festival International de la Peinture, Cagne-sur-mer. 1976 — XI Menton International Art Biennial; "Dieci Anni in Italia 1956-1966", Studio Mar-coni, Milan. 1977 — "La Contraddizione del Segno", Sala Civica, Turin. 1981 — "Linee della Ricerca Artistica in Italia 1960-1980", Palazzo delle Esposizioni, Rome; "Artisti Italiani in Danimarca". 1982 — "Proposta", Padiglione d'Arte Contemporanea, Ferrara; "Registrazione di Frequenze", Galleria Civica d'Arte Moderna, Bologna.

Claudio Olivieri
Born in Rome in 1934. Lives and works in Milan.

One-man exhibitions: 1960, 1965 — Salone An-nunciata, Milan. 1961 — Galleria George Lester, Rome. 1969, 1971, 1975 — Galleria del Milione, Milan. 1970 — Galleria La Nuova Loggia, Bologna; Galleria I Quattro Venti, Palermo. 1971 — Galleria Contini, Rome. 1974 — Westfälischer Kunstverein, Münster. 1974, 1980 — Galleria La Piramide, Florence. 1976 — Galleria Peccolo, Livorno. 1977, 1981 — Galleria Banco, Brescia. 1977 — Galleria Capricorno, Venice. 1978 — Galerie Stivenson Palluel, Paris; Galleria Forma, Genoa. 1979 — Galleria Lorenzelli, Milan. 1980 — Venice Biennale; Galleria Il Sole, Bolzano.
Group exhibitions: 1970, 1971 — "L'Immagine Attiva", Rotonda della Besana, Milan. 1972 — Rome Quadriennale. 1975 — "La Nouvelle Pein-ture Italienne", Galerie Espace 5, Montreal;

Galerie Templon, Paris. 1977 — Documenta, Kassel. 1979 — "Pittura-Ambiente", Palazzo Reale, Milan. 1981 — "Linee della Ricerca Artistica in Italia 1960-1980", Palazzo delle Esposizioni, Rome; "Il Segno Sensibile", Villa Manzoni, Lecco; Museo di Castelvecchio, Verona. 1982 — "Registrazione di Frequenze", Galleria Civica d'Arte Moderna, Bologna.

Gianfranco Pardi
Born in 1933 in Milan where he lives and works.
One-man exhibitions: 1959 — Galleria Alberti, Brescia. 1969 — Galleria La Colonna, Milan. 1967, 1970, 1971, 1972, 1974, 1976, 1978, 1981 — Studio Marconi, Milan; Galleria Il Canale, Venice. 1968, 1973 — Galleria La Chiocciola, Padua. 1969, 1972 — Galerie Foncke, Gand. 1970 — Salone Annunciata, Milan. 1975 — Galerie Rencontres, Paris; Studio G7, Bologna. 1976 — Centro Design, Lugano; Galleria La Piramide, Florence. 1977 — Galleria Bassi e Pero, Milan. 1979 — Galleria Martano, Turin. 1979, 1982 — Galleria Plurima, Turin.
Group exhibitions: 1965 — "La Figuration Narrative dans l'Art Contemporain", Paris. 1968 — Salon de la jeune peinture, Paris; "The Power of Fine Arts", Sydney; "Aspekte aus Italien", Innsbruck. 1970 — "Neue Italienische Kunst", Rolandseck; "Internationale Kunstmesse", Basel. 1971 — "20 Artisti Italiani", Museum of Modern Art, Mexico City. 1972 — Palazzo Reale, Milan. 1975 — "Spazio Attivo/Struttura", Studio Marconi, Milan and the Galleria Rondanini, Rome. 1977 — Galleria d'Arte Moderna, Turin. 1978 — "Metafisica del Quotidiano", Bologna. 1979 — Sistina Società per l'Arte, Bologna. 1980 — Biennial of Menton. 1981 — "10 Scultori Contemporanei", Athens; "Linee della Ricerca Artistica in Italia 1960-1980", Rome; Milan Triennale.

Giuseppe Uncini
Born in Fabriano in 1929. Lives and teaches in Rome.

He has always worked on art objects, starting to exhibit his own work more than thirty years ago. He has assiduously participated in the most important Italian and international exhibitions. His artistic speculation takes into account the following elements above all: Form / Space / Matter / Technique. He has never managed, and still does not manage, to live on his work. He is certainly not the only one. Many foreign critics have written about him and all — absolutely all — Italian critics have done so.

Valentino Vago
Born near Milan in 1931. Lives and works in Milan.
One-man exhibitions: 1960, 1961, 1965, 1969, 1971, 1977 — Salone Annunciata, Milan. 1968,

1973, 1975 — Galleria Morone 6, Milan. 1969 — Galleria Cadario, Rome. 1971 — Galleria Martano Due, Turin. 1973 — Galleria Editalia, Rome. 1974 — Galleria La Piramide, Florence; Galleria Mantra, Turin; 1975 — Galleria Rondanini, Rome; Galerie de Causans, Paris; International Art Fair, Cologne; Galleria Rotta, Genoa. 1976 — Galleria Civica, Valdagno. 1977 — Studio G7, Bologna. 1978 — Galleria Weber, Turin; Galleria Quadrum, Lisbon. 1980 — Palazzo Reale, Milan; Galleria Nuovo Spazio, 2, Venice.
Group exhibitions: 1955 — Rome Quadriennale. 1970 — "L'Immagine Attiva", Mantua. 1971 — Rotonda della Besana, Milan; Musée de l'Athénée, Geneva. 1972 — Biennial of Sao Paolo, Brazil. 1974 — XXVIII Milan Biennale "Flash-Art", Kunstmuseum, Cologne; "I.K.I. '74", Düsseldorf. 1975 — "Critique-Theorie-Art", Galerie Rencontres, Paris. 1976 — "Europa-America. L'Astrazione determinata 1960-1976", Galleria Civica, Bologna. 1977 — International Exhibition, Museum of Modern Art, Belgrade. 1981 — "Linee della Ricerca Artistica in Italia 1960-1980", Palazzo delle Esposizioni, Rome. 1982 — "L'Opera Dipinta", University of Parma and Rotonda della Besana, Milan.

Arte povera, Arte concettuale, Multimedia

Vincenzo Agnetti
Born in Milan in 1926 where he died in 1981.

One-man exhibitions: 1967 — Palazzo dei Diamanti, Ferrara. 1968, 1969 — Galleria Visualità, Milan. 1970 — Galleria Blu, Milan. 1971, 1976 — Galleria La Tartaruga, Rome. 1972 — Galleria Françoise Lambert, Milan; Galleria Martano, Turin; Galleria Schema, Florence; he won the Pascali Award: one-man exhibition at the Museo di Bari. 1972, 1980 — Galleria Toselli, Milan. 1974 — Galerie Verna, Zurich; Galleria Rumma, Naples; Galleria Bonomo, Bari; Galleria Forma, Genoa. 1974 — Galleria Seconda Scala, Rome; his own room at the Ostwall Museum, Dortmund. 1974, 1978, 1980 — Galleria Castelli, Milan. 1980 — Padiglione d'Arte Contemporanea, Milan. 1981 — Galleria Bruna Soletti, Milan. 1982 — Galleria Comunale d'Arte Moderna, Bologna.
Group exhibitions: 1968 — Archivio Storico, Venice Biennale. 1970 — "Vitalità del Negativo", Rome. 1972 — Documenta 5, Kassel. 1973 — Rome Quadriennale, Biennial of Sao Paolo; "Contemporanea", Rome. 1974 — Venice Biennale, book section. 1976 — Taidemuseum, Helsinki. 1976 — Venice Biennale. 1977 — Galleria Nazionale d'Arte Moderna, Rome; New Delhi Triennial. 1978 — Venice Biennale; Palazzo Grassi, Venice. 1980 — Venice Biennale.

Alighiero Boetti
Born in Turin in 1940. Lives and works in Rome.

Exponent of arte povera he presented his work with the group at the Galleria Bertesca in Genoa in 1967. Above all Boetti makes use of found objects which in his hands become objects of use. In fact, he utilises the most varied materials combining them into a playful and conceptual structure. It is also here that his work detaches itself from pauperism exalting the "sensibility" of matter in preference to visual theorization. Recently Boetti has worked on the possibility of the plural work, manifold and autonomous. It is in this sense that one of his works in which his name is doubled in *Alighiero & Boetti* should be read: a duet rather than an ego divided, a duet in which different acts, times and persons meet in order to give life to interminable research.
Boetti has held numerous one-man exhibitions in Milan, Turin, New York, Munich; in 1978 the Basel Kunsthalle gave him a large retrospective exhibition. He has participated in numerous group exhibitions, including the Venice Biennale; "Prospekt 68" and "69" at the Düsseldorf Kunsthalle; "Vitalità del Negativo" in Rome in 1970; "Persona" in Belgrade in 1971; "Contemporanea" in Rome in 1973; "Sette Artisti Italiani" at the Boymans Museum in Rotterdam in 1977.

Beppe Devalle
Born in Turin in 1940. Lives and works in Milan.

He received his diploma from the Liceo Artistico of Turin and at the Accademia Albertina. He began working at the end of the 1950's. He taught at the Liceo Artistico of Turin and was in charge of the special course on Theory of Form and Figuration at the Accademia Albertina. He participated at the Venice Biennale in 1966 and 1972 as well as the Rome Quadriennale of 1972. From 1977 until 1980 he was in charge of the course "Theory of Perception" and "Psychology of Form" at the Accademia di Brera in Milan. In 1979 the Regione Piemonte organised a retrospective exhibition in the rooms of Palazzo Chiablese in Turin. Since 1980 he has held the Chair of Painting at the Accademia di Brera in Milan. He participated in the Italian section of the 1982 Venice Biennale.

Emilio Isgrò
Born in Barcellona (Sicily) in 1937. Lives and works in Milan.

One-man exhibitions: 1966 — Galleria Il Traghetto, Venice. 1967 — Galleria Apollinaire, Milan. 1969 — Galleria del Naviglio, Milan. 1970 - Galleria Schwarz, Milan. 1972 — Studio Santandrea, Milan; Galerie Senatore, Stuttgart; Galleria Blu, Milan. 1973 — Istituto Italiano di Cultura, Stockholm; Galleria LP 220, Turin; Galleria La Bertesca, Genoa. 1974 — Studio G7, Bologna; Li Rumma, Naples; Galleria Blu, Milan. 1975 — Stu

dio Trisorio, Naples; Galleria Blu, Milan. 1976 — Scuderie della Pilotta, Parma; Il Capricorno, Venice. 1977 — Padiglione d'Arte Contemporanea, Ferrara; Galleria Lastaria, Rome; Galleria Schema, Florence. 1978 — Studio Ennesse, Milan. 1979 — Rotonda della Besana, Milan. 1981 — Galleria Luisella d'Alessandro, Turin.
Group exhibitions: 1965 — "Poesia Visiva", Galleria La Caraba, Genoa. 1970 — "Concrete Poetry?", Stedelijk Museum, Amsterdam. 1972 — XXXVI Venice Biennale. 1973 — "Italian Visual Poetry", Finch Museum, New York; "Scrittura Visuale in Italia", Museo Civico, Turin; "Contemporanea", Rome. 1977 — First prize at the Biennial of Sao Paolo. "Arte in Italia 1960-1977", Galleria Civica, Turin. 1978 — Venice Biennale. 1979 — "Testuale", Rotonda della Besana, Milan.

Jannis Kounellis
Born in Athens in 1936. Lives and works in Rome.

The beginning of his artistic activity was characterized by an interest in informal painting. In 1960 he joined the Roman school with Pascali, Schifano, Fioroni, interesting himself in some fetishistic aspects of the contemporary world and moving close to a sign technique of a Pop type. They are signs which refer to a daily semiology, to an archaic semantic. The recovery of the object led him to enlarge the surface of the painting in order to make it extend its limits into space, until reaching the reconstruction of a real *environment*. In his specific case this is the recovery of nature, animal and vegetal. In 1966 he exhibited a white painting with an enormous rose in black fabric around which there were cages containing live birds. In 1967 he presented works like *Pappagallo*, a live animal balancing on steel wires, and *Cavalli* (Galleria L'Attico, Rome).
Besides his numerous one-man exhibitions in private galleries and museums in both Italy and abroad Kounellis has exhibited his works at numerous international exhibitions such as the Venice Biennale and Documenta in Kassel.

Eliseo Mattiacci
Born in Cagli di Pesaro in 1940. Lives and works in Rome.

One-man exhibitions: 1967 — Galleria La Tartaruga, Rome. 1968, 1969, 1971, 1972, 1976 — Galleria L'Attico, Rome. 1969 — Galerie Alexandre Iolas, Paris. 1971 — Galleria Toselli, Milan. 1972 — Galleria Schema, Florence. 1973 — Galleria Alexandre Iolas, Milan. 1974 — the Alexandre Iolas Gallery, New York. 1978 — Galleria La Salita, Rome. 1979 — Jean and Karen Bernier Gallery, Athens; Galleria de Foscherari,

Bologna; Galleria Il Capricorno, Venice; Galleria Cavellini, Brescia. 1980 — Galleria E Tre, Rome. 1981 — Padiglione d'Arte Contemporanea, Milan. 1982 — Galerie Apper + Fertsch, Frankfort on the Main.
Group exhibitions: 1961 — Galleria d'Arte Moderna, Rome. 1965 — Rome Quadriennale. 1967 — "Lo Spazio dell'Immagine", Foligno; VI Paris Biennial; "Mattiacci-Pascali", Galleria Nazionale d'Arte Moderna, Rome. 1969 — "Prospekt 69", Kunsthalle, Düsseldorf; Kunstmuseum, Lucerne. 1971 — "Vitalità del Negativo", Rome. 1972 — Venice Biennale, Rome Quadriennale. 1973 — Museum of Philadelphia. 1975 — Rotonda della Besana, Milan; Biennial of Sao Paolo; Museum of Tokyo. 1976 — Galleria Nazionale d'Arte Moderna, Rome. 1978 — Venice Biennale. 1980 — Palazzo delle Esposizioni, Rome. 1982 — "Exploration in Italian Art", Sydney; "11 Italienische Künstler, Munich.

Mario Merz
Born in Milan in 1925. Lives and works in Turin.

He began his activity within the area of the post-informal and then passed to "assemblage" in which the objects utilised were put into relationship and rendered vital by the presence of a tube of neon. This research developed towards 1966 and became part of the arte povera movement, theorized by Celant. Merz's interest is directed towards space and the surrounding energy culminating in the architectonic attention which is realized in *Igloos*. Since 1968 his research has been directed towards applying and developing Fibonacci's mathematical series in images.
Merz has held numerous one-man exhibitions in Italian and foreign galleries, including 1969 — Galleria L'Attico, Rome; Galleria Sperone, Turin; Galerie Sonnabend, Paris. 1972 — Galleria Sperone, Turin. His most important group exhibitions include 1968 — Kunsthalle, Düsseldorf; 1969 — Stedelijk Museum, Amsterdam; 1978 — Venice Biennale in the historical part of the exhibition where he reexhibited the *Igloo* of 1968). 1980 — Venice Biennale.

Maurizio Mochetti
Born in 1940 in Rome where he lives and works.

One-man exhibitions: 1968 — Galleria La Salita, Rome. 1969, 1976, 1981 — Galleria dell'Ariete, Milan. 1970 — Galleria Christian Stein, Turin. 1971 — Galleria L'Attico, Rome; Galerie Friedrich, Munich; Lucio Amelio, Naples. 1971, 1972, 1979 — Galleria Françoise Lambert, Milan. 1972 — Editalia, Rome; Galerie Friedrich, Munich and Cologne. 1974, 1975, 1980 — Galleria del Cortile, Rome. 1975 — Stedelijk Van Abbemuseum, Eindhoven. 1977, 1979 — Galleria Ugo Ferranti, Rome. 1977, 1980, 1982 — Galle-

ria Persano, Turin. 1978 — Städtische Kunsthalle, Düsseldorf. 1979 — Galleria E Tre, Rome. 1981 — Galerie Walter Storms, Munich. 1982 — Forum Kunst, Rottweil.
Group exhibitions: 1969 — First Pascali Award; Kunstverein, Hamburg; first sculpture award at the VI Paris Biennial. 1970 — Venice Biennale; "Vitalità del Negativo", Rome. 1973 — X Rome Quadriennale. 1974 — "Kunst bleibt Kunst", Cologne. 1976 — Sydney Biennial. 1977 — Istituto Italiano di Cultura, Tokyo. 1978 — Venice Biennale. 1979 — "Le Stanze", Genazzano. 1981 — Palazzo delle Esposizioni, Rome. 1982 — Künstler Werkstätten, Munich; Venice Biennale; "Exploration in Italian Art", Sydney.

Giulio Paolini
Born in Genoa in 1940. Lives and works in Turin.

One-man exhibitions: 1964, 1971 — Galleria La Salita, Rome. 1965, 1968, 1970, 1972, 1975 — Galleria Notizie, Turin. 1966, 1971 — Galleria dell'Ariete, Milan. 1967, 1969 — Galleria del Leone, Venice. 1967, 1978, 1981 — Galleria Christian Stein, Turin. 1969 — Studio La Tartaruga, Rome. 1971, 1974, 1975, 1976, 1977, 1978, 1981 — Galerie Paul Maenz, Cologne. 1972, 1974 — Galleria Bonomo, Bari. 1972 — Modern Art Agency, Naples; Sonnabend Gallery, New York. 1973 — Galleria Toselli, Milan; Galleria Françoise Lambert, Milan; Galleria L'Attico, Rome; Galleria Sperone-Fischer, Rome; Royal College of Art, London. 1973, 1976, 1979 — Studio Marconi, Milan. 1973, 1975, 1977, 1980 — Galerie Annemarie Verna, Zurich. 1974 — Museum of Modern Art, New York. 1975 — Galerie Art in Progress, Munich; Galleria D'Alessandro/Ferranti, Rome; Studio G7, Bologna. 1976 — Samangallery, Genoa; University of Parma. 1976, 1978 — Galerie Yvon Lambert, Paris. 1976, 1981 — Banco, Brescia. 1977 — Sperone Westwater Fischer Gallery, New York; Städtisches Museum, Mönchengladbach; Mannheimer Kunstverein e. V. 1977, 1979 — Lisson Gallery, London. 1977, 1980 — Galleria Ugo Ferranti, Rome. 1978 — Museo Diego Aragona Pignatelli Cortes, Naples; A.R.C. 2, Musée d'Art Moderne de la Ville de Paris. 1979 — Stedelijk Museum, Amsterdam; Museum of Modern Art, Oxford. 1981 — Galleria Nazionale d'Arte Moderna, Rome. 1982 — Padiglione d'Arte Contemporanea, Milan; Kunsthalle Bielefeld; Von der Heydt-Museum, Wuppertal; Neuer Berliner Kunstverein, Berlin.

Vettor Pisani
Born in Naples in 1934. Lives and works in Rome.

Architect, sculptor, painter and theatre author. Son of a Navy officer, of Venetian origin, from the Island of Ischia, and of a strip-tease dancer,

he was born on one of the numerous trips which his mother made in order to follow Vettor's father, from port to port, in Naples in 1934. Entrusted to his father's family for his education he lived on the Island of Ischia until 1946. He moved to Naples where he attended the school of the Jesuits and subsequently began architectural studies. At the age of nineteen he totally abandoned his family in order to follow a Rosicrucian Master as a disciple. In 1970, after long years of study in complete silence, he exhibited for the first time in Rome, winning the Italian National Award of Art Criticism. He founded a theatre and Rosicrucian school of art in Rome.

Michelangelo Pistoletto
Born in Biella in 1933. Lives and works in Turin.

One-man exhibitions: 1960 — Galleria Galate, Turin. 1964, 1967 — Galerie Sonnabend, Paris. 1964, 1966, 1967, 1970, 1971, 1973, 1975 — Galleria Sperone, Turin, Rome and Milan. 1965 — Galerie Friedrich, Munich. 1966 — Studio of Pistoletto "Oggetti in meno", Turin; Palais des Beaux Arts, Brussels. 1968 — Galleria L'Attico, Rome; a personal room at the Venice Biennale. 1969 — Museum Boyman-van Beuningen, Rotterdam. 1970, 1973 — Galleria dell'Ariete, Milan. 1973 — Galleria Marlborough, Rome. 1975 — Art Agency Gallery, Tokyo; Galleria Christian Stein, Turin. 1976 — Incontri Internazionali d'Arte, Rome; retrospective exhibition at Palazzo Grassi, Venice. 1976, 1978, 1979, 1980 — Galleria Persano, Turin. 1977 — Museo Villa Pignatelli d'Aragona, Naples. 1978 — retrospective exhibition at the Nordjillands Kunstmuseum, Aalborg; Galerie National, Berlin; "Pistoletto in Berlin", 14 Commune spaces in the city, Berlin. 1979 — Rice Museum, Houston; Los Angeles Institute of Contemporary Art. 1980 — University Art Museum, Berkeley; Museum of Modern Art, San Francisco. 1981 — Ala Gallery, New York. 1982 — Galleria Toselli, Milan.
Selected group exhibitions: 1966 — Venice Biennale; prize at the Biennial of Sao Paolo; V Paris Biennial. 1968 — Documenta 4, Kassel. 1970 — Museum of Modern Art, New York; Palazzo delle Esposizioni, Rome. 1976 — Venice Biennale. 1978 — Venice Biennale. 1981 — Centre Pompidou, Paris. 1982 — Documenta 7, Kassel.

Franco Vaccari
Born in 1936 in Modena where he lives and works.

One-man exhibitions: 1970 — Galleria Blu, Milan. 1972 — XXXVI Venice Biennale. 1975 — Galleria Cavellini, Brescia. 1976 — Galleria De' Foscherari, Bologna. 1977 — Studio Marconi, Milan. 1978 — Galerie Gaetan, Geneva; Remont Gallery, Warsaw. 1979 — Studio Marconi, Milan; P.A.C. Genoa. 1980 — XXXIX Venice Biennale.

Group exhibitions: 1973 — "Combattimento per un'immagine", Galleria d'Arte Moderna, Turin; "Foto Linguagem", Museum of Modern Art, Rio de Janeiro; "Trigon 73", Neue Galerie, Graz. 1974 — "Fotomedia", Museum am Ostwall, Dortmund; "Narrative Art I", Galleria Cannaviello, Rome. 1975 — "A Space: A Thousand Words", RCA Gallery, London; "Ricerca Artistica Attuale in Italia", Istituto Italiano di Cultura, Tokyo. 1976 — "Les boites du XXsiècle", Musée d'Art Moderne de la Ville de Paris. 1977 — "Settimana Internazionale della Performance", Galleria Comunale d'Arte Moderna, Bologna. 1979 — XVI Milan Triennale. 1980 — "Camere Incantate", Palazzo Reale, Milan. 1981 — "La Linea della Ricerca Artistica in Italia 1979/1980", Palazzo delle Esposizioni, Rome. 1982 — "Il Mestiere delle Arti", Castello Sforzesco, Milan.

Michele Zaza
Born in Molfetta where he lives and works.

One-man exhibitions: 1972, 1974 — Galleria Diagramma, Milan. 1973, 1975 — Galleria Marilena Bonomo, Bari. 1974, 1979 — Banco/Massimo Minini, Brescia. 1974 — Galleria Forma, Genoa. 1975, 1979 — Galerie Verna, Zurich. 1976 — Galleria Alessandro-Ferranti, Rome; Galleria Lucio Amelio, Naples. 1976, 1978, 1981 — Galerie Yvon Lambert, Paris. 1977, 1980 — Galleria Françoise Lambert, Milan. 1978, 1979, 1980 — Samangallery, Genoa. 1980 — Leo Castelli Gallery, New York; Galleria Capricorno, Venice. 1981 — A.R.C. 2, Paris. 1982 — Erika + Otto Friedrich, Bern; Arte Borgogna, Milan.
Group exhibitions: 1973 — Museum of Modern Art, Rio de Janeiro. 1974 — "Contemporanea", Rome. 1976 — IX Paris Biennial. 1977 — "Giulio Paolini Michele Zaza", Fine Arts Building, New York; Documenta 6, Kassel. 1979 — "Europa 79", Stuttgart; "Artemisia", Galerie Yvon Lambert, Paris. 1980 — XXXIX Venice Biennale; "Camere incantate", Palazzo Reale, Milan; "Ils se disent peintres — ils se disent photographes", A.R.C. Musée d'Art Moderne de la Ville de Paris. 1981 — "Arte Italiana 1960-1980", Rome. 1982 — Documenta 7, Kassel.

Gilberto Zorio
Born in Andorno Micca in 1944. Lives and works in Turin.

From the beginning Zorio's work was characterized by an interest in searching out the most hidden laws within matters. In 1967 he held his first one-man exhibition, at the Galleria Sperone in Turin, where the works exhibited showed strange gravitational effects. In his work we continuously rediscover related materials unknown since antiquity and conversely, others which characterize our technological society. He has had numerous one-man exhibitions including 1969 — Galerie Sonnabend, Paris. 1970 — Sonnabend Gallery, New York. 1971 — Galleria Fiori, Florence. Group exhibitions include III Biennial of young painting at the Galleria Comunale in Bologna, the 10th International Art Exhibition of Japan, Tokyo, the VII Paris Biennial, the X Rome Quadriennale.

Scultura

Pietro Coletta
Born in Bari in 1948. Lives and works in Milan.

Exhibitions: 1972 — Premio San Fedele, Milan; XV Festival dei Due Mondi, Spoleto. 1973 — X Rome Quadriennale. 1974 — XXVIII Milan Biennale; "Dal Progetto all'Opera", Museo di Castelvecchio, Verona. 1976 — "Gubbio 66", Gubbio. 1977 — "03-23-03", Montreal and Galerie Nationale du Canada, Ottawa. 1979 — "Le Alternative del Nuovo", Palazzo delle Esposizioni, Rome; Museo Progressivo, Livorno; Parco Massari, Ferrara; "La Section d'Or", Pinacoteca Comunale, Ravenna; "Pittura-Ambiente", Palazzo Reale, Milan. 1980 — "Arte e Critica", Galleria Nazionale d'Arte Moderna, Rome. 1981 — "Strutture Virtuali", Biblioteca Civica of Saronno and the Museo di Castelvecchio, Verona; "Linee della Ricerca Artistica in Italia 1960-1980", Palazzo delle Esposizioni, Rome. 1982 — Venice Biennale; "Exploration in Italian Art", Power Gallery of Contemporary Art, Sydney.

Pietro Consagra
Born in Mazara del Vallo in 1920. Lives and works in Rome.

He was among the founders — in 1947 — of the "Forma" group and of the review *Forma I*, affirming the values of an abstract expressive language. In the same year, together with other artists, he organised the first abstract art exhibition at the Art Club in Rome and held a one-man exhibition at the Galleria Mola followed, the year after, by another at the Galleria Sandri in Venice. Besides his numerous one-man exhibitions Consagra has been invited to participate in the most important group exhibitions and artistic events in Italy and abroad, including: his own room at the 1956 Venice Biennale; the Gran Premio for sculpture at the Venice Biennale of 1960; he participated in the competition for "The monument to the political prisoner", London, 1953; from 1955 to 1959 showed at the Biennial of Sao Paolo in Brazil; he won the prize at the Carnegie Institute of Pittsburg in 1958; "Aspetti dell'arte italiana contemporanea" at the Galleria Nazionale d'Arte Moderna, Rome, 1964; International Exhibition of Contemporary Sculpture at

he Museum of Paris; he also showed at the 'enice Biennale of 1982. Two large retrospective xhibitions were held at the Palais des Beaux ,rts in Brussels (1958) and at the Boymans 1useum in Rotterdam (1966). In 1973 he exibited at the Palazzo dei Normani in Palermo hile in 1978 he was given a large open air exibition in Matera.

1ario Nanni
orn near Siena in 1922. Lives and works in ,ologna.

1e has been present at a large number of naonal and international exhibitions including Ausstellung — Kunst und Widerstand", Viena, 1954; "Mostra Nazionale di Arti Figurative", poleto. 1957; "Premio San Benedetto del Trono", 1957; Biennale internazionale Repubblica di ,an Marino 1959-1965; Morgan's Paint, Rimini, ,ubiana, Ravenna, 1961, 1971; "Nuove Prospetive della Pittura Italiana", Museo Civico, ,ologna 1962; "Exposition internationale de ravure", Lubiana, 1963, 1965; "Exposition de ,venes pintores italianos", Madrid, 1963; Nuove Tendenze", Premio del Fiorino, ,lorence 1963; IX Rome Quadriennale, 1965; VII nternational Mediterranean Biennial, Alexanria (Egypt), 1967; "Mostra Internazionale di ,cultura all'Aperto", Legnano, 1967; "Al di là ,ella Pittura", San Benedetto del Tronto, 1969; Nuovi Materiali nuove Tecniche", Caorle, 1969; Gennaio 70", Museo Civico, Bologna; "Amore 1io" 1970; "Geografie dell'Attenzione", Palazzo ,ei Diamanti, Ferrara, 1973; "Immagini di 'isualità", Museo d'Arte Contemporanea, Livor-,o, 1975; "Distratti dall'Ambiente", Galleria 'Arte Moderna, Bologna, 1978; "Metafisica ,el Quotidiano", Galleria d'Arte Moderna, Bolo-,na, 1978; "Testuale", Rotonda della Besana, 1ilan, 1979; "Generazione Anni Venti", Rieti, 980.

1rnaldo Pomodoro
,orn in Morciano di Romagna in 1926. Lives and ,orks in Milan.

1e began work as a theatrical designer, and, ,rom 1950 on, has worked in the field of ,ewellery. His first exhibition of sculptures was ,eld in Milan in 1955. With other artists he ,rganised the exhibitions of the "Continuità" ,roup in 1961-1962. In 1965 he held his first 1merican one-man exhibition at the 1arlborough-Gerson Gallery. From 1966 to 1968 ,e taught, as artist in residence, in various 1merican universities. In 1967 he participated in ,he Universal Exhibition in Montreal with his ,culpture Grande Sfera. He was awarded the ,rize at Sao Paolo in 1966 and of the Venice Bien-,ale of 1964. In 1967 he was awarded one of the ,ix prizes of the Pittsburg International Exhibi-

tion of the Carnegie Institute. Since 1968 his works have been shown in travelling exhibitions in Europe and America. A first large exhibition of "sculptures in the town" was shown in Pesaro in 1971. A retrospective exhibition of his works from 1955 up to 1974 was held by the Milan Commune at the Rotonda della Besana. A new research work, centred upon "Pietrarubbia's work", was exhibited in 1976 at the Marlborough and Storm King Gallery in New York. In the autumn of the same year a comprehensive exhibition was held at the Musée d'Art Moderne de la Ville de Paris. The artist, in the meantime, has further developed his activity by way of large habitable sculptures.

Giò Pomodoro
Born in Orciano di Pesaro in 1930. He lives and works in Milan.

He followed technical studies, never attending academies. His first works, as far as the practice of sculpture was concerned, date back to the early '50s. From those years until the early '60s he carried out his works using the technique of negative moulds cut in clay, plaster and cuttlefish bone. He exhibited some of these works formed by the accumulation of "signs", in silver, which he dedicated to E. Pound's *Pisan Cantoes*, at the Venice Biennale in 1956. During the late '50s he abandoned these "sign" experiences by developing them into the "stretch canvas surfaces", which he exhibited at the Venice Biennale of 1962 and at the Marlborough Gallery in New York in 1967.
His one-man exhibition at the Martha Jackson Gallery in New York in 1971 closed the period of the "stretch canvas surfaces" and from this moment on almost all his works were carried out in marble and stone, bronze casting of the same being almost completely excluded. The use of stone is directed to a re-appropriation of the external dimension for the public and collective use of sculpture. The external dimension and the collective use are intrinsic, traditional values of sculpture, which are necessary today so that sculptural practice may recover a meaning and direction with regard to civil usage. The external spaces and the collective aims of artistic work have been removed, in large part, from sculpture, from sculptural practice and active community participation, confined within the passive spaces of the private sector and of museums. The practical and theoretical action of Giò Pomodoro in the last decade was and is entirely directed towards the aim of discovering this external and collective dimension, peculiar to sculpture. Exhibited in this exhibition, therefore, are the "studies" of two already realized and large works and their relative photographic documentation.

Giuseppe Spagnulo
Born near Taranto in 1936. Lives and works in Milan.

He had his first contact with sculptural material at a very early age in his fathers' workshop where he learnt to work at the lathe. In 1959 he enrolled at the Accademia di Brera in Milan, also working as an assistant in the studios of Fontana and Pomodoro. Since 1960 he has dedicated himself to sculpture. His first works were in stoneware and in stone (1960-1965), then in wood and iron (1965-1976). Since 1976 he has conceptualised his work more and more, beginning with the themes of cardboard, landscapes and archeology. In 1980 he spent a year in Berlin, invited by the DAAD, and here he carried out some large works which refer back to the roots of his cultural tradition, from Puglia to Greece. In 1981 he exhibited these works at the Nationalgalerie of Berlin in an exhibition entitled "Erotico, Retorico, Eroico". Since 1965 he has exhibited in numerous galleries and museums in both Italy and abroad.

Mauro Staccioli
Born in Volterra in 1937. Lives and works in Milan.

In 1964 he participated in various exhibitions, showing paintings and engravings. He exhibited his sculptures for the first time at the IX Rome Quadriennale. There followed numerous events in private galleries and public spaces in which a critical reading of space prevailed.
Principal exhibitions: 1972 — "Scultura in Città", Volterra. 1973 — "Sculture Contemporanee nello Spazio Urbano", Parma; "Volterra 73". 1974, 1975 — Studio Santandrea, Milan; "Spazio Attivo-Struttura", Studio Marconi, Milan; 1977 — "Lettura di un Ambiente", Castello Visconteo, Vigevano. 1978 — Venice Biennale. 1979 — "Incontri di Martinafranca", Martinafranca. 1981 — Mercato del Sale and Studio Santandrea, Milan; "La Critica dell'Arte", Galleria Civica d'Arte Contemporanea, Ancona; "Deserto", S. Agostino, Bergamo; "Il Luogo della Forma", Castelvecchio, Verona; "30 anni di arte italiana 1950-1980", Lecco. 1982 — Städtische Galerie, Regensburg; Celle-Art Spaces.

Nuove tendenze

Luciano Bartolini
Born in Fiesole in 1948. Lives and works in Florence.

One-man exhibitions: 1975 — Galleria Françoise Lambert, Milan. 1976 — Galleria Ugo Ferranti, Rome. 1977 — Galleria Françoise Lambert, Milan. 1978 — Galleria Schema, Florence; Galerie Paul Maenz, Köln. 1979 — Galerie

Michèle Lachowsky, Brussels; Galleria Pasquale Trisorio, Naples; Centre d'Art Contemporain, Geneva. 1980 — Galerie 't Venster, Rotterdam; Venice Biennale; Galerie Chantal Crousel, Paris. 1981 — Galleria Françoise Lambert, Milan; Galerie Walter Storms, Munich; Galleria Ginevra Grigolo, Bologna; Villa Romana, Florence. 1982 — Galleria Alberto Weber, Turin.

Francesco Clemente
Born in Naples in 1952. Lives and works in Rome and in Madras.

One-man exhibitions: 1971 — First one-man exhibition in Rome. 1974 — Galleria Area, Florence. 1975 — Galleria Sperone, Rome, Turin; Banco, Brescia; Galleria Toselli, Milan. 1976 — Galleria Sperone, Rome; Galleria De Domizion, Pescara. 1977 — Galleria Paola Betti, Milan. 1978 — Centre d'Art Contemporain, Geneva; Art and Project, Amsterdam; Galerie Paul Maenz, Cologne. 1979 — Art and Project, Amsterdam; Lisson Gallery, London; Galleria Mazzoli, Modena; Galleria De Crescenzo, Rome; Galleria Lucio Amelio, Rome; Galleria Sperone, Turin; Galerie Paul Maenz, Cologne. 1980 — Sperone Westwater Fischer Gallery, New York; Galerie Paul Maenz, Cologne; Padiglione d'Arte Contemporanea, Milan; Art and Project, Amsterdam; Galleria Diacono, Rome; Galleria Sperone, Rome. 1981 — Sperone Westwater Fischer Gallery, New York; Verening voor het Museum van Hedebdaagse Kunst, Gent; Anthony D'Offay Gallery, London.
Group exhibitions: 1975 — XII Biennial of Sao Paolo. 1977 — Paris Biennial, Musée d'Art Moderne, Paris. 1979 — "Perspective 79", Basel Artfair; "Europa 79", Stuttgart; "Le Stanze", Genazzano. 1980 — "Aperto 80", Venice Biennale; "Westkunst", Cologne.

Omar Galliani
Born in 1954 in Montecchio where he lives and works.

One-man exhibitions: 1977, 1980, 1981 — Studio G7, Bologna. 1978 — Galleria Civica del Teatro, Parma. 1979 — Galleria Peccolo, Livorno; Galerie Drehscheibe, Basel; Politecnico, Rome; Galleria Forma, Genoa. 1980 — Galleria Primo Piano, Rome; Museo Archeologico, Syracuse. 1981 — Galleria La Salita, Rome; Artra Studio, Milan; Castel Sant Elmo, Naples.
Group exhibitions: 1979 — International Drawing Triennial, Kunsthalle, Nuremberg; "Le Alternative del Nuovo", Palazzo delle Esposizioni, Rome; "L'Annunciazione di Antonello", Museo Bellomo, Syracuse; "Il Nuovo Contesto", Studio Marconi, Milan. 1980 — "Fiat Lux", Alessandria; "Nuova Immagine", Milan Triennale; "Arte e Critica", Galleria Nazionale d'Arte Moderna, Rome; "Magico Primario", Palazzo dei

Diamanti, Ferrara. 1981 — "Enciclopedia", Galleria Civica, Modena; XVI Biennial of Sao Paolo; "Linee della Ricerca Artistica in Italia", Palazzo delle Esposizioni, Rome; "La Ruota del Lotto", Palazzo dei Convegni, Jesi. 1982 — "La Storia, il Mito", Galleria d'Arte Moderna, Verona; "Generazioni a Confronto", University of Rome; "100 Anni di Arte Italiana, 1880-1980", Municipal Museum, Tokyo; XII Paris Biennial.

Marcello Jori
Born in Merano in 1950. Lives and works in Bologna.

One-man exhibitions: 1977, 1982 — Galleria De' Foscherari, Bologna. 1978 — Studio Morra, Naples. 1980 — Studio Trisorio, Naples. 1981 — Studio Marconi, Milan; Galleria Alberto Weber, Turin; "One Man Shows", Naples.
Group exhibitions: "La Settimana della Performance", Galleria d'Arte Moderna, Bologna. 1980 — "I Nuovi Nuovi", Galleria Comunale d'Arte Moderna, Bologna; "The Italian Wave", Holly Solomon Gallery, New York; "Arte e Critica", Galleria Nazionale d'Arte Moderna, Rome; "Ut Pictura Poesis", Pinacoteca Comunale, Ravenna. 1981 — "Enciclopedia-Il Magico Primario in Europa", Galleria Civica, Modena; "Razionale Decorativo", Turin; "La Qualità", Ferrara; "Aljofre Barroco", Noto (Syracuse); "La Frase e il Discorso", Cortina d'Ampezzo. 1982 — "Due Generazioni a Confronto", University of Rome; "Registrazione di Frequenze", Galleria Comunale d'Arte Moderna, Bologna; Paris Biennial; Venice Biennale.

Luigi Mainolfi
Born in 1948 near Avellino. Lives and works in Turin.

One-man exhibitions: 1972, 1973 — Centro Arte Europea, Naples; Galleria Oggetto, Caserta. 1976 — Galleria Marin, Turin. 1977 — Studio Morra, Naples; Nuovi Strumenti, Brescia; Galleria Il Tritone, Biella. 1978 — Galleria Piero Cavellini, Brescia. 1980 — Galleria Arco D'Alibert, Rome; Studio G7, Bologna. 1981 — Galleria Tucci Russo, Turin; Galleria P. Pero, Milan; Galleria Piero Cavellini, Brescia; Galleria Dossi, Bergamo; Castel Sant'Elmo, Naples. 1982 — Apper + Fertsch, Frankfurt.
Group exhibitions: 1977 — "La Settimana Internazionale della Performance", Bologna. 1979 — Sistina Società per Arte, Arte Fiera, Bologna. 1980 — "I Nuovi Nuovi", Galleria Comunale d'Arte Moderna, Bologna; "Nuova Immagine", XVI Triennale, Milan. 1981 — "Linee della Ricerca Artistica in Italia", Palazzo delle Esposizioni, Rome; "La Qualità", Ferrara; Biennial of Sao Paolo. 1982 — "Generazioni a Confronto", University of Rome; "La Sovrana Inattualità",

Padiglione d'Arte Contemporanea, Milan; "11 Italienische Künstler", Künstler Werkstätten, Munich; XL Venice Biennale; Documenta, Kassel.

Piero Manai
Born in 1951 in Bologna where he lives and works.

One-man exhibitions: 1978 — Galleria Martano, Turin; Galleria G7, Bologna; Galleria Ginevra Grigolo, Bologna. 1979 — Galleria La Piramide, Florence. 1980 — Galleria Arco D'Alibert, Rome; Palazzo dell'Arengo, Rimini. 1981 — Galleria De Foscherari, Bologna; Parallelwindow Gallery, New York.
Group exhibitions: 1980 — "Nuova Immagine", Palazzo della Triennale, Milan. 1981 — "20 Anni di Pittura in Italia", Palazzo delle Esposizioni, Rome. 1982 — Paris Biennial.

Giuseppe Maraniello
Born in Naples in 1945. Lives and works in Milan.

One-man exhibitions: 1977 — Galleria Diagramma, Milan. 1978 — Galleria Cavellini, Brescia. 1980 — Galleria Fabjbasaglia, Bologna; Artra Studio, Milan; Galleria Diagramma/Luciano Inga Pin, Milan. 1981 — Galleria Fabjbasaglia, Bologna.
Group exhibitions: 1975 — "Campo 10", Galleria Diagramma, Milan; "Fotomedia", Rotonda della Besana, Milan; "Photography as Art-Art as Photography", Maison Européenne de la Photographic, Chalon sur Saôn. 1977 — "Pratica", Studio Marconi, Milan. 1979 — "L'Estetico e il Selvaggio", Galleria Civica d'Arte Moderna, Modena. 1980 — "Italiana-Nuova Immagine", Loggetta Lombardesca, Ravenna; "Dieci Anni Dopo-I Nuovi Nuovi", Galleria Comunale d'Arte Moderna, Bologna; "Linee della Ricerca Artistica in Italia 1960-1980", Palazzo delle Esposizioni, Rome; "La Qualità", Padiglione d'Arte Contemporanea, Ferrara. 1982 — "Forma Senza Forma", Galleria Civica, Modena.

Gianfranco Notargiacomo
Born in 1945 in Rome where he lives and works.

One-man and group exhibitions: 1971 — Galleria La Tartaruga, Rome. 1972 — Galleria La Salita, Rome. From 1979: 1979 — The meetings on work communications of contemporary artists at the Istituto di Storia dell'Arte of the University of Rome. 1980 — XI Paris Biennial; "Magico Primario", Palazzo dei Diamanti, Ferrara. 1981 — "Enciclopedia", Museo Civico, Modena; "Arte e Critica", Galleria Nazionale d'Arte Moderna, Rome; "Linee della Ricerca Artistica in Italia 1960-1980", Palazzo delle Esposizioni, Rome; "La Ruota del Lotto", Pinacoteca of Jesi; "Per-

sonal One-Man Shows", Castel Sant'Elmo, Naples; Artra Studio, Milan; Galleria G7, Bologna; Galleria Vigato, Alessandria. 1982 — "Generazioni a Confronto", Istituto di Storia dell'Arte dell'Università, The Meeting, Rome; "Mostre Parallele", Museo A. Forti, Verona; "Officine e Ateliers", Casa del Mantegna, Mantua; "Settimo Cielo"; Galleria Weber, Galleria Il Mulino, Turin; XL Venice Biennale; Galleria Weber, Turin.

Luigi Ontani
Born in Vergato Montovolo. Lives and works in Rome.

Mimmo Paladino
Born near Belluno in 1948. Lives and works in Milan.

One-man exhibitions: 1977, 1979, 1981 — Galleria Lucio Amelio, Naples. 1977, 1980 — Galleria dell'Ariete, Milan. 1978, 1980 — Galleria Persano, Turin. 1978, 1980 — Galerie Paul Maenz, Cologne. 1978, 1980 — Galleria Toselli, Milan. 1979 — Galleria Mazzoli, Modena; Art and Project, Amsterdam. 1980 — Galerie Verna, Zurich; Badischer Kunstverein, Karlsruhe; Nosei Gallery, New York. 1980, 1982 — Marian Goodman Gallery, New York. 1981 — Mario Diacono, Rome; Kunstmuseum, Basel; Kestner Gesellschaft, Hanover; Groninger Museum, Groningen; Galleria d'Arte Moderna, Bologna; Schellmann & Klüser, Munich. 1982 — Waddington Gallery, London; Museums Verein, Wuppertal.
Group exhibitions: 1979 — "Le Stanze", Genazzano. 1980 — Kunsthalle, Basel; Museum Folkwang, Essen; Stedelijk Museum, Amsterdam; Venice Biennale. 1981 — "A New Spirit In Painting", Royal Academy of Art, London; Paris Biennial; "Westkunst", Cologne. 1982 — Sydney Biennial; Documenta 7, Kassel; "Portraits et Figures", Galerie Beyeler, Basel.

Salvo
Born in Leonforte in 1947. Lives and works in Turin.
One-man exhibitions: 1970 — Galleria Sperone, Turin. 1970, 1976 — Galleria Françoise Lambert, Milan. 1971 — Galerie Yvon Lambert, Paris. 1971, 1972, 1973, 1974, 1975, 1980, 1981 — Galerie Paul Maenz, Cologne. 1972, 1981 — Art and Project, Amsterdam. 1973 — John Weber Gallery, New York; Galleria Sperone-Fischer, Rome. 1973, 1974 — Galleria Toselli, Milan. 1974 — Galerie 't Venster, Rotterdam. 1975 — Galleria Banco, Brescia. 1976 — Galleria di Palazzo Galvani, Commune of Bologna. 1977 — Museum Folkwang, Essen; Kunstverein, Mannheim. 1978 — Galleria Stein, Turin. 1982 — Museum Van Hedendaagse, Gand.
Group exhibitions: 1970 — Kunstmuseum,

Lucerne. 1971 — "Arte Povera", Kunstverein, Munich; Kunsthalle, Düsseldorf. 1972 — Documenta 5, Kassel. 1973 — VIII Paris Biennial; Kunstverein, Hanover. 1974 — Städtisches Museum, Leverkusen; Indianapolis Museum of Art. 1976 — Venice Biennale. 1978 — Kunsthalle, Hamburg. 1979 — "Testuale", Rotonda della Besana, Milan; "Le Stanze", Genazzano; "10 Anni Dopo-I Nuovi Nuovi", Galleria d'Arte Moderna, Bologna; "The Italian Wave", Holly Solomon Gallery, New York. 1981 — "La Ruota del Lotto", Jesi; "La Qualità", Ferrara; "Linee della Ricerca Artistica in Italia 1960-1980", Palazzo delle Esposizioni, Rome; Biennial of Sao Paolo, Brazil.

Aldo Spoldi
Born in 1950 in Crema where he lives and works.
He exhibited for the first time in a one-man exhibition at the Galleria Diagramma/Luciano Inga Pin, in Milan, in 1978. He presents works whose titles refer to theatrical events about to take place. His painting is strictly connected to the theatre as is shown in the *Manifesto della Pittura Teatrica* compiled by him in 1979 and presented with an exhibition at the Studio d'Arte Cannaviello in Milan. In 1981 he held the exhibition "Maestro Pulce" at the Studio Marconi, in Milan, in which the pictorial materials are staged: the instruments of painting become a show.
Group exhibitions: 1979 — "Il Nuovo Contesto", Studio Marconi, Milan. 1980 — "10 Anni Dopo-I Nuovi Nuovi", Galleria Comunale d'Arte Moderna, Bologna; "Nuova Immagine", Palazzo della Triennale, Milan; "The Italian Wave", Holly Solomon Gallery, New York. 1981 — XI Paris Biennial; A.R.C. Musée d'Art Moderne Paris; "Magico-Primario", Palazzo dei Diamanti, Ferrara; "La Qualità", Padiglione d'Arte Contemporanea, Ferrara; "Linee della Ricerca Artistica in Italia 1960-1980", Palazzo delle Esposizioni, Rome; "Art International d'Aujourd'hui", Palais des Beaux Arts, Brussels. 1982 — "Registrazione di Frequenze", Galleria Comunale d'Arte Moderna, Bologna; XL Venice Biennale.

Performance, Nuova spettacolarità, Immagine sonora

Giuseppe Chiari
Born in 1926 in Florence where he lives and works.
Studied mathematics and music. In 1947 he started his own jazz-club, he began to compose about 1950 and joined Fluxus in 1962.
In his music-performances he has made use of, among other things, instruments transformed from their original form and objects that belong more usually to "every day life". His instructions for "Lavoro" (1965) were: "All round the per-

former are many different things placed in the most complete disorder. He arranges them in the proper order. He follows his own idea of what their proper order is".
Chiari is also known for his (mostly rough-lettered) statements, such as "Art is Easy" and "All Music is The Same", in catalogues, on posters, etc.

Luisa Cividin / Roberto Taroni
Luisa Cividin born in Trieste in 1955. Roberto Taroni born in Milan in 1956.
They live and work in Milan.

Performances: 1977 — Out Off, Milan. 1978 — "II Settimana Internazionale della Performance", Bologna. 1979 — "Passaggio a Sud Ovest", Palazzo Reale, Caserta; Autunno Musicale, Como; "Lo scarto dell'occhio", Sixto/Notes, Milan; Franklin Furnace, New York. 1980 — "Teatro e Musica verso nuove forme espressive", Pistoia; I.C.C, Antwerp; Künstlerhaus, Hamburg; "Cirque Divers," Liegi. 1981 — Galleria Nazionale d'Arte Moderna, Rome; Kölnischer Kunstverein, Köln; Folkwangmuseum, Essen; Kunstakademie, Düsseldorf; "3 Symposium International d'Art Performance", Lyon; "Invasioni Spaziali", Florence. 1982 — Von-der-Heydt Museum, Wuppertal; "Continuità della Performance", Galleria Comunale d'Arte Moderna, Bologna; Pinacoteca di Brera, Milan.

Dal Bosco/Varesco
Francesco Dal Bosco born in 1955 in Trento where he lives and works.
Fabrizio Varesco born in 1954 in Trento where he lives and works.

They began their work of performances in 1976 with "Addio mia amata". There then followed the performances "Lettere d'amore" in Paris, "Sentieri selvaggi" in Mantua and Milan, "Humphrey Bogart è stato qui" in 1978 in Bologna; the film "Distant drums" at the festival of Abano Terme; "Miami", of 1979, in Trento, Bologna, Milan and Caserta; "Stelle", of 1980, at the Castello Sforzesco in Milan, Ferrara and Rome; the film "Stanze" presented at the Collective for Living Cinema in New York; "Cow boy esotico", of 1981, in Antwerp, Bologna, Rome, Ravenna etc. with a sound track by Tony Rusconi from the Orchestra Recording House of Milan. In November 1981 they founded the cinematographic production company called "Missione Impossibile" and produced the full-length film "La notte che vola", winning a special prize for cinematographic research at the "Film Maker" festival organised by the Province of Milan. And for the Italian Television Network (RAI) they produced the telefilm "Killer di primavera" and "Cow boy esotico".

All the performances and actions are dedicated to the cinema.

Falso Movimento

Mario Martone born in Naples in 1959; Tomas Arana born in Auburn (California) in 1955; Andrea Renzi born in Rome in 1963; Licia Maglietta born in Naples in 1954; Lino Fiorito born in Ferrara in 1955; Pasquale Mari born in Naples in 1959; Angelo Curti born in Naples in 1959; Daghi Rondanini born in Bari in 1958.
They live and work in Naples.

Productions: 1977 — "Avventure al di là di Tule". 1978 — "L'incrinatura; Musica da camera"; "L'apprendista stregone"; "Altre circostanze". 1979 — "Segni di vita"; "Verso il nulla"; "Theatre functions critical/terminated"; "Falso Movimento live"; "Dallas 1983". 1980 — "Rosso texaco"; "Soft mediterraneo". 1981 — "Controllo totale". 1982 — "Tango glaciale"; "Otello". 1982 awarded "Premio Mondello" and the Italian critics prize.

Gaia Scienza

1976 — "La rivolta degli oggetti", Rome, Salerno, Cosenza; "Luci sulla città", Cosenza. 1977 — "Cronache marziane", Rome, Pistoia; "Una notte sui tetti", Rome. 1978 — "Blu oltremare", Pistoia, Mantua, Rome, Bologna; "Sogni proibiti", Milan; "L'uomo che sapeva troppo", Cosenza; "Malabar Hotel", Cosenza, Palermo, Rome, Pistoia. 1979 — "La macchina del tempo", Rome, Terni; "Il nodo di Gordio", Rome; "Il ladro di Bagdad", Caserta. 1980 — "Ensemble", Rome; "Chamber music ensemble", Rome; "Ensemble: la corrente del golfo", Pistoia; "Variations III" by J. Cage, Rome. 1981 — "Così va il mondo", Rome; "Turchese", Rome, Terni, Perugia, Palermo, Florence, Cologne, Düsseldorf, Essen; "Etonnante", Livorno; "Scintille", Varese. 1982 — "Gli insetti preferiscono le ortiche", Rome, Sydney; "Fashion show", Rome.

Arrigo Lora-Totino
Born in 1928 in Turin where he lives and works.

Founder and director of *Antipiugiù*, a review of experimental literature (4 numbers from 1960 to 1966) and of *Modulo*, a review of contemporary culture, the first number of which was an international anthology of concrete poetry (Genoa, March 1966). In 1964, with the musician Enore Zaffiri and the plastic operator Sandro de Alexandris, he founded the *Studio di informazione estetica* in Turin for research into interrelations between visual and sound poetry, plastics and electronic music and for the diffusion of constructivist plastic research. In 1966 he was the organiser of the visual poetry exhibition at the Faculty of Architecture in Turin (see *Il Com-*

passo, no 1, ottobre 1966, Turin). In 1969 he was the organiser of the exhibition of concrete poetry at Ca' Giustinian (Venice Biennale, September-October 1969). In 1978, for Cramps Records (Milan) he published *Futura, Poesia Sonora*, an anthology in seven L.P.'s of sound poetry and a historical-critical presentation from Italian Futurism up until the present day.

Adriano Spatola
Born in 1941. Lives and works in Molino di Brazzano.

As a critic he has published *Verso la poesia totale* and as a visual poet has published a long series of *Zeroglifici*. He directs the poetry review *Tam Tam* and the periodical of sound poetry *Baobab*. His volumes of poetry include *Diversi accorgimenti*. Amongst his most important performances are: "Teoria & Pratica dell'Apoesia", Pavia; "P.77", Venice; "La città favolosa", Mantua; "The End of the Game", University of California, Berkeley; "Seconda Settimana Internazionale della Performance", Bologna; "Poetry Readings at the Ned Kelly Tavern, Sydney; "La musica e la performance", La Spezia; "The 12th International Sound Poetry Festival", New York; "Poésie sonore", Le Havre; "Poésie sonore", Rennes; "Poésie sonore", Centre Beaubourg, Paris; "2° Festival internazionale dei poeti", Piazza di Siena, Rome; "Poésie à la limite du son", Liège; "Toward a Total Poetry", Venice (Los Angeles); "Setimana d'accions poetiques", Valencia.

Antonio Syxty
Born in Buenos Aires in 1957. Lives and works in Como.

In 1975 he attended theatre courses in the United States at the Western Michigan University and at the Kalamazoo Art Center. He attended the Scuola d'Arte Drammatica "Piccolo Teatro" in Milan from 1977 to 1979. In 1978 he joined the Out-Off Cultural Association of Milan which produces all of his shows. Since 1978 he has been concerned with experimental theatre. He has realised numerous shows and performances in Milan, Rome, Florence, Naples, Bologna and in numerous other Italian towns. He has participated at events and festivals of theatre research in both Italy and abroad. In 1980 he created the "Antonio Syxty Fan Club". He has written a book and contributes to daily papers with columns and articles.
Productions: 1978 — "Ingredients: five holes and three rings waterproof". 1979 — "W, M o di alcuni tentativi di salare il sale e attraversare un muro". 1980 — "Kennedy", "Nuova Zelanda". 1981 — "Copertine", "Famiglia Horror". 1982 — "Il grido (bassa marea)".

Giuliano Zosi
Born in Rome in 1940. Lives and works in Milan.
1951 — Began to study the piano at the Liceo Musicale in Bologna. 1952 — first composition of a Suite for piano: *Sette pezzi fantastici*. 1955-1961 — He returned to Rome where he continued his piano studies at the Conservatorio di S. Cecilia. He later began composition studies. He met the soprano Erminia Santi and began a series of concerts with her in Italy. 1962-1965 — Period of intensive studies of counterpoint and the fugue under the direction of Irma Ravinale. 1965-1968 — He moved to Florence where he concluded his studies of composition. He took part in the '68 revolutionary movement in Rome, joining the Roman underground movement together with Luca Lombardi, Domenico Guaccero, Mauro Bortolotti and Antonello Neri. Together they founded the Gruppo Rinnovamento Musicale. 1965-1971 — He lived in Florence where he studied electronic music. He was, in the meantime, busy composing *Ritratto di Gregor Samsa*, a symphonic work which won the Oscar Esplà competition of 1974. 1968-1976 — He taught composition, Nuova Didattica at the Conservatorio of Pesaro: he began a period of experimentation at various levels, from the analytic to the didactic. He perfected his studies in composition at the Accademia di S. Cecilia; he graduated in electronic music. 1977 — He moved to Milan where he founded the Ricerca Intercodice Suono Giallo Group.

Film and Video

Ferruccio Ascari
Born in Lecce in 1949. Lives and works in Milan.

"Collective for Living Cinema", New York; 1980 — "Audio Works", Sixto Notes, Milan; Künstlerhaus, Hamburg; Venice Biennale, "Progetto speciale: Il tempo e la memoria"; "Mixed Media", Capo d'Orlando; RAI, Fonosfera; 1981 — "Ombre Metropolitane"; Galleria d'Arte Moderna, Rome; "Cronografie", Rotonda della Besana, Milan; "The Bank", Amsterdam; Incontri Internazionali di Martinafranca; "Ultimi Segnali", Varese; 1982 — "Simposio Internazionale", E.L.A.C., Lyon; Zona, Florence; Spazio Zero, Rome; "Punto d'Osservazione", Naples.

Valentina Berardinone
Born in Naples in 1929. Lives and works in Milan.

One-man exhibitions: 1958 — Galleria del Naviglio, Milan. 1960 — Galleria dell'Ariete, Milan; Galleria de Arte Moderna, Sao Paolo, Brazil. 1969 — Galleria dell'Ariete, Milan. 1973 — Galleria dell'Ariete and Galleria Milano, Milan. 1977 — Galleria Lastaria, Rome. 1979 — Galleria dell'Ariete.

Group exhibitions: 1969 — "Campo Urbano" (intervention), Como. 1970 — Biennale D'Art (séction du cinéma d'art), Menton; Rassegna d'Arte Contemporanea, Acireale. 1971 — Galleria Stein (projection of films), Turin. 1973 — XV Triennale, Milan. 1974 — "Fotomedia", Museum am Ostwall, Dortmund; "Film d'artista", Museo Progressivo, Livorno. 1975 — International Centrum ("Cinema di artisti"), Antwerp. 1977 — "Ipotesi 80", Expoart, Bari; "Arte in Italia 1960-1977", Galleria d'Arte Moderna, Turin; "Il Gergo Inquieto", Palazzo del Comune, Genoa. 1978 — Venice Biennale (section "Cinema di artisti"); "The International Drawing Triennial", Wroclaw (Poland); "L'Occhio dell'Immaginario", Galleria d'Arte Moderna, Turin, 1979 — Centre Beaubourg and Cinémathèque Française, "Cinéma d'Artiste en Italie", Paris. 1980 — "Camere Incantate" (installation and film), Palazzo Reale, Milan. 1981 — "Linee della Ricerca Artistica in Italia 1960-1980", Palazzo delle Esposizioni, Rome; Centre Beaubourg, "Identité Italienne" (séction du cinéma expérimental), Paris.

Cioni Carpi
Born in Milan in 1923. Lives and works in Milan and Canada.

One-man exhibitions: 1960 — Fairleigh Dickinson University, painting Rutherford, N.J. 1962 — Galerie Mira Godard, painting Montreal. 1972 — Galeria Iolas, stretcherless paintings and films, Madrid; Diagramma, "Progressive Analyses", multimedia with slide and film projections, Milan; Galerie Meyer, stretcherless paintings and films, Lausanne. 1973 — Galerie Grafikmeyer, "Palimpsests" and first version of "Violence as Palimpsest" slide installation, Karlsruhe. 1974 — Yellow Now, "Palimpsests", Liège; Diagramma, "Transfigurations" and the film "Transfiguration Zero", Milan. 1975 — Véhicule Art, "Transfigurations" and "Transfiguration Zero", Montreal; A Space, "Transfigurations" and "Transfiguration Zero", Toronto. 1976 — Galleria Borgogna, audio-visual installation/performance, Milan; Centro Internazionale Brera, films from 1960 to 1974, Milan. 1977 — Vancouver Art Gallery, wallworks, films and audiovisual installation/performance, Vancouver; Galleria d'Arte Moderna, audio-visual installation/performance, Bologna. 1978 — Palazzo Reale, "Milano '80", audio-visual installation/performance and film, Milan; Marilena Bonomo, "Between Life and Life" and film, Bari. 1979 — Studio Marconi, "Between Life and Life", Milan. 1980 — Museo de Arte Contemporaneo, "7 Countries, 7 Days", installation/performance, Caracas; Arnolfini Gallery, "One to come and one to go", wallworks, films, installations, Bristol; Palazzo Reale "Camere Incan-

tate", Milan. 1981 — XXXIX Venice Biennale; Galleria d'arte contemporanea, Films on Art, Montreal.

Claudio Cintoli
Born in Imola in 1935. Died in Rome in 1978.

Fernando De Filippi
Born in Lecce in 1940. Lives and works in Milan.

One-man exhibitions: 1965 — Galleria Il Cavallino, Venice. 1966 — Galleria Il Centro, Naples. 1967 — Galleria Del Levante, Rome. 1969 — Studio Santandrea, Milan. 1971 — Galleria Arte Borgogna, Milan; Wspolczesna Gallery, Warsaw. 1973 — Galleria Arte Borgogna, Milan; Palais des Beaux Arts, Brussels. 1974 — A.R.C. 2 Musée d'Art Moderne de la Ville de Paris, Paris. 1975 — Cultural Center, Belgrade; Galerie Lara Vincy, Paris; Palazzo dei Diamanti, Ferrara. 1976 — Galleria Toselli, Milan; XXXVI Venice Biennale (personal room — Attualità Internazionali). 1977 — Mercato del Sale, Milan. 1978 — Quadrum Gallery, Lisbon. 1979 — Salone Annunciata, Milan; Galleria Rotta, Genoa; Galerie St. Petri, Lund. 1980 — Franklin Furnace, New York; Studio Trisorio, Naples; I.C.C. Antwerp; Studio Grossetti, Milan; Museum of Modern Art, Vancouver.
Group exhibitions: 1964 — Rome Quadriennale. 1966 — Salone Internazionale dei Giovani, Venice, Turin, Milan. 1970 — XXXIV Venice Biennale. 1972 — "Engagierte Kunst", Vienna. 1974 — "Lives" Fine Art Building, New York. 1979 — Galleria d'Arte Contemporanea, Modena; "Testuale", Rotonda della Besana, Milan. 1980 — "Camere incantate", Palazzo Reale, Milan; Venice Biennale. 1981 — "Linee della Ricerca Artistica in Italia 1960-1980", Palazzo delle Esposizioni, Rome.
He participated as a film maker at the following: 1976 — "Arte e cinema in Italia", I.C.C., Antwerp. 1978 — XXXVIII Venice Biennale; Centre Pompidou, Paris. 1980 — Giornate Internazionali del Cinema d'Artista, "Cine Qua Non", Florence.

Fonosfera
Armando Adolgiso born in Naples. He lives and works in Rome.
Pier Pinotto Fava born in Matera. He lives and works in Rome.

Yervant Gianikian & Angela Ricci Lucchi
The live and work in Milan. 1975 — Film Studio 70, Rome. 1976 — Cinema Biennale, "Proposte Nuovi Film", Venice; Cineclub Brera, Milan. 1977 — "Settimana internazionale Performance", Museo d'Arte Moderna, Bologna; Palazzo dei Diamanti, Ferrara; Cineclub Brera, Milan; "Il Gergo Inquieto", Cinema d'avanguardia in Italia, Palazzo Turdi, Genoa. 1978 —

Galleria d'Arte Moderna, Turin; Pinacoteca di Ravenna; "Giornate Internazionali del Cinema d'Artista, Florence; "Arte e Cinema", Venice Biennale; Cinémathèque Française, Paris; Centre George Pompidou, Paris. 1979 — Third International Avant-Garde Film Festival, National Film Theatre, London; "Words", Bochum Museum, Bochum; "Words", Palazzo Ducale, Genoa. 1980 — Film Co-Op, London; South West Independent Film Tour, England; "Camere incantate", Palazzo Reale, Milan; Anthology Film Archive, New York; Tour in the U.S.A. 1981 — "Identité Italienne", Centre Pompidou, Paris; "Linee della Ricerca Artistica in Italia 1960-1980", Rome; Philadelphia Museum of Art; C.R.T., Milan; Facoltà Lettere e Filosofia, Turin; Movie Club, Turin; Tour in the U.S.A. 1982 — "Incontri Cinematografici", Salsomaggiore.

Andrea Granchi
Born in 1947 in Florence where he lives and works.

One-man exhibitions: 1980 — personal room in "Camere Incantate", Palazzo Reale, Milan. 1982 — Galleria De Amicis, Florence. Group exhibitions: 1974 — Venice Biennale Cinema d'artista section. 1975 — Cinema d'artista, Museo Progressivo, Livorno; Cinema d'artista, I.C.C., Antwerp. 1977-1978 — "Seripla, arte moltiplicata dentro e fuori d'accademia", Turin; *Arte e Cinema in Italia*, Museo Civico, Ravenna; "La mano dell'occhio", Florence; "Arte e Cinema, documenti storici e attuali", Venice Biennale; "Cinema d'artista in Italia 1960-1978", Cinémathèque Française/Centre Pompidou, Paris, International Graphic Biennial, "La spirale dei nuovi strumenti", Florence. 1979 — Third Avant-guard Festival, London; "Cine Qua Non", Florence. 1980 — "Camere incantate", Milan. 1981 — "Linee della ricerca artistica in Italia 1960-1980", Rome; Cambridge Animation Festival, Cambridge. 1981-1982 — "Lo spazio scenografico della televisione Italiana", Milan Triennale; "Iride, schedule d'arte", Villa Romana, Florence.

Ugo La Pietra
Born in Bussi in 1938. He lives and works in Milan.

One-man exhibitions: 1972 — Galleria Schema, Florence. 1975 — Neue Galerie, Graz; Mercato del Sale. 1976 — Institut de l'environment, Paris. 1977 — Palazzo dei Diamanti, Ferrara. 1980 — Werkbund, Berlin.
Group exhibitions: 1968 — Museum of Contemporary Crafts, New York. 1969 — La Nuova Loggia, Bologna; Campo Urbano, Como; Museum am Ostwall, Dortmund. 1972 — Museum of Modern Art, New York; "Contemporanea", Rome. 1974 — Museum Joounem, Graz. 1975 — Royal Col-

lege of Art, London; Galleria d'Arte Moderna, Bologna; International Cultural Centrum, Antwerp. 1976 — Venice Biennale. 1977 — Museo Civico, Turin, 1978 — Venice Biennale. 1979 — Centre Pompidou, Paris. 1980 — Palazzo Reale, Milan. 1981 — Palazzo delle Esposizioni, Rome; Rotonda della Besana, Milan. 1982 — IDZ, Berlin. As well as various editions of the Milan Triennale.

Plinio Martelli

Born in 1945 in Turin where he lives and works. Filmography: 1967 — "IV Dimensione", 16mm black & white, sound track, 15' (projection in negative). 1968 — "Mariafotografia", 16mm black & white, sound track, 15' (projection in negative). 1969 — "Swine Sheep", 16mm black & white, sound track 30'. 1976 — "Tv (television)", S/8mm colour, magnetic sound track, 20' (actors: Enzo Reda, Maria Reda). 1976-1977 — "Ogni corpo occupa un suo spazio", S/8mm colour, magnetic sound track, 30' (Actor: Enzo Reda). 1977 — "Skin Deep (Pelle incisa)", S/8mm colour magnetic sound track, 20' (actors: Enzo Reda, Maria Reda). 1978 — "La Sala delle Torture", S/8mm colour, magnetic sound track, 25' (actors: Tony Armando, Enzo Reda, Maria Reda); "La Commedia dell'Arte", ovvero "Il castello della voluttà", S/8mm colour, magnetic sound track (direct take), 20' (actors: Enzo, Claudia, Tony, Vittorio). 1979 — "The End", S/8mm colour, sound track (direct take), 25' (actors: Tiziana Arnaboldi, Paolo Di Leonardo, Rosy Galeone, Michele Ordine, Adriano Valianti). 1980 — "Andante falso-Moderatamente", 16mm colour, sound track, 15' (actors: Tiziana Arnaboldi, Paolo Di Leonardo, Rosy Galeone); "Comunicazione a circuito chiuso", Electronic black & white, sound track (direct take), 25', (actors: Paolo Di Leonardo, Rosy Galeone).

Antonio Paradiso

Born at Santeramo, near Bari, in 1936. Lives and works in Milan.

He studied at the Brera School of Art in Milan, under Marino Marini. He has held exhibitions in Italy and abroad. For ten years he has travelled in the Sahara deserts, carrying out palaeanthropological research in order to combine scientific experiment with anthropological art. Among the most important of these journeys have been: "Crossing of the Tenere", August 1975, Milan and back on the Djanet track, 40 days. Three Land Rovers. "Bidon V", August 1976, Milan and back via the Agadez-Tamanrasset track, 40 days, one Land Rover, one Fiat Campagnola. Up "The Nile", December 1979, Milan-Khartoum-El Obeid-Kadugli and back, 90 days, one Land Rover, one Mercedes Unimog. Since 1977 he has been working on the anthropological theatre. Paradiso lives and works in Milan.

Luca Maria Patella

Born in 1938 in Rome where he lives and works.

He is known for the complex technical and semantic relations which he has promoted in his work: painting, photography, films, graphics, writing.
One-man exhibitions: Galleria L'Attico, Rome; Galleria Apollinaire, Milan; Incontri Internazionali d'Arte Rome; Galerie Vincy, Paris; Mercato del Sale, Milan. Retrospective exhibitions: International Cultural Centrum, Antwerp, 1976; Pinacoteca Provinciale, Bari, 1976 (he was awareded the "Premio Pascali"); Museo dell'Università, Parma, 1977; Casa del Mantegna, Mantua, 1978; Museo de Arte Contemporaneo, Sao Paolo and Rio de Janeiro, 1982. Group exhibitions: Venice Biennale 1966, 1972, 1978, 1980; Biennials of Tokyo and Kyoto, 1966, 1968, 1979; Paris Biennial, 1967 (he was awarded an International Prize); Museum of Modern Art, New York, 1970 ("Information"); Biennale of Sao Paolo, 1975; International Cultural Centrum, Antwerp, 1975 ("Aspecten Actuele Kunst uit Italië"); Cinémathèque Nationale-Centre Beaubourg, Paris, 1978; Palazzo Reale, Milan, 1980 ("Camere incantate"); Biennial of New Delhi, 1982.

Fabrizio Plessi

Born in Reggio Emilia in 1940. Lives and works in Milan and in the Veneto region.

Since 1962 he has participated at all of the most important artistic events in both Europe and the U.S.A. In 1970 he showed at the Experimental Pavilion of the XXXV Venice Biennale, in 1972 at the XXXVI Venice Biennale.
In 1975 he was invited to show in the Video section of the Paris Biennial; in 1978 at the Venice Biennale in the Fotografia section; in 1980 at the Venice Biennale in the Cinema Musica section.
Since 1968 he has worked exclusively on the theme of water, alternating installations with films, videotapes with performances, involving different media although becoming increasingly more interested in the television means. He was in fact one of the very first Italian artists to use this means, experimenting with different techniques and looking for alternative supports. The most recent period has seem him very interested in the relationship of sound/image, the video/film and the video/theatre/live.
After "Travel" of 1974, special prize at the Art Film Festival at Asolo, and after "Imprevisto/improvviso" of 1974, "Un buco nell'acqua" of 1974 and "Blu + Blu" of 1975, his first full-length film was "Splash" of 1977 which was — and remains — one of the first outpourings of electronic band in 16mm films.

Michele Sambin

Born in Padua in 1951 where he lives and works.

Since 1968 he has carried out research which has always had the relationship between image and sound as its centre, investigating the most diverse forms with the help of a vast range of expressive and technical means. Initially he made use of cinematographic techniques, realising some films with which he participated at numerous international festivals of experimental cinema. Having graduated in electronic music he experimented in research with the computer and videotape, which very soon became the principal instrument of his works; with this means he produced performances, realised installations and produced numerous art tapes in which the vast range of expressive potential of the television means is investigated. The experiences realised in this field have been continuously re-elaborated in a parallel graphic-pictorial production and are also to be found in the most recent theatrical activities of the "TAM teatromusica" group, founded by him.

Gianni Emilio Simonetti

Born in Rome in 1940. Lives in Milan.

Filmography: "Teoria e pratica dell'architettura spontanea" (1970); "Morire a Parigi" (1974).

Lenders to the exhibition

Art & Project, Amsterdam
Banco/Massimo Minini, Brescia-Milan
Brionvega, Milan
Roberta Cerini, Vergiate
Civiche Raccolte d'Arte, Milan
Carletto Dani, Florence
Tullia Denza, Brescia
Anthony d'Offay, London
Ferrarese, Turin
Teresita Fontana, Milan
Galerie Maeght, Paris
Galleria De' Foscherari, Bologna
Galleria La Salita, Rome
Galleria Mantra, Turin
Galleria Tucci Russo, Turin
Luciano Giaccari, Varese
Carlo Grossetti, Milan
Teresa Iannacone, Molfetta
Lorenzetti Arte, Milan
Valeria Manzoni, Milan
Mercato Del Sale, Milan
Marco Nino, Turin
Franz Paludetto, Turin
Giorgio Persano, Turin
Pinacoteca Civica, Iesi
Giovanola Renardet, Rome
Fabio Sargentini, Rome
Filippo Schettini, Milan
Studio Carrieri, Martina Franca
Studio Grossetti, Milan
Studio Marconi, Milan
Waddington Galleries, London
Alberto Weber, Turin

Photographic credits

Claudio Abate, Rome;
Aurelio Amendola, Pistoia;
Attilio Bacci, Milan;
Aldo Ballo, Milan; Foto Studio Boschetti, Milan;
Erminio Bottura, Milan; P. Bressano, Turin;
Jean Brokerhof; Angelo Bufi, Molfetta;
Carlo Cantini, Florence; Mario Carrieri, Milan;
Lorenzo Capellini, Milan;
Mimmo Capone, Rome; Enrico Cattaneo, Milan;
Giorgio Colombo, Milan;
Bob van Dantzig, Amsterdam; Foto Stampa;
Luca Fiorentino; Reinhard Friedrich, Berlin;
Xandra Gadda; Fabrizio Garghetti, Milan;
Achim Graf, München;
Giorgio Gramatieri, Bologna; Erika Kiffl;
Nanda Lanfranco, Genoa;
Salvatore Licitra, Milan; Titti Marchese, Milan;
Piero Marsili; Silvia Masotti Lelli, Milan;
André Morain, Paris; Maria Mulas, Milan;
Ugo Mulas, Milan; Luciana Mulas, Milan;
Antonia Mulas, Milan;
Paolo Mussat Sartor, Turin;
Mauro Neroni, Rome; Studio Pedrotti, Bolzano;
Paolo Pellion di Persano, Turin;
Salvatore Piermarini, Rome; Francesco Radino;
Piccio Raffanini; Ferruccio Rampazzi, Turin;
Enzo Ricci, Turin; Giovanni Ricci, Milan;
Oscar Savio, Rome; Cristhophe Schimmel;
Fabio Simion, Milan; Guido Simonetti;
Soprintendenza alle Gallerie Roma II;
Galleria Nazionale d'Arte Moderna, Rome;
Studio Gris, Milan; Studio C.N.B. & C., Bologna;
George Tatge; Lorenzo Trento, Padova;
Gianni Ummarino by Studio Marconi, Milan.